KABUKI GREATS

Domestic Dramas

歌舞伎名演目 ── 世話物

Supervised by SHOCHIKU

監修　松竹株式会社

はじめに

　このたび、弊社の監修により「歌舞伎名演目」が出版される運びとなりました。
　現在でもしばしば上演されている人気演目のあらすじ、登場人物、見どころなどを3巻にわたり、写真とともに紹介する企画です。

　本書はその第二巻で、「世話物」の作品16演目を紹介します。
　「世話」とは、「世」間の「話」というほどの意味であり、世上に起こることは善悪を問わず題材となります。いわば江戸時代の現代劇で、アウトローや名もなき市井の人々が登場します。
　世話物では衣裳や台詞、演技も誇張の少ない写実的なものとなり、演者には、リアルな味わいが求められます。今や失われてしまった江戸時代の風俗習慣が舞台上で再現されることも楽しみのひとつです。
　江戸と上方で地域色あふれる演目が生まれ、多くの作品が今に伝承されていますが、本書ではバランスを考慮し演目を厳選いたしました。

　歌舞伎には古くから演者の芸を楽しむという側面があり、脚本や演出においてもストーリーの展開や整合性より、場面の美しさや面白さが優先されることもあります。そのため、あまり細かすぎるあらすじはかえってわかりにくくなるおそれもあり、また、舞台を見ればわかるような展開を羅列するだけの無味乾燥なものに陥ってしまうこともあります。
　そこで本書では、演目の魅力や内容を数行で表す、いわばキャッチコピー的な文章で、演目のイメージを大づかみでつかんでいただくと同時に、簡潔なあらすじとコラム、写真などの多彩な切り口で全体像を伝えることを主眼といたしました。

　歌舞伎の魅力は舞台にあり、書物ではなかなか伝えきることは難しいのですが、お読みになった後でその演目をご覧になった際、演技や舞台がよりお楽しみいただけるような実用にも役立つ一冊を心がけました。
　本書が歌舞伎ご愛好の方々のご観劇のよき手引きとなることはもとより、本書で歌舞伎に初めて触れる方々が劇場に足をお運びいただくきっかけとなれば幸いでございます。

松竹株式会社

Foreword

We are pleased to present the next volume in the *Kabuki Greats* series. The goal of this three-part project is to compile synopses, character profiles, and highlight notes of some of the most oft-performed kabuki plays, along with pictures to aid in understanding and visualization.

Domestic Dramas, the second volume of the series, introduces sixteen *sewamono* plays. *Sewamono,* or domestic dramas, are plays mostly from the Edo period which depict contemporary events involving colorful casts of commoners and outlaws. These plays take the most literal interpretation of the term *sewa* (talk of the world) by depicting events as they are without making any lofty statements about good and evil.

Sewamono feature realistic depictions of characters, including relatively subdued costumes, scripting, and performances. The ambiance of Old Edo recreated on stage is yet another of the charms of this rich genre.

The *sewamono* repertoire includes a great variety of plays from both the Kanto and Kansai regions, and each features a unique depiction of the region in which it is set. Because of this, we took great care to include a balanced selection of plays in this volume.

In kabuki, the impact of the actors' performance is often the most important part of the show. This has been the case since ancient times, and some may be surprised to hear that plot and consistency are sometimes considered secondary to the sheer beauty and impact of a scene. Because of this, some plays are actually more difficult to understand after reading a detailed synopsis. Indeed, what is meant to be a spectacular show may turn into a cut-and-dry series of events if more emphasis were placed on plot.

In editing this book, we regularly consulted with the writers concerning this aspect of the theater. We wanted to ensure that the charms of kabuki were conveyed in short and appealing language that doesn't require the reader to think too deeply. We only wish to convey the broad strokes of the plot in concise language, while also offering photographs and highlight columns to help readers gain a balanced view of kabuki from different vantage points.

The delights of kabuki are something that can only be seen on the stage. Even so, we hope that our book may offer a practical understanding of the fundamentals of kabuki, allowing readers to enjoy this unique artform more fully.

This book is not only meant to be a guide to kabuki lovers, but also an introduction to the theater for those who have never experienced it for themselves. It is our sincere hope that this book inspires newcomers to make their way to the theater and experience the fascinating world of kabuki for themselves.

SHOCHIKU Co., Ltd.

目次

01 助六 すけろく
Sukeroku —— 10

02 東海道四谷怪談 とうかいどうよつやかいだん
Tokaido Yotsuya Kaidan —— 20

03 盟三五大切 かみかけてさんごたいせつ
Kamikakete Sango Taisetsu —— 30

04 桜姫東文章 さくらひめあずまぶんしょう
Sakura Hime Azuma Bunsho —— 42

05 三人吉三廓初買 さんにんきちさくるわのはつがい
Sannin Kichisa Kuruwa no Hatsugai —— 52

06 青砥稿花紅彩画 白浪五人男 あおとぞうしはなのにしきえ しらなみごにんおとこ
Aoto Zoshi Hana no Nishikie —— 64
— Shiranami Gonin Otoko

07 天衣紛上野初花 河内山 くもにまごううえののはつはな こうちやま
Kumo ni Mago Ueno no Hatsuhana —— 78
— Kochiyama

08 梅雨小袖昔八丈 髪結新三 つゆこそでむかしはちじょう かみゆいしんざ
Tsuyu Kosode Mukashi Hachijo —— 90
— Kamiyui Shinza

Contents

09 与話情浮名横櫛 よわなさけうきなのよこぐし
Yowanasake Ukina no Yokogushi —— 100

10 籠釣瓶花街酔醒 かごつるべさとのえいざめ
Kagotsurube Sato no Eizame —— 110

11 神明恵和合取組 め組の喧嘩 かみのめぐみわごうのとりくみ めぐみのけんか
Kami no Megumi Wago no Torikumi —— 120
— Megumi no Kenka

12 一本刀土俵入 いっぽんがたなどひょういり
Ippon-gatana Dohyo-iri —— 130

13 女殺油地獄 おんなころしあぶらのじごく
Onnakoroshi Abura no Jigoku —— 138

14 曽根崎心中 そねざきしんじゅう
The Love Suicides at Sonezaki —— 148

15 伊勢音頭恋寝刃 いせおんどこいのねたば
Ise Ondo Koi no Netaba —— 156

16 夏祭浪花鑑 なつまつりなにわかがみ
Natsumatsuri Naniwa Kagami —— 166

カバーイラストレーション：『籠釣瓶花街酔醒』八ツ橋
Cover illustration: *Kagotsurube Sato no Eizame*: Yatsuhashi

KABUKI PLAYS

演目紹介

Domestic Dramas

世話物

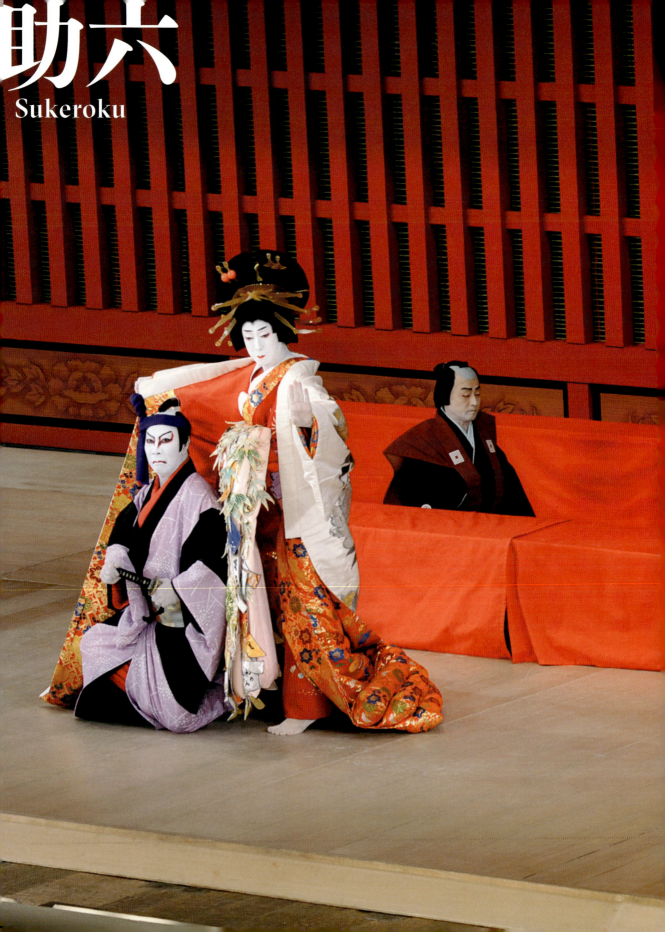

助六
Sukeroku

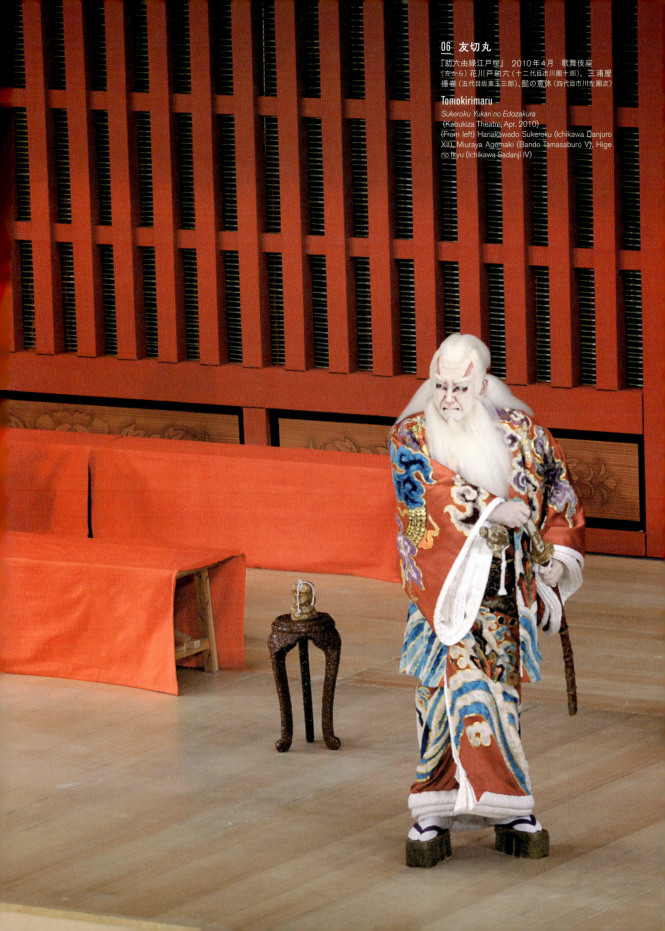

06 友切丸

『助六由縁江戸桜』 2010年4月 歌舞伎座
（左から）花川戸助六（十二代目市川團十郎）、三浦屋揚巻（五代目坂東玉三郎）、髭の意休（四代目市川左團次）

Tomokirimaru
Sukeroku Yukari no Edozakura
(Kabukiza Theatre, Apr. 2010)
(From left) Hanakawado Sukeroku (Ichikawa Danjuro XII), Miuraya Agemaki (Bando Tamasaburo V), Hige no Ikyu (Ichikawa Sadanji IV)

あらすじ / Synopsis

江戸っ子が磨き上げ、江戸っ子が愛した、江戸っ子たちの芝居。これが好きなら、あなたも江戸っ子の仲間入り

悪態だらけで、喧嘩だらけで、洒落だらけで、遊びだらけで、きれいで、面白くて、楽しくて、最後には何も残らない。そんな芝居が現代にあるという奇跡。

——— A play made by and for the people of Edo. If you like this play, you can consider yourself an Edokko, too!

A play filled with foul language, quarrels, and puns that is at once beautiful, hilarious, and thoroughly entertaining, it is truly a miracle that this one has survived to today.

01 揚巻の登場

桜時の江戸吉原仲ノ町。大店「三浦屋」の格子先。花魁たちが全盛の花魁揚巻を待ち受けていると、酔った揚巻の一行が現れる。そして揚巻に手紙が届けられる。恋人の助六の母からであった。助六が毎夜吉原に来て喧嘩をしていることを案じ、もう助六を呼んでくれるなという内容である。揚巻は母の心を察し、自分の恋心とあわせ、女のはかなさを嘆く。

02 白玉・意休の出、悪態のつらね

続いて揚巻の妹分の花魁白玉が、お大尽髭の意休とその子分たちと連れ立ってやってくる。意休は揚巻に執心ながら、気も多く、金に飽かす野暮な遊びぶりである。揚巻の前で助六の悪口を言い始めると、揚巻は意休に向かい悪態を次々述べ立て、その場を立つが、白玉が取りなして店のうちに入る。

03 助六登場

尺八の音が聞こえ、助六が登場する。黒の着付に紫の鉢巻、水際立った男ぶりである。格子先の花魁衆はじめ女たちは全員、我先に吸付莨（たばこ）を差出し大歓待。煙管を欲しがる意休に、助六は足で煙管を差し出すなど、無礼な態度。さらに意休の悪口を言って絡んでいく。

01 Agemaki's Entrance

Yoshiwara Nakanomachi, Edo. Cherry blossom season. At the Miuraya brothel, the clientele wait for Agemaki, the most sought-after geisha. A letter arrives for her from her lover Sukeroku's mother. Worried about her son who has recently taken to picking fights with strangers in Yoshiwara, her letter tells Agemaki not to see Sukeroku anymore. Sympathetic to Sukeroku's mother, Agemaki laments the sad lot of women in this world.

02 Shiratama and Ikyu's Entrance

Agemaki's colleague and mentee Shiratama arrives with the wealthy Hige no Ikyu and his retinue. Though he's in love with Agemaki, Ikyu is a fickle and rather uncouth man who proceeds to slander Sukeroku in front of Agemaki. When Agemaki berates him for his conduct, Ikyu makes to leave but Shiratama helps defuse the situation.

03 Sukeroku's Entrance

Sukeroku makes a spectacular entrance to the notes of a shakuhachi flute, wearing black robes and a purple headband. The geisha all scramble to be the first to welcome him, and after arriving he proceeds to act incredibly rude toward Ikyu. He eventually begins insulting Ikyu to pick a fight with yet another stranger.

04 喧嘩と名乗り

そこへ意休の子分くわんぺら門兵衛が出てくる。傾城たちと一緒に風呂に入ろうとしたが振られてしまったのだ。通りかかったうどん屋福山のかつぎ（出前持ち）が突きあたったためますますいきり立つ。おとなしく謝っていたかつぎも、腹に据えかねて啖呵を切る。助六はうどんを買い取り、門兵衛にかける。騒ぎのさなかに、奴の朝顔仙平も現れ、助六の名を尋ねる。助六は一党に向かって名乗りを上げる。

そして門兵衛、仙平が刀を抜くと、助六は刀を取り上げ、長さをあらため、二人を叩きのめす。さらに助六は意休の頭に下駄を乗せ、ますます挑発する。

意休が刀を抜こうとするが思い直し、鞘に納める。その様子を見た助六は意休の脇息を切るなどやりたい放題。大勢を相手に喧嘩が始まり、意休らは店に入っていく。

05 白酒売

喧嘩を終え、一人残った助六に声をかける男がいる。白酒売の格好をしているがそれは助六の兄で、実は曽我十郎。助六は実は曽我五郎であった。

兄弟は親の仇を討ちたいために苦労をする身の上。それゆえに毎日の喧嘩を兄は心配し、意見をしに来たのであった。

しかし助六の喧嘩には訳があった。兄弟の父は源氏の重宝「友切丸」の刀を紛失しておとがめを受けており、仇討のためには友切丸を捜し出さなければならないのである。そのため、人の多い廓でわざと喧嘩をしかけ、刀を抜かせ、友切丸を捜していたのだ。それを聞いた十郎は、助六に喧嘩を教わり、一緒に始めることにする。

そこへ客を送る揚巻の声。客と思い、助六と白酒売のふたりが喧嘩を売ったのは母満江。助六の身を案じる母は、喧嘩ができないようにと、破れやすい紙の着物を与え、兄と帰っていった。

06 友切丸

そこに意休の声。揚巻は裲襠（うちかけ）のうちに助六を隠す。しかし悪口を言う意休に、助六はたまりかねて飛び出す。ところが、意休は助六に兄弟団結して親の仇を討てと思いがけない意見の上、兄弟に見立てた香炉台を斬って見せる。その時抜いた刀こそ友切丸。いきり立つ助六を、揚巻は意休の帰り際を待つようなだめる。

04 Quarrel and Introduction

Kuwanpera Monbei, one of Ikyu's supporters, arrives and attempts to take the geisha into the bath with him, but is rejected. The udon shop worker Fukuyama no Katsugi happens by just then and runs into Monbei, further angering him. Katsugi apologizes but eventually loses his patience and snaps at Monbei. Just then, Sukeroku decides to buy some udon from Katsugi and throw it onto Monbei's head. At the height of this quarrel, Monbei's servant Asagao Senpei arrives, demanding Sukeroku's name, and Sukeroku confronts the crowd and introduces himself.

Monbei and Senpei draw their swords, but Sukeroku takes up his own sword and strikes the two down. Sukeroku further antagonizes them, putting sandals on Ikyu's head.

Ikyu makes to draw his sword but thinks better. When Sukeroku sees this, he realizes he can do as he pleases. As he begins fighting with the crowd, Ikyu and his retinue go back inside the brothel.

05 The White *Sake* Seller

After the quarrel ends, a man dressed as a white *sake* seller calls out to Sukeroku. Soon he realizes that it is actually Sukeroku's brother Soga no Juro, and it is revealed that Sukeroku himself is actually Soga no Goro.

The Soga brothers are charged with avenging their father's death, yet Juro can't understand why Goro spends his days picking fights with strangers.

As it turns out, however, there is a reason for Sukeroku's (actually Goro) belligerent ways. Their father had lost the Minamoto clan's treasured sword Tomokirimaru, and it must be found in order for the brothers to exact their revenge. Therefore, Goro spends his time in the pleasure quarters starting fights with anyone he comes across in hopes that the current holder of Tomokirimaru will draw the blade and reveal it to him. Now that Juro understands his brother's intentions, he decides to help him.

Just then Agemaki's voice is heard seeing a patron off. The brothers automatically accost this client, but it is soon revealed to be their mother Manko in disguise, come to dissuade Sukeroku from picking any more fights by making him wear a paper kimono that will tear easily. She then leaves with Juro, still disguised as a white *sake* seller.

06 Tomokirimaru

Ikyu now reappears and Agemaki hides Sukeroku beneath her flowing bridal robes. Sukeroku, however, cannot bear the insults he hears coming from Ikyu and bursts out of his hiding. Unaware that Sukeroku is one of the Soga brothers who seek revenge, Ikyu draws his sword and cuts down the incense stand the brothers have set up. Sukeroku sees that Ikyu's sword is none other than Tomokirimaru, his father's sword. He is enraged at this revelation, but Agemaki convinces him to wait until Ikyu leaves to act.

07 水入り

夜更けの廓。助六は意休と仙平が三浦屋から出てくるのを待ち伏せしていた。意休は実は伊賀平内左衛門という平家の遺臣。頼朝に恨みを持ち、頼朝を仇と狙う兄弟を味方に引き入れようと、友切丸を盗んでいたのだ。助六は意休を斬り、刀を手に入れるが、自分も斬られ手傷を負う。人目を避け、天水桶の中に隠れ、出てきたときに気を失ってしまう。揚巻の介抱で気が付き、危機を脱した助六は友切丸を手に、廓を落ち延びていく。

07 In the Water

Late night in the pleasure quarters. Sukeroku lies in wait for Ikyu and Senpei to exit Miuraya. Ikyu's true identity is the Taira clan retainer Iga Heinaizaemon, who stole the sword in hopes of turning the Soga brothers to his side to help kill Yoritomo whom he has a grudge against. Sukeroku now kills Ikyu and retrieves the stolen sword, but in doing so he sustains a wound to his arm as well. He hides in a rain barrel to avoid suspicious eyes, but loses consciousness when he climbs out. When he wakes, he finds that Agemaki has nursed him to health. Now with sword in hand, he safely escapes the pleasure quarters.

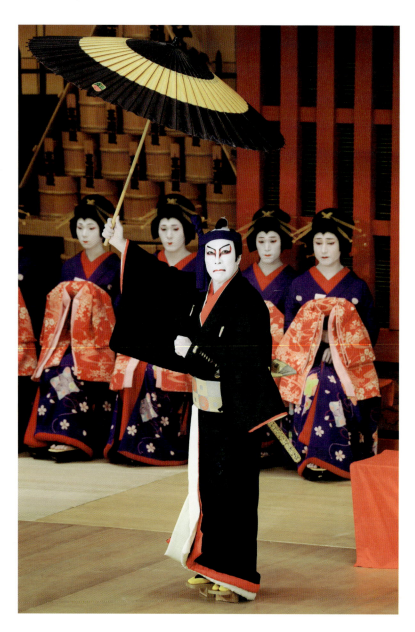

03 助六登場

『助六由縁江戸桜』 2010年4月
歌舞伎座
花川戸助六（十二代目市川團十郎）

Sukeroku's Entrance
Sukeroku Yukari no Edozakura
(Kabukiza Theatre, Apr. 2010)
Hanakawado Sukeroku (Ichikawa Danjuro XII)

作品の概要

演目名
助六

作者
不詳

概要

　江戸歌舞伎を代表する演目の一つである。市川團十郎家では助六の登場場面（出端）の音曲に河東節を用い、『歌舞伎十八番の内　助六由縁江戸桜』の名題で上演。尾上菊五郎家では清元で『助六曲輪菊』として上演と、演者によって音曲と名題が変わるのが通例で、ほかに長唄や常磐津が使用される。そのため、この稿では『助六』と総称している。

　「助六」は、長い時間をかけて確立されたものであり、成立時点については意見がわかれる。二世團十郎が助六という人物に扮したのを初演とすることが多く、本書でもそれに従うが、すでに上方にあった助六と揚巻の心中事件を扱った狂言を江戸に移したものだといわれる。二世團十郎の二度目の助六で、曾我の世界と結びつき、三度目で扮装が確立したといわれる。河東節を用いての上演はもっと後になる。

　掲載あらすじは、現行の台本によっているが、水入りまでの上演は少ない。また、俳優により演出に多少の異同があるが、共通する内容を示している。

初演

正徳3（1713）年、江戸・山村座上演の『花館愛護桜（はなやかたあいごさくら）』で、二世市川團十郎がはじめて助六に扮したのが初演とされる。通称「助六」。

Overview

Title
Sukeroku

Writer
Unknown

Overview

　Sukeroku is a representative piece of Edo kabuki. In the Ichikawa Danjuro tradition, Sukeroku's entrance is accompanied by *Kato-bushi* music, and the play is billed as *Sukeroku Yukari Edozakura* of the 18 Kabuki Greats. In the Onoe Kikugoro tradition it is performed under the title *Sukeroku Kuruwa no Momoyogusa*. It is common for the title and style of music to change depending on the actors starring in it, and therefore we have used the common title of Sukeroku here.

　Sukeroku developed over a long period of time, and opinion is divided as to when the play developed into what it is today. Many claim that it was first performed by Danjuro II, and we tend to agree with this assessment. It is worth noting, however, that it is said that this performance was derived from a *kyogen* play that dealt with Sukeroku and Agemaki's love suicide which was written and performed in Kyoto before coming to Edo. So it could be said that Danjuro II's Sukeroku was the second version, and the integration of the Soga brothers constitutes the third version of the play. The use of *kato-bushi* music was yet a later development.

　The synopsis given here is based on the script used in modern performances, but it is rare for the play to be performed all the way up to the final scene. There is also great variation depending on the actors starring in a given performance, and as such, only the common elements of the story have been covered here.

Premiere

First performed at the Yamamuraza Theatre in Edo, 1713 as part of *Hanayakata Aigo no Sakura*. Feat. Ichikawa Danjuro II as Sukeroku. Commonly known as Sukeroku.

登場人物 / Characters

花川戸助六 実は 曽我五郎
はなかわどのすけろく じつは そがのごろう

花の吉原で遊女たちの人気を一身に集める男伊達の総本山・花川戸助六、実は親の仇を狙う曽我五郎。毎夜毎夜廓に通い相手かまわず喧嘩を吹っかけては刀を抜かせることで有名だが、それも紛失した名刀友切丸を捜し出すため。吉原で全盛を誇る三浦屋の揚巻とは相思相愛の仲。曽我五郎すなわち江戸荒事の強さを持つが、母から勧められた紙衣（かみこ）に着替え上方和事の味も併せ持つ。

Hanakawado no Sukeroku / Soga no Goro

Popular among the geisha of Hana no Yoshiwara, Sukeroku's true identity is Soga Goro, one of the Soga twins seeking vengeance for his father's death. He is known as a ruffian who picks fights with anyone in sight, but this is actually part of his search for the famed sword Tomokirimaru which belonged to his father. He has a romantic relationship with Miuraya Agemaki, and though his Edo-style *aragoto* role, there is great depth to his character. When he changes into a paper kimono (*kamiko*) offered by his mother, his character is infused with the gentler wagoto style.

髭の意休
ひげのいきゅう

余るほどの金に飽かして毎夜吉原に通い、三浦屋の揚巻を口説き続ける大尽は人呼んで「髭の意休」、実は伊賀平内左衛門という元は平家の武士である。相も変わらず揚巻に入れあげるが、一心に助六を思う揚巻は一向になびかない。その助六にもきつい悪態をつかれ、頭に下駄を乗せられても刀は抜かず。しかし香炉台を斬って見せた瞬間、それが友切丸であることを助六に見破られる。

Hige no Ikyu

A man of vast wealth who often visits Agemaki at Yoshiwara, "Hige no Ikyu" is what many call this character, though his true identity is Iga Heinaisaemon, a former Taira clan samurai. He makes many advances toward Agemaki but she remains faithful to Sukeroku. When Sukeroku picks a fight with Hige no Ikyu, he refuses to draw his sword even when a sandal is placed on his head. When he finally does draw his sword and cuts down an incense burner, Sukeroku sees immediately that he has the stolen blade Tomokirimaru.

白酒売新兵衛 実は 曽我十郎
しろざけうりしんべえ じつは そがのじゅうろう

助六すなわち五郎の荒事と対照的に、和事の柔らかみを持った兄・十郎を登場させるのは歌舞伎の曽我物のお約束。五郎が毎夜喧嘩を繰り返すのを知り意休をしにやってくるが、その喧嘩も友切丸を捜すためと分かり喧嘩の手伝いをしようと申し出る。「鼻の穴へ屋形船を蹴込むぞ」「股アぐれ」と真似をしてみるがどうも様にはならない。やがて現れた母の満江にも悪態をつき恐縮する。

Shinbei the White *Sake* Seller / Soga no Juro

Shinbei (Soga Juro) is a gentle wagoto character to contrast the *aragoto* style of his brother, Sukeroku (Soga Goro). Though he initially comes to stop his brother from getting into fights, when he finds out that Goro is doing so only to ascertain the whereabouts of the sword Tomokirimaru, he decides to help his brother. He attempts to emulate his brother's rough language which only serves to show how ill-suited he is to such a rough lifestyle. His mother Manko eventually appears in disguise and, when he finds out her identity, Juro immediately regrets speaking to her in such distasteful language.

三浦屋揚巻
みうらやあげまき

吉原三浦屋の遊女だが、美しさと格、人気、そして凛とした意気地どれを取っても並ぶ者のない随一の花魁である。横恋慕する髭の意休から助六の悪口を言われると、「例えていわば雪と墨」「暗がりで見てもお前と助六さん、取り違えて良いものかいなあ」と、この上ない悪態をつく。相手にどれほど権力と金があろうとも一歩も引かぬその姿勢は江戸庶民の喝采を浴び、今また現代人をも魅了する。

Miuraya Agemaki

A geisha of the highest class at Yoshiwara Miuraya, Agemaki possesses beauty, character, charm, and fortitude. When Sukeroku's jealous rival Hige no Ikyu speaks ill of him in front of her, Agemaki shoots back, saying the two are "like snow and ink" and that "even in the dark one would be a fool to mistake the two of you for one another". She is a stunningly strong woman who stands her ground no matter how much power or money her enemies have. This quality made her as popular among Edo audiences as she is today.

三浦屋白玉
みうらやしらたま

揚巻の朋輩でやや妹分にあたる花魁。髭の意休と連れ立って花魁道中を華やかに繰り広げ艶やかに登場する。揚巻が意休にさんざんの悪態をつき、揚句はその場を立ち去ろうとするのをひきとめてなだめ、穏便に持っていこうと心を遣う。揚巻に負けず劣らず美しく華やかであるが、これからまだ花を大きく咲かせようという売り出しの若女方にとって、まさしく格好の役である。

Miuraya Shiratama

A fellow geisha who is like a younger sister to Agemaki, she adds vitality to the procession of geisha when she arrives with Hige no Ikyu. When Agemaki berates Ikyu, Shiratama consoles him and helps to defuse the situation as he goes to leave. A beautiful woman on the same level as Agemaki, Shiratama is an excellent role for up-and-coming onnagata actors.

曽我満江
そがのまんこう

曽我五郎・十郎の母親。助六の喧嘩沙汰を心配し、揚巻に会うため男装をして吉原へやってくる。相も変わらず喧嘩を続ける助六たちの前に現れ、兄の十郎は知らずに悪態をつく母と知れると俄かに縮み上がる。そして助六には喧嘩をすれば破れてしまう紙衣を与え、喧嘩を戒めるよう諭す。歌舞伎の手法でいえば、紙衣は上方和事の象徴そのものである。

Soga no Manko

Mother to the Soga brothers, Manko disguises herself as a man to enter the brothel and speak to Agemaki out of concern for Sukeroku's disgraceful behavior. She eventually comes to Sukeroku and his brother to confront them, but Juro berates her before he realizes who she is. He immediately regrets his words, and she admonishes Goro for his belligerence, giving him a paper kimono that will rip should he get into any more fights. In kabuki terms, such a kimono (called a *kamiko*) is a symbol of the gentle *wagoto* style, so the meaning of this gesture (stop all this fighting!) should be apparent to kabuki-goers.

くわんぺら門兵衛
かんぺらもんべえ

髭の意休の子分で男伊達の親分格だが、いかにも無粋で嫌がられ、助六にも好きなようにいたぶられる。遊女と風呂へ入ろうともくろむが一人も来ず、揚句は「女郎の湯漬けをかっ込むぞ」と悪態をつく有様。通りかかった福山のかつぎにからんだ末、助六に頭からうどんをかけられ斬られたと勘違いで大騒ぎ。軽めの敵役だが、重鎮の役者が演じて芝居を大きくする面白味のある役である。

Kanpera Monbei
One of Hige no Ikyu's associates and a character with high status in the region, Kanpera Monbei is nonetheless unrefined, widely disliked, and insulted greatly by the belligerent Sukeroku. He attempts to get the geisha to get in the bath with him, but they all refuse, greatly angering him. He gets into a tiff with Fukuyama no Katsugi, who happens to pass by, but ends up humiliated and killed by Sukeroku as the result of a misunderstanding. Though Monbei is a minor villain, he is an important character who brings a lot of color to the stage, and thus is normally played by an experienced actor.

福山のかつぎ
ふくやまのかつぎ

賑やかな鳴物と共に花道から駆け出してくる出前持ちは福山のかつぎ。一心に走るうち、くわんぺら門兵衛に突き当たって剣突を食わされ、「御免なすってくだせえやし」といくら謝っても取り合わないので、ついには尻っぱしょりで胡坐をかき赤い褌を広げて「緋縮緬の大幅だァ」と威勢の良い啖呵を切ってみせる。「福山」というのは江戸の芝居町にあった実在のそば屋の名。

Fukuyama no Katsugi
Katsugi comes running onto the stage from the hanamichi accompanied by energetic music. In a rush to deliver food, he runs into Monbei who berates him for his rudeness. No matter how much he apologizes, the two get nowhere and eventually the exasperated Katsugi, giving up on diplomacy, plops down cross-legged, spreads his bright red apron out before him, and makes biting remarks at his opponent.

通人里暁
つうじんりぎょう

吉原で通人といえば廓遊びの作法に通じ遊び方を心得た、いわば上等な客。ここではそれを思い切り漫画的に描いてみせる。いかにも若旦那という風を吹かせ、この吉原は我が物と陶酔するが助六に股をくぐらされてびっくり、ここでその時流行の事柄や流行語を取り入れ現代風に自由な工夫をするのがお約束。数多いこのお芝居の登場人物の中でもとりわけ人気が高く得な役である。

Tsujin Rigyo
A top client of Yoshiwara who is well-versed in the ways of the pleasure quarters. His character is drawn in a cartoonish way, invoking the stereotypical image of a young lord who thinks the world is his oyster. Sukeroku, of course, cuts him down a peg as he is wont to do with anyone who crosses his path. It is common for actors to improvise by referencing current events in the scene where Rigyo is confronted by Sukeroku. Rigyo is one of the most popular characters of this show.

朝顔仙平
あさがおせんぺい

くわんぺら門兵衛の手下でひときわ滑稽な形(なり)をした色奴。朝顔煎餅という実際に売り出されている商品をこの登場人物に重ね、劇中でさらなる姉妹商品の一大広告を展開するというのもこの『助六』ならではの趣向。「砂糖煎餅が孫」「羽衣煎餅はおらが姉様」「双六煎餅とは折り合い兄弟」「姿見煎餅はおらが従兄」「竹村の堅まき煎餅が親分」と「煎餅尽くし」を次々とまくしたてる。

Asagao Senpei
One of Kuwanpera Monbei's servants, the comical ladies' man Asagao Senpei is a play on the "asagao senbei," a type of rice cracker. Sukeroku is known for its playful inclusion of great advertisements for "sister products," each different types of senbei corresponding to family members of Asagao Senpei.

国侍利金太
くにざむらいりきんだ

国侍というのは参勤交代で江戸へ出てきた田舎侍で、江戸の町にその数は多く、しかし吉原などの遊所では無粋で野暮な客として大抵馬鹿にされていた。この侍も肩をいからしていかにも強そうに歩いてくるが、助六にいきなり刀を抜かれさらに「股くぐれ」と股をくぐらされる。助六からは弱い侍と見えたようだが、江戸庶民の侍階級への意趣返しの一端でもあったようだ。

Kunizamurai Rikinda
A "country samurai" who moved to Edo with the Daimyo he serves, Rikinda is often made fun of at Yoshida for his uncouth ways. He walks with an air of strength that comes from his status, but Sukeroku confronts and berates him as part of his attempt to find the missing sword. Though Sukeroku thinks him a weakling, his actions are also indicative of the common folk's general dislike of the samurai class.

※登場人物の読み方は歌舞伎の慣例によっています。

*The readings of character's names are printed according to the conventions of the kabuki theater.

みどころ
Highlights

1. 揚巻の裲襠 — Agemaki's Uchikake Robe

揚巻は五節句に因んだ豪華な仕立ての裲襠（うちかけ）や帯を着るが、ストーリーとの直接の関連はない。これは最初に着る正月の裲襠。黒繻子地に門松に竹、伊勢海老を戴く注連飾、羽子板に羽根などが刺繍されている。

Agemaki wears a gorgeous uchikake robe and obi sash commonly associated with festivals in Japan, but these have no direct connection to the story. Agemaki's uchikake is one commonly worn for the new year. The base is black satin with various embroidered patterns relating to the new year including pine, bamboo, decorated cords, and ornamental paddles.

2. 助六は実は曽我の五郎 — Soga Goro in Disguise

喧嘩が三度の飯より好きという助六だが、実はその本名は曽我の五郎時致という。親の仇工藤祐経をいつか討とうと念願している青年なのだが、仇討のためにはまず、紛失中の「友切丸」という源氏の名刀を捜し出さなければならない。それで助六は毎夜喧嘩をしては、相手に抜かせた刀を吟味しているというわけだ。髭の意休というお大尽が持つ刀が「友切丸」らしいと目星をつけているので、散々にからかって刀を抜かせようとする。

Sukeroku loves quarreling even more than food, but his true identity is Soga Goro, who is seeking vengeance for his father's death. His target is Kudo Suketsune, but first he needs to locate the lost family sword Tomokirimaru, a famed blade of the Minamoto clan. This is why Sukeroku is starting fights with anyone he comes across, hoping that they will draw their sword. When he finds out that a wealthy man named Hige no Ikyu has Tomokirimaru, Sukeroku sets out to make him draw the sword to confirm it with his own eyes.

3. 花魁道中 — Procession of Geisha

芝居の前半では、花の吉原仲之町を舞台にした遊女たちの華麗な道中が見られる。男衆に日傘を差し掛けさせ、豪華な飾りのついた裲襠（うちかけ）に、派手な刺繍の帯を前結びにして、下駄で外八文字を描きながら練り歩く。新造と呼ばれる妹女郎衆や、身の回りの世話をする子供の禿（かむろ）、年上の番頭新造、遣手、茶屋の女将を従えている。江戸吉原の妓楼と茶屋のあいだを行き来した花魁道中の再現に、目が奪われるひとときだ。

In the first half of the play we see the lavish procession of geisha called *oiran-dochu*. Male servants hold the geisha's umbrellas as they walk daintily through the street in their gorgeously decorated uchikake robes and obi sashes knotted in the front. They are further accompanied by the young new geisha called *shinzo*, servant children called *kamuro*, and others. The reproduction of this gorgeous procession from the Edo period is one of the greatest highlights of the play.

4. 江戸一番のいい男、助六 —— Edo's Golden Boy, Sukeroku

助六は江戸一番のいい男。すっきりしたシャープな隈取で、粋な生締(なまじめ)の髷に江戸紫の鉢巻を結ぶのがトレードマーク。黒紋付に赤い裾をちらつかせ、足袋は玉子色。その助六が吉原で派手な喧嘩を繰り広げる。2時間を超える一幕物なのだが浮き浮きした気分があふれ、全く飽きさせない。大勢の遊女に、モテないお大尽、田舎侍、通人など江戸吉原そのままの登場人物も楽しい。夢のように豪華な歌舞伎十八番の演目である。

Sukeroku is truly the golden boy of Edo. His character wears a sharp *kumadori* with fine lines, sports a stylish *namajime* hairstyle, and is never seen without his trademark purple headband. His crested robes are black with fluttering red fringe, his socks a pleasant egg-white. As he gets into quarrels in the Yoshiwara pleasure quarters, audiences see all of the staple characters of *Yoshiwara*—countless geisha, the wealthy man who is unpopular with the ladies, the country samurai, and the well-educated and worldly *tsujin*—giving the audience no opportunity to become bored in this 2-hour one-act play. It is a truly magnificent work that has rightly earned its place among the Eighteen Great Kabuki Plays.

5. 間夫と客とは、雪と墨 —— Like Snow and Ink

揚巻は吉原一の傾城(けいせい)。傾城とは「城を傾けるほどの美女」という意味で、遊女の代名詞。揚巻は恋人に似合いの、なかなか気の強い女性だ。イヤな客が気に障ったら、人前でも堂々と悪態をつく。助六との仲を「鬼の女房にゃ鬼人がなる」と自負したり、また「間夫(まぶ)と客とは雪と墨、暗闇で見ても見間違えるものかいな」と言ったりする。間夫は遊女が惚れる恋人のこと。お客に向かって、「あんたは墨だ」と言ってのけるのだ。

Agemaki is the most beautiful geisha in Yoshiwara, or *keisei* in Japanese. This term refers to a woman so beautiful that she can bring down a castle, a perfect name for Agemaki. She is just as strong-willed as her lover Sukeroku, and does not hesitate to disparage a man she doesn't get along with. She refers to her relationship with Sukeroku, saying "only a fellow monster can become a monster's wife," and tells her customer off by saying "Sukeroku and you are like snow and ink. Even in the dark one would be a fool to mistake the two of you for one another."

6. 助六寿司 —— Sukeroku Sushi

芝居はご覧になってなくても、かんぴょう巻とお稲荷さんがセットになったお寿司を「助六寿司」と呼ぶことはご存じだろう。これがなんで助六か、一説をご紹介しよう。お稲荷さんは「お揚げ」で包んでできていて、海苔巻の「巻」と合わせると「揚」+「巻」で、「揚巻(あげまき)」。これが助六の恋人「揚巻」に通じるから。助六が言うせりふでも「揚巻の助六とも言われる」と自慢しているわけで、二人はセットで有名だった。

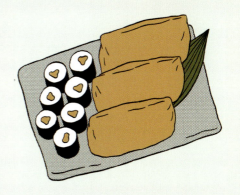

Even if you've never seen the play, you may have seen a sushi set called "Sukeroku Sushi" in stores. It includes *kanpyo* (dried gourd) rolls and inari sushi (rice wrapped in sweetened deep-fried tofu). One theory states that this set is named after Sukeroku because one sushi is wrapped in fried tofu (*age*) and the other, rolled (*maki*), the two words in Japanese joining to make the name Agemaki, Sukeroku's lover in the play. Sukeroku himself says proudly that "some call me Agemaki's Sukeroku," and both the sushi set and the couple are quite famous.

東海道四谷怪談
Tokaido Yotsuya Kaidan

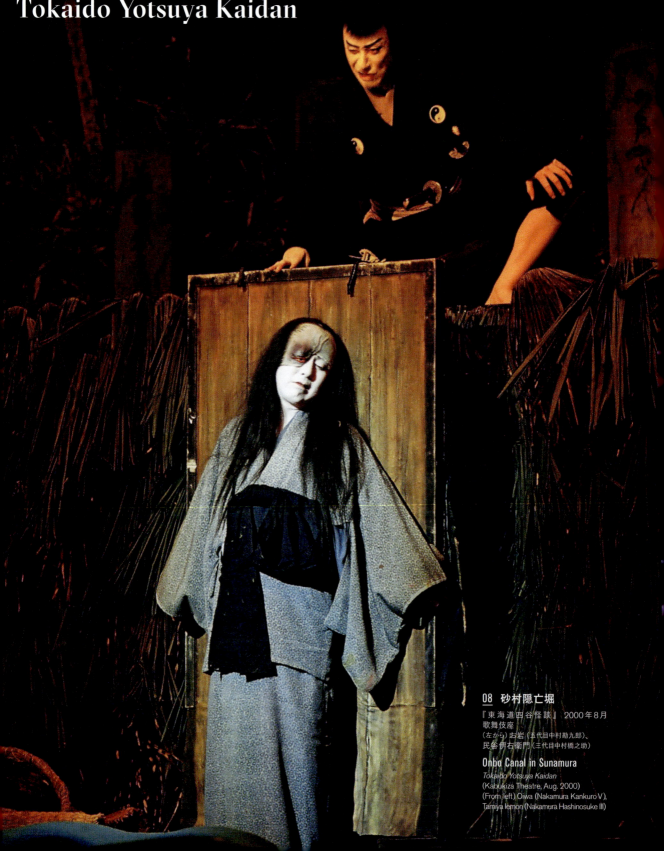

08 砂村隠亡堀
『東海道四谷怪談』 2000年8月
歌舞伎座
（左から）お岩（五代目中村勘九郎）、
民谷伊右衛門（三代目中村橋之助）

Onbo Canal in Sunamura
Tokaido Yotsuya Kaidan
(Kabukiza Theatre, Aug. 2000)
(From left) Oiwa (Nakamura Kankuro V),
Tamiya Iemon (Nakamura Hashinosuke III)

あらすじ / Synopsis

江戸の下層社会にうごめく人々のたくましく生きる姿。
忠義の武士の仇討を讃える「忠臣蔵」と合わせ鏡の物語

言わずと知れた怪談狂言の傑作にして四世鶴屋南北畢生の名作。
誰でも知るお岩様のストーリー。

─── A timeless story of the struggles of the lower classes of Edo Society.
The other side of *Chushingura*'s depiction of a warrior's loyalty.

A masterpiece of the horror genre that needs no introduction,
one of Tsuruya Nanboku IV's finest works.
The unforgettable story of Oiwa.

01　浅草観世音額堂

　浅草観音の境内に現れた薬売直助。もとは塩冶家の家臣奥田家に仕えていたが、塩冶判官が高師直を刃傷に及んで塩冶家断絶以来、薬売となって暮らしている。直助は同じ塩冶家の家臣四谷左門の妹娘お袖に惚れているが、そのお袖が、浪人暮らしを助けるため密かに売春宿に出ていることを知る。

　また、塩冶家の浪人民谷伊右衛門は、境内で物乞いをしていた舅の四谷左門と出会う。伊右衛門は、左門の姉娘お岩の夫だが、伊右衛門が御用金を盗んだのを知っている左門は、伊右衛門から岩を取り戻した。妻と復縁したいという伊右衛門の頼みを、左門ははねつける。

　伊右衛門の隣家に住む、高師直の家臣伊藤喜兵衛と、伊右衛門を慕っている孫娘お梅が通りかかり、伊右衛門を見送っていると、乞食になっていた塩冶家の浪人奥田庄三郎が話しかける。庄三郎は塩冶方の廻文状を奪われてしまうが、小間物屋に身をやつした、塩冶家の浪人佐藤与茂七がそれを取り返す。

02　宅悦地獄宿

　直助はお袖に会いに、按摩宅悦が営む地獄宿と呼ばれる

01　The Asakusa Kannon Pavilion

　Naosuke comes to Asakusa Kannon Temple selling medicine. Though formerly an ally of the Okuda family that served the En'ya house, he has had to sell medicine to make a living ever since the En'ya house was terminated due to the notorious incident with the evil Ko no Moronao. Naosuke is in love with Osode, the elder daughter of Yotsuya Samon who also served En'ya, but finds out that she is secretly working as a prostitute after her father become a ronin.

　Meanwhile, Tamiya Iemon, another former En'ya retainer, comes upon Samon, who has come to beg at the temple. Samon has recently taken his other daughter Oiwa back from her husband Iemon after finding out he had extorted money. Iemon tells Samon he wants to make up with Oiwa, but Samon rejects his proposal.

　Oume and her father Ito Kihei (Iemon's neighbor) happen by then and see Iemon off as he leaves the temple. Ito Kihei is a wealthy retainer of Ko no Moronao, and Oume is deeply in love with Iemon. As they see Iemon off, the former En'ya retainer Okuda Shozaburo calls out to them. He ends up losing an important document belonging to the former En'ya house, but Yomoshichi, yet another En'ya loyalist, retrieves it.

02　Takuetsu's Brothel

　Naosuke goes to meet Osode at a brothel run by the *anma* masseur Takuetsu, but she is busy entertaining

売春宿に来るが、お袖の夫の与茂七も宿に来て振られてしまう。直助は、恋の恨みの与茂七を殺そうと、与茂七の持つ提灯を目当てに追いかけてゆく。

03 浅草暗道地蔵

庄三郎と与茂七は互いに衣服を取り替え、与茂七は廻文状を持ち鎌倉に向かう。

04 浅草裏田圃

直助は与茂七と思い庄三郎を殺し、また一方、伊右衛門は四谷左門を斬って止めを刺す。死骸をみつけたお岩とお袖。伊右衛門と直助は、何食わぬ顔で親と夫の仇討を約束し、お岩は伊右衛門ともとの夫婦にもどり、お袖は直助と名ばかりの夫婦となる。

05 雑司ヶ谷四ツ谷町伊右衛門浪宅

伊右衛門の家では、宅悦の紹介で雇った小仏小平が、民谷家に伝わる薬を盗んだので大騒ぎ。小平は元の主人の病気を治したい一心で盗みを働いたのであった。

お岩は伊右衛門の子を出産するが、病がち。そこに隣の伊藤喜兵衛から見舞いの薬が届く。伊藤家の度重なる親切に感謝しつつお岩は薬を飲むが、急に苦しがりはじめる。

06 伊藤喜兵衛宅

伊藤家が渡した薬は、顔が変わる毒薬。お岩の顔が変われば伊右衛門も愛想を尽かし、恋い慕うお梅を娶ってくれるだろうという算段。伊右衛門は高師直への仕官を条件にお梅との縁組を承知する。

07 元の伊右衛門浪宅

相好がすっかり変わってしまったお岩。宅悦からそのわけを聞くと、伊藤家へ恨みを言いに行くといって、髪を梳き始めるが髪が抜けおちる。外出を止める宅悦ともみあううち、お岩は刀が喉に誤って刺さり死ぬ。帰宅した伊右衛門は小平を殺し、お岩の間男に仕立て、ふたりの死骸を戸板の裏と表に釘で打ち付けて川に流す。伊右衛門はお岩の死霊によって花嫁としてやってきたお梅と喜兵衛を殺してしまう。

08 砂村隠亡堀

鰻掻きの権兵衛と名を改めた直助は、伊右衛門と再会する。そこに流れてくる戸板。戸板を引き上げるとお岩、裏には小平の死骸。やがて伊右衛門、直助、通りかかった与茂七

Yomoshichi, who is actually her husband. Later, the jealous Naosuke follows Yomoshichi as he leaves the brothel, intending to kill him.

03 An Alley in Asakusa

Shozaburo and Yomoshichi, knowing that Yomoshichi is being followed, change outfits along the road to trick Naosuke, and Yomoshichi takes custody of the secret document.

04 The Rice Fields in Asakusa

Naosuke kills Shozaburo, thinking he is Yomoshichi, and Iemon murders Yotsuya Samon. When Oiwa and Osode discover the bodies, Naosuke and Iemon both pretend that they had nothing to do with the murders, promising to avenge them. Consoled by these lies, Oiwa returns to Iemon and Osode becomes Naosuke's unofficial wife.

05 Iemon's Residence in Yotsuya

At Iemon's house, Kobotoke Kohei, hired at Takuetsu's recommendation, is caught stealing the Tamiya family's secret medicine. He had only intended to use the medicine to help his former master who is sick, but now is in serious trouble.

Oiwa has given birth to Iemon's child but is prone to get sick now. One day a gift of medicine is sent over by the neighboring Ito Kihei's house, but as soon as the grateful Oiwa drinks the medicine she feels violently ill.

06 Ito Kihei's Residence

The medicine sent by the Ito house is actually a poison that changes the face of anyone who drinks it. Kihei hopes that Iemon will lose affection for his wife if her face changes, shifting his love to Kihei's daughter Oume. Under the condition that he be given a position in Ko no Morono's service, Iemon agrees to marry Oume.

07 Iemon's Former Home

Oiwa's face has been disfigured by the poison, and she hears from Takuetsu that it was the Ito house's doing. When she begins combing her hair to leave the house and express her anger, however, she finds her hair has begun to fall out. As Takuetsu makes to stop her leaving, her throat is suddenly slit by Iemon, who also murders Kohei, framing the two for infidelity. Their corpses are strung up outside and thrown into the river in disgrace. As Iemon welcomes his new bride Oume, however, he is haunted by the angry spirit of Oiwa and made to murder both Oume and Kihei.

08 Onbo Canal in Sunamura

One day Naosuke, who has disguised himself as an eel fisherman by the name Gonbe now, meets Iemon once more and finds the corpses of Oiwa and Kohei floating down the river nailed to planks of wood. Under the darkness of

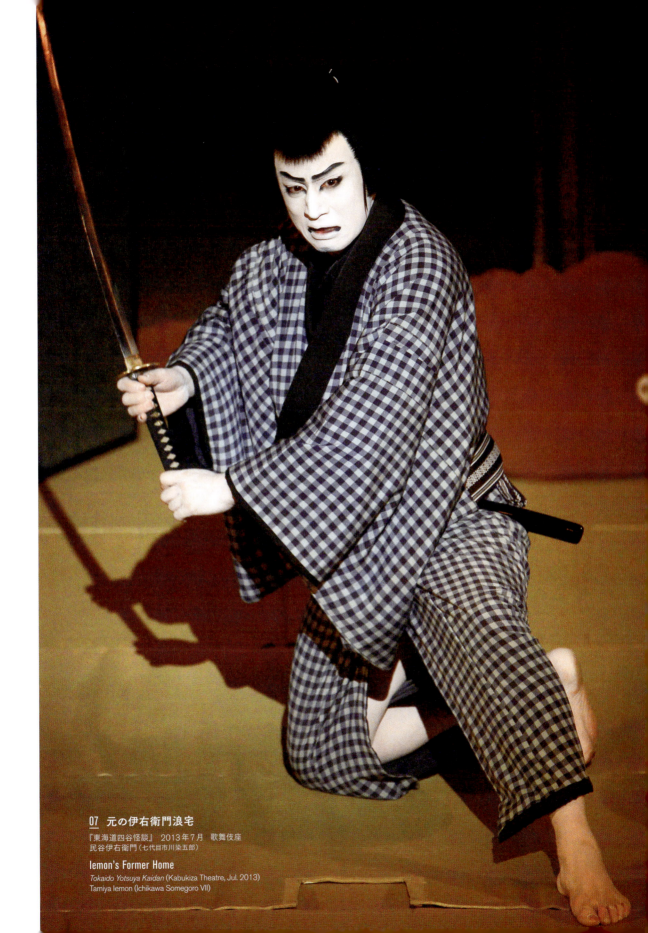

07 元の伊右衛門浪宅
『東海道四谷怪談』 2013年7月　歌舞伎座
民谷伊右衛門（七代目市川染五郎）

Iemon's Former Home
Tokaido Yotsuya Kaidan (Kabukiza Theatre, Jul. 2013)
Tamiya Iemon (Ichikawa Somegoro VII)

が闇の中で探りあい、与茂七の廻文状は直助に、直助の焼き印の入った鰻掻きの棒が与茂七の手に渡る。

09 深川三角屋敷の場

深川では、直助とお袖が仮の夫婦として暮らしている。お岩の死を知ったお袖は、本当の夫婦になって姉の仇をとってほしいと直助と契りを交わす。そこに鰻掻きの焼き印を手掛かりに与茂七がやってくる。死んだはずの与茂七の姿に驚く直助とお袖。ふたりの亭主を持ったお袖は自ら手引きしてふたりに殺される。やがてお袖のほぞの緒書きから、直助とお袖が実の兄妹であること、また、与茂七と思って殺したのはかつての主人庄三郎だったと知った直助は、お袖を刺した出刃包丁を腹に突き立てる。

10 小汐田隠れ家

小仏小平の亡霊が届けた、民谷家の薬により、塩冶浪人小汐田又之丞の病が癒える。

11 滝野川蛍狩り

蛍の飛び交う滝野川。美しい岩と伊右衛門が寄り添うが、やがて恐ろしい亡霊に変わる。それは伊右衛門の見た夢であった。

12 蛇山庵室

伊右衛門が隠れ住む本所の蛇山庵室。お岩の亡霊は、伊右衛門の母はじめ悪事に加担した者たちを次々に殺す。

13 仇討

佐藤与茂七らが現れ、伊右衛門を討ち取る。

night, Yomoshichi also happens by, and as the three feel about in the darkness, Yomoshichi's secret document is handed to Naosuke and Naosuke's branding iron is passed to Yomoshichi.

09 The Sankaku Manor in Fukagawa

Now Osode and Naosuke live along the Fukagawa river as husband and wife. After hearing of her sister Oiwa's death, Osode officially married Naosuke in exchange for a promise that he would avenge her sister. Just then Yomoshichi comes carrying Naosuke's eel brand, surprising the couple who had thought he was dead. Ashamed at having two lovers, Osode has the two men kill her, and Naosuke, shocked to find out that Osode is actually his sister and that the man he thought he had killed is still alive, cuts open his own stomach with a knife.

10 The Oshioda's Secret House

Kobotoke Kohei's spirit succeeds in stealing the Tamiya medicine he had failed to steal in life, and delivers it to the Oshioda house, saving his former master Matanojo.

11 Catching Fireflies in Takinogawa

Takinogawa is alight with fireflies as the beautiful Oiwa and Iemon huddle together in love… But this is only a dream of Iemon's.

12 The Hermitage on Snake Mountain

Iemon now lives in a hermitage on Snake Mountain. The angry spirit of Oiwa has haunted and killed many people involved in Iemon's evil schemes, including his own mother. Now the frightened Iemon makes to run away from his hermitage.

13 Revenge

As he makes to run away, Iemon is met by Yomoshichi, who kills him, bringing the play to its conclusion.

作品の概要

演目名

東海道四谷怪談

作者

四世鶴屋南北

概要

本作の背景には忠臣蔵の世界があり、初演時は『仮名手本忠臣蔵』と交互に、二日がかりで上演された。忠臣蔵の晴れがましい仇討と、不忠の武士伊右衛門の筋が対比されている。

「浪宅（伊藤喜兵衛宅含む）」「隠亡堀」「庵室」の三場面は、演技や演出、大道具の仕掛けなどに初演以来重ねられた工夫が今に伝えられており、その意味でも貴重な演目であると同時に、その工夫がいまだに劇的効果を上げていることにも驚かされる。

最近の上演では、この三場面を中心に、「浅草観音」「地獄宿」などの序幕と、「仇討」などをつけ、お岩伊右衛門の筋を完結させることが多く、「夢の場」や「三角屋敷」は上演が少ない。さらに原作では「三角屋敷」の間には、「小汐田又之丞隠れ家」の場が挿入されるが、ほとんど上演されない。『いろは仮名四谷怪談』など多くの別名題があり、場割の名称なども上演により異同がある。掲載のあらすじは、全場面のあらすじに、場面の通称と近年使われている場割を示した。

初演

文政8（1825）年7月江戸・中村座で、三世尾上菊五郎のお岩・小平・与茂七、七世市川團十郎の伊右衛門ほかで初演。四世鶴屋南北作。通称「四谷怪談」。

Overview

Title

Tokaido Yotsuya Kaidan

Writer

Tsuruya Nanboku IV

Overview

The story of *Kanadehon Chushingura* serves as the backdrop of this play, and at its premiere the two were played back-to-back over the course of two days. The heroic revenge of En'ya shown in *Chushingura* perfectly contrasts the gritty story of the disloyal Iemon.

Since it's first performance, *Tokaido Yotsuya Kaidan* has featured large-scale stage pieces and a variety of unique effects, especially in the "Residence" (including Ito Kihei's residence), "Canal," and "Hermitage" scenes. Because of this, not only is it an important play in the repertoire of kabuki, but it also never fails to stun audiences with its dramatic flourishes.

Recent performances take the aforementioned scenes and add in other relevant scenes—the "Asakusa Kannon" and "Revenge" scenes, for example—to round out the story and give it a sense of completion. Other scenes, such as Iemon's dream and the "Sankaku Manor" scenes, are rarely performed, and yet others are almost never shown. The play itself goes by many other names, and even specific scenes are given different titles depending on the performance. The synopsis given here includes the most commonly performed scenes today, and uses the most commonly used titles.

Premiere

First performed at the Nakamuraza Theatre in Edo, July 1825. Feat. Onoe Kikugoro III as Oiwa / Kohei / Yomoshichi, Ichikawa Danjuro VII as Iemon, and others. Written by Tsuruya Nanboku IV. Commonly referred to as *Yotsuya Kaidan (The Yotsuya Ghost Story)*.

登場人物 / Characters

民谷伊右衛門
たみやいえもん

塩冶家の浪人で家中の四谷左門の娘・お岩を妻としているが、伊右衛門が御家の金を横領したことに気付いていた左門がお岩を連れ戻そうとしたため、左門を斬り殺してしまう。しかし何食わぬ顔で親の仇を捜すといってお岩とよりを戻してしまう。だが子供が生まれた後、隣家の伊藤喜兵衛の孫娘お梅との結婚を承諾する。色悪という役柄の典型で、色白の二枚目ながら冷たい血が体内に流れる非道な極悪人。

Tamiya Iemon

Tamiya Iemon takes care of Oiwa, daughter of Yotsuya Samon, a ronin who formerly served the En'ya house. They are not officially married but live together like a married couple. Iemon kills Samon when he tries to take his daughter back, having realized that Iemon actually embezzled money from his house. The two-faced Iemon then acts as though he knows nothing about it, swearing to Oiwa that he will avenge her father. Later, after the birth of their child, Iemon plans to abandon his wife and marry the granddaughter of their neighbor Ito Kihei. He is the archetypical *iroaku* (handsome villain), a handsome and charming man whose blood runs cold on the inside.

直助権兵衛
なおすけごんべえ

塩冶家の奥田将監（しょうげん）という武士に使える中間（ちゅうげん）だったが、薬売となり藤八五文という薬を売っている。お袖に惚れていて亭主の佐藤与茂七を殺すが、実は着物を取り替えていた奥田庄三郎だった。四谷左門を殺した民谷伊右衛門と同様、夫の仇を捜すという大義名分を立ててお袖と仮の夫婦となる。しかし生きていた佐藤与茂七が現れしかもお袖が実の妹とわかり、畜生道を悔いてお袖を殺した上で自害する。

Naosuke Gonbei

Formerly a servant of the En'ya house, Naosuke now sells medicine. He is in love with Osode, he attempts to murder her husband Sato Yomoshichi but mistakenly kills Okuda Shozaburo. Like Iemon's promise to Oiwa, Naosuke promises to avenge Osode's husband and the two come to live together as husband and wife, though not technically married. When it is later revealed that Yomoshichi is alive, and furthermore that Osode is actually his sister, the distraught Naosuke kills Osode and himself.

佐藤与茂七
さとうよもしち

塩冶家の浪士でお袖の夫。高家への討入準備のため小間物屋に身をやつしている。地獄宿で女房のお袖と「客と娼妓」の関係で出会ってしまい、その場で直助と三角関係の様相をみせる。直助に命を狙われるが、用心のため奥田庄三郎と着物を替えていたため命拾いする。三角屋敷で久々の再会を果たしたお袖は直助とすでに夫婦、その二人ともが命を落とした後、ついに恨み重なる伊右衛門を討つ。

Sato Yomoshichi

A ronin who once served Lord En'ya, Yomoshichi is in hiding and preparing for a plot to avenge his former master. He happens upon his wife Osode when visiting the brothel where she works and finds out about her suitor Naosuke, who plans to murder him. Okuda Shozaburo decides to wear Yomoshichi's kimono to trick the murderous Naosuke. As was expected, Naosuke attempts to murder Yomoshichi but instead murders Shozaburo. When Yomoshichi reunites with Osode later, he finds that she and Naosuke are already married. Osode is killed, Naosuke commits suicide, and at the end of the play Yomoshichi kills the evil Iemon.

お岩
おいわ

伊右衛門の女房で四谷左門の娘。お袖という義理の妹がいる。父が伊右衛門の手に掛かって殺されたとは知らず、父の仇を捜してくれるという伊右衛門の言葉を信じてしまう。子供が生まれた後は伊右衛門に邪険にされ、さらに伊藤喜兵衛宅から届けられた薬（毒薬）を飲むと俄かに形相が変わり、やがてはずみで小刀が首に刺さって落命、恨みのこもった亡霊は伊右衛門や伊藤家の者たちを呪う。

Oiwa

Oiwa is Iemon's wife, Yotsuya Samon's daughter, and Osode's sister-in-law. She blindly believes Iemon's promise to avenge her father, not knowing that it was actually Iemon who killed him. After she gives birth to Iemon's child, she finds that he no longer has any affection for her, and is eventually poisoned with medicine sent by the neighbor Kihei's home. This poison disfigures her face and Iemon decides to murder her. After her death she reappears as a vengeful ghost who haunts Iemon and Kihei house.

お袖
おそで

四谷左門の娘でお岩の妹だが、実の親子姉妹ではなく養女で実の兄もいるはず。夫の佐藤与茂七は塩冶家の家臣だったがお家が断絶した後は行方がわからず、浅草観音境内の楊枝店に雇われながら夜は地獄宿の私娼となっている。そこで奇遇にも夫の与茂七と巡り会うが、ほどなく夫は殺され、仇討のために直助権兵衛と仮の夫婦の約束をする。後に与茂七が生きていて再会するが、二人の亭主に挟まり死を選ぶ。

Osode

Yotsuya Samon's daughter and younger sister to Oiwa, Osode is not related by blood to Oiwa and actually has an older brother. Her husband Yomoshichi once served the En'ya house, but is missing ever since the house's fall. Without her husband's support, she now works at the Asakusa Kannon Temple during the day and as an unlicensed prostitute at night. She happens to meet her husband Yomoshichi as a customer at the brothel she works at, but he is soon after murdered. When Naosuke promises to avenge her husband, she agrees to become his wife, but comes to an untimely death later when she finds out that Yomoshichi is actually alive.

宅悦
たくえつ

表向きは按摩だが小心者の悪党で実は地獄宿すなわち売春宿を営んでおり、お岩の妹であるお袖もそこで身を売っている。民谷伊右衛門にはいいようにこき使われ、毒薬で形相の変わったお岩に言い寄って間男を演じるよう命じられた上、世にも恐ろしいその現場を体験する。たまたま按摩治療に声をかけられたところでお袖に会い、姉のお岩が伊右衛門に殺されたことを伝える。

Takuetsu

Takuetsu claims to be an *anma* masseur, but actually runs the brothel where Osode works. He is manipulated by the evil Iemon into framing Oiwa for infidelity. He happens to meet Osode on a call for a massage treatment, and there he tells her that her sister Oiwa was killed by Iemon.

小仏小平
こぼとけこへい

民谷伊右衛門の家で雇われ奉公をしているが、親は塩冶家の家臣・小汐田又之丞の家来筋。又之丞が浪人している上に難病となったため民谷家秘伝の薬を持って逃げたが結局捕らえられ、指を折られるなどきつい折檻の上に縛られて監禁される。お岩を邪魔者とした伊右衛門は、お岩と小平が不義をしたと見せかけて二人の死骸を戸板に括り付けて流す。やがてお岩の霊と小平の霊は伊右衛門を苦しめる。

Kobotoke Kohei
A servant at Iemon's home whose father once served Matanojo, a former retainer of the En'ya house. Matanojo is now a ronin and suffers from a serious illness. Kohei attempts to steal a secret medicine from the Tamiya house but is caught and has his fingers broken as punishment. He is then locked up and framed by Iemon for having an illicit affair with Oiwa. Both he and Oiwa have their corpses hung up, but eventually return as spirits to torment the evil Iemon.

お弓
おゆみ

伊藤家の後家で、お梅の母。お梅の願いを叶えて伊右衛門を婿に取ったが、殺されたお岩とお平の霊に祟られ伊右衛門の手によって父と娘が殺される。ついにお家は没落、砂村の隠亡堀（おんぼうぼり）で流浪の身となっているところに伊右衛門が現れ、それとは知らず伊右衛門を仇と唱えると不意を突かれて堀へ蹴落とされてしまう。

Oyumi
Widow of the Ito house and Oume's mother, Oyumi suffers a tragic fate. Though her daughter Oume is accepted into Iemon's house, the spirits of Oiwa and Kohei haunt Iemon and cause him to murder both her father and her daughter, severing the family line. Finally, she turns to a life of vagrancy, but is eventually found by Iemon who drowns her in a river.

四谷左門
よつやさもん

塩冶家の浪人で、お岩とお袖の父。お家に対しては忠臣であるが昔かたぎで世渡りもまずく、娘が身を崩して働きに出ている上、自らは物乞いをする始末。お岩の夫の伊右衛門が御用金を横領したことに気付きお岩を連れ戻そうとするが、復縁を迫る伊右衛門の怒りを買ってしまい、ついに殺される。

Yotsuya Samon
A ronin who formerly served the En'ya house, Yotsuya Samon is Oiwa and Osode's father. He is loyal to his master but with little luck. After his master's house is terminated, he becomes a beggar and his daughter a prostitute. He attempts to retrieve his daughter from Iemon when he finds out he stole money from his house, but is killed by the enraged Iemon.

伊藤喜兵衛
いとうきへえ

高師直（こうのもろのう）の家臣で、民谷伊右衛門の隣に住まいするが伊右衛門とは打って変わったことに裕福な家。孫娘のお梅が伊右衛門に恋しているので婿に取ろうと、お岩に血の道の薬と偽って面体くずれる秘法の毒薬を与える。やがてお岩の居なくなった伊右衛門の家で孫娘のお梅と祝言の席に着くが、殺された小仏小平の霊が取り付き、その姿に狂った伊右衛門に斬り殺される。

Ito Kihei
The evil Ko no Moronao's retainer, Ito Kihei's household is incredibly wealthy, contrasting his neighbor Iemon. A deeply cruel and unfeeling man, he offers his daughter Oume for Iemon to marry, sending poison disguised as medicine to Iemon's wife Oiwa to get her out of the way. After Oiwa's death, a celebration is held to welcome Oume into Iemon's home, but the enraged spirit of Kobotoke Kohei appears and kills Iemon for framing him for acts of infidelity with Oiwa.

お梅
おうめ

伊藤喜兵衛の孫娘。隣家の民谷伊右衛門に惚れて思い焦がれるあまり恋患いになってしまう。喜兵衛の尽力で伊右衛門と祝言を上げるが、お岩の死霊に翻弄された伊右衛門により斬り殺されてしまう。

Oume
Ito Kihei's daughter, Oume is deeply in love with Iemon who lives in the neighboring house. Though her father helps make it possible for her to marry Iemon, she is eventually killed by Iemon who is haunted by the enraged spirit of his former wife Oiwa.

奥田庄三郎
おくだしょうざぶろう

塩冶家の浪人で奥田将監の子息。主君の仇討のため密書を運ぶなど奔走するが、用心のため佐藤与茂七と着物を交換する。そのため与茂七と思った直助に殺され、しかも身元がばれないようにと顔をつぶされたため、与茂七の妻・お袖も人違いとは気づかなかった。

Okuda Shozaburo
A ronin formerly in the En'ya house's service, Shozaburo is Okuda Shogen's son. Though busy with a plot to avenge his fallen master, the ever cautious Shozaburo decides to exchange robes with Yomoshichi, who is in danger. He is eventually murdered by Naosuke, who meant to kill Yomoshichi and mutilates his face so that the corpse's identity cannot be discerned. Thus, even Yomoshichi's wife Osode is fooled into believing her husband is dead.

みどころ
Highlights

1. 塩冶浪人民谷伊右衛門
—— The Ronin Tamiya Iemon

お岩の夫民谷伊右衛門は塩冶家の浪人である。『忠臣蔵』に描かれる浪士たちとかつて同僚だったが、公金横領という不正を働いて浪人した。同じ家中であった舅から女房との離縁を言い渡されると、舅を闇討にしてしまう自分勝手な人物。欲望のままに生きる伊右衛門は、仇討のために苦労する浪士たちと対照的なキャラクターだ。本作初演は、『仮名手本忠臣蔵』の途中に本作を織り交ぜ、最後に討入、というスタイルでの上演だった。

Oiwa's husband Tamiya Iemon is a ronin who used to serve En'ya, the judge from the famous play *Chushingura*, and was discharged after extorting public funds. Because of this, Iemon's father-in-law pressures him to divorce his wife, but is then killed. An avaricious and self-centered character, Iemon contrasts the other En'ya retainers who are plotting to avenge their former master. When it debuted, *Yotsuya Kaidan* was inserted into a performance of *Kanadehon Chushingura*, leading up to the raid to avenge En'ya.

2. 於岩稲荷田宮神社
—— Oiwa Inari Tamiya Shrine

題名では東海道四谷宿の怪談と謳っているようだが、事件の舞台は東京の四谷である。四谷には於岩稲荷田宮神社がある。上演前に主な役者と興行主たちが公演中の無事を祈願に訪れることでも有名である。お祓いを受けないと、俳優やスタッフも含めた舞台関係者に故障が起きるという、いわゆる劇場伝説もある。ちなみにモデルになったお岩は幸せな人だったそうで、祈願すると良縁に恵まれる御利益があるとか。

As the title indicates, Yotsuya Kaidan takes place in Yotsuya, a district in Tokyo and the location of Oiwa Inari Tamiya Shrine. There is a superstition in the theater that if you don't receive a shinto rite of purification from the shrine, that there will be accidents during the production of this play. Furthermore, it is said that the Oiwa whom the character is based on had a happy life, and because of this many visitors pray for a happy relationship at Tamiya Shrine.

3. 「これが、私の顔かいのう」
—— "This can't be my face…"

隣家の娘に見染められた伊右衛門は、お岩を殺してしまおうとしたわけではない。顔がただれるという毒薬をもらい、よい薬だと言ってお岩に飲ませ、その上宅悦に不倫を仕掛けさせ、追い出そうとしたのだ。醜くただれた顔に気づかないお岩に、宅悦がついに鏡を突きつける。当時、産後は鏡を見てはいけないという俗信もあった。鏡のなかに変わり果てた自分の顔を見たお岩が言うのが、このせりふだ。ここで、お岩の気持ちが大きく変わる。

Iemon does not kill Oiwa simply because he fell in love with young girl livin next door. He receives medicine from the neighbors for the sick Oiwa which is actually a poison that causes the drinker's face to swell up. Furthermore, Takuetsu frames her of adultery and Iemon attempts to throw her out of the house. Finally, Takuetsu gives Oiwa a mirror and she finally sees her difigurement. It is at this moment that she says the famous lines, "This can't be my face…," and her demeanor completely changes.

4. 戸板返しの表裏 —— Both Sides of the Plank

召使い小仏小平も哀れ。民谷家伝来の妙薬を盗んだのが見つかり、手指を折られるなどひどい暴行を受け殺されてしまう。小平とお岩は戸板の裏表に打ち付けられ面影橋から川に捨てられる。お岩と並ぶ被害者小平は、同じ役者が二役早替わりで演じる。川下に流れ着いた戸板の片方に恨めしい顔のお岩の亡霊が張り付いていて、戸板をくるりと返すと、折れた指が蛇に変化した小平になって「お薬くだされ」と訴える。ぞっとするみどころだ。

Kobotoke Kohei suffers an equally sad fate. He is caught trying to steal the Tamiya family's secret medicine and has his fingers broken as punishment. He is eventually murdered after being framed for infidelity with Oiwa, both of whom are then tied to opposite sides of a great plank of wood and thrown into the river. These two characters are actually played by the same actor, requiring great skill to switch between roles quickly. When the plank of wood is shown floating in the river, we see Oiwa's disfigured face on one side, and Kohei on the other, his broken fingers becoming snakes and asking for medicine in a truly bone-chilling scene.

5. 提灯抜けから宙乗り —— A Spectacular Aerial Stunt

無惨な死に方をして亡霊となったお岩は、伊右衛門をさんざんに苦しめる。その苦しめ方にいろいろ趣向が凝らされるのが、「四谷怪談」の大きな見どころだ。本物の火を使う「提灯抜け」は、代表的な仕掛け。伊右衛門の住まいに吊された大きな提灯に火がついて激しく燃え上がり、あっという間に丸い穴があくと、そこからお岩役者がするりと抜け出て宙乗りになる。お岩は長い長い灰色の着物の裾を引いて浮かび上がり、伊右衛門を悩ませる。

After her death, the enraged spirit of Oiwa torments Iemon. The form this torment takes is the result of painstaking stage effects, and is one of the highlights of *Yotsuya Kaidan*. One of the most representative effects is the *chochin-nuke*, by which the head of the deceased is shown within a *chochin* lantern, a truly dazzling effect that uses actual fire. In *Yotsuya Kaidan*, the fire in a great chochin flares up, burning a hole in the lantern and revealing the deceased Oiwa who jumps forth in a dramatic aerial stunt. The ghastly Oiwa slowly rises from the trailing folds of her grey robes, frightening her former husband Iemon.

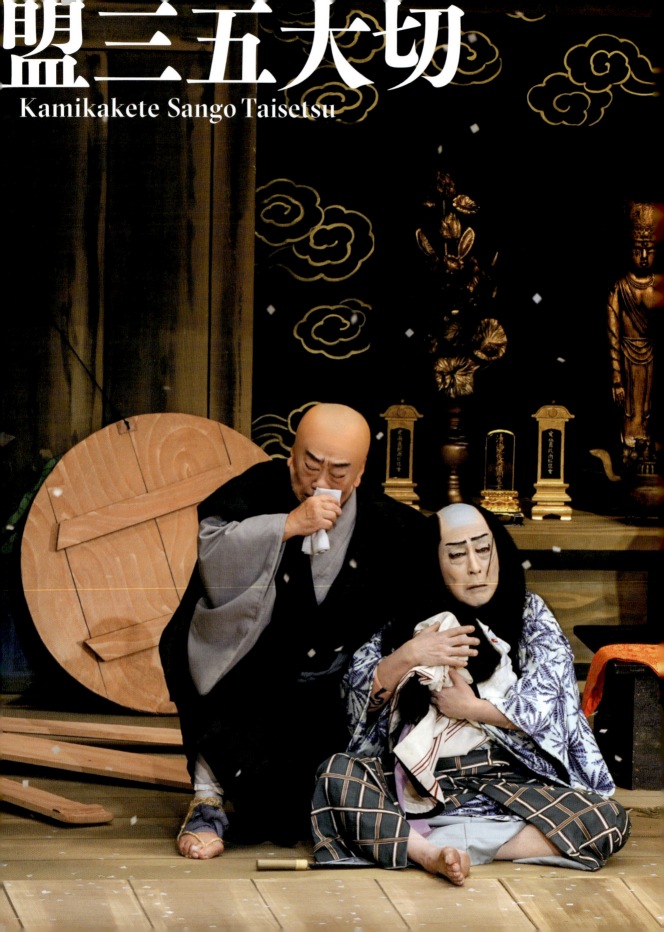

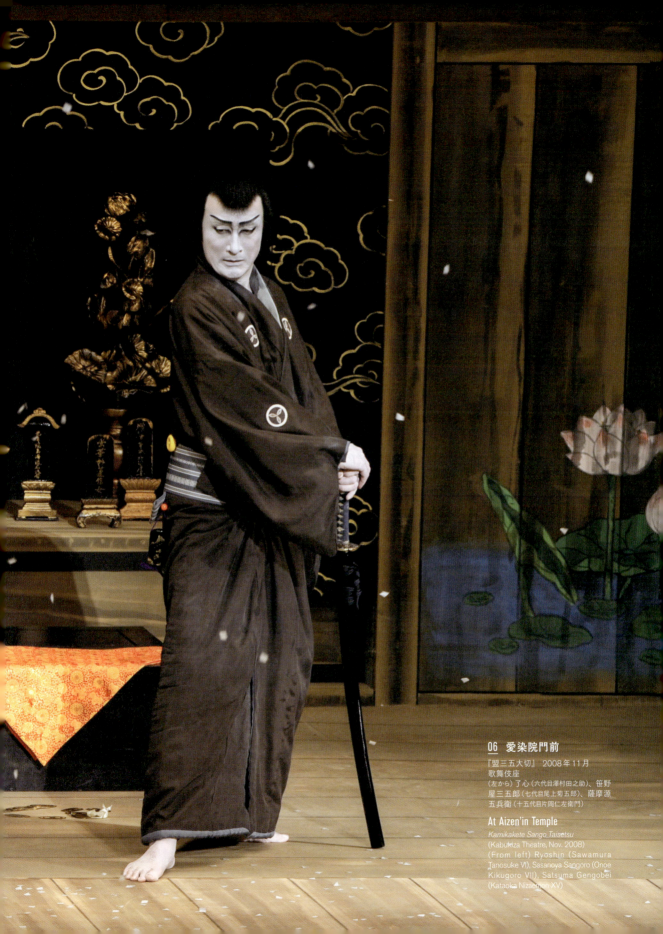

06 愛染院門前
『盟三五大切』 2008年11月
歌舞伎座
(左から)了心(六代目澤村田之助)、笹野屋三五郎(七代目尾上菊五郎)、薩摩源五兵衛(十五代目片岡仁左衛門)

At Aizen'in Temple
Kamikakete Sango Taisetsu
(Kabukiza Theatre, Nov. 2008)
(From left) Ryōshin (Sawamura Tanosuke VI), Sasanoya Sangorō (Onoe Kikugorō VII), Satsuma Gengobei (Kataoka Nizaemon XV)

あらすじ / Synopsis

身どもを鬼には、おのれら二人がいたしたぞよ。
150年の時を経てよみがえった異色作。
忠義のために人を騙して巻き上げた金の行方は……

「五大力（ごだいりき）」の文字は恋のまじない。それが「三五大切」と彫り直されていた。
逆上した男は女の首を斬り落とし、懐に入れて夜道を帰っていく。
昭和に入って再評価された人気作品。緊密な構成で人間の深部を鋭く描く異色作。

A monster I am, but the two of you made me so...
A unique piece, revived after 150 years.
A deeply ironic story of a man who unwittingly betrays his master while trying to fulfil his duty...

A tattoo that expresses a woman's love is but a lie. The betrayed man kills her, taking her head with him into the night.
This play became wildly popular during the Showa period (1926–1989).
It is a tightly constructed play that bores deep into the psyche of its characters.

01　佃沖新地鼻

　夜も更けた佃の沖、舟を浮かべているのは姐妃と異名をとる深川芸者の小万と船頭の笹野屋三五郎の夫婦。三五郎は父親に勘当されているが、その父から旧主のために百両の金の工面を頼まれた。三五郎は小万に入れ上げている薩摩源五兵衛という浪人から、さらに金を搾り取るようしかける。

02　深川大和町

　深川大和町源五兵衛の浪宅。小万に入れ上げ、家財一式を売る源五兵衛に、若党六七八右衛門が意見する。源五兵衛は実は不破数右衛門といい塩冶家の家臣であったが、盗賊に御用金を盗まれた落度によって浪人となった。その後、塩冶家は主君判官の刃傷事件でお家断絶、源五兵衛は金を工面して、主君の仇討の仲間に加わろうとしているのであった。

　そこに小万がやってくる。小万の二の腕には「五大力」という入れ黒子がある。源五兵衛への心中立てに彫ったと話す小万に、すっかり気をよくする源五兵衛。

01　At Sea in Tsukuda

Late night on the sea in Tsukuda. The geisha Koman, who has taken the strange name of "Dakki," rides in a boat with her husband Sasanoya Sangoro. Sangoro's father has disowned him but asked that he raise 100 *ryo* for the sake of their former master. Because of this, Sangoro plots to trick the ronin Satsuma Gengobei out of 100 *ryo* by using his wife Koman, with whom Gengobei is in love.

02　Fukagawa Yamatocho

Gengobei sells everything he has to obtain Koman, but his servant Rokushichi Hachiemon tries to dissuade him. It is revealed that Gengobei is actually Fuwa Kazuemon, a former retainer of the late Lord En'ya. He lost his status after money was stolen from the house, and before the fateful incident that led to En'ya's death and the termination of his house. Because of this, Gengobei has been trying to raise funds to restore his position and join the plot to avenge his former master.

As he is speaking with Hachiemon, Koman arrives and shows Gengobei a tattoo on her left arm, a sign of her love for and willingness to commit lovers' suicide with Gengobei. This makes Gengobei completely forget about his other duties once more.

また、そこに源五兵衛の伯父、富森助右衛門が百両の金子を持ってやってくる。助右衛門はこれで仇討に加わるようにと金を渡す。小万からそのことを聞いた三五郎は、言葉巧みに源五兵衛を誘い出す。

03　二軒茶屋

深川二軒茶屋では、小万の身請け話をでっち上げ、源五兵衛から百両を巻き上げる算段が進んでいる。小万は源五兵衛という相手がいるからと身請けを断り、腕の五大力の入れ黒子をみせる。仇討に加わるために大事の金ゆえ、源五兵衛は辛抱しているが、小万が自害しようとするに及び、伯父の用立ててくれた百両を差し出してしまい、それを見た助右衛門は、縁を切ると言い渡して去っていく。望みを絶たれた源五兵衛は小万を連れて帰ろうとするが、三五郎は小万が自分の女房だと明かす。何もかもが、金を巻き上げるための芝居であったことにようやく気付いた源五兵衛は、無念をこらえ帰って行く。

04　五人切の場

その夜、三五郎たちは仲間の内びん虎蔵の家に集まっている。三五郎は計略の成功に気をよくし、小万の腕の五大力の彫り物に、「三」と土偏を加え、「三五大切」と変えた。夜更け、源五兵衛が忍び入り次々と五人の男女を斬り殺すが、三五郎と小万は難を逃れる。

05　四谷鬼横町

四谷鬼横町の長屋では、昨日引っ越してきたばかりの八右衛門が幽霊を見たと言って引っ越しする騒動が持ち上がっている。次の店子としてやってきたのは、三五郎と小万である。

そこに現れた僧の了心。了心は三五郎の父徳右衛門である。三五郎は源五兵衛から巻き上げた百両を父に渡す。了心は三五郎の勘当を許し、旧主へ百両を渡すために出かけていく。

その時源五兵衛が訪ねてくる。おびえる三五郎と小万に、源五兵衛は酒を渡す。そこに役人の出石宅兵衛が源五兵衛を捕らえにやってくるが、居合わせた八右衛門が名乗り出て罪をかぶる。

その夜幽霊が現れる。幽霊の正体は弥助。幽霊騒ぎで次々に店子を入れ替え、礼を儲けていたのである。弥助は源五兵衛が持参した酒を飲み始めるが、血を吐いて苦しみ出す。源五兵衛の酒は毒酒だったのだ。

やがて了心が戻ってきて、旧主が三五郎に会って金の礼を言

Just at that moment, Gengobei's uncle Tomimori Sukeemon arrives with a delivery of 100 *ryo* to help him join the plot to avenge En'ya. Koman then uses her silver tongue to trick Gengobei out of this money.

03　The Niken Teahouse

At a Teahouse called Niken-jaya, Gengobei hears a false rumor that Koman is to be redeemed from her geisha service by another man, and he is made to believe that he must pay 100 *ryo* if he wants her. Koman shows Gengobei her tattoo again, saying that she refused the man who was going to redeem her out of love for him. Though Gengobei hesitates to use the money his uncle gave him to avenge his former master, Koman threatens to kill herself, manipulating him into paying the money for her. Gengobei's uncle Sukeemon sees this and immediately disowns his nephew. When Gengobei attempts to take Koman with him, however, Gengobei reveals that she is in fact his wife, and Gengobei returns home alone, bitterly angry.

04　The Slaughter

That night, Sangoro and his men gather at Uchibin Torazo's home. Sangoro is pleased that his plans have gone so well, and Koman's tattoo is shown to have been changed to express loyalty to Sangoro instead of Gengobei. That night, the enraged Gengobei sneaks into the house and kills five of the people staying there, but Sangoro and Koman manage to escape.

05　An Alleyway in Yotsuya

Sangoro and Koman arrive at a tenement that has recently been vacated due to the previous tenant (Hachiemon) seeing ghosts there.

A priest named Ryoshin soon arrives at the tenement. He is actually Sangoro's father Tokuemon, come to retrieve the 100 *ryo* he asked his son for. After receiving the money, Ryoshin lifts his son's disinheritance and leaves to take the money to his former master.

Gengobei then arrives, frightening Sangoro and Koman, who believe he seeks revenge. However, Gengobei has only come to offer them some *sake*. An officer arrives just then to arrest Gengobei for the murders he recently commited, but Hachiemon takes the blame in his stead.

That night, Yasuke appears dressed as a ghost. He has been doing this in order to scare new tenants away and make money off of their moving-in fees. Yasuke sees the *sake* that Gengobei delivered and begins to drink some, but he immediately coughs up blood, as the *sake* was poisoned.

When Ryoshin returns to the tenement, he gives Sangoro his former master's thanks and then transports Sangoro to his temple in a barrel to hide him. Gengobei later comes by to see whether Sangoro and Koman drank his poisoned *sake*, but instead sees Koman alive and well. Enraged to see her tattoo, which now expresses love for Sangoro, he puts a knife

05 四谷鬼横町
『盟三五大切』 2008年11月 歌舞伎座
(左から) 笹野屋三五郎 (七代目尾上菊五郎)、小万
(五代目中村時蔵)

An Alleyway in Yotsuya
Kamikakete Sango Taisetsu
(Kabukiza Theatre, Nov. 2008)
(From left) Sasanoya Sangoro (Onoe Kikugoro VII),
Koman (Nakamura Tokizo V)

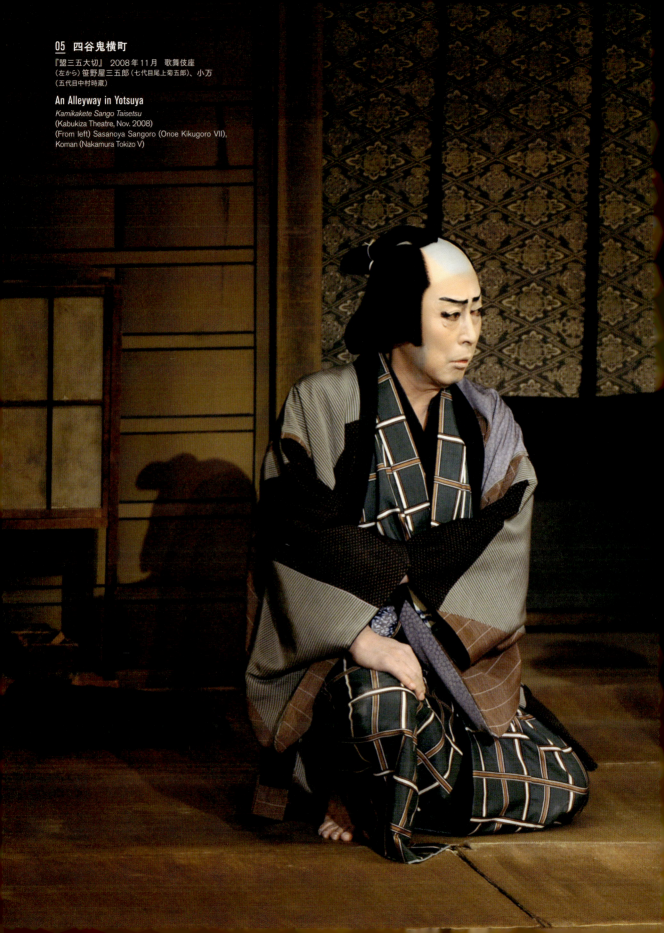

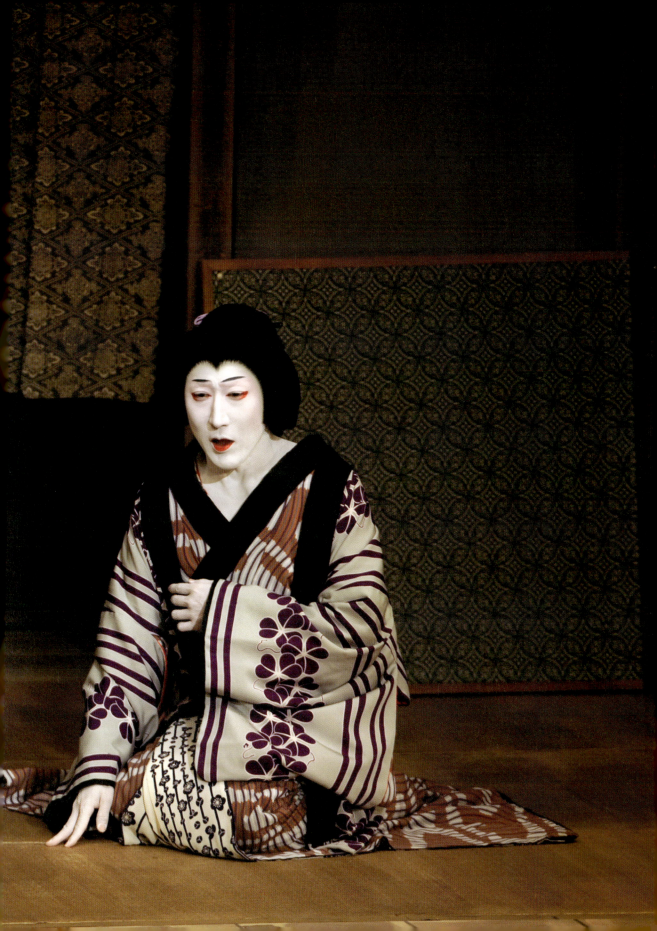

うと伝える。了心は、三五郎を樽に忍ばせて寺へと運んでいく。

　毒酒を三五郎と小万が飲んだか確かめるために、源五兵衛が再びやってきた。小万の腕の彫り物が「三五大切」と変わったのを見て憤った源五兵衛は、小万の手に持たせた刀で幼子を惨殺し、さらに、小万も斬り殺す。

06　愛染院門前

　源五兵衛が小万の首を懐に入れ、愛染院の庵室に戻ると了心がやってくる。三五郎の父の旧主とは、源五兵衛すなわち不破数右衛門であった。

　源五兵衛が、自分の犯した罪を打ち明け、自害しようとすると傍らの樽から声がして出刃包丁を腹に突き刺した三五郎が出てくる。

　父の主人のために必要な金を、その主人から奪い取ったと知った三五郎は、源五兵衛の犯した罪も全て引き受けると言って息絶える。

　源五兵衛は塩冶浪士不破数右衛門に戻り、義士の仲間とともに討入に出立する。

in Koman's hand and forces her to kill her baby, and then proceeds to kill her.

06　At Aizen'in Temple

　Gengobei puts Koman's decapitated head in the sleeve of his robes and returns to his hermitage at Aizen'in Temple. As he returns, Ryoshin arrives, revealing that the "former master" of Ryoshin and Sangoro was actually Fuwa Kazuemon, who has been disguised as Gengobei.

　Gengobei reveals his horrible crimes and decides to commit suicide, but just then Sangoro emerges from the barrel and stabs himself in the stomach. In dying, he takes responsibility for the deeply ironic crime of stealing from his master to secure money for that same master.

　Gengobei returns to his true identity as the ronin Fuwa Kazuemon and joins the plot to avenge his fallen master En'ya.

作品の概要

演目名

盟三五大切

作者

四世鶴屋南北

概要

　二幕六場。『東海道四谷怪談』を大入りで打ち上げ、その後日談という内容を持つ。『東海道四谷怪談』と同じ、忠臣蔵の忠義の仇討が背景にある。「五大力」というまじないの文字を「三五大切」と書き変え、愛情のもつれで殺人が起こる先行作に、「忠臣蔵」や「四谷怪談」などを混ぜて脚色した。作品自体の評価は初演時より高かったが、興行は不入りで打ち切り。その後一度再演されたが上演は絶える。大正期に新国劇、戦後は新劇などが脚本に注目し取り上げているが、歌舞伎では昭和51（1976）年、国立小劇場において郡司正勝の補綴演出により復活したのが、初演から数えて151年、再演からも130年以上たっての上演であった。

　旧主の仇討のために金を騙し取ったが、貢ぐ相手は騙し取った本人。また、その本人は大量殺人を犯しても、そのまま忠義の士として仇討に加わるなど、南北の筆は忠義、仇討という大きな物語の裏側をえぐる。緻密な構成で人間の深部を鋭く描く異色作である。

初演

文政8（1825）年9月江戸・中村座で、五世松本幸四郎の源五兵衛と家主、七世市川團十郎の三五郎、六世岩井半四郎（当時二世粂三郎）の小万ほかで初演。四世鶴屋南北作。

Overview

Title

Kamikakete Sango Taisetsu

Writer

Tsuruya Nanboku IV

Overview

　After the success of *Tokaido Yotsuya Kaidan*, *Kamikakete Sango Taisetsu* was written as a sequel. Like *Yotsuya Kaidan*, this piece also uses the revenge plot of *Chushingura* as its backdrop. It uses the plot device of an altered tattoo used to deceive a lover and adds elements from both *Chushingura* and *Yotsuya Kaidan*. Though this play was popular at its debut, it suffered from low theater attendance around that time. It had one revival, but was never performed again due to the emerging popularity of the *Shinkokugeki* (New National Theatre) and *Shingeki* (New Theatre). Finally in 1976 (151 years after its debut and 130 after its first revival), *Kamikake* was revived at the national theater with the help of the late theater critic Masakatsu Gunji.

　A samurai who needs money to avenge his late master charges his former servant with the task of finding the money. In an ironic twist, however, the servant's son mistakenly embezzles the money from the very samurai he is supposed to be working for. Add to that a gruesome massacre, and we see that Nanboku's brush has a special way of peeling away the gloss of "loyalty" and "revenge" to show the ugly truth beneath.

Premiere

First performed at the Nakamuraza Theatre in Edo, September 1825. Feat. Matsumoto Koshiro V as Gengobei and the landlord, Ichikawa Danjuro VII as Sangoro, Iwai Hanshiro VI (known as Kmesaburo II at the time) as Koman, and others. Written by Tsuruya Nanboku IV.

登場人物 / Characters

薩摩源五兵衛 実は 不破数右衛門
さつまげんごべえ じつは ふわかずえもん

身分を隠しているが実は塩冶家の不破数右衛門。御用金を盗まれて浪人となり、さらに塩冶家は主君判官の刃傷事件でお家断絶、源五兵衛は百両の金を工面して仇討の仲間に加わろうとしている。しかし一方で芸者の小万に入れあげ、伯父が届けてくれた百両を小万の身請けに使ってしまうが、その身請け話は小万と亭主の三五郎が仕組んだ真っ赤な嘘、ついに小万をはじめ沢山の人を惨殺する。

Satsuma Gengobei / Fuwa Kazuemon

Former En'ya house retainer Fuwa Kazuemon lives in hiding as Satsuma Gengobei after becoming a ronin for failing to stop a burglar from stealing money from the house. After becoming a ronin, the En'ya house was terminated and Master En'ya killed. Because of this, Gengobei is now trying to gather 100 *ryo* (a unit of money) in order to restore his reputation and join in the plot to avenge his late master. His uncle delivers this sum to him to help with his efforts, but then Gengobei hears that his lover, the geisha Koman, is to be sold off to another man. A lie spread by Koman and her husband Sangoro, this nonetheless sways the gullible Gengobei to spend the money to buy Koman for himself.

妲妃の小万
だっきのこまん

美しくも妖しい悪女と異名を取る深川芸者だが、三五郎の女房で名はお六。夫の父親が元の主人（不破数右衛門）のために金を必要としているので芸者となったが、自分に惚れている源五兵衛をうまく金づるにしている。腕の「五大力」の刺青は源五兵衛を一途に思う証拠といって百両の金を巻き上げるが、後に細工をして「三五大切」と変え、源五兵衛の怒りにさらに火をつける。

Dakki no Koman

The beautiful but sinister Koman takes on the peculiar name of Dakki. She is married to Sangoro, whose father requests money to help his former master Kazuemon. She therefore becomes a geisha and makes Gengobei fall in love with her. She shows him a tattoo on her arm that is a sign of her love for him in order to convince him to purchase her for 100 *ryo*, but afterward it is shown that her tattoo had been altered and actually expresses love for her husband Sangoro. When Gengobei finds out, he is deeply enraged.

六七八右衛門
ろくしちはちえもん

源五兵衛に仕える忠義心の強い若党で、小万への執着を断って討入に加わるよう源五兵衛に意見する。後に源五兵衛が五人斬りをした時には、自分が身替りとなって罪をかぶり縄につく。

Rokushichi Hachiemon

A strong and faithful servant of Gengobei, Hachiemon encourages Gengobei to abandon his love for Koman and focus on his duty to avenge the late Lord En'ya, but Gengobei refuses to listen and ends up embroiled in a gruesome slaughter. The faithful Hachiemon takes the fall for this crime.

笹野屋三五郎
ささのやさんごろう

笹野屋という船宿の船頭。塩冶家の不破数右衛門に仕えていた父から百両の工面を頼まれ、そのため女房の小万に芸者勤めをさせている。やがて小万に惚れている源五兵衛が百両の金を持っていることを知り、小万の身請け話をでっち上げてそっくり奪ってしまう。必要としていたその金は父の元主人・不破数右衛門のためだが、まさか数右衛門と源五兵衛が同一人物とは知らなかった。

Sasanoya Sangoro

The boatman Sasanoya Sangoro is married to Koman and pressured by his father to get 100 *ryo* to give to their former master Fuwa Kazuemon. He therefore has his wife act as a geisha in order to trick Gengobei into buying her for 100 *ryo*. Ironically, it is finally revealed that his father's former master Fuwa Kazuemon and the man he stole from, Gengobei, are actually the same person!

富森助右衛門
とみのもりすけえもん

塩冶家の浪士。源五兵衛すなわち不破数右衛門の伯父という設定になっており、主君の仇討に加わるために必要な百両の金を源五兵衛に届けに来る。

Tominomori Sukeemon

A ronin who formerly served Lord En'ya and Gengobei's uncle, Tominomori Sukeemon helps his nephew by giving him the 100 *ryo* necessary to join the plot to avenge Lord En'ya.

了心
りょうしん

元は徳右衛門といい塩冶家の不破数右衛門に仕えていたが、浪人となっている主人を思い、仇討に加われるように百両の金の工面に奔走する。そのため願人坊主となりお岩稲荷再建立といって金を集め、さらに倅の三五郎やその女房の小万の助けを借りるが、ようやく手に入った百両が実は主人である不破数右衛門から奪い取ったものであったとは。

Ryoshin

The priest Ryoshin is Sangoro's father and used to serve Fuwa Kazuemon in Lord En'ya's house. Back then he went by the name of Tokube, but now is a ronin who is trying to get 100 *ryo* so that Kazuemon can join a plot to avenge Lord En'ya. He charges his disowned son Sangoro and his wife Koman with getting the money, which they succeed in doing, but it turns out that they have stolen the money from Ryoshin's master Kazuemon himself, disguised as Gengobei.

くり廻しの弥助
くりまわしのやすけ

四谷鬼横町の長屋の大家で、お岩の幽霊に化けて次々と借家人を追い出し家賃だけせしめる欲深い人物だが、実は小万の兄。元は神谷家の中間で土手平といい、御用金を盗んでそれが不破数右衛門を浪人させる原因ともなっていた。ここへ逃げるように駆け込んで住み込むのは三五郎と小万、そして源五兵衛が酒を置いてゆくが毒の仕込まれたその酒を呑んだ弥助は苦しんで死ぬ。

Kurimawashi no Yasuke

A tenement landlord, Yasuke is a deceptive man who pretends to be a ghost in order to scare off new tenents to make extra money. He is Koman's older brother and is the man who stole money from Lord En'ya's house, leading to Fuwa Kazuemon's discharge. Sangoro and Koman eventually flee from the enraged Gengobei and end up in Yasuke's tenement. When Gengobei finds them there, however, he does not kill them, instead delivering a package of poisoned *sake*, which Yasuke ends up drinking and dying.

菊野
きくの

深川の芸者で小万の朋輩。伊之助といい仲で、源五兵衛をだます計略に一役買うが、源五兵衛を気の毒に思っている。寝込みを襲われ伊之助と共に源五兵衛に殺される。

Kikuno

Koman's friend and fellow geisha, Kikuno is Inosuke's lover and though she has her own role in the plot to trick Gengobei, she feels pity for him. She is mistakenly murdered (along with Inosuke) by Gengobei, who thinks she is Koman.

お先の伊之助
おさきのいのすけ

船頭で三五郎の仲間。小万の兄に化けて三五郎と共に源五兵衛をだまし百両を巻き上げる手伝いをするが、その晩に恋仲の芸者・菊野と寝ているところを三五郎と小万と見誤った源五兵衛に殺される。

Osaki no Inosuke

A boatman and friend of Sangoro, Osaki no Inosuke pretends to be Koman's brother to trick Gengobei into purchasing her, but is later murdered along with his lover Kikuno by Gengobei, who mistakes the two for Sangoro and Koman.

内びん虎蔵
うちびんとらぞう

三五郎の仲間。源五兵衛からまんまと金をせしめた連中がこの虎蔵の家に集まって気を良くし、小万の刺青を彫り直して悦に入るが、寝静まった後、源五兵衛が忍び込んで凄惨な殺しの現場と化す。

Uchibin Torazo

Sangoro's friend who puts Sangoro and his men up at his home after they successfully embezzle money from Gengobei. He fixes Koman's altered tattoo for her and gloats about their success, but that very night Gengobei sneaks in as they sleep and murders everyone except for Sangoro and Koman, who manage to escape.

※登場人物の読み方は歌舞伎の慣例によっています。

*The readings of character's names are printed according to the conventions of the kabuki theater.

みどころ
Highlights

1. 「五大力」は手紙のおまじない
—— Godairiki—a Vow, a Deception

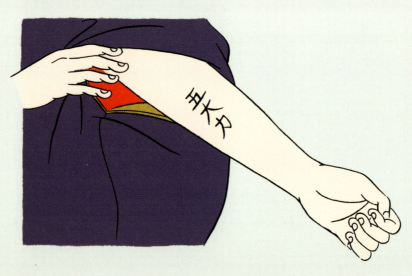

江戸時代のある頃、手紙の封じ目に「五大力」の文字を書くと、五大力菩薩の加護で、手紙がちゃんと届くというおまじないが流行した。転じて「五大力」は誓いの文字ともなった。本作の先行作『五大力恋緘』では、芸者の小万が実直な武士源五兵衛に本当に惚れて、心中立てに「五大力」の文字を三味線の胴に書く。本作では、小万が源五兵衛を騙すために腕に「五大力」と刺青を入れる。「五大力」の女の気持ちがまったく逆なのだ。

In this play, the geisha Koman tricks Gengobei into believing she is in love with her by showing him a tattoo on her arm with kanji reading *godairiki*. This is a common inscription written on the seal of a letter that has come to symbolize a vow or oath. In another play entitled *Godairiki Koi no Fujime*, Koman is truly in love with Gengobei and writes *godairiki* on a shamisen to signify her intention to commit lovers suicide with him. But in this play, her intention is only to deceive Gengobei.

2. 隅田川と船の風情
—— Sumida River by Boat

歌舞伎大道具の優れた技術のひとつに、川や海をゆく船を操るわざがある。廻り舞台を動かしながら川面を船がきれいに滑るように見せる。隅田川に船を浮かべ、恋人との涼しい逢瀬を楽しむ場面はなんとも風情豊かだ。船上なので、誰に遠慮も要らないひそひそ話の場面にもなる。しかし、この芝居のはじまりでは、芸者小万と三五郎が船中で悪巧みを相談しているそばへ、騙す相手の源五兵衛の船が不意に近づいて、ドキリとさせられる。

Boat rigging in kabuki is one of the most impressive large-scale stage props that uses a *mawari-butai* to smoothly show the river flowing by the boat. The lovers' rendevous on the Sumida River in just such a boat rigging offers a unique and beautiful vantage. Appearing at the beginning of the play, the geisha Koman and her lover Sangoro discuss their evil plot in what they believe is complete privacy, only to be startled when Gengobei, the man they intend to deceive, passes by in his own boat.

3. 四谷怪談の後日談
—— Sequel to the Yotsuya Ghost Story

本作は『東海道四谷怪談』の後日談として初演されている。源五兵衛の仕返しを恐れ、下町から四谷へ引っ越した小万と三五郎だが、その家はかつて『四谷怪談』の主人公民谷伊右衛門が住んでいて、幽霊が出るという設定になっている。実は強欲な家主が夜中に幽霊を装って脅かしているのだが、二人はちっとも怖くない。彼らにとっては死んだ幽霊より、生きた源五兵衛のほうが、ずっと怖いのだ。

This play premiered as a sequel to *Tokaido Yotsuya Kaidan*. Koman and Sangoro move to Yotsuya to escape Gengobei, who wants vengence, but the house they move into is the former home of Tamiya Iemon (a character from Yotsuya Kaidan), now haunted by ghosts. In reality, the greedy landlord is pretending to be a ghost to scare off new tenants and make some extra money. Koman and Sangoro, however, are not scared in the least, fearing the living Gengobei far more than a mere ghost.

4. 新劇、歌舞伎、映画での復活
—— In *Shingeki, kabuki,* and film

グロテスクで暗い話なので初演は不評、長く上演は途絶えていた。しかし昭和44年劇団青年座が新劇として上演し、2年後には『修羅』というタイトルで映画化もされる。リアルな衝動殺人、勧善懲悪でない結末などが注目されたのだろう。昭和51年に国立小劇場で、郡司正勝演出により、ついに歌舞伎として復活上演される。小万が玉三郎、三五郎が孝夫（現・仁左衛門）、そして源五兵衛が辰之助（三世松緑）で強烈な印象を残した。

The dark and grotesque nature of the play made it unpopular when it debuted, and it was not performed for many years. In 1969, however, it was revived at the Gekidan Seinenza Theatre as a *shingeki* (new drama) production. Two years later it was adapted into a film called *Shura*. Perhaps the realistic depiction of murder and the plot which refuses to reward the good and punish the bad was refreshing to audiences at the time. 1976 saw the kabuki revival at the National Theatre produced by Masakatsu Gunji. The performance starred Tamasaburo as Koman, Takao (now Nizaemon) as Sangoro, and Tatsunosuke (Shoroku III) as Gengobei in a truly stunning performance.

5. 男の本音
—— A Man's True Feelings

源五兵衛はプライド高い侍で、メンツを潰されて殺人鬼と化すように見えるが、実は女へのすさまじい未練を胸に秘めている。ついに女を捜し当てて殺すと、その生首を懐に入れ雨のなかを帰っていく。自分の家へ戻ると首と差し向いで、冷え飯を食う。首の口もとに飯を向け、「われと二人、食事をせんと思うたに」などとつぶやく。男の本音が覗く、ぞっとする場面だ。首は本首といって、役者が首だけ出す仕掛け。一瞬、目を開ける！

Gengobei seems like a proud samurai who let his loss of face get the best of him, turning him into a cold-blooded murderer, but he holds onto a lingering tenderness for the woman he loved. After killing his ex-lover, Gengobei takes her severed head home with him and places it opposite him at his dining table. In a chilling scene that shows a deranged but somehow loving Gengobei offering the head some rice, we hear him mutter to himself, "I never thought we'd share a meal like this, just the two of us." This scene is performed with the actual actor who plays Koman, his body carefully hidden to make it look like a severed head. Look carefully and you'll see Koman suddenly open her eyes!

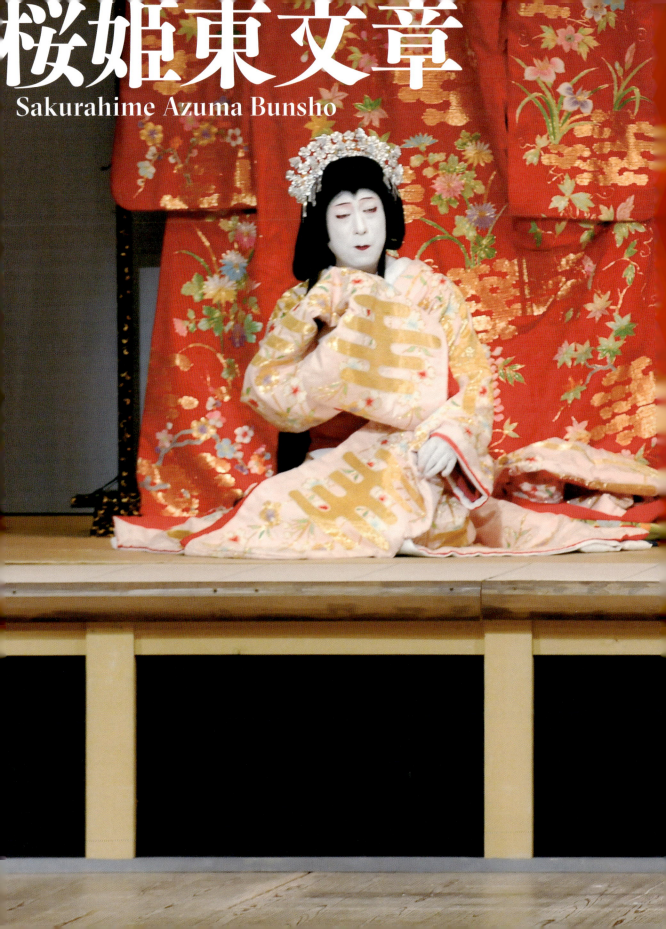

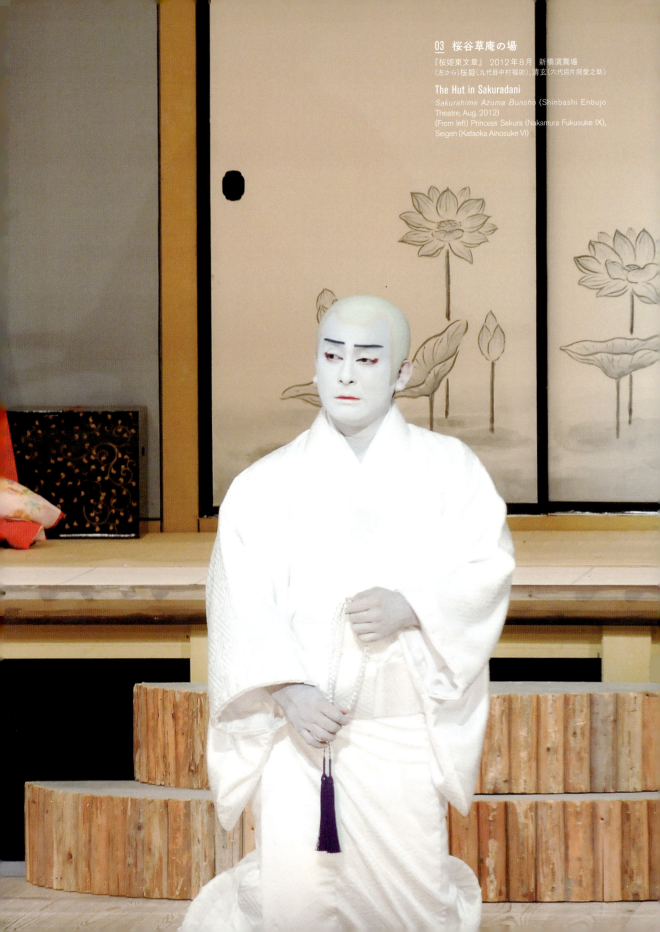

03 桜谷草庵の場

『桜姫東文章』 2012年8月 新橋演舞場
(左から)桜姫(九代目中村福助)、清玄(六代目片岡愛之助)

The Hut in Sakuradani
Sakurahime Azuma Bunsho (Shinbashi Enbujo Theatre, Aug. 2012)
(From left) Princess Sakura (Nakamura Fukusuke IX),
Seigen (Kataoka Ainosuke VI)

あらすじ / Synopsis

お姫様から下級の娼婦へ、人を殺して、またお姫様に。あれよあれよという間に変わっていく一人の女性の遍歴

お姫様は生まれ変わり!? 衝撃の発端から大詰めまで、
桜姫の数奇な遍歴が繰り広げられる人気作品。
これほど面白いのに150年埋もれていた禁断の問題作。

From princess to prostitute, prostitute to murderer, and finally a princess again, This is the dazzling story of a truly fascinating woman.

Starring a princess who is a reincarnation, this play takes audiences on a truly incredible roller-coaster of a journey. It's hard to believe that such a unique play went unperformed for 150 years!

01 江の島稚児が淵

修行僧清玄は、稚児白菊丸と江の島稚児が淵で心中をはかる。お互いの名を記した香箱の蓋を左手に握りしめ、白菊丸は断崖から海に飛び込むが、気後れした清玄は生き残る。

02 新清水の場

十七年後。吉田家の息女桜姫は生まれつき左手が開かない。さらに父、弟が殺害され、家宝「都鳥の一巻」も盗まれ、新清水(鎌倉の長谷寺)で出家しようとしている。高僧になった清玄が念仏を唱えると、姫の左手が開き香箱の蓋が現れる。そこには「清玄」と書かれてあった。それを見た清玄は、姫が死んだ白菊丸の生まれ変わりであると悟る。

03 桜谷草庵の場

出家の準備のため草庵にいる桜姫は、やってきた釣鐘権助という男の、二の腕の釣鐘の刺青を見て驚く。一年前屋敷に忍びこんで自分を強姦した男の二の腕に釣鐘の刺青があり、その男のことが忘れられなかった姫は、自分の二の腕にも同じ刺青を彫っていた。姫はその折に懐胎し、子供を産み落としていた。出家の志も忘れ、場所が寺であることもわきまえず、思わず権助に抱きつく桜姫。しかし姫を付け狙う入間悪五郎らの企みでことが露見し、権助は逃亡。その場に落ちて

01 At Chigogafuchi Beach

The Priest Seigen and his male lover Shiragiku decide to commit lovers suicide together, but while Shiragikumaru throws himself into the sea while holding an incense box lid engraved with Seigen's name, Seigen hesitates and does not die with Shiragiku.

02 At Shinkiyomizu Temple

17 years later, the young Princess Sakura, born to the Yoshida family, is in great distress. She has been unable to open her left hand since birth, her father and younger brother have commited suicide, and a precious family scroll called Miyakodori no Ikkan has been stolen. The princess is now a nun at Shinkiomizu Temple, and she has Seigen, now a head priest, pray over her. As Seigen intones the nenbutsu prayer, Princess Sakura's hand opens to reveal the lid to the incense box that Shiragikumaru held when he died. Seigen now realizes that she is the reincarnation of Shiragikumaru.

03 The Hut in Sakuradani

Princess Sakura is preparing to take the tonsure and become a nun at a thatched hut in Sakuradani when a man arrives with a tattoo of a bell on his arm. The princess is shocked to see this and realizes that he is Tsurigane Gonsuke, the man who snuck into her house and raped her the previous year. So as never to forget him, she had the same tattoo put on her arm, and even went on to have his child. Forgetting her plan to become a nun, Princess Sakura

いた香箱から清玄に疑いがかかる。清玄は罪を受け入れ、桜姫とともに不義の罪で追放される。

04 稲瀬川の場

破戒堕落の清玄と桜姫は鎌倉の稲瀬川で晒し者にされる。里親から戻された子を抱える姫に、清玄は夫婦になろうと迫る。当惑する姫。やがて、悪五郎と吉田家の忠臣粟津七郎と姫の弟・松若丸の争いがおこり、その混乱のなか姫は逃げ、赤子が清玄の手に残される。

05 三囲土手の場

姫を探し求める清玄は、隅田川のほとり、三囲神社の鳥居まで来る。そこへ零落した桜姫もさまよい来るが、暗闇で互いに確認できないまま別れていく。

06 岩淵庵室の場

主君たちと同じ不義の罪で追われた桜姫の局長浦と清玄の弟子残月。二人が住まう本所岩淵の庵室に、清玄が病で寝込んでいる。二人は清玄の金を取ろうとし、青蜥蜴の毒を飲ませようとする。もみ合っているうちに毒を浴びた清玄は、顔半面青あざとなった上に首を絞められる。二人は墓掘りとなっていた権助に墓を掘らせる。

やがて人買いに騙された桜姫が庵室につれてこられる。姫と再会した権助は、姫を千住小塚原の女郎屋に売ろうと相談に出かける。

折しも落雷で清玄が蘇生し、すさまじい形相で桜姫をくどく。桜姫が稚児・白菊丸の生まれ変わりであると語り、心に従わないのならと出刃包丁を振りかざす清玄。もみ合ううちに清玄は権助が掘った墓穴に落ち、包丁で喉を刺し死んでしまう。

やがて庵室に戻り、姫を連れていく権助の顔には、清玄と同じ青あざが浮かぶ。

07 山の宿町権助住居の場

権助は浅草山の宿で家主になっているが、故あって赤子を預かる羽目となる。やがて桜姫が千住小塚原の女郎屋から戻されてくる。二の腕の刺青から、「風鈴お姫」の異名をとり人気であったが、夜な夜な清玄の幽霊が現れるので嫌がられ家に戻されてきたのだ。そこへ清玄の亡霊が現れ、清玄と権助は実の兄弟であること、そばにいる赤子が稲瀬川で別れた子であることを告げる。そこへ酔って帰ってきた権助は、自分は盗賊の忍ぶの惣太で、吉田家当主を殺害して都鳥

suddenly hugs Gonsuke, but Irima Akugoro arrives and Gonsuke must run away. The incense box lid engraved with Seigen's name is found, throwing suspicion on him, but Seigen accepts the accusation that he and Sakura are lovers. The two are thereafter thrown out of the temple.

04 The Inase River

The former priest Seigen and Princess Sakura now live in shame along the Inase river. Sakura has her child with her now, and Seigen pressures her to marry him. Sakura, however, is hesitant to accept his hand, and eventually flees when a fight breaks out between Akugoro, Yoshida family retainer Awazu Shichiro, and her brother Matsuwakamaru.

05 On the Bank of Mimeguri

Seigen arrives at the torii gate at of Mimeguri Shrine near the Sumida riverbank. He is searching for Princess Sakura, who is indeed loitering around the shrine, having fallen into dire circumstances. In the darkness of night, however, the two cannot see each other's face and end up going on their separate ways.

06 The Iwabuchi Hermitage

Princess Sakura's former servant Nagaura and Seigen's younger brother Zangetsu currently live in shame for their affair, much like Seigen. Seigen is now bedridden in the hovel where they live, and the two plot to steal his money by poisoning him. A skirmish ensues with Seigen and his face is half covered in the poison, which causes his skin to turn blue. They finally choke Seigen to death and charge Gonsuke, now a gravedigger, to dig a grave for their victim.

Princess Sakura eventually comes to the hovel, having been tricked into a life of servitude. She meets Gonsuke there, who leaves to make arrangements to sell her to a brothel.

Just then a bolt of lightning falls and Seigen is ressurected. He pleads with Princess Sakura, explaining that she is the reincarnation of his lover Shiragikumaru, threatening her with a knife should she refuse him. The two scuffle, the knife falls into the grave, and finally Seigen falls in the grave and is impaled by the knife.

After Seigen dies, Gonsuke returns, but now he has the same discoloration on his face that Seigen had.

07 At Gonsuke's Home at Yama no Shuku

Gonsuke is now the landlord of Yama no Shuku in Asakusa, and comes to have custody of Sakura's baby, not knowing it is his. Meanwhile, Princess Sakura is sent back to Gonsuke from the brothel. Though she was lovingly known by the nickname "chime princess" due to the bell on her arm, she was sent back due to the ghost of Seigen who appeared before her nightly. Now Seigen appears once again at Yama no Shuku, explaining that he and Gonsuke are brothers and that the child is the same one that he parted ways with at the

の一巻を奪い、桜姫の弟・梅若丸をも殺害したことを白状する。桜姫は一巻を取り戻し、仇の血を引いた赤子と権助を殺害する。

08　三社祭礼の場

　三社祭でにぎわう浅草寺雷門の前。松若丸や粟津七郎も揃い、吉田家再興が叶い、桜姫は元の姫君に戻る。

Inase River. Just then, a drunk Gonsuke appears and admits to having killed the Yoshida family head (Sakura's father) and stolen the treasured scroll. Princess Sakura then retrieves the scroll and kills both the baby and Gonsuke.

08　The Sanja Shrine Festival

　Asakusa is bustling with people during a popular festival. Matsuwakamaru and Awazu no Shichiro are present and celebrate the restoration of the Yoshida house with Sakura, who is a princess once more.

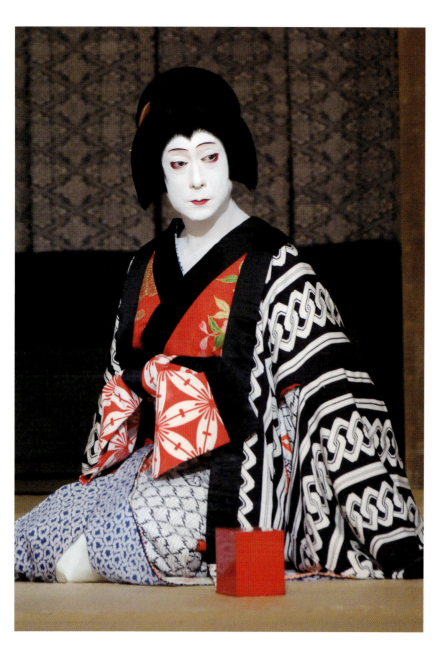

07　山の宿町権助住居の場

『桜姫東文章』 2012年8月
新橋演舞場
桜姫（九代目中村福助）

At Gonsuke's Home at Yama no Shuku

Sakurahime Azuma Bunsho
(Shinbashi Enbujo Theatre, Aug. 2012)
Princess Sakura (Nakamura Fukusuke IX)

作品の概要 / Overview

演目名 / Title

桜姫東文章

Sakurahime Azuma Bunsho

作者 / Writer

四世鶴屋南北

Tsuruya Nanboku IV

概要 / Overview

　四世鶴屋南北の名作として、世に知られている。初演以後上演が絶えるが、昭和に入って何度か復活が試みられた。なかでも昭和42（1967）年3月国立劇場で復活された脚本（郡司正勝補綴・演出）が好評で、以降この脚本演出が定着している。国立の復活は初演以来上演されていなかった発端の「江の島稚児が淵の場」を150年ぶりに復活し、桜姫が清玄と心中した白菊丸の転生であることを明示するなど、南北の奇想を活かしたものである。

　僧清玄が桜姫への恋慕に迷って殺される「清玄桜姫」の物語と、都の公家吉田家のお家騒動である「隅田川物」と呼ばれる先行の作品群を下敷きに当時の世相を織り込んで作られた。下級女郎になった姫が、下卑た言葉と姫の言葉をまぜこぜに言うなど奇抜な趣向をはじめ、南北の得意な生世話の技巧が十分に活かされている。原作は七幕十二場あるが、掲載のあらすじは前述の郡司正勝補綴台本によっている。

　Sakurahime is known as one of Tsuruya Nanboku's most famous plays. It debuted in 1817 but was never played again until the Showa era (1926–1989). From then onward, it was performed many times to wild popularity. The skript that debuted in March 1967 was particularly popular, and eventually became the standard version of the play as performed today. The opening scene ("Chigogafuchi") was revived at the National Theater 150 years after its debut, which revealed to audiences the fact that Princess Sakura is Shiragikumaru's reincarnation and other unique touches of Nanboku's imagination.

　Sakurahime combines the story of Seigen and Princess Sakura with elements of the *sumida-mono* sub-genre and contemporary society. It displays Nanboku's originality in many ways, including the peculiar princess-turned-prostitute story which juxtaposes high and vulgar language to great effect. The original script was in seven acts and twelve scenes, but our synopsis is based on a script that was edited by Gunji Masakatsu.

初演 / Premiere

文化14（1817）年3月江戸・河原崎座にて、五世岩井半四郎の桜姫、七世市川團十郎の清玄と釣鐘権助ほかで初演。四世鶴屋南北作。通称「桜姫」。

First performed at the Kawarazakiza Theatre in Edo, March 1817. Feat. Iwai Hanshiro V as Princess Sakura, Ichikawa Danjuro VII as Seigen and Tsurigane Gonsuke, and others. Written by Tsuruya Nanboku IV. Commonly referred to as *Sakurahime*.

登場人物 / Characters

白菊丸 (しらぎくまる)

鎌倉の稚児で修行僧の清玄と恋仲となり、互いに来世で結ばれようと江の島の稚児が淵で心中する。その時香箱の蓋と身に互いの名を記し、形見としてしっかりと携えていた。白菊丸は潔く入水して瞬く間に波の内へと消え去るが、清玄は鋭い岸壁の恐ろしさに震えて死に遅れ、うろたえてしまう。

Shiragikumaru

Shiragikumaru becomes romantically involved with the priest Seigen in Chigo, Kamakura, and the two decide to commit a lovers' suicide together by throwing themselves into the sea at Chigogafuchi. Shiragikumaru holds the lid of an incense box engraved with Seigen's name as he bravely throws himself into the sea, but Seigen is too afraid and does not join him in death.

清玄 (せいげん)

鎌倉長谷寺の高僧だが、かつて白菊丸と心中となって生き延びたあの清玄。桜姫の開かぬ左手を念仏で開かせるが、中から香箱の蓋が転げ落ち白菊丸の生まれ変わりと知る。しかし釣鐘権助が仕出かした不義の罪を着せられ、寺を追放されて破戒僧へと転げ落ちてゆく。残月に毒殺されそうになるがついには桜姫ともみ合った末に死ぬ。その後も桜姫の枕元に夜な夜な現れ執念深く付きまとう。

Seigen

After failing to join his male lover Shiragikumaru in death, Seigen lived on to become head priest at the Hase Temple in Kamakura. He prays over Princess Sakura's left hand, which causes it to open revealing the incense box lid engraved with his name. Seigen then realizes that the princess is Shiragikumaru's reincarnation. He is subsequently accused by Gonsuke of having an affair with Sakura, which results in his being thrown out of the temple as a disgraced priest. He is later poisoned by Zangetsu but does not actually die, though he soon dies anyway at the hand of Princess Sakura. After his death, he visits her every night as she sleeps, a testament to the strong bond he has with her.

残月 (ざんげつ)

鎌倉長谷寺の僧で清玄の弟子。清玄を追い出して自分がその地位に座ろうと画策するが、桜姫の局の長浦との密通がばれ、こちらも寺を追放される。清玄と同様に貧しい暮らしの中、清玄が大切に持っている香箱を金と思い込み青蜥蜴の毒を飲ませて殺す企てをするが、再会した桜姫に言い寄っているところを権助に見つかり、身ぐるみ剥がされてすごすごと引き上げてゆく。

Zangetsu

Seigen's brother and a fellow priest at Hase Temple, Zangetsu plots to take his brother's place as head priest after he is removed from that position. However, his secret affair with Sakura's chambermaid Nagaura is exposed, and he suffers the same fate as his brother. He plots to poison Seigen to steal what he thinks is money but is in fact the incense box from Seigen's botched lovers' suicide. However, Gonsuke finds Seigen just when he is reunited with Princess Sakura and takes all of his belongings.

桜姫 (さくらひめ)

吉田家の息女だが実は死んだ白菊丸の生まれ変わり。それゆえ生まれつき左手が開かずその手の中には香箱の蓋が詰まっていた。父は殺されお家の重宝の「都鳥の一巻」も紛失、出家を思い立ったところで釣鐘権助に出会う。実は闇夜で男に犯され子供まで産んだが、恋しさからその男と同じ釣鐘の刺青をしていた。権助と夫婦になるものの売られ、細腕の刺青から「風鈴お姫」という遊女になる。しかし毎夜清玄の幽霊が現れる。

Princess Sakura

The daughter of the proud Yoshida family and Shiragikumaru's reincarnation. Because she is a reincarnation, she is cursed with a left hand that will not open (and which secretly holds the incense lid engraved with Seigen's name). Her father has been killed and the family's treasured scroll called Miyakodori no Ikkan has been stolen. Now alone, she decides to become a nun, but is raped by a man named Tsurigane Gonsuke and gives birth to his child. Out of love for her rapist, she gets a tattoo of a bell on her arm, just like Gonsuke has, but when they meet again later on he sells her and she becomes a geisha known as "chime princess." The ghost of Seigen, however, visits her every night at the brothel, which causes trouble for business there.

釣鐘権助 (つりがねごんすけ)

忍ぶの惣太という悪党だが、腕に釣鐘の刺青があるところから釣鐘権助と異名を取っている。かつて吉田の館に入り込み暗闇で桜姫を犯したが、秘かにその時の子を桜姫が産み落としていた。桜姫と夫婦になり権助は墓場の穴掘り、桜姫は風鈴お姫と称する遊女に身を落としてしまう。しかし「都鳥の一巻」を持っていたことが桜姫に知れ、この権助こそお家と父の仇と姫に成敗される。

Tsurigane Gonsuke

Though his true name is Shinobu no Sota, the villain of this story goes by the name Tsurigane Gonsuke after the tattoo of a bell on his arm. He sneaks into the Yoshida residence and rapes Princess Sakura, who later gives birth to his child. Later the two are wed and Gonsuke becomes a gravedigger, but he eventually chooses to sell her as a prostitute. In the end, the princess finds out that Gonsuke is the one who stole her family's treasured scroll and murdered her father, and because of this she kills him to restore her family's name.

長浦 (ながうら)

桜姫の局で吉田家の奥を差配していたが、長谷寺の僧の残月との密通が露見してお家を追放され、残月との貧しい暮らしとなっている。その残月が桜姫と再会して口説くので嫉妬して責めるが、結局は権助に世帯道具の一切を巻き上げられて残月共々傘一本だけを与えられて追い出される。

Nagaura

Princess Sakura's chambermaid who managed the Yoshida house, Nagaura is driven from her house after her illicit affair with the priest Zangetsu is revealed. The two now live in poverty, and Zangetsu blames Princess Sakura, whom he berrates when they meet later. During this fight, however, Gonsuke takes all of their belongings, leaving Zangetsu and Nagaura with only a single umbrella to their name.

入間悪五郎
いるまあくごろう

桜姫の許婚で、姫の左手が開かないので疵物と破談にしていたが、開いたと聞き改めて縁談を結ぼうとする。しかし桜姫が不義を働いたと知ると清玄に罪をなすり付けて追放し、あわよくば姫も我が手にと考えている。かねてから権助と通じて吉田家の乗っ取りを企んでいる。

Iruma Akugoro

Iruma Akugoro is engaged to Princess Sakura for a time, but the marriage is cancelled due to the strange condition of her left hand which will not open. When he hears her hand has finally opened, he is thrilled to re-enter into marriage talks, but then hears of her alleged illicit affair with Seigen. He takes this opportunity to drive Seigen from the temple, but still hopes to make Sakura his wife. From the beginning, he has been working with Gonsuke to take over the Yoshida house.

有明の仙太郎
ありあけのせんたろう

浅草の鳶職で、三社の祭りに女房を質において金を借りるという気負い肌。実は吉田家の忠臣・粟津七郎（あわずのしちろう）だが、お家再興のために身をやつして「都鳥の一巻」を探している。

Ariake Sentaro

A carpentor in Asakusa who uses his wife to borrow money, Sentaro is actually the Yoshida retainer Awazu no Shichiro, who is painstakingly searching for the lost family scroll in order to restore the house.

松井源吾
まついげんご

吉田家の家臣だが、入間悪五郎と共に吉田家の横領を企んでいる。

Matsui Gengo

Retainer of the Yoshida family, Matsui Gengo is working with Iruma Akugoro to seize control of the Yoshida house.

葛飾のお十
かつしかのおじゅう

有明の仙太郎の女房だが、実は吉田家の奴・軍助の妹。桜姫に幽霊がついて売りものにならないと帰されてくると、その代わりに遊女へと売られてゆく。

Katsushika no Oju

Ariake Sentaro's wife, Katsushika no Oju is actually a servant of the Yoshida family. She is sold to the brothel in place of Princess Sakura, who is frequently visited by a ghost and is difficult to make money from.

※登場人物の読み方は歌舞伎の慣例によっています。

みどころ
Highlights

1. 心中の生き残り〜清玄の悔い
—— Seigen's Regret

江戸時代には男性同士の恋は衆道（しゅうどう）と言われた。江の島稚児が淵には、衆道の恋に悩んだ美しい稚児が淵に飛び込んだ、という謂れがある。本作はこのエピソードを発端に仕組んでいる。清玄は若い頃、白菊丸という稚児と叶わぬ恋に落ち、稚児が淵で心中を決心。しかし白菊丸だけが飛び込み、清玄は死に損ねてしまう。恋人を先立たせた悔悟と形見の香箱を懐に秘め、清玄は厳しい修行を積んで高僧となっていたのだ。

Male homosexuality was called Shudo (pederasty), and there is a story of a young boy in Enoshima who was so troubled by his homosexual relationship that he drowned himself in Chigogafuchi. Sakurahime was inspired by this story, and features the priest Seigen, who in his early years as a monk had a relationship with a boy named Shiragikumaru. The two decided to commit a lovers' suicide together, but while Shiragikumaru readily killed himself, Seigen was too hesitant. Regretting that day bitterly, Seigen held onto an incense box that represented his love for Shiragikumaru throughout his life and even after he became a head priest.

2. 因縁なんて知りません〜桜姫
—— Princess Sakura's Karmic Bond

吉田家の桜姫は生まれつき左手が開かないが、控えめなタイプではない。家宝の盗難、弟の行方不明など不幸が重なり、出家を決心したまでは大人しい感じなのだが、胸の内には深い恋の悩みがあった。実は闇夜に襲われて懐妊し、相手の男が忘れられない。男に再会するとためらわず出家を止にして、男の胸に飛び込む。清玄から「白菊丸の生まれ変わりだ」と言い寄られても、前世のことには興味はない。自分に正直に生きるお姫様だ。

Princess Sakura of the Yoshida house is a reserved young woman who has been unable to open her left hand since birth. She falls into difficult circumstances when her family is robbed and her brother goes missing, and eventually decides to become a nun. She is raped in the middle of the night before she can take the tonsure the house, however. She becomes pregnant and also falls in love with the man who raped her. She decides not to become a nun after all after reuniting with the man, and shows no interest in her previous life when Seigen tells her that she is Shiragikumaru reincarnated. To the last, Princess Sakura is honest to herself and her own feelings.

3. 「たがよ、たがよ」
—— Soothing the Child

「たがよ、たがよ」は泣く子をあやす古い言葉。「誰が泣かしたよ、誰が泣かしたよ」というほどの意味だ。香箱に書かれていた清玄の文字から、桜姫の赤子の父は清玄と決めつけられ、清玄は赤子を押しつけられ寺を追われ、乞食同然にさまよう。気高い僧侶であった清玄が、悄然と泣く子をあやす「たがよ、たがよ」には哀愁と、桜姫への妄執が見える。赤子を見つめる清玄の独り言が「これも誰ゆえ桜姫」。清玄を泣かすのが桜姫なのだ。

The lines "tagayo, tagayo," is an antiquated phrase that was used to calm a child and essentially means, "who, who made you cry?" When Princess Sakura's incense box lid engraved with Seigen's name is found, Seigen is accused of being the father of Sakura's baby and is chased out of the temple along with the child. Now a beggar, the dejected Seigen is seen soothing the child, saying "tagayo, tagayo." As he stares at the child he mutters to himself, "who could it be but Princess Sakura." She is the one who has made Seigen cry.

4. 隅田川物のキャラクターたち
—— "Sumida River Works"

能『隅田川』は、都からさらわれ隅田川で死んだ梅若丸を探す母の物語。江戸時代には、これに清玄桜姫などを絡ませ膨らませた芝居がたくさん生まれた。『雙生隅田川』は梅若丸と、双子の弟松若丸が登場するお話。『隅田川続俤』では、重宝を探す松若丸が江戸の道具屋の奉公人を装う。本作の桜姫は、梅若松若の姉にあたる。『隅田川花御所染』は松若丸を巡り清玄尼と桜姫姉妹が争う話。『都鳥廓白浪』では、松若丸が女装して傾城になる。

The noh play Sumidagawa is the story of a mother who searches for her son who was kidnapped and died at the Sumida River. This basic story became the basis for many plays to follow which feature the river, including the story of Seigen and Princess Sakura. Such works are called Sumidagawa-mono, or "Sumida River Works." Futago Sumidagawa, for example, features twin brothers named Umewakamaru and Matsuwakamaru, and in Sumidagawa Gonichi no Omokage the same Wakamatsumaru is seen working as a servant at a shop in Edo while searching for a lost treasure. Sakurahime, another piece in this tradition, features Princess Sakura, who is the elder sister of the twins. Sumidagawa Hana no Goshozome, meanwhile, features a fight between Princess Sakura and a female version of Seigen who is her sister. Mikodori Nagare no *Shiranami*, another *sumidagawa-mono*, features a cross-dressing Matsuwakamaru who transorms into a beautiful woman.

5. 綯い交ぜ
—— The Naimaze Method

「綯い交ぜ(ないまぜ)」は鶴屋南北が得意とした作劇手法。ふたつ以上の違う世界を、縄のようにより合わせるもので、『桜姫東文章』では古風な隅田川の世界に清玄桜姫をからめ、安女郎がお姫言葉を使って評判になった世間話をまぜる。そこに「女郎に売られたお姫」というギャップあるキャラクターが誕生する。桜姫は、夫が実は親の仇と知ると殺してしまい、すっかり元の姫に戻る。まるで空中ブランコのジャンプのような転身である。

Naimaze refers to a dramatic tecnique used by Tsuruya Nanboku which takes two different worlds in a single play. Sakurahime, for example, throws Seigen and Princess Sakura into the world of the Sumida River, and incorporates an old anecdote of a prostitute who used the high language of a princess in the envisioning of Sakura, a princess who is sold into the sex trade. Within the plays plot, too, characters move between worlds at an alarming rate—Princess Sakura kills her husband who is her father's murderer, allowing her to return to the status of a Princess in the restored house.

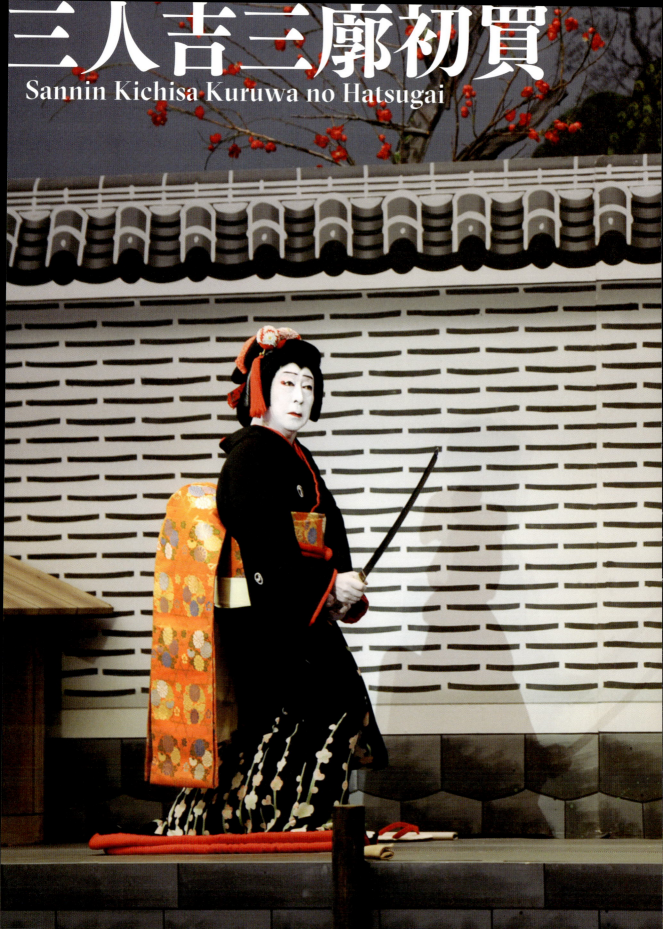

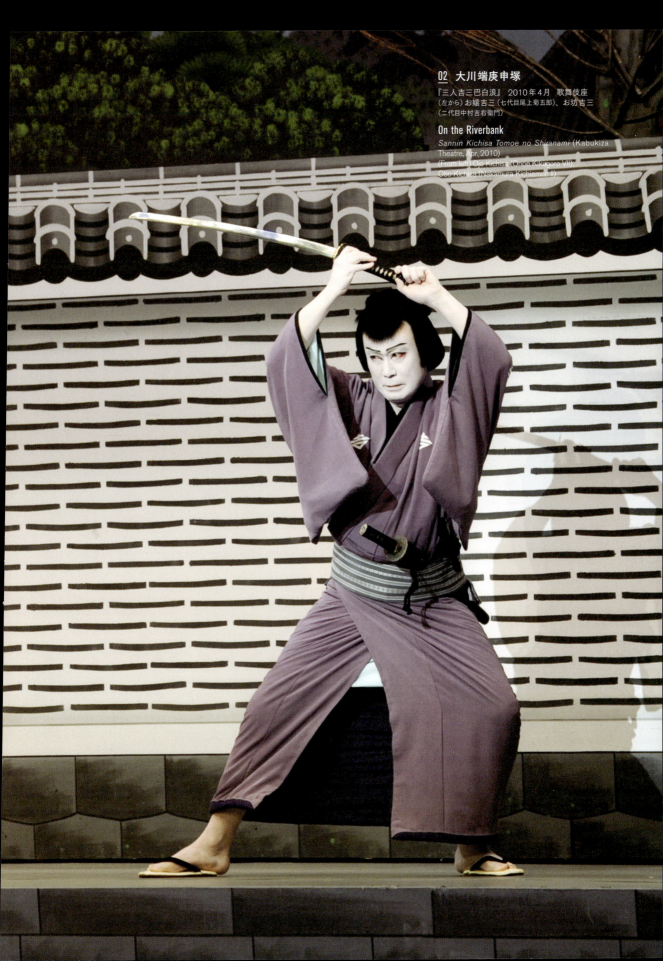

02 大川端庚申塚

『三人吉三巴白浪』 2010年4月 歌舞伎座
(左から) お嬢吉三 (七代目尾上菊五郎)、お坊吉三
(二代目中村吉右衛門)

On the Riverbank
Sannin Kichisa Tomoe no Shiranami (Kabukiza Theatre, Apr. 2010)
(From left) Ojo Kichisa (Onoe Kikugoro VII),
Obo Kichisa (Nakamura Kichiemon II)

あらすじ / Synopsis

月もおぼろに白魚の……。
名せりふを歌い上げるのは、女装の泥棒。
幕末を駆け抜けた若いアウトロー三人の姿

音楽性豊かなせりふで語られる、悲しくも恐ろしい因果話。
幕末の江戸の町の、爛熟と退廃、闇がそくそくと身に迫る、本当は恐ろしい名作。

"The hazy moon, like a nicefish..."
sings a crossdressing thief,
one of the three young outlaws who star
in this riveting play.

A story of dreadful karmic bonds narrated with gorgeous musicality. The fullness and decadence of Edo is displayed in full force in the final act of this truly dreadful drama.

01 大川端に至るまで

　安森源次兵衛は将軍頼朝から預かった名刀庚申丸を土左衛門伝吉に盗まれ、申し訳に切腹、御家はお取り潰しとなった。その庚申丸は、伝吉が盗む際に吠えかかる孕み犬を斬ったはずみで川に落ちてしまった。

　十年以上時がたち、川から引き揚げられた庚申丸は道具屋木屋の手に渡り、海老名軍蔵が百両で買った。軍蔵は研屋与九兵衛に庚申丸を預けるが、その夜死んでしまう。軍蔵に百両を貸していた金貸しの太郎右衛門は、その代価にと与九兵衛から庚申丸を奪いとる。

　一方、木屋の手代十三郎は、使いの帰りに夜鷹の客となり、庚申丸の代金百両を落としてしまう。

　金を落として身投げしようとする十三郎を止めたのは伝吉。話のうちに、夜鷹は伝吉の娘のおとせで、落とした金はおとせが持っていることがわかり、十三郎は伝吉の家に向かう。

01 The Story So Far...

　The Yasumori clan is ruined after the treasured sword Koshinmaru was stolen when in Yasumori Genjibei's custody. At that time, the thief Denkichi killed a pregnant dog using Koshinmaru and dropped the sword in the river, resulting in a terrible curse.

　Over ten years later, the sword has been retrieved from the river and is into the hands of a local second-hand shop. Eventually, a man named Ebina Gunzo purchases the sword for 100 *ryo* and places it in Togiya Yokubei's charge. That night, however, Gunzo is killed, and Taroemon steals the sword from Yokubei as payment for lending Gunzo the money used to buy it.

　Meanwhile, late at night the clerk Juzaburo finishes his business for the day and decides to take a prostitute. He ends up losing the 100 *ryo* that was paid for the sword, and in his despair decides to throw himself in the river. Denkichi stops him, however, and he finds out that the prostitute he had hired is Denkichi's daughter Otose. Apparently Otose has the lost money, and so Juzaburo goes with Denkichi to his home.

02　大川端庚申塚

夜更けの大川端。おとせは百両の金を女装の盗賊お嬢吉三に奪われ、川へ落とされてしまう。それを見た太郎右衛門が金を奪おうとするが、逆に庚申丸を奪われてしまう。思いがけなく手に入った百両にほくそ笑むお嬢に、駕籠の中の男が声を掛ける。男は元侍の盗賊で、お坊吉三。二人は百両をめぐって刀を抜いて争う。割って入ったのは元坊主の盗賊和尚吉三。命を懸けての仲裁に感じ入ったお嬢とお坊は、和尚を兄貴分として義兄弟の盃を交わし、争いの元となった百両は和尚吉三が預かる。

03　割下水土左衛門伝吉内

おとせは八百屋久兵衛に救われ帰宅した。久兵衛は息子が奉公先の金を持ったまま行方が知れぬので捜しているが、その息子とは十三郎。思いがけず再会した十三郎とおとせ。どうやらお互い憎からず思っている様子。

久兵衛の話によれば、十三郎は拾い子。実子は男ながら女姿で育てたが五歳のとき行方知れずになり、捜して歩く帰り道に寺の門前で拾ったのが十三郎だという。それを聞いた伝吉は内心驚く。というのも、おとせは実は男女の双子で、女の子を手元に残し男の子を寺に捨ててきた。その男の子が今いる十三郎なのだ。

そこに伝吉の息子の和尚吉三がやってくる。昨夜大川端で得た金を父に渡そうと来たのだが、悪事の金と拒否される。

やがて一人になった伝吉は、十三郎とおとせの二人が、当時畜生道と忌み嫌われた近親相姦におちたのは、かつて庚申丸を盗んだ時に孕み犬を殺した報いであろうかと、過去の罪業の深さにおののく。父の懺悔を立ち聞いた和尚は、仏壇に百両を置いていく。それを知った伝吉は、金を投げ返すが、通りがかった釜屋武兵衛が持ち去る。

04　本所お竹蔵前

お坊は、武兵衛から百両を奪いとり、さらに後を追ってきて、百両を取り返そうとした伝吉を、和尚の父とは知らず殺してしまう。そこへおとせと十三郎が父の身を案じて来かかり、お坊吉三の落とした証拠の品を拾う。

05　巣鴨在吉祥院本堂

和尚が住まう巣鴨の吉祥院をお坊が訪ねてくる。悪事が露見し三人とも追われる身となっているのである。和尚は役人に、お嬢とお坊の二人を差し出せと命じられ、内心逃がすつもりで引き受ける。

02　On the Riverbank

Late at night on the riverbank, Ojo Kichisa steals the money from Otose and throws her into the river. Taroemon sees this and attempts to steal the money again from Ojo but instead Ojo steals the sword Koshinmaru from him. As Ojo is reveling in his luck, a man calls out to him. The man's name is Obo Kichisa, a former samurai turned thief. The two draw swords and begin to fight over the money, but a third Kichisa appears. The level-headed Osho Kichisa breaks up the fight and takes charge of the money himself as the three drink together and swear an oath of brotherhood.

03　At Denkichi's Place

Yaoya Kyubei, who was searching for his son Juzaburo, saves Otose and returns her to her home. Juzaburo eventually comes to the house and meets with Otose once again. Both are pleased to see one another again.

It is revealed that Juzaburo was adopted by Kyubei. His real son was raised as a girl until he went missing at the age of five. It was when searching for his then five-year-old son that Kyubei found Juzaburo abandoned in front of a shrine. Secretly Denkichi is shocked to hear this news, believing Juzaburo to be Otose's twin brother whom he left at a temple years ago.

Just then, Denkichi's son Osho Kichisa arrives and attempts to give his father the money he has found. Denkichi, however, refuses the dirty money.

When Denkichi is finally alone, he laments his fate. His daughter and son have entered into an incestuous relationship, which is surely karmic retribution for the pregnant dog he killed years ago when stealing the sword Koshinmaru. Osho overhears his father and leaves the money on the family's Buddhist altar. Denkichi sees this and throws the money away, which is then picked up by a man named Kamaya Buhei.

04　Otakegura

Obo finds Buhe and kills him to take back the money. He then runs into Denkichi, who was pursuing Buhe to retrieve the money. Unaware that he is Osho's father, Obo kills him, and Otose and Juzaburo later come by and retrieve evidence dropped by Obo.

05　Kisshoin Temple Main Hall

Obo comes to Kisshoin Temple where Osho lives. He reveals that their crimes have been outed and all three Kichisas are now wanted. An official comes and demands that Osho submit Ojo and Obo to him, though secretly he intends to let them escape.

Otose and Juzaburo eventually arrive and report the death of their father and show evidence indicating Obo was the murderer. Obo overhears this and finally realizes that the man he killed was in fact Osho's father.

三人吉三廓初買

あらすじ

56

02　大川端庚申塚

『三人吉三巴白浪』　2010年4月　歌舞伎座
和尚吉三（十二代目市川團十郎）

On the Riverbank
Sannin Kichisa Tomoe no Shiranami
(Kabukiza Theatre, Apr. 2010)
Osho Kichisa (Ichikawa Danjuro XII)

08　本郷火の見櫓

『三人吉三巴白浪』　2004年2月　歌舞伎座
（左から）お嬢吉三（五代目坂東玉三郎）、和尚吉三（十二代目市川團十郎）、お坊吉三（十五代目片岡仁左衛門）

The Watchtower
Sannin Kichisa Tomoe no Shiranami
(Kabukiza Theatre, Feb. 2004)
(From left) Ojo Kichisa (Bando Tamasaburo V), Osho Kichisa (Ichikawa Danjuro XII), Obo Kichisa (Kataoka Nizaemon XV)

やがておとせと十三郎が和尚に父の死を伝えにやってくる。その証拠から思い当たる下手人はお坊。また、二人の話を陰で隠れて聞いていたお坊は、自分が殺して百両を盗んだのが和尚の父親であることを知る。

その時本堂の欄間からお坊に声を掛けるものがある。お嬢もこの寺に隠れていたのである。

お嬢も、今の話から、自分の奪った百両が原因で和尚の父が殺されたことを知る。二人は和尚への申し訳に死ぬ決意をする。

06　巣鴨在吉祥院裏手墓地

一方、和尚は畜生道に落ちたおとせと十三郎を墓場で殺し、その首をお嬢お坊の身替りに仕立てる。

07　巣鴨在吉祥院元の本堂

二人が死のうとしたところに和尚がおとせと十三郎の首を持参する。やがてお嬢の刀が庚申丸であることが判明し、お嬢はお坊の持っていた百両の金を久兵衛に、お坊はお嬢の持っていた庚申丸を実家に渡そうと吉祥院を逃げていく。

08　本郷火の見櫓

捕手に届けた首が偽物と知れて和尚は捕らえられ、お嬢とお坊を捕らえるために町中の木戸が閉められている。お嬢とお坊は木戸越しに再会し、櫓の太鼓を叩いて木戸を開け、和尚を逃がす。そして来かかった久兵衛に庚申丸と百両を託す。三人は覚悟を決め、三つ巴に刺し違えて壮絶に果てる。

Just then a voice calls to Obo. Ojo, it turns out, is also hiding in the temple. He realizes the money he originally stole is the reason for Denkichi's death. Both Ojo and Obo, therefore, decide to give their lives in penance.

06　Kisshoin Cemetery

While Obo and Ojo talk, Osho kills Otose and Juzaburo in the cemetery for their incestuous relationship. He decides to submit their heads in place of Obo and Ojo's in order to save them.

07　Kisshoin Main Hall

Just as Ojo and Obo are to kill themselves, Osho brings the heads of Otose and Juzaburo. It is finally revealed that Ojo has the treasured sword Koshinmaru and the three decide to return everything to its proper place. Ojo is to take the money Obo has and give it to Kyubei, while Obo must take the sword held by Ojo to return to its rightful owner. After this, the three will leave town to escape the authorities.

08　The Watchtower

When the inspector sees that the submitted heads are not those of Obo and Ojo, he has Osho taken into custody and closes all barriers in the town in order to catch the other two fugitives. Ojo and Obo, however, are already outside of the town gates. They beat a drum in the watchtower to have one of the gates opened and allow Osho to escape. After this they meet Kyubei with whom they entrust both the money and sword. Finally, the three determine to die together as blood brothers. Piercing each other in a three-way circle, the sworn brothers meet their deaths bravely.

作品の概要

演目名

三人吉三廓初買

作者

河竹黙阿弥

概要

　原作は七幕の長編で、三人の吉三の名を持つ盗賊を中心とした筋と、通人木屋文里と遊女一重の情話からなる。作者黙阿弥会心の作だったが、初演は不入りであったという。明治に入って上方や名古屋で何度も上演されたが、黙阿弥生前には江戸・東京で再演はされなかった。人気作品となったのは明治32（1899）年東京明治座上演の際、『三人吉三巴白浪』の名題により上演してからで、その際、文里一重の情話を抜いて、三人吉三の筋を通す現在の形式に整えられた。文里一重の件はごくまれに上演される。庚申丸という刀と、百両の金が人々の手に渡るうちに繰り広げられる因果話が陰影深く描かれている。それと同時に、三人の盗賊の出会いを描いた「大川端庚申塚」などは、人口に膾炙した名せりふの応酬で、歌舞伎の音楽性にあふれた名場面として知られ、この場だけでもしばしば上演されている。掲載のあらすじは現在上演される『巴白浪』のものである。

初演

安政7（1860）年1月、江戸市村座で、四世市川小團次の和尚吉三と文里、八世岩井半四郎（当時三世粂三郎）のお嬢吉三と一重、九世市川團十郎（当時初世河原崎権十郎）のお坊吉三ほかで初演。河竹黙阿弥（当時は河竹新七）作。通称「三人吉三」。

Overview

Title

Sannin Kichisa Kuruwa no Hatsugai

Writer

Kawatake Mokuami

Overview

　Originally a long-form play in seven acts, the play once consisted of two stories: that of the three Kichisa thieves, and the love story of dilletante Kiya Bunri and prostitute Hitoe. Written by Mokuami, the play was not well received at first. Though played during the early Meiji period in Nagoya and Kyoto, it wasn't performed again in Edo/Tokyo until after Mokuami's death. It wasn't until an 1899 performance at the Tokyo Meijiza Theatre that the play gained popularity. Billed as *Sannin Kichisa Tomoe no Shiranami*, this performance omitted the Bunri / Hitoe love story entirely, establishing the story as we know it today. The love story is only very rarely performed these days. Deep karmic bonds are gradually revealed through the story of the sword Koshinmaru and the stolen money that constantly changes hands, pulling the audience into the darkness shrouding the characters. At the same time, the play shows the lighthearted meeting of the three Kichisa thieves in a quaint scene called "River Bank" that has captivated audiences over the years. The scene is so popular that it is sometimes performed on its own. The Synopsis given here is based on the currently used *Tomoe no Shiranami* script.

Premiere

First performed at the Edo Ichimuraza Theatre, January 1860. Feat. Ichikawa Kodanji IV as Osho Kichisa and Bunri, Iwai Hanshiro VIII (Kumesaburo III at the time) as Ojo Kichisa and Hitoe, Ichikawa Danjuro IX (Kawarasaki Gonjuro I at the time) as Obo Kichisa. Written by Kawatake Mokuami (Kawatake Shinshichi at the time). Commonly known as *Sannin Kichisa*.

登場人物 / Characters

お嬢吉三 (おじょうきちさ)

女装した盗賊だが、元は八百屋久兵衛の息子で幼少時からお七と呼ばれて女の姿で育てられ、五歳の時に行方知れずとなりやがて旅役者の女方から悪の道へと入ったという。節分の夜に大川端でおとせから百両を奪い、その様子を見ていたお坊吉三、さらにそこへ通り掛かった和尚吉三、いずれも同じ「吉三」と名乗る三人ゆえ義兄弟の約束を交わす。三人の中でもお嬢はとりわけ華のある主人公。

Ojo Kichisa

A crossdressing thief who was raised by Kyubei. His childhood nickname was Onana and he was raised as a girl but went missing at the age of five. He is said to have acted in female roles with a travelling theater troupe, but eventually turned to crime. He steals 100 *ryo* from Otose on Setsubun (a holiday at the end of winter) but is seen by two other men with the same name of Kichisa: Osho Kichisa and Obo Kichisa. The three swear their brotherhood to one another due to their common namesake. Ojo is the protagonist, and as such he is also the most colorful character of the three Kichisas.

お坊吉三 (おぼうきちさ)

元は旗本・安森(やすもり)家の息子で、そのお坊ちゃんというところからお坊と呼ばれる。父の安森源次兵衛は名刀の庚申丸(こうしんまる)を盗まれたために切腹したが、その刀を盗んだのが和尚吉三の父親・土左衛門伝吉という因縁。また百両の金を安森家再興のためゆかりの人物に渡そうとするが、土左衛門伝吉からこれを無心され、同じ目的であったとは知らずに伝吉を斬り殺してしまう。

Obo Kichisa

Obo is a former member of the Yasumori house which served the shogun. His name is a reference to being called obo-chan (young master) due to his high status. His father, Yasumori Genjibei, committed seppuku after the treasured sword Koshinmaru was stolen on his watch. The thief was in fact Osho's father Dozaemon Denkichi, a fact that points to a karmic bond between the Kichisas. Obo eventually tries to hand the money stolen by Ojo to a relative to go toward the restoration of the Yasumori clan, but Denkichi appears and demands the money for himself. Obo kills Denkichi, unaware that their goals for the money are in fact the same.

おとせ (おとせ)

土左衛門伝吉の娘で夜の女の商売・夜鷹に出ていた。十三郎が落としていった百両を届けようと探すが、その金はお嬢吉三に奪われてしまう。金を無くした十三郎が死のうとしているのを助けたのは父の伝吉、やがて二人は恋仲となる。しかし二人は実の双子の兄妹で、その事実を知った兄の和尚吉三の手によって二人とも殺されてしまう。真実を明かさなかったのが兄のわずかな情けだった。

Otose

Denkichi's daughter, Otose is a prostitute who is looking for Juzaburo to return the 100 *ryo* he had lost. Ojo Kichisa steals the money, however, and Juzaburo tries to kill himself. Ojo saves him and eventually Otose and he become lovers. However, Otose's brother Osho Kichisa finds out they are in fact separated twins and kills them both. Cruel as this may be, Osho chooses not to reveal what he knows to her before killing her, an act of kindness meant to spare her more pain in her final moments.

和尚吉三 (おしょうきちさ)

お嬢吉三とお坊吉三が百両の金を巡って争うところに割って入り、その場を収めた和尚吉三はやや貫禄もあり一つ格上といった兄貴分。その名の通り寺の坊主崩れの盗賊だが、その父親の土左衛門伝吉もさらにひと癖ある人物。お嬢吉三に百両を奪われ川に落とされたおとせというのはこの和尚吉三の妹、百両も一旦は和尚が預かるが次々と人の手に渡り、さらに人間関係は深く絡み合う。

Osho Kichisa

Osho is a more serious and dignified older-brother character who steps in as Ojo and Obo are fighting over the stolen money. As the title Osho (high priest) suggests, he is a former priest turned thief, and his father Dozaemon Denkichi is an even more eccentric character. Otose, whom Ojo stole money from and threw in the river, is actually Osho's younger sister. Because of this, Osho ends up holding onto the money, but over the course of the play it passes through many hands as the relationships between characters deepen.

土左衛門伝吉 (どざえもんでんきち)

安森家から名刀の庚申丸を盗んだのはこの伝吉。その時、孕んだ犬を殺した祟りか、その晩に生まれた子に犬のような斑点があり、その衝撃が元で女房が命を落としてしまった。そこで自分の悪事を後悔して流れ着いた水死体(=俗に土左衛門)の供養をする日々となった。安森家のために百両の金が必要で、お坊吉三が持っている金を求めるが、実は同じ目的だったお坊と争いとなり殺されてしまう。

Dozaemon Denkichi

Denkichi is the man who stole the sword Koshinmaru from the Yasumori clan. A cursed man for killing a pregnant dog, his wife gave birth to a child with dog-like spots, the shock of which led to her death. After this, Denkichi, regretting his past evils, dedicates himself to memorializing his dead wife. When he finds out about the stolen money, he wishes to use it to help restore the Yasumori clan. He asks Obo Kichisa to give it to him, but an altercation ensues, and he is killed even though the two have the same goal in mind.

十三郎 (じゅうざぶろう)

八百屋久兵衛の息子として育ったが、実は幼い時に捨てられた土左衛門伝吉の子で、おとせとは双子の兄妹。奉公している店の金を無くし死のうとしているのを伝吉に助けられ、出会ったおとせと恋仲になる。後に真実を知った兄の和尚吉三はそのまま二人を生かしておくわけにもゆかず、追われる身のお嬢・お坊の兄弟分の身替りとして二人を殺し、その首を差し出すことを決心した。

Juzaburo

Kyubei's adopted son, Juzaburo was abandoned by his real father Denkichi when he was a child. He is in fact Otose's twin brother and is saved by Denkichi when he attempts suicide after losing money belonging to his place of work. He thus meets Otose and falls in love, unaware of their familial relationship. When Otose's brother Osho finds out about their relationship, he decides he must kill the two, and in doing so saves his sworn brothers Ojo and Obo. These two are wanted dead, and Osho placates their pursuers by submitting Otose and Juzaburo's heads instead.

八百屋久兵衛
やおやきゅうべえ

実の息子は幼い時に行方知れずとなり、捜し歩くうち寺の門前に捨てられていた子を見つけ息子として育てたのが十三郎（実の息子はお嬢吉三という盗賊になっている）。川に落とされたおとせを助けて親の伝吉のもとへ届けると、そこには伝吉に助けられた十三郎がいて、その場の身の上話で真実がわかる。また巡り巡った百両と庚申丸は八百屋久兵衛から安森家へ渡りお家再興に役立つ。

Yaoya Kyubei

Kyubei's real son Ojo Kichisa has been missing since he was very young. In his place, he raised Juzaburo who was abandoned in front of a Buddhist temple. When Kyubei saves Otose from the river, he takes her to Denkichi and finds Juzaburo there. Juzaburo has just been saved by Denkichi, and because of this turn of events, his true identity becomes apparent. Through this complicated series of events, the 100 *ryo* that has passed through so many hands is eventually given to the cause of the Yasumori clan's restoration.

みどころ
Highlights

1. こいつは春から縁起がいいわえ
—— Spring is the Season of Good Luck

お嬢吉三が、大川端から月を見上げてにんまり言うせりふ。ちょうど節分で、明日は春。旧暦なので、月も朧に霞んでいる。ちょうど「御厄払いましょう、厄落とし」と触れ歩く声も聞こえてくる。節分に人の厄落としを引き受けて回る、厄払いの門付（かどづけ）の風習が昔はあったのだ。お嬢は"夜鷹を突き落として厄落としができ、金も入って縁起がいい春だぜ"と思っているわけだ。泥棒ならではのブラックテイストの名せりふ。

Ojo Kichisa comments on the good luck that comes with spring from the banks of the river. It is *setsubun*, a holiday celebrating the last day of winter. From the streets you can hear people exclaiming "expel evil, begone pestilence," part of the rites of *setsubun*, which included door-to-door exorcism ceremonies. Ojo shows his dark thief's humor with the famous lines, "into the river with the nightwalkers, expelling pestilence and getting some cash out of it too—what a lucky season spring is!"

2. 白浪作者の最高傑作
—— The Premier *Shiranami* Play

白浪とは、中国の故事に由来する盗賊をあらわす言葉。ペリーの浦賀来航以降、外国の開国要求に揺れ幕藩体制が揺らぎ出した幕末に、芝居では盗賊が活躍する白浪物が大流行した。本作が初演された1860年の3月には桜田門外の変が起きている。河竹黙阿弥は白浪物をたくさん書いて白浪作者と呼ばれ、その多くに主演した四代目市川小團次が泥棒役者と賞賛されている。なかでも黙阿弥自身が一番の傑作と自負したのが、この作品だ。

Shiranami is a term that refers to bandits and is derived from Chinese history. Since Commodore Perry arrived, forcing the re-opening of Japanese ports to foreign countries, the former shogun-centered government began to collapse, and *shiranami-mono*, plays starring bandits, became very popular. In 1860, when *Sannin Kichisa* debuted, the Chief Minister Ii Naosuke was assassinated in the Sakuradamon Incident. From here onward, Kawatake Mokuami wrote many *Shiranami-mono*, often starring Ichikawa Kodanji IV to great praise. Among his work, *Sannin Kichisa* is Mokuami's self-proclaimed premier masterpiece.

3. 義兄弟の義≠忠義
—— The Unique Brothers' Oath

百両の奪い合いから一転して、同じ吉三という名前を持つ三人が意気投合し、義兄弟の契りを交わすことになる。それぞれの腕をわずかに切って出た血汐を同じ皿に絞り、皆で飲む。そこには忠義や義理はなく、ピュアな兄弟の約束だった。三人には思わぬ因縁があることが次第に明らかになっていくのだが、それでも、義兄弟の情を大切に生きていくところが本作の特徴。和尚吉三は義兄弟のために、本当の妹と弟の首を身替わりにしている。

The three Kichisas meet in a series of events involving an act of thievery, and immediately get along. They swear a blood oath to one another, drinking each other's blood from cups. This oath, however, is not a normal oath of loyalty or devotion. Rather, it is simply an acknowledgement of their brotherhood. Though they do not find out about their complex karmic connection until later, the three vow to cherish their connection as sworn brothers, one of the most charming characteristics of the play. Osho Kichisa goes as far as giving up his real sister and brother's heads in the place of his fellow Kichisa brothers'.

4. 犬の因縁 —— Karmic Retribution

複雑に因縁が絡む話だが、その一端である犬の因縁にご注目。和尚吉三の父伝吉がその昔お坊吉三の屋敷で盗んだ刀で、吠えついた孕み犬を殺した報いが一家に祟る。まず伝吉の女房が痣だらけの子を産んで自殺してしまう。それ以前に産んでいた男女の双子は別々に育ち、知らずに恋人の関係を持ってしまう。これは畜生道に落ちたことになり、その報いで死にゆく双子に痣が浮き、身振りが犬のようになる。黙阿弥の神経は本当に細かい。

This play involves a complex web of karmic bonds, one of with involves a dog. Osho Kichisa's father Denkichi had stolen a treasured sword from Obo Kichisa's home, killing a pregnant watch dog in the process. He was thus cursed for this terrible act, leading to a number of tragedies in his family. First there was the birth of a disfigured child and his distraught wife's subsequent suicide. Furthermore, his previous children, a boy and girl who were raised separately, eventually meet and fall in love. As punishment for their immoral relationship, they are eventually killed. Before their death, however, they become disfigured with strange markings on their skin, and their mannerisms come to resemble those of a dog in a subtle reference to their father's curse. Mokuami's attention to small details like this is truly marvelous.

5. 八百屋お七 —— Oshichi the Greengrocer

八百屋お七は火炙りの刑に処せられた実在の娘である。火事がきっかけで巡り逢った巣鴨吉祥院の寺小姓吉三に恋をして、会いたい一心で放火して火炙りになったという。これは井原西鶴の『好色五人女』などの小説や芝居の題材になった。本作にはその趣向がちりばめられており、三人の名前が吉三。お嬢吉三は八百屋の娘お七として育ち、和尚は吉祥院の所化崩れである。火の見櫓のラストシーンは『櫓のお七』そのままの構図である。

Oshichi the greengrocer was a real person who was burnt at the stake for falling in love with a young page at Kissho Temple named Kichisa and causing a fire in an attempt to meet with him. This became the basis for a number of novels and dramas, including *Sannin Kichisa*, which takes the page's name for its three protagonists. In *Sannin Kichisa*, Ojo is raised as the girl Oshichi, Osho is a priest at Kissho Temple. The final scene at the watchtower takes the same structure of another piece called *Yagura no Oshichi*.

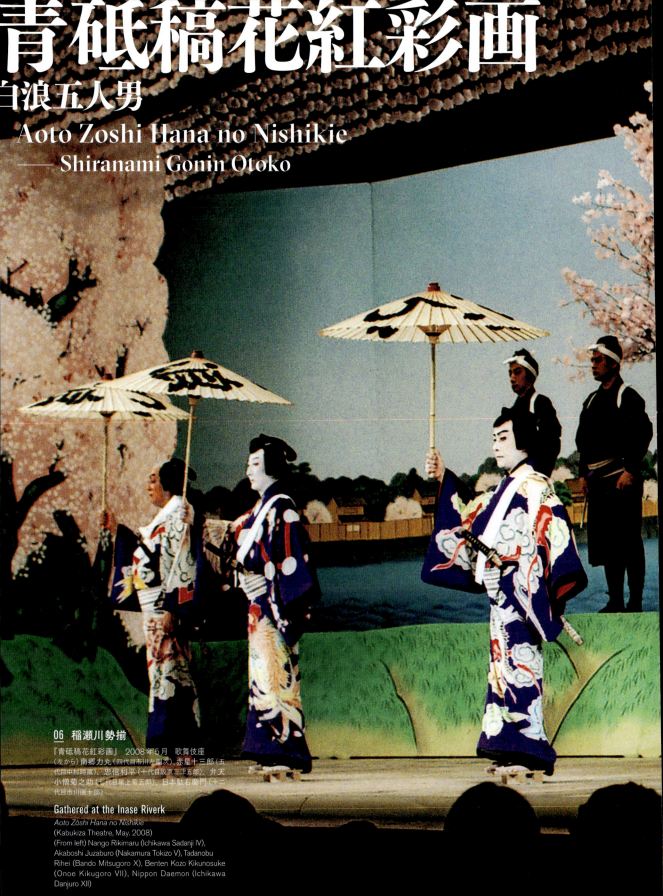

青砥稿花紅彩画
白浪五人男
Aoto Zoshi Hana no Nishikie
—— Shiranami Gonin Otoko

06 稲瀬川勢揃
『青砥稿花紅彩画』 2008年5月 歌舞伎座
(左から) 南郷力丸（四代目市川左團次）、赤星十三郎（五代目中村時蔵）、忠信利平（十代目坂東三津五郎）、弁天小僧菊之助（七代目尾上菊五郎）、日本駄右衛門（十二代目市川團十郎）

Gathered at the Inase Riverk
Aoto Zōshi Hana no Nishikie
(Kabukiza Theatre, May. 2008)
(From left) Nango Rikimaru (Ichikawa Sadanji IV), Akaboshi Juzaburo (Nakamura Tokizo V), Tadanobu Rihei (Bando Mitsugoro X), Benten Kozo Kikunosuke (Onoe Kikugoro VII), Nippon Daemon (Ichikawa Danjuro XII)

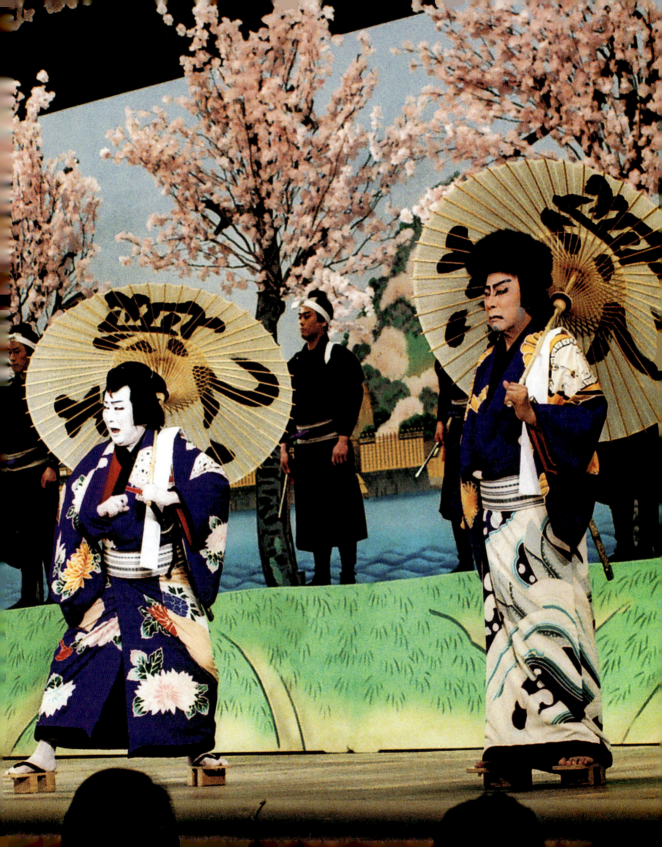

あらすじ　　　　　　　　　　Synopsis

錦絵のような華やかな舞台。よく知られた名せりふ。娘と思ったのが実は男で泥棒。その泥棒の因果話……。繰り広げられる、歌舞伎ならではのめくるめく世界

五人の泥棒が名乗りをあげる「だけ」の場が、歌舞伎屈指の名場面になる。せりふ、動き、音楽、大道具、小道具、衣裳、かつら、細部にまで工夫が凝らされ、一体となって一つの場面を創り上げる。歌舞伎の美意識、面白さの集大成！

——— A stage brimming with color, some of the most famous lines in the repertoire, a crossdressing thief, and the fascinating karmic bonds that connect that thief to his victim... Enjoy the unique charms of kabuki in this dazzling production.

Featuring one of the most impressive scenes of the kabuki repertoire, everything about this play—the script, performance, music, large-scale stage props, costumes, and many more fine details—make for a truly opulent experience that shows the unique aesthetic of kabuki.

01　初瀬寺花見

　小山家の千寿姫は、許嫁信田小太郎の追善のために鎌倉の初瀬寺に参詣するが、死んだはずの小太郎と出会い、契りを結ぶ。姫は結納に信田家から贈られた「胡蝶の香合」を小太郎に預け、その場から小太郎と駆け落ちをする。信田家の旧臣赤星十三郎は、千寿姫が供えた百両を盗んだとして信田家を勘当される。その百両をめぐり、盗賊忠信利平と、小太郎の奴・駒平が争う。

02　神輿ヶ嶽

　千寿姫をともない神輿ヶ嶽まで来たところで、小太郎は正体を現す。その名も弁天小僧菊之助という盗賊。弁天は「胡蝶の香合」を手に入れるため小太郎になりすまして姫に近づいたのである。奴の駒平というのも盗賊仲間の南郷力丸。それを知った千寿姫は谷底に身を投げる。その様子を窺ってい

01　Flower-viewing at Hase Temple

　Princess Senju of the Oyama house comes to Hase Temple in Kamakura for a memorial in honor of her late fiance Shinoda Kotaro only to run into him and find that he is still alive. The two exchange vows and the princess recieves a butterly-patterned incense box as a wedding gift from the Shinoda family. Kotaro holds onto the box as the two elope together.

　Meanwhile, the former Shinoda retainer Akaboshi Juzaburo is disinherited after stealing 100 *ryo* from the princess, and the thief Tadanobu Rihei and Kotaro's servant Komahei are fighting over the stolen money.

02　Mt. Mikoshigadake

　As Princess Senju and Kotaro arrive at Mikoshigadake Mountain, Kotaro reveals his true identity. He is actually the thief Benten Kozo Kikunosuke, who killed the real Kotaro in order to steal the butterfly-patterned incense box from

た駄右衛門は、香合を奪おうと弁天小僧と斬りあうが、歯が立たぬと観念した弁天は、駄右衛門の子分となる。

03　稲瀬川谷間

谷間では、身を投げるも一命をとりとめた千寿姫と赤星十三郎が出会う。姫は改めて稲瀬川に身を投げ、赤星が姫の後を追おうとするところを、忠信利平がこれを止める。二人のやりとりから、忠信が赤星の家来筋であることがわかる。忠信は先程手にした百両を赤星に贈り、既に駄右衛門に従う忠信同様、赤星もまた一味に加わる。こうして駄右衛門、忠信、弁天、南郷、赤星――「白浪五人男」の顔が揃う。

04　雪の下浜松屋店先

鎌倉雪の下の浜松屋に、若党・四十八を供に連れた美しい武家娘が現れる。早瀬主水の息女だという娘は、婚礼のための品物を選ぶうちに、ひそかに鹿子の裂を懐に入れる。めざとく見ていた店の番頭は、帰ろうとする娘の懐から鹿子の裂を引き出し、「万引き」をとがめて娘の額を算盤で打つ。しかし四十八の話から、鹿子は他の店・山形屋の品であったことが分かる。

取り返しのつかない過失に、青ざめる店の者たち。店の若旦那・宗之助が四十八に詫びるが、四十八は店主・浜松屋幸兵衛を相手取る。娘につけられた額の傷を言い立て、法外な金を要求する四十八に対し、浜松屋に呼ばれた鳶頭も憤慨して啖呵を切る。しかし幸兵衛は事を穏便に済ませるため、四十八の言うとおり百両を出して詫びるのであった。

金を受け取り、さて帰ろうという娘と四十八を、店の奥に居合わせた侍・玉島逸当が呼び止めた。逸当は二人を騙りと見抜き、更にはちらりと見えた腕の刺青を証拠に、娘を男と見破る。図星をさされた二人は、にわかに伝法なその正体を現す。

女装の盗賊は、元は江ノ島の稚児、弁天小僧菊之助。四十八と偽っていたのはその兄貴分の南郷力丸であった。名を明かした二人が、居直って役人に突き出せと悪態をつくのに対し、幸兵衛は弁天が受けた傷の膏薬代として二十両を差し出す。なおもしぶる弁天を南郷が説き伏せ、二人はようやく腰を上げる。浜松屋を出た二人は、今日の稼ぎを山分けして悦に入る。

05　雪の下浜松屋蔵前

一方、浜松屋では幸兵衛、宗之助が逸当を店の奥へ招き入れ、礼物を贈ろうとするところ、逸当は礼には金を、それも有り金残らずもらいたい、と大刀を抜いて突きつける。そこ

the princess. His servant Komahei, too, is actually the thief Nango Rikimaru. The betrayed Senju decides to kill herself by jumping down into the valley below, after which Daemon, who has been watching Benten, attacks and attempts to steal the incense box. Benten, realizing he can't win, decides to serve Daemon instead.

03 The Inase River Ravine

Princess Senju, who failed to kill herself, meets Akaboshi Juzaburo in the valley near the Inase River. The princess attempts suicide again by throwing herself in the river, but Akaboshi chases her. Tadanobu Rihei appears and stops the two as they are fighting, and it is revealed that Tadanobu is a retainer of Akaboshi's house. He decides to give Akaboshi the 100 *ryo* he just attained and join the gang, which now consists of five men—Daemon, Tadanobu, Benten, Nango, and Akaboshi—and they are called the *"Shiranami Five"* (Shiranami Gonin Otoko).

04 Hamamatsuya in Yuki no Shita

A young samurai daughter arrives at Hamamatsuya in Yuki no Shita, Kamakura. Accompanied by a young retainer, the young woman is shopping for fabric to be used for wedding garments, claiming to be the daughter of the high-ranking Hayase Mondo. As she browses the merchandise, she slips a piece of cloth into her kimono sleeves, but is caught by the head clerk at the shop. When the clerk accuses her of stealing, her retainer explains that the cloth she supposedly stole was actually bought at another store.

Deeply embarrassed, Sonosuke, a young clerk, apologizes to the retainer, who demands 100 *ryo* as compensation for a wound inflicted on the young daughter. Tobigashira is called to the shop and begins to argue with the retainer, but the shop proprietor Kobei, who wishes to resolve things quietly, hands over 100 *ryo*.

Tamashima Itto stops the young woman and her retainer as they are leaving, pointing out a tattoo on the woman's arm and claiming that she is actually a man. The two are suddenly revealed to be swindlers.

The woman is actually Benten Kozo Kikunosuke, and the retainer Nango Rikimaru. Though the two are angry to have been caught, Kobei kindly offers twenty *ryo* to pay for medicine for Nango's wound. Nango manages to calm down his partner Benten, and the two leave the store and split their spoils for the day.

05 Before the Hamamatsuya Warehouse

After the swindlers have left, Sosuke invites Itto into a back room of the store and offers a reward for his help. Itto, however, draws his sword and demands they give him all the money they have on hand. Just then, Benten and Nango return, reporting to Itto that they have successfully tied up the other shop workers. It is now revealed that Itto is actually Daemon in disguise.

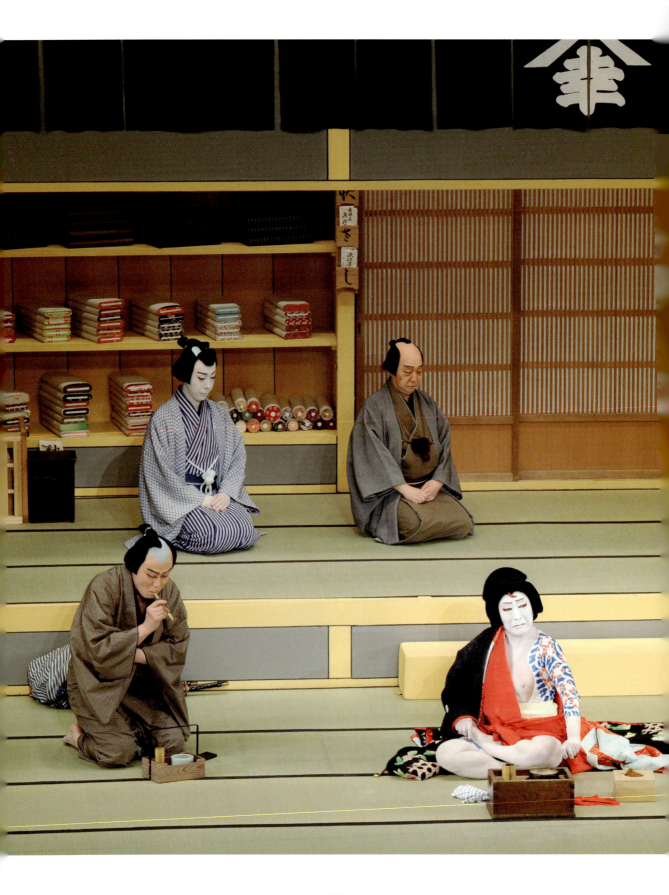

04 雪の下浜松屋店先

『弁天娘女男白浪』2010年3月
歌舞伎座
（左から）南郷力丸（二代目中村吉右衛門）、浜松屋宗之助（五代目尾上菊之助）、浜松屋幸兵衛（六代目中村東蔵）、弁天小僧菊之助（七代目尾上菊五郎）、日本駄右衛門（九代目松本幸四郎）

Hamamatsuya in Yuki no Shita
Benten Musume Meo no Shiranami
(Kabukiza Theatre, Mar. 2010)
(From left) Nango Rikimaru (Nakamura Kichiemon II), Hamamatsuya Sonosuke (Onoe Kikunosuke V), Hamamatsuya Kobei (Nakamura Tozo VI), Benten Kozo Kikunosuke (Onoe Kikugoro VII), Nippon Daemon (Matsumoto Koshiro IX)

Aoto Zoshi Hana no Nishikie — Shiranami Gonin Otoko

Synopsis

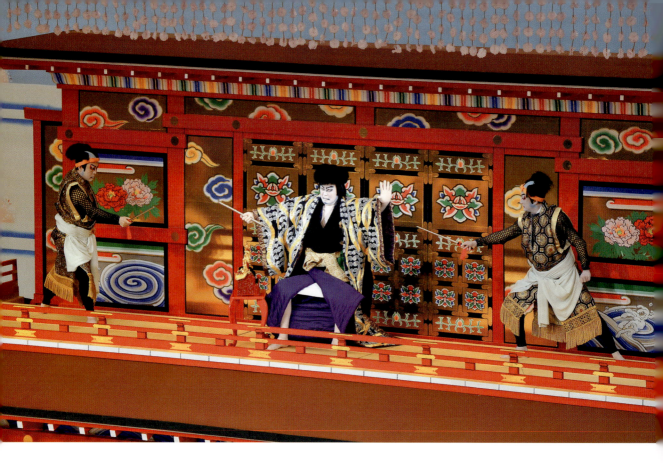

08 極楽寺山門
『弁天娘女男白浪』 2013年4月　歌舞伎座
(左から) 関戸の吾助実は大須賀五郎 (六代目中村松江)、日本駄右衛門 (二代目中村吉右衛門)、岩渕の三次実は川越三郎 (二代目中村錦之助)

The Gokuraku Temple Gate
Benten Musume Meo no Shiranami (Kabukiza Theatre, Apr. 2013)
(From left) Sekito Gosuke (actually Osuka Goro) (Nakamura Matsue VI), Nippon Daemon (Nakamura Kichiemon II), Iwabuchi Sanji (actually Kawagoe Saburo) (Nakamura Kinnosuke II)

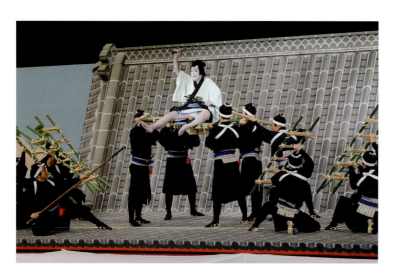

07 極楽寺屋根立腹
『弁天娘女男白浪』 2013年4月　歌舞伎座
弁天小僧菊之助 (七代目尾上菊五郎)

The Gokuraku Temple Roof
Benten Musume Meo no Shiranami (Kabukiza Theatre, Apr. 2013)
Benten Kozo Kikunosuke (Onoe Kikugoro VII)

へ押し入って来た弁天小僧と南郷が逸当に、店の者は縛り上げた、と上首尾を報告する。玉島逸当こそ、日本駄右衛門その人であった。

　しかしやりとりの内、宗之助が駄右衛門の実子、幸兵衛が弁天小僧の実の親であること、さらには、幸兵衛が元は小山家の家臣で、行方不明の「胡蝶の香合」を捜していることが明らかとなり、不思議な因縁に一同長嘆する。折しも役人の追手が迫る中、駄右衛門らは浜松屋に別れを告げる。

06　稲瀬川勢揃

　駄右衛門・弁天・南郷・忠信・赤星の五人は舟で逃げようと稲瀬川の土手に勢揃いする。そこを待ち受けていた捕手に囲まれるが、五人は臆することなく、めいめい生い立ち来歴を語りつつ名を名乗り、捕らえられるものなら捕らえてみよ、と捕手に挑む。大立廻りの末、五人は京での再会を約束してこの場を落ちて行く。

07　極楽寺屋根立腹

　「胡蝶の香合」はめぐりめぐって、駄右衛門の子分・狼の悪二郎の手に渡る。弁天小僧は極楽寺の屋根上で、仲間を裏切った悪二郎を斬るが、悪二郎はいまわの際に胡蝶の香合を屋根上から投げ落とし、胡蝶の香合は滑川へと消えてゆく。大勢の捕手に取り囲まれた上、もはや実の父・幸兵衛に胡蝶の香合を渡すことも果たせない今、覚悟を決めた弁天小僧、屋根の上で立腹（たちばら）を切って果てる。

08　極楽寺山門

　極楽寺山門に潜む駄右衛門は、周囲を取り囲む捕手をも悠然と見渡していたが、弁天小僧の立腹を聞き及び、その早い死を悼む。一方、名奉行の誉れ高い青砥左衛門藤綱は、滑川の中からかの「胡蝶の香合」を拾い上げていた。青砥左衛門の姿に、もはやこれまでと観念した駄右衛門は、自ら縄にかかろうとする。その潔さに感服した青砥左衛門は、これを捕らえようとする従者を制し、捕らえた獲物を解き放す仏教の「放生会」にちなんでこの場はいったん駄右衛門を逃すこととし、双方、後日の対決を約して別れる。

However, it is soon revealed that the store clerk Sonosuke is actually Daemon's son and that Kobei is actually Benten's father. Furthermore, Kobei is a former Oyama house retainer who has been searching for the incense box in Daemon's hands. Everyone is momentarily shocked at what seems to be a deep karmic connection between them, but soon Daemon must leave the shop as officers are on their way to arrest him and his men.

06　Gathered at the Inase River

Daemon and his men gather by the banks of the Inase River but are soon surrounded by officers. The fearless five each state their name and famous exploits, then taunt the officers. At the end of a great *tachimawari* fight scene, the five part ways, vowing to meet again

07　The Gokuraku Temple Roof

The Incense box eventually makes its way into the hands of Daemon's servant Okami no Akujiro. Tenben, however, betrays his comrades and kills Akujiro on the roof of Gokuraku Temple in an attempt to get the box. Akujiro drops the incense box as he dies, and it is lost in the currents of the Name River. Now surrounded by enemies, and having failed in his mission to help his father Kobei, Benten decides to kill himself rather than be captured.

08　The Gokuraku Temple Gate

Daemon watches calmly as the officers surround the temple. When he hears about Benten's death, however, he is deeply saddened. Meanwhile, Aoto Saemon Fujitsuna, a high-ranking official from the magistrate's office, has found and picked up the incense box. Daemon is now resigned to his capture and gives himself up. Aoto Saemon, however, is impressed by Daemon's actions and decides to let him escape. As they part, Daemon and Saemon promise to settle things between them another time.

作品の概要 / Overview

演目名 / Title

青砥稿花紅彩画―白浪五人男

Aoto Zoshi Hana no Nishikie
— Shiranami Gonin Otoko

作者 / Writer

河竹黙阿弥

Kawatake Mokuami

概要 / Overview

世話物の人気作の随一。「白浪五人男」と呼ばれる五人の盗賊を描いた作品で通称ともなっている。弁天小僧が女の姿で呉服店に乗り込む「浜松屋の場」と、五人男が、掛詞や縁語を用いた七五調の名せりふで己の生涯を高らかに誇る「稲瀬川勢揃の場」の上演が最も多く、この二場を中心として上演する際『弁天娘女男白浪』などの題名で上演されることが多い。通し上演の際には本名題『青砥稿花紅彩画』が用いられる。細緻に工夫された演技手順、音楽などもみどころで、江戸世話物の代表作。

「勢揃」は言ってしまえば「泥棒たちが自ら名乗る」というだけの場面なのだが、せりふ、音楽、大道具、衣裳などが視覚や聴覚に訴え、葛藤やドラマといった西洋演劇由来の価値観、論理とは全く違う演劇世界に誘う。この場面を作り上げた先人たちのセンスと、堅いことは言わずに娯楽として享受してきた庶民の懐の深さを感じられる演目である。

掲載のあらすじは、現在通しで上演される際の場割と台本によっている。

The most popular *sewamono* of all time, *Aoto Zoshi Hana no Nishikie* is commonly referred to as *Shiranami Gonin Otoko*, the name of the gang of bandits featured in the play. The "Hamamatsuya" scene featuring the cross-dressing Benten Kozo, and "Gathered at the Inase River" which shows each of the five bandits introducing themselves in gorgeous poetic language, are the two most oft-performed scenes. When performed together, they are often billed under the title *Benten Musume Meo no Shiranami*. For toshi-kyogen performances, the standard title *Aoto Zoshi Hana no Nishikie* is used. With incredible attention to detail, stunning performances, and sublime music, it is one of the representative pieces of Edo *sewamono*.

The grand scene featuring the five bandits gathered by the river features stunning lines, magnificent music, large-scale stage props, and gorgeous costumes that are bound to tickle your senses, signifying a dramatic aesthetic that contrasts the western tradition which focuses on conflict and logic. This play cannot fail to convey the warm spirit of the common folk who have enjoyed it since its debut.

The synopsis given here gives a summary of the *toshi-kyogen* version of the script.

初演 / Premiere

文久2（1862）年3月江戸・市村座で、五世尾上菊五郎（当時十三世市村羽左衛門）の弁天小僧、三世關三十郎の日本駄右衛門、四世中村芝翫の南郷力丸ほかの配役で初演。河竹黙阿弥作。通称「白浪五人男」ほか。

First performed at the Ichimuraza Theatre in Edo, March 1862. Feat. Onoe Kikugoro V (Ichimura Uzaemon XIII at the time) as Benten Kozo, Seki Sanjuro III as Nippon Daemon, Nakamura Shikan IV as Nango Rikimaru, and others. Written by Kawatake Mokuami. Commonly referred to as *Shiranami Gonin Otoko*, among other alternate titles.

登場人物 / Characters

弁天小僧菊之助
べんてんこぞうきくのすけ

白浪五人男と呼ばれる盗賊集団のひとりで、女装して悪事を働く華のある主人公。歌舞伎の中でも屈指のヒーローである。江の島の弁天様（弁財天）の稚児上がりで弁天小僧と呼ばれ、しかし盗みを繰り返して島から追い出された。呉服店浜松屋に武家の息女と称してやって来るが、男と見破られて入れ墨をした名うての盗賊の本性を現す、その変わり身の鮮やかさと威勢のいい啖呵は最高の見せ場。

Benten Kozo Kikunosuke

One of the Shiranami Five (*Shiranami Gonin Otoko*), Benten is the rowdy protagonist who dresses as a woman to swindle the Hamamatsuya fabric merchant. From Enoshima, his name is a reference to the goddess of art and wisdom worshipped there, but he has been banished from the island due to his thieving ways. He impersonates a wealthy young woman to try to swindle the fabric merchant Hamamatsuya, but is outed as a man due to his conspicuous tattoo. Benten's sudden transformation from gentle lady to fiersome bandit is one of the highlights of the play.

南郷力丸
なんごうりきまる

弁天小僧とは幼い頃から共に育った仲、悪事に手を染めるのも一緒で常に弁天のサポート役に回る。女装した弁天と連れだって浜松屋へやってきて強請（ゆすり）を働き、正体をあばかれた後にひときわ凄みを見せるが、引き上げる時の弁天とのやり取りには仲の良さが漂い、小気味の良い憎めない性格も浮き彫りになる。稲瀬川の勢揃いでは五人の中でもとりわけ勇ましくふるまって最後を締める。

Nango Rikimaru

Nango Rikimaru was raised from an early age with Benten, and now helps him with his illegal activities. Benten and he impersonate a wealthy young woman and her retainer to swindle the Hamamatsuya fabric merchant, but are eventually found out. Nango's interaction with Benten during this scene shows off his kindness and the strength of their bond. He gives one of the most rousing shows of the five bandits in the scene by the Inase River.

赤星十三郎
あかぼしじゅうざぶろう

元は信田左衛門という武家に仕えていた中小姓。それゆえ物腰が柔らかく前髪の付いた若衆姿で登場する。「今牛若」と呼ばれたその持ち前の美しさが、勢揃いした五人男の中で異彩を放つ。主家のため百両を盗んだが大勢に責められ、たまたま行き逢った千寿姫と共に自害しようとしたところを忠信利平に救われ、それを機に日本駄右衛門の一味に加わるという運命の出会いを得る。

Akaboshi Juzaburo

Formerly a low-ranking samurai in the service of Shinoda Saemon's house, Akaboshi has a soft demeanor and wears bangs that give him a youthful air. A beautiful man, Akaboshi adds his own special flare to his introduction when the five bandits gather by the Inase River. After stealing money for his master, he is disinherited and attempts to kill himself together with Princess Senju, but Tadanobu Rihei stops them. This becomes the impetus for Akaboshi to join Daemon's gang.

日本駄右衛門
にっぽんだえもん

「賊徒の張本（ちょうほん）」と名乗る白浪五人男の首領。遠州浜松の生まれで陸から海へと股に掛ける大盗賊だが「盗みはすれど非道はせず」と義賊としての誇りも見せる。浜松屋で立派な侍ぶりで弁天小僧と南郷力丸をやり込めた後、すっかり信用させた主人から有り金すべて脅し取ろうという大胆さはどこか痛快でもある。極楽寺山門で青砥左衛門と向き合い、その姿は石川五右衛門を彷彿とさせる。

Nippon Daemon

The leader of the Shiranami Five, Daemon is a noble thief from Totomi Province whose motto is "steal, but do no injustice." After chasing Benten Kozo and Nango Rikimaru from Hamamatsuya, gaining the trust of the proprietors, he then demands all of their money in a stunning reversal that audiences can't help but admire. His bravery in confronting Aoto Saemon is reminiscent of the great Ishikawa Goemon.

忠信利平
ただのぶりへい

江戸育ちで「ガキの頃から手癖が悪く」とは本人の名乗りの弁。日本駄右衛門の一の子分。赤星十三郎の窮地を救い身分を明かしてみれば赤星が主人筋にあたることがわかり、一味に引き入れる。吉野や奈良を回っての旅がらすで、寺や豪家に押し入っては盗みを働くお尋ね者。忠信利平という名は、源義経の家臣で吉野を旅した佐藤忠信の名を拝借したという。

Tadanobu Rihei

"My hands have been sticky since I was a child." This is how the Edo-raised thief Tadanobu Rihei describes himself. A former ronin, he now serves as Daemon's right-hand man. When he saves Akaboshi Juzaburo from a difficult situation, he realizes their families have a master-servant relationship and decides to serve Akaboshi. He is wanted for stealing from wealthy houses and temples in Yoshino and Nara, and has borrowed his name from Sato Tadanobu, Minamoto Yoshitsune's retainer.

浜松屋幸兵衛
はままつやこうべえ

鎌倉の呉服屋・浜松屋の主人。女装した弁天小僧と供侍に化けた南郷力丸が店へやって来て盗みを働いたと大騒ぎになるが、逆に開き直られ収まらぬ騒動を主人の幸兵衛が百両を出そうと肚の大きいところを見せる。しかしそれも騙りとわかり、さらに日本駄右衛門に店の有り金全部を脅し取られようとするが、その経緯の中で弁天小僧が十数年前に人混みで取り違えた実の我が子と知る。

Hamamatsuya Kobei

A fabric merchant and the proprietor of Hamamatsuya. The shop is in trouble after the staff accuses a wealthy young woman of stealing. The woman is actually the swindler Benten, but Kobei, a just man, offers 100 *ryo* as compensation for a wound inflicted upon him. Though Kobei realizes that Benten is a swindler, Daemon later attempts to rob him of all his money. During the robbery, however, it is revealed that Benten is actually his son who had been lost ten years before.

浜松屋宗之助
はままつやそうのすけ

浜松屋の倅。弁天小僧たちの騒動の最中に帰ってきて何とかなだめようと苦心するが、結局父・幸兵衛の裁量に救われる。さらにそれも騙りとわかり解決の立役者となった侍・玉島逸当に父共々礼を尽くす。が、彼は実は日本駄右衛門という盗賊一味の首領。店の有り金を出せぬなら命を貰うと脅される中での身の上話、やがて日本駄右衛門が十数年前にはぐれた実の父親であったことがわかる。

Hamamatsuya Sonosuke
The son of the Hamamatsuya merchant. He returns to the shop as Benten is causing a stir and attempts to diffuse the situation. After the samurai Tamashima Itto helps them to see that Benten is a swindler, Sonosuke and his father thank him profusely, only to find that Itto is actually Nippon Daemon, the leader of the gang of bandits who then demands all of the money they have on hand. It is soon revealed, however, that Daemon is actually his father.

千寿姫
せんじゅひめ

小山判官の息女。父を亡くし許婚の信田小太郎（しだのこたろう）も行方知れずという中、桜が咲き乱れる鎌倉の初瀬寺（はせでら）にやって来ると凛々しく美しい若殿に遭遇。名を問えばその人こそ思いを寄せる信田小太郎と知れ、自ら恋を仕掛けて駆け落ちするが、実はなんと弁天小僧という盗賊。逃げ場もなく谷底へ身を投げて一旦は奇跡的に命を取り留めるが、ついには身を恥じて再び川へと身を沈める。

Princess Senju
Daughter of Inspector Oyama and engaged to Shinoda Kotaro, Princess Senju believes her missing fiance to be dead, and comes to Hasedera Temple for his memorial. Surprised to meet him there and find that he is actually alive, she vows her love to him and leaves with him. When she finds out that Kotaro is actually the bandit Benten Kozo, she throws herself into the nearby ravine, but fails to die. Deeply ashamed, she then throws herself in the river, attempting to kill herself once again.

鳶頭清次
とびがしらせいじ

喧嘩・もめ事の仲裁役といえば鳶の頭、というのが江戸時代あるいは芝居の中でのお約束。浜松屋にやって来た美しい武家の娘が万引きを働いたとの知らせを受け、いち早く駆け付けたのが鳶頭の清次。娘の額に傷をつけた代償に店からの十両で話を付けようと持ちかけるが鼻先であしらわれ、突っ返されては黙っていられない。威勢よく啖呵を切ってみたものの、ここは相手の方が一枚上手。

Tobigashira Seiji
As a rule in the theater, the tobigashira (head of the tobi firefighters) takes on the role of mediator when disputes break out. Tobigashira Seiji is the official who is called to Hamamatsuya when a wealthy young woman (Benten in disguise) is caught stealing. After it is shown that the woman did not actually steal any money, Seiji suggests the shop offer 10 ryo in compensation for the wound inflicted on Benten, but this is immediately rejected, angering him greatly. In the end, however, Benten is outranked by the wealthy woman (though this is only a trick).

青砥左衛門藤綱
あおとさえもんふじつな

鎌倉時代の武士で名奉行と誉れ高く、実在とされる人物。ある日鎌倉の滑川（なめりかわ）に十文を落とし、わずか十文とはいえ天下の回り物ゆえ五十文で松明（たいまつ）を買い求めてそれを探し出したという逸話が伝えられる。この演目の大詰「極楽寺山門の場」の後に登場し、まさしく逸話の通り滑川で十文を探すうち弁天小僧が落とした信田家の重宝も共に拾い上げ、山門の上の日本駄右衛門と対峙する。

Aoto Saemon Fujitsuna
A high-ranking magistrate of high esteem, Aoto Zaemon Fujitsuna is based on an actual person. In life he was known for searching the Nameri River for 10 *mon* (a unit of money) that he had lost, going as far as to purchase a torch for 50 *mon*, a sum far more than that lost. In this play he appears in the finale at Gokuraku Temple, where he finds the treasured incense box of the Shinoda house while looking for 10 *mon* in the river. He then confronts Nippon Daemon in a dramatic final scene.

みどころ
Highlights

1. 弁天小僧の晴れ着
—— Benten Dressed to the Nines

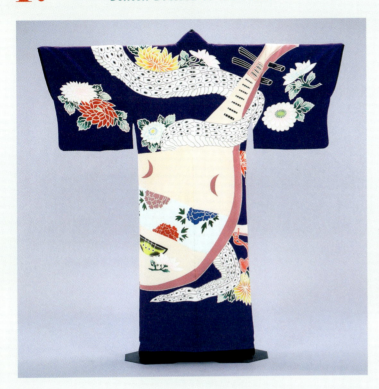

稲瀬川勢揃の場面で、弁天小僧菊之助が着る紫縮緬の晴れ着。弁財天には付きものの楽器である琵琶に、守護神の大蛇をまとわせた模様が大きく染め抜かれ、役名の菊之助にちなんだ菊も華やかにちりばめられている。

At the Inase River, the protagonist Benten Kozo Kikunosuke is dressed in his most elaborate costume, purple crepe robes. These robes feature a beautiful pattern of the god of music Benzaiten with his biwa harp and the guardian snake deity dyed in outline. His robes also feature chrysanthemums, a flower symbolic of Benten's role in the play.

2. 七五調のせりふ
—— A Script in Verse

男と見破られた弁天小僧が、振袖を脱いで彫り物を見せながら言う「知らざあ言って　聞かせやしょう」に始まる名せりふが七五調の代表格。以後も「浜の真砂と五右衛門が歌に残した盗人の」と七音五音でせりふが綴られる。聴かせどころを音楽的に美しい言葉に仕上げるのが黙阿弥の大きな特徴で、聴いていて気分がいい。勢揃いの名乗りも同様。そのほか『三人吉三』の「月も朧に白魚の……」、『髪結新三』の傘尽しなども七五調である。

Benten Kozo's exclamation after his disguise is blown are some of the most famous poetic lines in the kabuki repertoire. His monologue in this scene is entirely in the 5-7 syllabic pattern common in Japanese poetry, and as Mokuami is known for, has a musical quality to it that has captivated audiences over the years. The scene with the Shiranami Five gathered by the river is another scene filled with poetic language. Other plays with this type of language include *Sannin Kichisa* and *Kamiyui Shinza*.

3. 白浪作者は明治になっても
— Outlaw Stories, from Edo to Meiji

河竹黙阿弥は多くの白浪物をヒットさせた。『三人吉三巴白浪』と『白浪五人男』は今でもたいへん人気が高く、喝采を受けている。盗賊の芝居が痛快なのには、時代を超えて共通するところがあるのだろう。幕末にはこのほか『鼠小僧』『十六夜清心』『鋳掛松』など多くの白浪物を書き、明治になってからも『髪結新三』『河内山』などアウトローの芝居を書き、散切り頭の明治の泥棒を描いた『島衛月白浪』で、引退を表明している。

An example of *shiranami-mono* (*sewamono* dramas featuring bandits as protagonists), Kawatake Mokuami *Shiranami Gonin Otoko* is wildly popular even today. There is a certain thrill about outlaw stories that seems to transcend time itself. *Shiranami* is just one of many *shiranami-mono* written by Mokuami at the end of the Edo (1603–1868) and beginning of the Meiji period (1868–1912). He wrote plays such as *Nezumi Kozo* and *Ikakematsu* during the late Edo, and *Kamiyui Shinza* during the Meiji period before signaling his retirement with *Shimadori Tsuki no Shiranami*.

4. 揃いの衣裳で名乗り
— The Gang Assembled in Matching Outfits

黙阿弥は様式美を構築する名手でもあった。稲瀬川に勢揃いした五人男がいよいよ捕縛されようというときに、紫縮緬の揃いの小袖で名乗りを上げる場面は錦絵そのままの美しさだ。一味のボス駄右衛門の衣裳は羅針盤に碇と綱の柄に染められている。このほか弁天小僧は江の島弁財天にあやかった楽器の琵琶と守護神の蛇に菊、忠信利平は雲に龍、赤星は北斗七星と鶏、南郷は稲妻に雷獣と、それぞれにふさわしい図柄が鮮やかに映える。

The writer Mokuami was also known as an expert in formal design. This is especially apparent in the scene on by the Inase River, where we see the five bandits facing off against their captors. The matching purple silk crepe of their robes in this dramatic scene is simply gorgeous. The leader of the gang, Daemon, wears a unique robe with a nautical pattern including compasses and anchors. Benten's costume features the Enoshima god of music with a *biwa* harp and the snake guardian deity decorated with chrysanthemums. Tadanobu Rihei's robes feature clouds and dragons, while Akaboshi's feature the constellation Ursa Major and chickens, and Nango's are patterned with lightning and a mythological beast called *raiju*. Each brilliant costume is designed to represent the character who wears it.

5. 石川五右衛門の辞世
—— The Passing of Ishikawa Goemon

太閤秀吉秘蔵の重宝「千鳥の香炉」を盗もうとした大盗賊石川五右衛門は、息子もろともに釜茹での刑にされたという。五右衛門の辞世が「石川や　浜の真砂は尽きるとも　世に盗人の種は尽きまじ」。浜の砂が尽きても、盗人は消えないという意味。弁天小僧の名せりふは、それを引用している。ちなみに五右衛門侵入時に、啼いて危急を告げ知らせたという「千鳥の香炉」はその後徳川家の宝物となり、現在は名古屋の徳川美術館に収められている。

The great outlaw Ishikawa Goemon was boiled alive with his son for attempting to steal a treasured incense burner from Toyotomi Hideyoshi. His death poem expresses the notion that, though the sand on the riverbanks may disappear, thieves will never vanish from this world, and Benten Kozo alludes to this poem in the play. The incense burner Goemon attempted to steal is said to have cried out like a bird to alert the house of the intrusion, and it was later kept as a treasure of the Tokugawa house. It is currently kept at the Tokugawa Art Museum in Nagoya.

6. がんどう返しとせり上がり
—— The Temple's Retreat and the Rise of the *Seri* Lift

大詰で、弁天小僧が極楽寺大屋根で壮絶な最期を遂げると、弁天を乗せたままの大屋根が後ろへ大きく傾いていき、下から山門にいる駄右衛門が姿を現す。この仕掛けが「がんどう返し」。駄右衛門が五右衛門を気取ったせりふを言うが、その目に見えているのは無数の捕手の提灯である。「せり上がり」の仕掛で、山門の大道具が上昇し、さらに土橋がせり上がってきて青砥左衛門藤綱の登場となる。大道具が縦に変化する豪華な仕掛けだ。

In the finale, after Benten Kozo's grand death on the roof of Gokuraku Temple, the great temple roof recedes as Daemon rises from below the stage. This stage mechanic is referred to as *Gando-gaeshi*. As Daemon faces down his captors, his lines allude to the legendary outlaw Goemon. Using another mechanic called *seri-agari* ("rising lift"), the temple gate where Daemon stands rises up as an earthen bridge emerges and Aoto Saemon Fujitsuna makes his grand entrance. This is one of the most elaborate mechanics in kabuki, involving a large-scale prop that moves vertically.

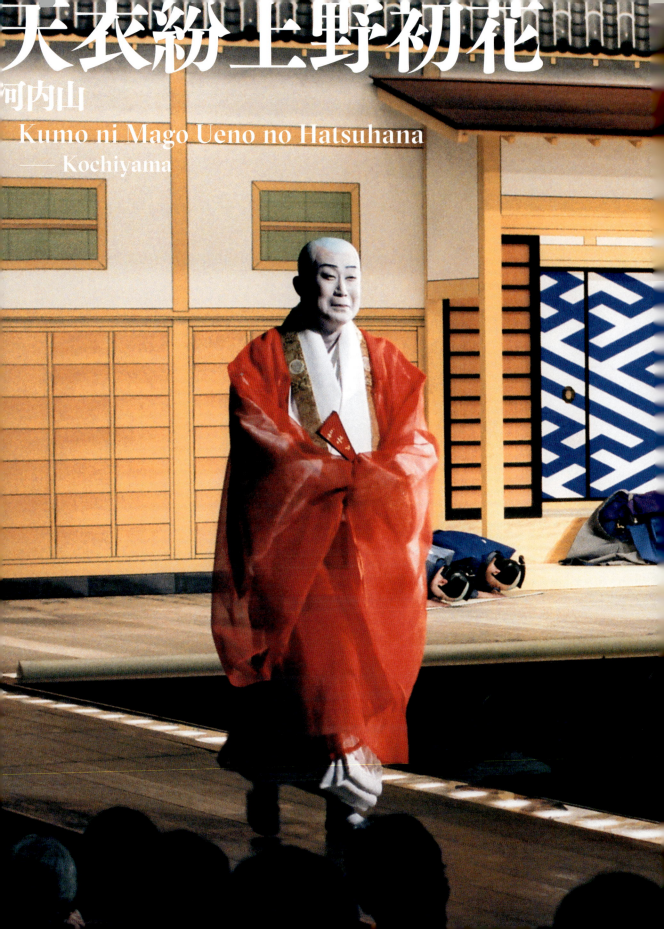

天衣紛上野初花
河内山

Kumo ni Mago Ueno no Hatsuhana
— Kochiyama

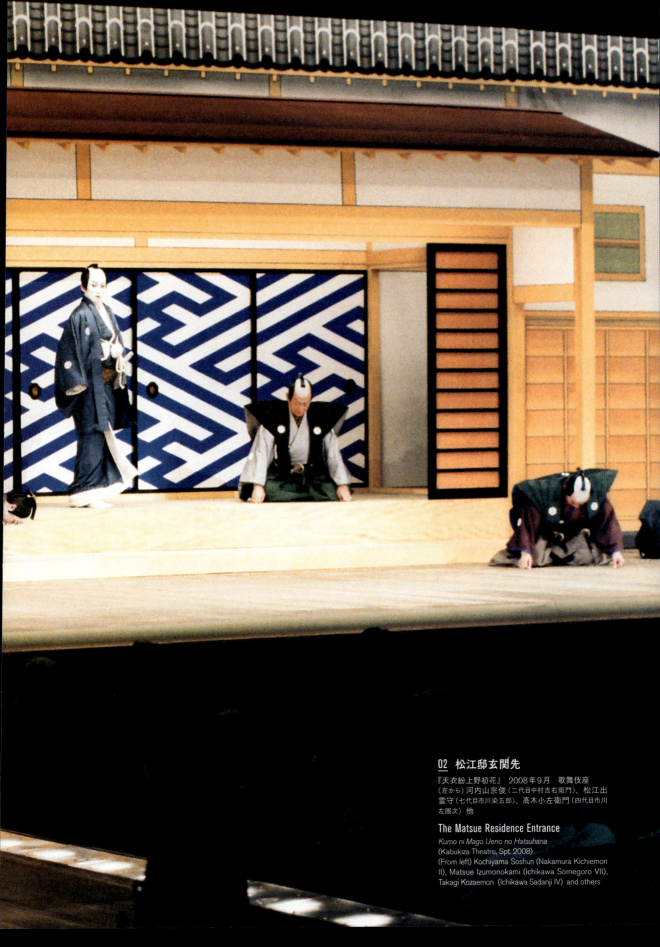

02 松江邸玄関先

『天衣紛上野初花』 2008年9月 歌舞伎座
(左から) 河内山宗俊(二代目中村吉右衛門)、松江出雲守(七代目市川染五郎)、高木小左衛門(四代目市川左團次)他

The Matsue Residence Entrance
Kumo ni Mago Ueno no Hatsuhana
(Kabukiza Theatre, Spt. 2008)
(From left) Kochiyama Soshun (Nakamura Kichiemon II), Matsue Izumonokami (Ichikawa Somegoro VII), Takagi Kozaemon (Ichikawa Sadanji IV) and others

あらすじ / Synopsis

それぞれ独立して観ても面白いが、
通しで観るのもまたひとしお。
黙阿弥の筆がさえる名作。
名せりふ、清元、耳に心地よい音で彩られる物語

悪事でも痛快無類。商家の娘の命を助けようと、大名家に単身乗り込む河内山。
騙りがばれてもびくともしないで切る啖呵。（河内山）
追われる男が、危険を冒して恋人に会いに来る……。音楽に乗せた切ない色模様。
雪の入谷に冴え返る音と心。（『雪暮夜入谷畦道』）

**Both stories are beautiful on their own, and yet more beautiful seen together.
Kumo ni Mago Ueno no Hatsuhana is a triumph of Mokuami's pen, full of striking lines and gorgeous *kiyomoto* music that have delighted audiences for generations.**

Audiences can't help but love the scoundrel Kochiyama as he fakes his way into a great daimyo's house to save a poor merchant girl. The villains think they have him when his cover is blown, but they have another thing coming to them… (Kochiyama)
A wanted man risks everything to see his love… Their brief reunion is underscored by gorgeous music that resounds through the snowy mountains. (A Snowy Evening Among the Rice Fields)

河内山（松江邸を中心としたあらすじ）

01　上州屋見世先

　質屋上州屋に、お数寄屋坊主の河内山宗俊がやってきて、ただの木刀で五十両貸せと無理を言う。数寄屋坊主とは江戸城で茶の接待をする役だが、この河内山は鉄火な性格で、なにかといわくつきの人物である。

　上州屋は何か取込がある様子。河内山は、上州屋の後家おまきから、大名の松江家に腰元奉公をしている娘のお藤が、殿様の妾になるよう強要され、断ったので部屋に閉じこめられている、と様子を聞き出す。さらに娘を救い出し

**Kochiyama Story
(primarily the Matsue Residence scenes)**

01　Joshuya Storefront

　Kochiyama arrives at the pawnshop Joshuya asking 50 *ryo* for a wooden sword, a ridiculous request. He serves at Edo Castle, serving tea and attending to the daimyo there, but he is short-tempered and prone to trickery.

　As Kochiyama asks about the shop he finds out that the proprietress Omaki is in a difficult position. Her daughter Ofuji was sent to the Matsue daimyo's residence as a chambermaid, but has been locked up after refusing to be the daimyo's consort. Omaki seeks Kochiyama's help, but he

03 大口屋寮
『雪暮夜入谷畦道』 2017年11月 歌舞伎座　片岡直次郎（七代目尾上菊五郎）

Oguchiya Dormitory
Yuki no Yube Iriya no Azemichi (Kabukiza Theatre, Nov. 2017)
Kataoka Naojiro (Onoe Kikugoro VII)

天衣紛上野初花　河内山　あらすじ

たいが、相手が大名ではとても敵わないとのおまきの言葉に、手付に百両、救い出したらさらに百両、都合二百両という破格の大金で娘の救出を請け負う。

02　松江邸広間〜同書院〜同玄関先

松江出雲守の屋敷では、出雲守が自分になびかぬ腰元浪路（お藤）を手討ちにしようとしている。家老高木小左衛門や近習頭宮崎数馬などが止めるが聞き入れず、数馬と浪路が不義をしているという北村大膳の讒訴を取り上げるありさま。

そこに、上野寛永寺から使いとの知らせが来る。上野の東叡山寛永寺の住職は、輪王寺宮といって親王がつとめ、将軍家たりとも粗略には扱えない身分。その使いとあるのに出雲守は会おうともしない。前触れもない宮の使いとは、もしや主君の乱行が耳に入り、その件でお咎めがあるのでは、と案じる小左衛門らであった。

そこへやってきたのは、法衣をまとい使僧になりすました河内山。しぶしぶ面会をした出雲守に向かい、浪路を親元へ帰すよう言い、さらに、この一件が老中まで聞こえると、お家お取りつぶしや国替えなどの大事になる。穏便に事を済ましたほうがいいのでは、とやんわり脅し、無理やり承諾させる。さらに河内山は、もてなしに出た数馬に、山吹のお茶を、と暗に金をねだる。

娘を家に帰し、金までせしめた河内山が、家臣らに見送られ帰ろうとする玄関先に、北村大膳が駆けつける。大膳は江戸城内で河内山の顔を見知っており、高頬のほくろを証拠に河内山と見破られてしまう。しかし開き直った河内山は、使僧と偽って浪路を取り返しにきたわけを話す。さらに、お数寄屋坊主は直参であり、大名といえどもうかつに手が出せないのをいいことに、自分を捕まえれば舌先三寸で松江家の乱行を吹聴すると脅す。小左衛門は松江家の名に傷が付くことを避け、何事もなかったかのように、河内山を宮の使いとして送り出す。

三千歳直侍のあらすじ（雪暮夜入谷畦道）

03　入谷村蕎麦屋〜（浄瑠璃「忍逢春雪解」清元）〜大口屋寮

町を外れた入谷村。さらに雪とあって人通りもない。そこにやってきたのはお尋ね者の片岡直次郎。蕎麦屋で酒と蕎麦を頼み暖を取るが、そのあとに入ってきたのがかねて見知りの按摩の丈賀。その話から恋人である大口屋の花魁三千歳が、直次郎を案じるあまりに病となり、近くにある大口屋の寮（別荘）に来ていること、そして丈賀が毎晩のように通って

demands 200 *ryo* as payment for his services: 100 *ryo* upfront, 100 after Ofuji is returned.

02 The Matsue Residence Parlor / Drawing Room / Entrance

Matsue Izumonokami attempts to behead Namiji (Ofuji's name as a chambermaid) for her refusal to be his concubine, but elder retainer Takagi Kozaemon and attendant Miyazaki Kazuma attempt to stop him. Another servant, Kitamura Daizen, stays on Izumonokami's good side by accusing the impudent Kazuma of having an illicit affair with Namiji.

Just then, a messenger priest from Kan'ei Temple arrives with a message for Izumonokami, but he refuses to see him. Kozaemon, therefore, goes to see him, worried that perhaps word of his master's questionable conduct has gotten around.

The messenger priest is actually Kochiyama in disguise, who tells a reluctant Izumonokami to release Namiji to her family, claiming that if word of his deeds were to reach the ears of the shogun's council, things would not go well for him. Convincing Izumonokami that it would be best to have this situation resolved amicably, he grudgingly returns Namiji. The ever-wily Kochiyama furthermore discreetly plies Kazuma for money when he brings him tea.

Having succeeded in getting Namiji back and obtaining some extra money, Kochiyama makes to leave. Kitamura Daizen comes running out just then and reveals Kochiyama's true identity. Kochiyama, however, is unfazed and reveals the truth of his actions readily, saying that due to his close proximity to the shogun, even a daimyo couldn't possibly harm him. He furthermore threatens to make Matsue's evil deeds known if they dare to capture him. Kozaemon, thinking of the Matsue house's reputation, allows Kochiyama to leave in peace, making no mention of his true identity.

Michitose and Naozamurai Story (A Snowy Evening Among the Rice Fields)

03 The Soba Shop in Iriya / Oguchiya Dormitory

Kataoka Naojiro arrives in Iriya on a snowy day. He warms himself with sake and soba noodles at a local soba shop and happens upon his acquaintance Joga, an *anma* masseur. He learns that the geisha Michitose is literally worried sick about Naojiro, who is her lover. He gives a letter he has written to Joga to pass on to Michitose in the Oguchi Dormitory where she is bedridden, and after they part he once again runs into someone he knows, his friend and fellow criminal Ushimatsu. After their meeting, Ushimatsu decides to betray his friend by turning him in, hoping for a lighter sentence for his own crimes.

Later, Naojiro comes to the dormitory, careful not to be seen by anyone. He is then ushered in by Michitose who has been waiting for him after receiving his letter. Naojiro, a wanted man, tells Michitose that this will be their final farewell, and the heartbroken Michitose asks him to kill

いることを知る。直次郎は三千歳への手紙を丈賀に託す。そこへ出会った暗闇の丑松。丑松も悪事仲間で、お尋ね者の身の上。丑松は直次郎を訴人し、引き換えに自らの罪を逃れようと決める。

　人目を忍んだ直次郎が寮にやってくる。手紙が届いているらしく、無事に招き入れられる。そこに現れた三千歳。直次郎はこれが今生の別れと決めているが、三千歳はいっそのこと殺してくれとせがむ。隣から聞こえてくるのは清元節の哀切な音。二人が名残を惜しんでいると、捕手が踏み込み、直次郎は雪の中を逃げていく。

―――――――――――――――――――――

　通し上演の場合は近年下記の場割で上演されることが多い。あらすじで触れていない、湯島天神境内、大口楼廻し部屋、同三千歳部屋、吉原田圃根岸道では、河内山や直次郎、三千歳、丑松のほか、剣術使いの金子市之丞が登場する。

　また、通し上演の場合は、「松江邸」に河内山と若侍に扮した直次郎の幕外に引っこみがついたり、「大口屋寮」の場で、金子市之丞が寮を来訪し、市之丞と三千歳が兄妹であることが判明する件が上演されたりするなど、台本演出に変更がある。

湯島天神境内
（上州屋見世先）→ 河内山
大口楼廻し部屋
同三千歳部屋
吉原田圃根岸道
（松江邸広間）→ 河内山
（同書院）→ 河内山
（同玄関先）→ 河内山
（入谷村蕎麦屋）→ 三千歳直侍
（大口屋寮）→ 三千歳直侍
池の端河内山妾宅

her. A melancholy *kiyomoto-bushi* tune plays, adding to the emotion of this scene. The two hardly have time to lament their sad lot before officers arrive looking for Naojiro. Finally Naojiro flees into the snowy night, gone as quickly as he had come.

―――――――――――――――――――――

　The following scenes are often played for *toshi-kyogen* productions of *Kumo ni Mago Ueno no Hatsuhana*. In some of the scenes not mentioned here, a swordsman named Kaneko Ichinojo appears.

　There is also a scene in the Matsue residence involving Kochiyama and Naojiro disguised as a young samurai, and a scene at the dormitory in which Kaneko Ichinojo is revealed to be Michitose's brother shown primarily in *toshi-kyogen* productions.

The Yushima Shrine
(Joshuya Storefront) → Kochiyama
A Room in the Oguchi Brothel
Michitose's Room
The Rice Fields near Yoshiwara
(Matsue Residence Parlor) → Kochiyama
(Drawing Room) → Kochiyama
(Entrance) → Kochiyama
(Soba Shop in Iriya) → Michitose and Naozamurai
(Oguchiya Dormitory) → Michitose and Naozamurai
The Home of Kochiyama's Mistress in Ikenohata

作品の概要

演目名

天衣紛上野初花―河内山

作者

河竹黙阿弥

概要

　全七幕あるが、現在では、お数寄屋坊主河内山宗俊のゆすりを中心とした件と、御家人片岡直次郎（直侍）三千歳の色模様を中心とした件、また、この二つの筋を中心に、前後を配した「通し」の三つの形で上演されることが多い。

　六人の悪党を描いた、二世松林伯圓の講釈『天保六花撰』の脚色。河内山の筋は、すでに明治7（1874）年に『雲上野三衣策前』として脚色、河原崎座で上演されている。これに直次郎と三千歳の筋と金子市之丞との確執などの筋を加え、七幕の長編に仕立てたもの。

　黙阿弥の代表作で、河内山のストーリーでは大名家に乗り込んだ河内山の痛快な啖呵が見どころであり、直侍の場面では清元を使っての直侍と三千歳の色模様などが名高い。三千歳と直侍のこれらの場面のみを独立させて上演する場合は『雪暮夜入谷畦道』の名題が用いられる。掲載のあらすじは、河内山の筋と、直侍（『雪暮夜入谷畦道』）のそれぞれのものと、通しの場合の場割と概要を示した。

初演

明治14（1881）年3月東京・新富座において、九世市川團十郎の河内山、五世尾上菊五郎の直次郎、八世岩井半四郎の三千歳ほかで初演。作者は河竹黙阿弥（当時二世河竹新七）。

Overview

Title

Kumo ni Mago Ueno no Hatsuhana — Kochiyama

Writer

Kawatake Mokuami

Overview

　Though originally in 7 acts, only the scenes showing the story of Kochiyama Soshun as well as the love story of Michitose and Naojiro are commonly performed today. A *toshi-kyogen* version is also sometimes performed, which includes the two stories and extra related stories to give context.

　The play is based on a *kodan* story by Shorin Hakuen II. The Kochiyama story had already been dramatized by 1874 in a play entitled *Kumono Ueno San'e no Sakumae*, which premiered at the Kawarazakiza Theatre. The modern version was written by adding the stories of lovers Naojiro and Michitose and Kaneko Ichinojo's antagonism to create a long-form 7-act play.

　One of Mokuami's masterpieces, the satisfying taunts of Kochiyama toward the evil daimyo are a highlight of the show along with the touching reunion of the lovers Michitose and Naozamurai, which is accompanied by *kiyomoto-bushi* music. When the love story is performed on its own, it is called *A Snowy Evening Among the Rice Fields*. Our synopsis gives a full summary of both the Kochiyama and lovers story, with an outline of the scenes included in *toshi-kyogen* productions.

Premiere

First performed at the Shintomiza Theatre in March, 1881. Feat. Ichikawa Danjuro IX as Kochiyama, Onoe Kikugoro V as Naojiro, Iwai Hanshiro VIII as Michitose, and others. Written by Kawatake Mokuami (Kawatake Shinshichi II at the time of this play's debut)

登場人物 / Characters

河内山宗俊
こうちやまそうしゅん

江戸城に勤めるお数寄屋坊主で、将軍近くで大名の世話や茶道の仕切りをしているため、ある種の特権がある。それをいいことに普段から強請（ゆすり）騙（かた）りと素行が悪い。屋敷奉公に上がった質屋の娘の難儀を救ってほしいと頼まれて二百両で請け負うと、東叡山（上野寛永寺）の使僧と名乗って乗り込む。帰るところで正体がばれるが、将軍様がついているのでどちらに転んでもこちらの勝ちと高笑い。

Kochiyama Soshun

A servant of Edo Castle, Kochiyama's duties include personal attendance to high-ranking daimyo and the serving of tea and food. Because this position grants him a certain level of privilege, he is known for his bad manners and a tendency to swindle people. When asked to help rescue Ofuji, he demands 200 *ryo* in payment for his services. When the deal is sealed, he impersonates a monk from Kan'ei Temple to get into Matsue's house where Ofuji is being kept. His disguise is blown as he makes to leave, but he laughs it off, knowing that he will be safe due to his proximity to the shogun.

和泉屋清兵衛
いずみやせいべえ

上州屋の親戚にあたる骨董商で、後家おまきの後見役となっている。娘を助け出すのに二百両と河内山が一方的に吹っ掛けるのでおまきもさすがにお願いとは言い出せず、他の者もどうせ河内山は騙りと一向に取り合わぬ中、清兵衛が進み出て「お数寄屋衆の宗俊様」とここはひとつ任せる所存。とはいえ上州屋に迷惑の掛からぬよう、手付の百両は私が出そうと肚の太いところを見せる。

Izumiya Seibei

A relative of the Joshuya shop family, Izumiya Seibei is an antiques dealer and Omaki's guardian after her husband's death. Though Omaki is troubled by Kochiyama's price of 200 *ryo* to rescue her daughter, Seibei notes his unique position at the castle as a reason to trust that he can do the job, and even helps out by paying half of the money himself.

浪路
なみじ

松江出雲守の腰元だが上州屋の跡取り娘で、行儀見習いで屋敷奉公に上がった。出雲守から妾にと望まれるが、許婚のある身といって断ると、殿の逆鱗に触れ屋敷内に幽閉されてしまう。さらに騒動の取り成しをした宮崎数馬が浪路と不義と訴えられて窮地に陥り、浪路は死ぬ覚悟もするが家老の高木小左衛門に救われる。やがてやって来た河内山の見事な働きで無事に家へと帰される。

Namiji

Matsue Izumonokami's chambermaid, Namiji is the heiress of the Joshuya shop, and as such arrangements have already been made for her to marry. Izumonokami, however, wants her to remain with him as his consort, and locks her away when she rightly refuses. He goes as far as to accuse his retainer Miyazaki Kazuma of illicit relations with Namiji, but the elder retainer Takagi Kozaemon helps to mitigate this conflict. Finally, Namiji is able to return home safely due to the persuasive Kochiyama.

おまき
おまき

下谷長者町にある質屋・上州屋の後家。夫亡き後の店を切り盛りしているが、一人娘のお藤（浪路）に婿が決まり後を託す目途も付いた矢先、松江出雲守の屋敷に奉公に上がっている浪路が殿の妾に上がれと強要され困惑に陥っている。店先にやってきた河内山宗俊に相談すると、前金で百両、成功後の後金で百両なら請け負うといわれる。無理とは思ったものの、和泉屋清兵衛の勧めで頼むこととなる。

Omaki

The widowed proprietress of a pawnshop called Joshuya, Omaki manages the store on her own now. She is pleased when her daughter Ofuji finds a potential husband, but then the powerful lord Matsue Izumonokami demands that Ofuji become his consort. Omaki bargains with Kochiyama Soshun to help save Ofuji, agreeing to give him 100 *ryo* up front, and 100 more once Ofuji is safely returned. Though she finds the sum to be unreasonable, Izumiya Seibei convinces her it will be worth it.

松江出雲守
まつえいずものかみ

松江藩の当主だが短気で誠に身勝手な人物。屋敷に奉公に上がっている浪路（お藤）を妾にしようとするが、許婚があるといって断られると逆上し、追い回すやら押し込めるやら。しかし東叡山の使僧といって現れた河内山の説得には抗しきれず浪路を家へと帰す。やがてお数寄屋坊主の河内山と知れるが、東叡山の門主も将軍様も一大名では頭が上がらず、ここは河内山に軍配が上がる。

Matsue Izumonokami

The short-tempered head of the Matsue clan, Izumonokami demands Namiji (also called Ofuji) become his consort and is enraged when she refuses and says that she already has a fiancé. He chases her through his manor and eventually locks her up in one of his rooms. He is persuaded by Kochiyama (who is disguised as a monk) to release Namiji, and though he eventually finds out Kochiyama's true identity, he realizes that his proximity to the Shogun make it impossible for him to retaliate.

高木小左衛門
たかぎこざえもん

松江家の家老。思慮分別に富み、松江侯のわがまま一方の振る舞いに毅然として対処し、お家のため身を挺して尽くす。浪路と数馬が窮地に陥ったところに現れ、殿様に向かって「あなた様はなあ」と諫めの言葉を投げかける。また浪路を取り戻しにやって来た河内山の正体が露見した後も、表向き使僧のまま帰すのが松江家の家名を傷つけぬ最善の策と見極め、冷静な判断を怠らない。

Takagi Kozaemon

Chief retainer of the Matsue house, Kozaemon is a shrewd man who deals with his spoiled lord with incredible resolve, finally forfeiting his own life for the sake of the house. When he sees Namiji and Kazuma being abused by his master, Kozaemon bravely remonstrates him. Furthermore, though he realizes Kochiyama's true identity, he realizes that letting Kochiyama leave under his monk's guise would be the best thing for the house's reputation.

北村大膳
きたむらだいぜん

松江家の家臣で重役。主君にすり寄って腰元の浪路を妾にさせようと積極的に図り、それを阻む宮崎数馬も不義者と陥れるが、家老・高木小左衛門の明晰な捌きに屈する。さらに浪路を救い出して帰ろうとする河内山宗俊に声をかけ、顔を見知ったお数寄屋坊主と見破るが、逆に居直った宗俊に封じ込められ、「馬鹿め!」と罵倒される。「とんだところへ北(来た)村大膳」とも揶揄される。

Kitamura Daizen

A retainer of the Matsue house and a vital role in this play, Kitamura Daizen plots to help his master make Namiji his consort. He accuses Kazuma of illicit relations with Namiji to this end, but is eventually stopped by the shrewd Takagi Kozaemon. As the disguised Kochiyama makes his leave, Daizen called out to him to reveal his true identity, but it is to no avail. Rather, Kochiyama, who knows he has the upper hand, merely makes fun of Daizen's foolishness in opposing him.

片岡直次郎
かたおかなおじろう

御家人(ごけにん=将軍家の家臣団のうち、御目見以下のやや下級の武士)崩れの遊び人で、お尋ね者となっている小悪党でもある。直侍と通称され、吉原大口屋の遊女・三千歳(みちとせ)とは深い仲である。積もる悪事が明るみに出て遠くへ高飛びを企てるが、ひと目三千歳に会いたいと雪の降りしきる入谷にやってくる。蕎麦屋で消息を知り、ようやく三千歳との短い別れだが、すでに追っ手が迫っている。

Kataoka Naojiro

A low-ranking vassal to the Shogun (*gokenin*), Kataoka Naojiro is a debauched playboy who plays a minor villain role in *Kumo ni Mago Ueno no Hatsuhana*. Often referred to as Naozamurai, he is involved with the geisha Michitose. He comes to visit her one last time before leaving town after his misdeeds are outed only to find that his pursuers have followed him.

丈賀
じょうが

吉原に出入りする按摩で、大口寮の三千歳のところにも療治でしばしば通っている。蕎麦が大好物で、吉原へ行き来の際は入谷にぽつんとある一軒の蕎麦屋に立ち寄り温かい蕎麦をすするのが何よりの楽しみ。そして雪の降りしきる寒い晩、気付かぬうち蕎麦屋に居合わせたのは思いもかけぬ直次郎、外で声をかけられ直次郎からの手紙をそっと三千歳に渡すよう頼まれる。

Joga

An *anma* masseuer who often comes to Yoshiwara and also treats Michitose's illness. He loves soba noodles, and never misses a chance to stop by his favorite noodle shop in Iriya. He runs into his acquaintance Naojiro one night and is asked to pass on a letter to Michitose.

宮崎数馬
みやざきかずま

松江出雲守の近習頭(きんじゅうがしら)を務める若き侍。腰元浪路を無理にでも妾にしようと理不尽に追い回す主君を懸命に諫めるが、かえって浪路との不義という根も葉もない疑いをかけられ、北村大膳などから咎めを受けそうになる。しかし高木小左衛門の捌きや、そこへ使僧と名乗ってやって来た河内山の訪問にようよう救われる。

Miyazaki Kazuma

Miyazaki Kazuma is a young samurai and head attendant to Matsue Izumonokami. He remonstrates his master for trying to make Namiji his consort, but his actions backfire when he is accused by Kitamura Daizen of having illicit relations with her. The wise Takagi Kozaemon mediates, however, saving him from a prickly situation. The disguised Kochiyama's appearance further draws attention away from this conflict.

三千歳
みちとせ

吉原の大口屋に抱えられる遊女で、直侍こと片岡直次郎とは深い馴染みの仲。とはいえ直次郎の行方が知れず、逢いたい思いが募るものの逢うことは叶わず、恋の病に臥せって入谷の大口寮で療養の身である。ようやく直次郎が忍び込んできて暫しの間の再会。一人で逃げるという直次郎にいっそ殺してと懇願するが、それよりも早く捕手が迫り、逃げる直次郎を後ろ髪引かれる思いで見送る。

Michitose

A geisha at the Yoshiwara brothel Oguchiya, Michitose is in love with Naojiro though she has no idea where he is now. Unable to meet with her love, her worry has her bedridden in Iriya. Naojiro eventually finds his way to her and they are briefly reunited. She asks him to kill her when he says that he must leave town, but before he can respond his pursuants arrive and he must leave as quickly as he came in.

暗闇の丑松
くらやみのうしまつ

河内山宗俊や片岡直次郎の一味となっている一人で、直次郎の弟分のような存在。こちらもお尋ね者だが入谷で再会した直次郎と互いに身の上を案じ合い、しかし三千歳のところへと急ぐ直次郎を見送るとにわかに心変わりし、訴え出て自分の罪を軽くしてもらおうと画策する。やがて直次郎のもとへは追っ手が迫ってゆく。

Kurayami no Ushimatsu

One of Kochiyama Soshun and Kataoka Naojiro's allies, Ushimatsu is like a younger brother to Naojiro. Both he and Naojiro are wanted men, which he finds out when he runs into Naojiro in Iriya. Though he is worried about Naojiro, he has a change of heart when he realizes he may be able to have his own sentence lightened by turning in his friend.

喜兵衛
きへえ

吉原大口屋の寮番で、息子の半七が金をだまし取られた一件などから片岡直次郎には恩義を感じている。ようよう訪ねてきた直次郎に、三千歳と手を取って共に甲州へお逃げなさいと勧める。

Kihei

Head of the Oguchiya dormitory, Kihei owes Naojiro for helping his son in the past. When Naojiro shows up to visit Michitose, he takes both their hands and implores them to escape together.

みどころ
Highlights

1. 天保六花撰 —— Tenpo Rokkasen

幕末から明治の講談師二世松林伯圓の講談。実在した茶坊主の河内山宗春、御家人崩れの片岡直次郎、博徒でのちに直次郎を裏切る暗闇の丑松、直次郎の恋人三千歳、剣客の金子市之丞、海産物商人森田屋清蔵の六人の暗躍を描いた白浪物である。伯圓は白浪物を得意としたので「泥棒伯圓」と言われた。浪曲としても流行し、度々映画化もされている。ちなみに河内山は獄死、直次郎は刑死した。三千歳が直次郎の墓を建立したことが知られる。

Tenpo Rokkasen is a kodan story written by Shorin Hakuen II. It is a shiranami-mono that depicts the stories of six primary characters: Kochiyama Soshun (based on a real person), the low-ranking vassal Kataoka Naojiro, the evil gambler Ushimatsu who betrays Naojiro, Naojiro's lover Michitose, the swordsman Kaneko Ichinojo, and the international merchant Moritaya Seizo. Known for his shiranami-mono, Hakuen was commonly called Dorobo Hakuen ("Thief Hakuen"). The story was also commonly performed accompanied by shamisen in the rokyoku style, and it has even been adapted into a film. The actual Kochiyama passed away in prison, and Naojiro was executed. Michitose is known as the person who built Naojiro's grave.

2. 直参と大名 —— Daimyo and Jikisan

江戸幕府は外様を含めた知行一万石以上の諸侯を大名、一万石未満の家臣を直参と呼んだ。直参には将軍家に御目見を許される旗本と御目見以下の御家人があった。直参とはもともと武将に直接仕える家来という意味。大名と直参は、互いに支配は及ばなかった。お数寄屋坊主の河内山は、侍ではないが直参である。もし大名が河内山を殺せばルール違反となり、御家の一大事となってしまう。それを見越した河内山が一枚上手である。

The shogun's retainers outside of Edo had different titles depending on the size of their fief. The highest ranked lords were called daimyo, while the next rank was called jikisan. Jikisan were allowed direct audience with the shogun's house and had vassals below them who did not have such privileges. Kochiyama is not a samurai, but a Jikisan. The murder of a Jikisan by a daimyo would be a severe crime that would not reflect well on the daimyo's house. Kochiyama uses this special privilege to his advantage in Kumo ni Mago.

3. 寛永寺の門主 —— Kan'ei Temple's Chief Priest

上野寛永寺門主は、三代目から代々皇族の輪王寺宮が勤めた。宮様なので幕府臣下の立場ではない。河内山は、その寛永寺門主のお使い僧になりすまして、大名家に立ち入ったのだ。門主が大名家の不行跡を将軍に言いつけられる立場であったか定かではないが、黙阿弥がこれを書いたのは明治14年で、すでに徳川幕府はなくなっている。初演の3月には上野で内国勧業博覧会が開かれていたという。実は、これを当て込んでの芝居であった。

The prince of Rinno Temple served as head priest of Ueno Kan'ei Temple from the third generation of the temple onward. The actual Kochiyama impersonated this prince's messenger, who would not be directly connected to the shogun, in order to enter the daimyo's residence. Whether his intention was to threaten to report the daimyo's actions to the shogun is uncertain, and by the time Mokuami wrote this play the Tokugawa Shogunate had already fallen. It was written and debuted to coincide with an industrial exhibition that took place in Ueno at the time.

4. 蕎麦は本物 —— Real Soba

恋人三千歳花魁にひとめ逢おうとする直次郎が、その前に立ち寄る蕎麦屋の場面では、温かい蕎麦が出される。これは劇場近くの蕎麦屋から調達する本物なので、客席から見ても本当に美味しそうである。直次郎が登場する前に、蕎麦屋で食べている人物は食べ方が少し野暮ったい。直次郎が現れると、これぞ江戸の食べ方というような見事に粋な食べっぷりを見せる。見ていた観客が終演後に蕎麦屋へ駆け込むことも多い。

Naojiro stops by a nearby soba shop on his way to see his lover the geisha Michitose. Look closely and you'll see that the hot soba noodles served to Naojiro are real noodles ordered from a soba shop near to the theatre. Though the other customers at the shop eat in a rather unrefined way, the stylish Naojiro eats in a much more elegant and refined manner as if to show the audience the proper Edo way to eat. Some audience members find themselves rushing to a nearby soba shop after the play.

5. 情緒纏綿の清元 —— The Emotional Music of *Kiyomoto*

恋人直次郎に逢えなくてぶらぶら病いになってしまった三千歳を、抱え主は入谷の寮で養生させている。雪道をやってきた恋人を飛び立つ思いで迎え入れる三千歳。しかしその喜びは短く、はかなく消え失せる。この絵のように甘く切ない一夜の逢瀬を盛り上げるのが、清元節の名曲「忍逢春雪解（しのびあうはるのゆきどけ）」。清元節は、豊後節に始まる江戸浄瑠璃のなかから独立した語り物で、愁いの深い情緒纏綿たる語り口が特長。

Michitose is sick in bed out of worry for her lover Naojiro. When he suddenly appears at the dormitory where she is being treated on a snowy night, she is overjoyed. But alas, their reunion is cut short, the accompanying *Kiyomoto-bushi* tune "Rendezvous in the Spring Snow" (*Shinobiau Haru no Yukidoke*) perfectly heightens the emotion of this scene.

梅雨小袖昔八丈
髪結新三

Tsuyu Kosode Mukashi Hachijo
—— Kamiyui Shinza

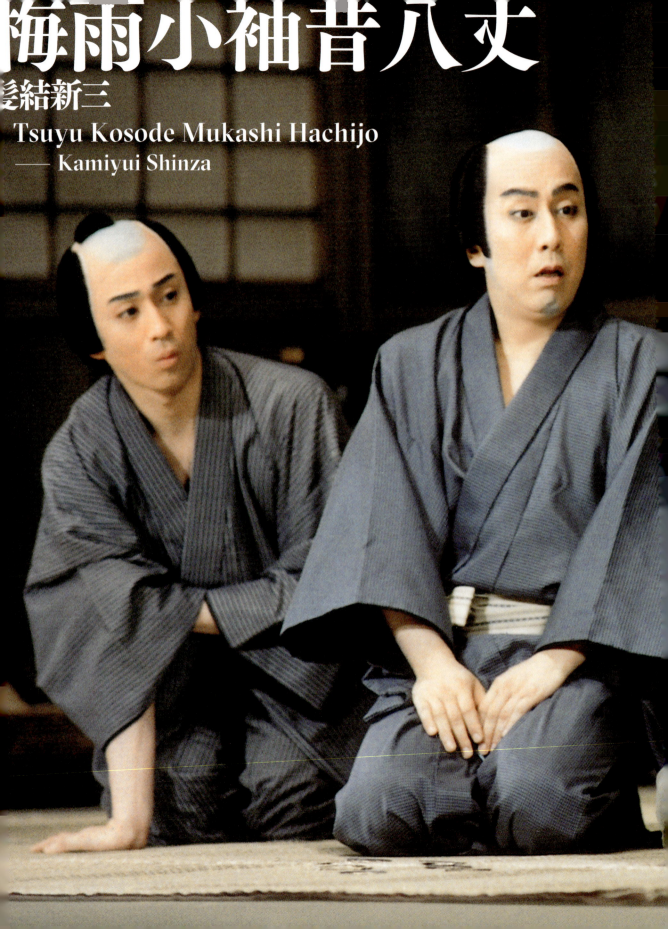

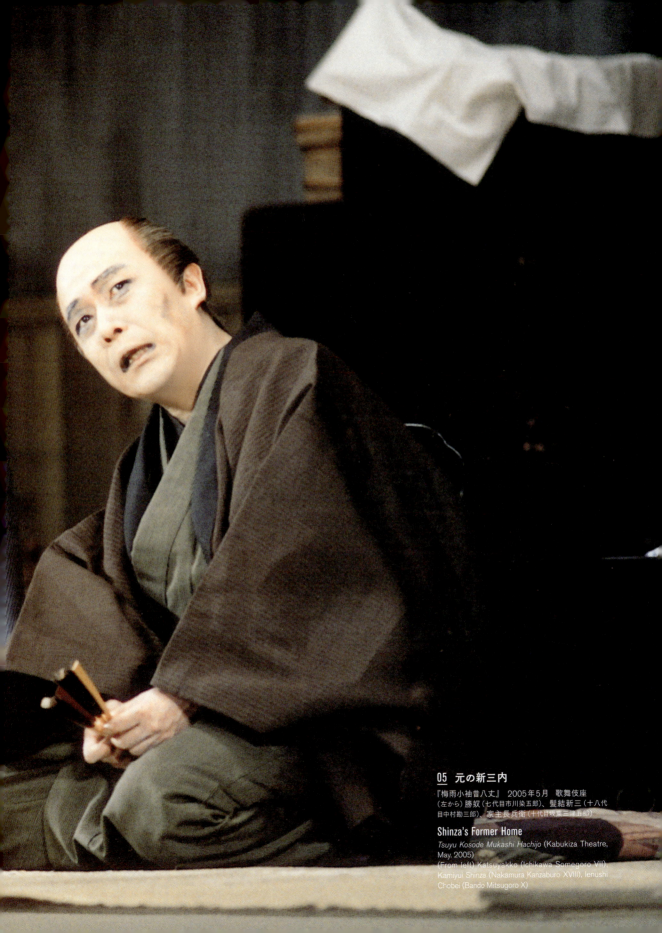

05 元の新三内

『梅雨小袖昔八丈』 2005年5月 歌舞伎座
(左から)勝奴(七代目市川染五郎)、髪結新三(十八代目中村勘三郎)、家主長兵衛(十代目坂東三津五郎)

Shinza's Former Home
Tsuyu Kosode Mukashi Hachijo (Kabukiza Theatre, May, 2005)
(From left) Katsuyakko (Ichikawa Somegoro VII), Kamiyui Shinza (Nakamura Kanzaburo XVIII), Ienushi Chobei (Bando Mitsugoro X)

あらすじ / Synopsis

見たこともないのに懐かしい、江戸の人びととその暮らし。
初夏の江戸下町を吹き抜ける風の色までが感じられる演目

時鳥（ほととぎす）や初鰹など初夏の風物を巧みに配し、苦み走った小悪党を主人公に、
江戸の下町の生活をいきいきと描き出した世話物の名作。
洗練され、磨き上げられた演出が今に伝わる。

Audiences can almost feel the downtown Edo breeze of early summer in this play that leaves you nostalgic for a place you've never even been.

With early summer staples like cuckoos and bonito fish spread throughout the story, audiences get a vivid veiw of downtown Edo life in this masterful *sewamono* piece.

01　白子屋見世先

江戸日本橋新材木町の材木問屋の白子屋は、主の死後、五百両という大枚の借金を作っていた。後家お常は、車力の善八の仲立ちで一人娘のお熊に婿をとらせ、その持参金で借金を返済しようとしている。お熊はすでに店の手代忠七と恋仲。二人の話を表で立ち聞きしていたのは白子屋に出入りの廻り髪結の新三。新三は忠七の髪を撫で付けながらお熊との駆け落ちを熱心に勧め、隠れる所に困るなら深川の富吉町にある自分の住まいに来るといいと言って白子屋を出る。忠七も性根を据えてお熊との駆け落ちを決意する。

02　永代橋川端

お熊を乗せた駕籠が通り、そのあとを新三と忠七が相合傘で雨をよけながら永代橋までやってくる。やがて新三はそれまでの態度を変え、もとからお熊は自分のものだから連れ出したのだと言い出す。騙されたと知った忠七は新三にすがりつくが、傘で散々に打たれ、蹴倒されてしまう。新三の住まいが深川のどこかも知らない忠七は、途方に暮れ身を投げようとするが、侠客弥太五郎源七に止められる。

03　富吉町新三内

新三の住む富吉町の長屋。新三の子分の勝奴が留守番をし

01　Shirokoya Storefront

The owner of the lumber firm Shirokoya in Zaimokucho has passed away, and the shop is now in debt. The widow Otsune now runs the business, and arranged for the rickshaw driver Zenpachi to marry her daughter Okuma and use the dowry to pay off the stores debts. Okuma, however, is in love with the clerk Tedai Chushichi. The wily barbar Shinza hears about the lovers' plight and plots to take Okuma as his own while pretending to help by offering his home in Tomiyoshicho as a hiding place for the two. Thinking that this will allow him to elope with Okuma, Chushichi accepts Shinza's offer.

02　The Riverbank by Eitai Bridge

While Okuma rides in a palanquin, Shinza accompanies Chushichi on foot as far as Eitai Bridge, where his demeanor suddenly changes. He claims that Okuma is his, revealing his deception to Chushichi. Chushichi frantacally grabs at Shinza, but Shinza beats him with the umbrella and then kicks him to the ground before leaving him in the rain. Not knowing where Shinza's home is, Chushichi throws himself in the river, but is saved by the chivalrous Yatagoro Genshichi.

03　Shinza's Home in Tomiyoshi

At Shinza's low-income *nagaya* home, Shinza's henchman Katsuyakko is away, but Okuma has been tied up and locked in a closet. Shinza returns from his morning bath

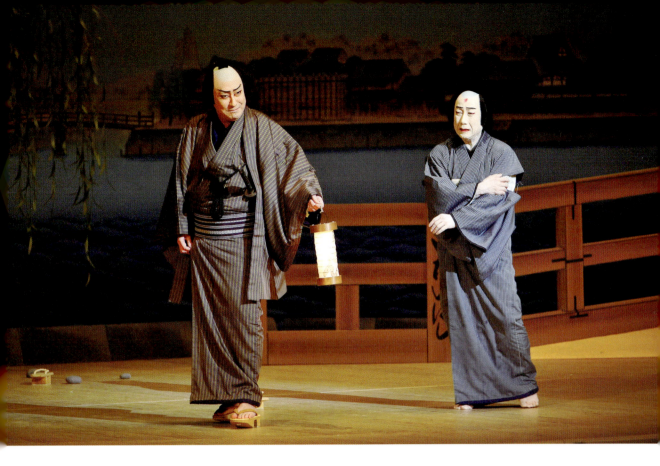

02　永代橋川端

『梅雨小袖昔八丈』　2013年8月　歌舞伎座
（左から）弥太五郎源七（三代目中村橋之助）、忠七
（三代目中村扇雀）

The Riverbank by Eitai Bridge
Tsuyu Kosode Mukashi Hachijo (Kabukiza Theatre, Aug. 2013)
(From left) Yatagoro Genshichi (Nakamura Hashinosuke III), Chushichi (Nakamura Senjaku III)

04　家主長兵衛内

『梅雨小袖昔八丈』　2011年11月　新橋演舞場
（左から）女房おかく（四代目片岡亀蔵）、家主長兵衛
（十代目坂東三津五郎）

Landlord Chobei's Home
Tsuyu Kosode Mukashi Hachijo (Shinbashi Enbujo Theatre, Nov. 2011)
(From left) Okaku (Kataoka Kamezo IV), Ienushi Chobei (Bando Mitsugoro X)

ており、連れて来られたお熊は縛られ、押入れに押し込められている。朝湯から帰ってきた新三は、高価な初鰹を買うなど、白子屋から大金が入ることを当てにしている様子。そこへ善八と源七が訪れた。

源七は用意していた十両を出し、これでお熊を返すように言う。下手に出ていた新三だったが、源七の親分風をきかした態度が気に食わず、金を叩き返した上にさんざんに悪態をついて源七を辱める。源七は、腹に据えかねたもののそのまま新三の家を善八とともに引き上げるのだった。その時、この長屋の家主の女房お角が声をかけてきて、善八は家主の家に赴く。

04　家主長兵衛内

家主の長兵衛は、新三への掛け合いを引き受け、善八が白子屋から預かっていた三十両を懐に新三の家へ向かう。

05　元の新三内

新三と勝奴は鰹を肴に酒を飲んでいる。そこへ長兵衛が来る。長兵衛は新三にお熊を返すのに三十両で了見しろと言う。三十両では承知せず、前科者のしるしである入れ墨を見せてすごむ新三に、もしこのまま収まらないなら奉行所に訴えると脅しをかける。新三は渋々ながらお熊を返すことにした。お熊は駕籠に乗せられ善八とともに白子屋へ帰った。

長兵衛は新三に十五両を渡し、「鰹は半分貰った」とばかり繰り返す。骨折り賃に半分の十五両を取るつもりなのだ。拒否するなら悪事を訴え出ると長兵衛が言い出すので、新三は承知するよりほかなかった。そこへ長兵衛の嫁・お角が来て、新三がためていた店賃二両を差し引くように言う。新三の手に渡ったのは結局十三両。ところがその時、長兵衛の家に空き巣が入り、箪笥の中身をそっくり持っていったとの知らせ。新三と勝奴はこれを見て、やっと溜飲を下げるのであった。

06　深川閻魔堂橋

弥太五郎源七は、新三に面目を潰されたのを忘れることができず、恨みを晴らそうと深川の閻魔堂橋まで出向いて、賭場から帰る新三を待ち伏せする。源七は刀を抜いて新三に斬りかかり、新三も匕首で歯向かうがついに殺されてしまう。

and buys an expensive fish in anticipation of money to come from Shirokoya. Just then Zenpachi and Genshichi arrive.

Genshichi comes with 10 *ryo* as payment, demanding that Okuma be returned. Shinza, however, angered by Genshichi's attitude, throws the money back and berates Genshichi. Though Genshichi is angry, he leaves the house with Zenpachi and is accosted by Okaku, the landlord's wife. He then follows her to landlord Chobei's home.

04　Landlord Chobei's Home

After negotiating with Zenpachi regarding Shinza, the landlord Chobei accepts 30 *ryo* that Zenpachi has brought from Shirokoya.

05　Shinza's Former Home

Shinza and Katsuyakko are eating their expensive bonito and drinking *sake* when Chobei arrives and demands that Shinza return Okuma for the 30 *ryo* he received from Zenpachi. Shinza, however, flaunts his tattoo, a sign of his ex-convict status and refuses the offer. Chobei then threatens to file a complaint at the magistrate's office, and Shinza reluctantly sends Okuma back to Shirokoya with Zenpachi in a palanquin.

Chobei hands Shinza 15 *ryo*, claiming that "half the fish is mine" as an excuse to take 15 *ryo* as payment for his troubles. Shinza has no choice but to accept, as Chobei threatens to file a complaint should he refuse. Furthermore, Okaku reminds Chobei to take 2 *ryo* as rent, so that Shinza only receives 13 *ryo*. At that moment, however, Chobei is notified that there has been a burglary at his home and he rushes off. Shinza and Katsuyakko are relieved to see their tormentors leave.

06　Enmado Bridge on the Fukagawa River

Yatagoro Genshichi, unable to forget his disgrace at Shinza's hands, goes to Enmado Bridge and lies in wait for Shinza to return from the gambling house. Genshichi unsheathes his sword and strikes at Shinza, who tries to strike back with a dagger but is nonetheless killed.

作品の概要

演目名

梅雨小袖昔八丈―髪結新三

作者

河竹黙阿弥

概要

河竹黙阿弥の代表作の一つ。時鳥や初鰹など初夏の風物を巧みに配し、江戸の下町の生活をあざやかに描き出している。

もとは四幕十一場の長編だが、現在では「髪結新三」の通称の通り、廻り髪結の小悪党新三の物語を抜き出して上演することが多い。掲載のあらすじは現在もっともよく上演されている場面のものである。

見どころ聞きどころは多く、「白子屋店先」で新三が忠七の髪を撫でつけながら駆け落ちをそそのかす場面では、江戸の生活を眼前に彷彿とさせる髪結いの手つきが世話物ならではの面白さ。続く「永代橋」で、本性を現し、忠七を踏みつけての傘づくしの台詞、颯爽とした引っ込み、「新三内」での生活感と、弥太五郎源七への威勢の良い啖呵、後半一転して大家にやりこめられる愛敬、「閻魔堂橋」での地獄づくしの台詞などが全篇にちりばめられている。

春錦亭柳桜の人情噺「白子屋政談」を素材にした作品で、本名題（タイトル）にある「昔八丈」は、白木屋お駒の婿殺しを描いた浄瑠璃「恋娘昔八丈」を効かせたもの。

初演

明治6（1873）年6月、東京・中村座で、五世尾上菊五郎の新三ほかにて初演。河竹黙阿弥（当時は河竹新七）作。通称「髪結新三」。

Overview

Title

Tsuyu Kosode Mukashi Hachijo
— Kamiyui Shinza

Writer

Kawatake Mokuami

Overview

Tsuyu Kosode Mukashi Hachijo beautifully depicts the early summer of downtown Edo life and is one of Kawatake Mokuami's most famous plays.

Though originally a long play in 4 acts and 11 scenes, these days the *Kamiyui Shinza* story is most often performed alone, and the play is often called by this name. The synopsis given here summarizes the most often performed scenes of the play.

There are a number of highlights in *Kamiyui Shinza*, including the "Shirakoya Storefront" scene that shows the cunning barbar Shinza carressing Chushichi's hair and suggesting he elope with Okuma. It is notable not only for its significance to the plot, but also for its depiction of the custom of *kamiyui* hairdressing that you won't see many places else. Shinza's lines in the "Eitai Bridge" scene and the depicition of daily life in the "Shinza Home" scenes are just a few of the other highlights of the place.

Based on a story from *rakugo* piece Shunkintei Ryuo, *Mukashi Hachijo* is a reference to a joruri puppet play called Koimusume *Mukashi Hachijo* that depicts a murder involving the *Shirakiya* lumber company.

Premiere

First performed at the Nakamuraza Theatre in Tokyo, June 1873. Feat. Onoe Kikugoro V as Shinza and others. Written by Kawatake Mokuami (known as Kawatake Shinshichi at the time). Commonly referred to as *Kamiyui Shinza*.

登場人物 / Characters

髪結新三 (かみゆいしんざ)

深川の裏長屋に住む髪結新三は店を方々廻って歩く「廻り髪結」。江戸っ子で気っ風のよさもあるが一癖も二癖もある油断のならない人物。日本橋の材木問屋・白子屋のひとり娘お熊をまんまとだまして長屋に監禁し、交渉に来た顔役の弥太五郎源七さえも罵倒して追い返す始末だが、その新三も家主の長兵衛には敵わない。身代金三十両に加え奮発した初鰹も見事に半分巻き上げられてしまう。

Kamiyui Shinza

A barbar living near the Fukagawa River who makes rounds to various shops in the area. A true "child of Edo," Shinza strikes an attractive figure but also has a few idiosyncracies. He captures and locks away the young Okuma, daughter of the Nihonbashi lumber company Shirakoya, and then proceeds to disparage Genshichi who comes to negotiate her return. He is no match for landlord Chobei, however, who comes with a ransom of 30 *ryo* to save Okuma. The imposing Chobei furthermore strong-arms Shinza into relinquishing half of the ransom and half of his bonito feast to him.

白子屋お熊 (しらこやおくま)

白子屋のひとり娘で手代の忠七とはかねてより恋仲。しかし店の経営がうまくゆかず多額の持参金付きの婿取りの話が進んでゆき、髪結新三の勧めを受けた忠七に従い新三の用意した駕籠で連れ去られる。結局お熊は忠七と離されて新三の長屋の押入れに監禁されるが、店からの救いの手もうまくゆかず、ようやく新三の天敵・家主長兵衛の機転と強欲のお蔭で救い出される。

Shirakoya Okuma

The young daughter of the Shirakiya lumber company and Chushichi's lover, Okuma is promised to another man in order for the store to receive a large dowry and help with their struggling finances. She accepts help from Shinza, but rather than help Okuma and Chushichi elope, Shinza beats Chushichi and steals Okuma for himself. He locks her away and refuses to return for even when Genshichi comes with a ransom, but eventually Okuma is saved by the landlord Chube, an enemy even Shinza can't stand up to.

車力の善八 (しゃりきのぜんぱち)

白子屋お熊の側に付いているお菊の叔父で、善八というその名の通り白子屋のため何かと力を尽くす根っからの善人。車力とは大八車などを使って運搬業に従事する業者のこと。白子屋の女主人・お常の頼みで婿探しに奔走したり、連れ去られたお熊を救うため弥太五郎源七に連れ立って新三の家を訪ねたり、ついには身代金の三十両を抱えて新三と家主に持って行くなど、身を粉にして働く。

Shariki no Zenpachi

A rickshaw driver who is to marry Okuma and give a hefty dowry to the Shirakoya family, Zenpachi is a virtuous man who would do anything to help the Shirakoya business. He helps Otsune in a number of ways, first by searching for an appropriate husband for Okuma, then by hiring Genshichi to help rescue her from Shinza. And finally, when Genshichi fails, he negotiates with Shinza's landlord who helps rescue Okuma.

手代忠七 (てだいちゅうしち)

白子屋の手代すなわち奉公人だが、ひとり娘お熊とは恋仲である。しかし店の商売が傾いてお熊が持参金付きの婿を迎えることとなり忠七は困惑、それを知った髪結新三から秘かに駆け落ちを持ちかけられる。しかしお熊が連れ出された後、新三から永代橋で足蹴にされ置き去りに……途方に暮れた忠七は川に身を投げようとするが、それを止めたのは侠客の弥太五郎源七だった。

Tedai Chushichi

A clerk at the Shirakoya lumber company, Tedai Chushichi is in love with Okuma. He is dismayed to hear that Okuma is to take another man as her husband in order to help with the store's finances. When the barbar Shinza hears about the lovers' troubles, he pretends to help them elope, but this is part of his plan to take Okuma for his own. Chushichi goes along with Shinza while Okuma is driven ahead to their hideaway, but is beaten and left alone at the Eitai Bridge along the way. At his wit's end, Chushichi throws himself into the river, but is saved by the chivalrous don Yatagoro Genshichi.

白子屋お常 (しらこやおつね)

日本橋で材木問屋を営む白子屋の当主。亡き夫に代わって由緒ある店を切り盛りする貞節な女主人であるが、次第に店も傾き先行きは細るばかり。車力の善八を頼って娘のお熊に持参金付きの婿取りの話を進めるが、しかしお熊と忠七が髪結新三の駆け落ち話に乗り、とんだ誘拐事件となった。娘の救出を乗物町の親分・弥太五郎源七に依頼するが、それも思い通りとはならなかった。

Shirakoya Otsune

The widowed proprietress of Shirakoya, Otsune has not done well for the business after her husband's passing. To help with finances, she arranges for the rickshaw driver Zenpachi to marry her daughter, bringing with him a hefty dowry. Okuma, however, is kidnapped and ransomed by Shinza. Otsune charges Genzo with returning her daughter but his negotiation is unsuccessful.

勝奴 (かつやっこ)

髪結である新三の下剃りの部分を受け持つ助手で子分、また居候（いそうろう）でもある。お熊の誘拐には駕籠を用意して手伝い、また鰹売りがやって来ると、買ったばかりの鰹を刺身にこしらえて家主にもふるまう器用者。いかにも若造だが、新三が弥太五郎源七の無力ぶりを罵倒すると、勝奴も「たがのゆるんだ小父さんさ」とあざ笑う。新三の悪党ぶりとやや対照的な小気味の良さも感じさせる。

Katsuyakko

Apprentice and henchman of the barbar Shinza, Katsuyakko is actually a freeloader who leeches off his master. He is a clever man who prepares the palanquin used to kidnap Okuma and slices the freshly purchased bonito fish for sashimi. A youthful and bright character in contrast to the overbearing villain Shinza, Katsuyakko can be seen making fun of Genshichi as Shinza disparages him.

肴売り新吉
さかなうりしんきち

「カッツオ！ カッツオ！」と威勢のいい売り声で登場する魚屋。この芝居全体に江戸下町の雰囲気や風俗が満載されている上、ワンポイントの端役ながらさらに強烈な季節感と江戸の香りを送り込む得な役。新三とのやり取りではテンポの良い江戸弁で世話物の味を出し、鰹を下ろす見事な手捌きも観客の目を釘付けにする。この鰹も後の展開で重要な役割を果たすことになる。

Sakanauri Shinshichi

A fish seller with a booming voice perfect for his profession, Shinshichi is a somewhat simple character, but his presence gives a sense of the atmosphere of old downtown Edo. He is seen speaking the rhythmic Edo dialect with Shinza, and his dexterous handling of his wares is bound to hold audiences in a trance. Of course, the fish he sells to Shinza plays an important role in the plot later on as well.

家主長兵衛
いえぬしちょうべえ

新三が住む深川の長屋の家主。今と違い家主といえば店子（たなこ）に対するあらゆる権限と責任を持ち、新三といえども頭の上がらない存在だが、さらにこの長兵衛は新三の二枚も三枚も上をゆく筋金入りの強欲者。百両と主張する新三に三十両で納得させ、やがて「鰹は半分貰ってゆくよ」と念を押す通り、鰹は半分、三十両の半分十五両も強奪して「大家さんには敵わねえ」と新三に言わせてしまう。

Ienushi Chobei

Shinza's landlord, Chobei is the greedy owner of all the tenements in the area, and his position makes him impossible for Shinza to stand up against. His avarice exceeds even Shinza's, as he takes more than half of the ransom money offered for Okuma's return and half of the expensive bonito fish Shinza has purchased. After haggling him down from 100 *ryo* to 30 *ryo* and furthermore skimming some of the money for himself, Chobei gloats at the now powerless Shinza, saying "You could never win against me, the landlord."

弥太五郎源七
やたごろうげんしち

新三に騙された手代忠七が川へ身を投げようとするのを救ったのがこの弥太五郎源七。やがて白子屋から頼まれ十両を持って新三のもとへ行くが、逆に新三から思い切り罵倒される。「乗物町の親分」といえば誰もが認める大親分だがそれも昔、今や歳を重ねた源七にその勢いはなくそこを新三に突かれたのだ。恥をかかされた源七は後に閻魔堂橋で新三を待ち伏せし恨みを晴らす。

Yatagoro Genshichi

Genshichi is the man who saves Chushichi from the river after he is deceived by the cunning Shinza. He is given 10 *ryo* to offer in exchange for returning Okuma, but is only ridiculed and driven off by the evil Shinza. Though once a powerful don in the area, Genshichi is old and feeble now, which Shinza takes advantage of. After his disgrace at Shinza's home, he lies in wait at Enmado Bridge, waiting for Shinza to come by so that he may exact his revenge.

みどころ
Highlights

1. 廻り髪結
—— Hairdressing House Calls

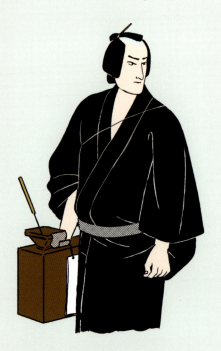

江戸時代には男も女も髪を結った。結い上げた髪は日が経つと乱れるので、結い直す。時間がない時は、櫛でなでつけて数日しのぐこともあった。忙しい町内を回って歩くのが、廻り髪結。コンパクトな道具箱に髪結の道具、櫛や鋏、髪を固める鬢付け油、髷をきっちり縛る元結（紙の細ひも）など一通り揃え得意先を歩く。道具箱を手に、元結で片袖だけ襷掛けにした新三の姿が小粋だ。忠七の髪をなでつける見事な手際もみどころ。

During the Edo period it was common for both men and women to dress hair. Hair was often worn up in a manner that would come undone over time. Some people used combs to straighten their hair out for a couple of days when they didn't have time to properly fix their hair. At times like these, *mawari-kamiyui* hairdressers would make rounds around town to help people with their hair. Such hairdressers make their rounds with a compact set of tools, including combs, scissors, oils, and paper ties. Seeing the hairdresser Shinza go to work with his tool kit in one hand, one sleeve tied back with cords, is one of the highlights of the show, especially the scene in which he combs Chushichi's hair.

2. 初鰹の値段
—— The Price of Bonito

この芝居を見ると、鰹が食べたくなる。江戸時代にも五月の初鰹は珍重された。相模湾で獲れたのを船で運ぶか、三浦あたりから早馬で江戸へ運ぶので高価になったという。新三が身代金の前祝いに、初鰹を一本買う。すぐに魚屋が路地で鰹を器用に二枚に下ろすのが、なんともあざやかな手つき。鰹の値は三分（さんぶ）で、一両の四分の三に相当する。「三分あれば単（ひとえ）の着物が一枚買える」と隣のおやじのせりふにある。

You may find yourself wanting to eat bonito after watching this show. During the Edo Period, bonito was an extremely expensive delicacy due to the fact that it had to be transported to Edo from Sagami Bay or Miura. In *Kamiyui Shinzai*, Shinza purchases some of the first bonito of the year to celebrate the coming ransom money. Watching the dexterous fish seller prepare the fish for him is one of the highlights of the show. He charges *sanbu*, or three-quarters of one *ryo*, and if you pay attention you can hear a nearby man comment, "For that price you could buy a *hitoe* kimono."

3. 傘づくしの啖呵 —— Beaten With an Umbrella

江戸時代の五月は旧暦だから、梅雨時である。新三の口車に乗ってしまった忠七が、あいにくの雨に傘を買う。だが、手のひらを返した新三に傘を取られた上に、散々に叩かれる。忠七を足蹴にした新三の凄みのある啖呵が聴きどころになっている。「これ、よく聞けよ。ふだんは帳場を廻りの髪結、いわば得意のことだから……」で始まり、ろくろ、はじき、柄（え）、油紙など和傘にまつわる単語が織り込まれた傘づくしになっている。

May in Edo according to the lunar calendar is the rainy season. In *Kamiyui Shinza*, Chushichi buys an umbrella as he and Shinza depart. Along the road, however, the duplicitous Shinza takes Chushichi's umbrella and beats him with it. Shinza then proceeds to disparage Chushichi, saying "Listen up. This is because you're one of my regulars…" The following monologue interweaves various words relating to Japanese-style umbrellas.

4. 騙されるほうも —— Assailant and Victim Alike

これは大人の芝居である。小悪党が主人公で、人をかどわかして身代金を手に入れる話なのに、溜飲が下がって、なんだか梅雨時の鬱陶しさをすっきり解消するような気分にさせてくれるから不思議だ。主人公が悪党で、騙される娘もその恋人もひどい目に遭うのだが、娘も恋人も少し自分勝手な性格に描かれているのがおもしろい。明治になってからできた芝居で、勧善懲悪を全うしていないというところが特徴でもある。

Kamiyui Shinza is a play geared toward adult audiences. Though it stars a scoundrel who kidnaps and ransoms a woman, it is an oddly cathartic piece that perfectly dispels the gloom of the season. The victims, too, are somewhat self-centered, which greatly lightens the atmosphere of the play. This is indicative of the trend in Meiji-period drama to depict stories that refuse to punish evildoers or reward kindness.

5. 大家と言えば親も同然 —— The Authority of the Landlord

新三の腕には前科を示す入れ墨が入っている。まともな長屋には住みにくいはずだが、新三の長屋の家主（大家）は、それに目をつぶって部屋を貸しているので、新三も頭が上がらないわけだ。当時家主は店子に揉め事があれば、店子を連れて奉行所へ訴え出る大きな権限を持っていて、奉行所などでも顔が利いた。言わば店子にとっては「大家と言えば親も同然」だった。家主の多くは、長屋の持ち主に雇われて家主業を営んでいた。

Shinza has a tattoo that indicates his criminal record. Unable to find proper housing because of this, Shinza's current landlord is doing a favor by turning a blind eye to his criminal record. Because of this, Shinza can't possibly stand up to him. Furthermore, landlords of tenements have the power to bring their tenants to the magistrate's office should trouble arise. This level of power over tenants led to the saying "the landlord is as good as a parent." Landlords are often hired by the owners of tenements to manage their properties.

与話情浮名横櫛
Yowanasake Ukina no Yokogushi

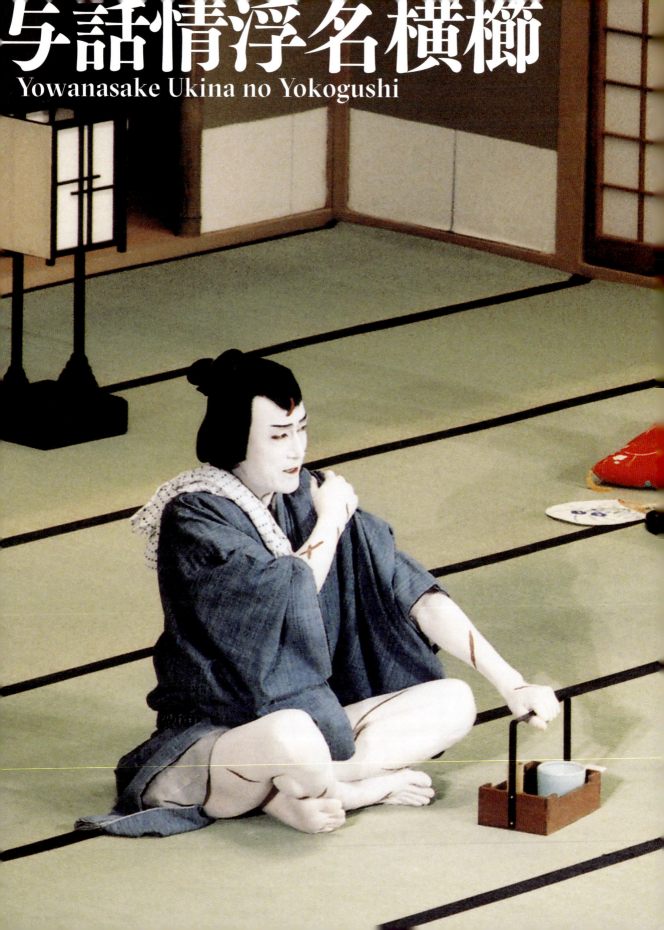

03 源氏店妾宅の場
『与話情浮名横櫛』 2005年4月　歌舞伎座
（左から）与三郎（十五代目片岡仁左衛門）、お富（五代目坂東玉三郎）

The Mistress' House in Genjidana
Yowanasake Ukina no Yokogushi (Kabukiza Theatre, Apr 2005)
(From left) Yosaburo (Kataoka Nizaemon XV), Otomi (Bando Tamasaburo V)

あらすじ

江戸を離れた木更津で出会った、江戸の男女。
危険な恋の始まりと逢瀬。
お互い死んだと思った恋人は生きていた……

「しがねえ恋の情けが仇……」女のために傷だらけになった男が謳い上げる、
恋の恨み、わが身の嘆き。その名せりふで知られた演目。
上演を重ねるうちに洗い上げ、洗練された巧緻な演出も見どころ。

Synopsis

──── Two lovers meet in Kisarazu on the outskirts of Edo, the start of a dangerous affair.
Both thought the other dead, but finally reunite...

"Our most bitter enemy is this pitiful thing called love…" These are the famous words of a man who risked his life for the woman he loved and paid dearly. Enjoy a truly exquisite performance, refined by decades of performance in the kabuki theatre.

01　木更津海岸見染

　上総国木更津。元は江戸深川の芸者で、この辺りの顔役の赤間源左衛門に身請けされて妾となっているお富が浜遊びに来ている。

　そこにやってきた江戸の小間物問屋伊豆屋の若旦那与三郎は江戸で放埒三昧の生活を送り、身柄を親類に預けられ、上総の木更津へ来ていた。

　実は与三郎は養子。伊豆屋では与三郎を養子に迎えた後、実子を授かった。伊豆屋の家督を弟に譲ろうと考えた与三郎は、わざと放蕩を重ね、勘当されようと考えたのだ。

　与三郎はお富を見染め、お富も木更津には見かけない江戸前の与三郎に惹かれる。

02　赤間源左衛門別荘

　ある夜、源左衛門の留守をさいわい、お富は赤間の別荘へ与三郎を呼び寄せた。つかの間の逢瀬を楽しむが、子分の知らせで戻ってきた源左衛門に見つかる。与三郎は源左衛門らになぶり斬りにされ、顔や体に三十四か所の傷をつけられる。お富は逃げ出して海に飛び込むが通りかかった船に助けられる。

01　Kisarazu Beach: Love at First Sight

　In Kisarazu lives Otomi, a former geisha who was bought by the local gang boss Akama Genzaemon. One day when she is visiting the beach, she sees a young man from Edo named Yosaburo who is the adopted son of the Izuya merchant family.

　After adopting Yosaburo, the Izuyas also had a real son. Yosaburo believes that his younger brother should be the one to inherit the business, and so he is living a life of debauchery in hopes of being disinherited.

　At the beach, Yosaburo sees and immediately falls in love with Otomi. This feeling is mutual, as Otomi is also attracted to Yosaburo, a young and stylish man from Edo.

02　At Akama Genzaemon's Villa

　One night, Otomi takes advantage of Genzaburo's absence to invite Yosaburo to the villa where she lives. The two rendezvous briefly but are soon found out by Genzaemon who was informed of their meeting by one of his henchmen. Genzaemon and his men severely mutilate Yosaburo's body and face, but don't kill him. Otomi, meanwhile, escapes and attempts to drown herself in the sea, but is saved by a passing boat.

03　The Mistress' House in Genjidana

　Three years later, Otomi is living in Kamakura under

03 源氏店妾宅の場

　三年後の鎌倉。お富は、船に乗り合わせていた質店和泉屋の番頭多左衛門の世話を受け、源氏店の妾宅で暮らしている。

　雨の中湯屋からお富が帰って来ると、番頭の藤八が雨宿りをしている。家に招き入れられた藤八はお富を口説こうとするが、お富は全く相手にしない。

　そうした中、顔に蝙蝠の刺青を入れた安五郎が、頬被りをした男を伴ってやって来る。安五郎はお富の許を時折訪ねては小遣い銭を強請る、土地の小悪党である。仲間内の喧嘩で大怪我をした連れの男を、湯治に行かせてやりたいので金子を恵んで欲しいと申し出る。申し出を断ると、あれこれと嫌がらせを言い出す安に、お富は仕方なく一分の金を与える。金を持って安が立ち去ろうとすると、連れの男が、「百両貰っても帰られない、ここの家の洗いざらいすべて俺のものだ」と言い始める。実は、この傷だらけの男は、今では向疵の与三郎と呼ばれる無頼漢となった伊豆屋与三郎であった。

　与三郎が生きていたと知って驚くお富。お富との恋ゆえに今の身の上になった自分に引き換え、囲われ者となって安穏と生きているお富の様子を見た与三郎は、恨みつらみを込めて様々に悪態をつく。そこへ多左衛門が戻って来る。多左衛門は与三郎に金子を与え、出直すようにと諭す。折からそこへ、店の若い者が多左衛門を迎えに来る。多左衛門はお富に自分の守り袋を渡す。その中の臍の緒書から、多左衛門がお富の実の兄であったことがわかる。

04 元山町伊豆屋（見世先／火の番小屋／元の見世先）

　与三郎はその後捕らえられ、一年前に島流しになっていたが、ようようの思いで島を抜け出した。島抜けは大罪。与三郎の養父は役所に呼び出され、見つけ次第突き出すように命じられた。匿えば親戚にまで累が及ぶとの厳しい達しである。すると与三郎が伊豆屋に忍んできて、通りかかった下男忠助に声をかける。忠助は与三郎を火の番の小屋に案内する。与三郎が幼いころから世話をしていた忠助に、与三郎はこれまでの経緯を話す。そして忠助は与三郎と父親によそながらの別れをさせる。

the protection of Tazaemon, the proprietor of the pawnshop Izumiya and the man who saved her when she attempted suicide.

When Otomi returns from the public bath one night, the clerk Tohachi is waiting under the eves for the rain to stop. She invites him inside the house to wait out the rain. When he steps into the house, Tohachi attempts to woo Otomi but she is completely uninterested. Later in the evening, a man with a tattoo of a bat on his face named Yasugoro comes to the house with a badly disfigured man.

Yasu is a local scoundrel known to come to Otomi's place often asking for money. As expected, Yasu attempts to swindle Otomi of her money, saying that he only wants to take his friend who was wounded in a fight to the hot springs to relieve his wounds. When Otomi refuses to give him money, Yasu threatens her and eventually she gives him a small amount. As Yasu makes to leave, however, the maimed man exclaims, "I won't leave even if you give us 100 *ryo*. Every last thing in this house belongs to me." Now a local ruffian who goes by the name of "Maimed Yosaburo," it turns out he is actually Izuya Yosaburo.

Otomi is shocked to learn that he is alive, and Yosaburo, seeing that Otomi now lives such a safe and comfortable life, is filled with resentment toward her. Tazaemon finally returns to the house and gives Yosaburo some money, asking him to leave. Just after this, a young worker from the shop comes to retrieve Tazaemon, but he leaves a charm pouch with Otomi. When she opens it, she finds a birth certificate revealing that Tazaemon is actually her older brother.

04 Izuya in Motoyamacho (Shop/Watch house/Old house)

Yosaburo is later captured and banished to a nearby island. Finding his life there unbearable, he manages to escape the island. Because of his crime of refusing banishment, however, authorities demand that Yosaburo's adopted father find and turn him in immediately, implying that hiding him would bring trouble to other relatives as well. Yosaburo eventually comes and hides at the Izuya shop, where he calls out to the servant Chusuke, whom Yosaburo has known from a young age. Chusuke takes him to the watch house, and Yosaburo tells him of everything that has happened to him. Finally, Chusuke has Yosaburo and his father meet one last time before Yosaburo and the two part on strained terms due to the circumstances.

01 木更津海岸見染

『与話情浮名横櫛』 2005年4月 歌舞伎座
(左から) 与三郎 (十五代目片岡仁左衛門)、鳶頭金五郎
(十八代目中村勘三郎)、お富 (五代目坂東玉三郎)

Kisarazu Beach: Love at First Sight
Yowanasake Ukina no Yokogushi (Kabukiza Theatre, Apr. 2005)
(From left) Yosaburo (Kataoka Nizaemon XV), Tobigashira Kingoro (Nakamura Kanzaburo XVIII), Otomi (Bando Tamasaburo V)

作品の概要

演目名

与話情浮名横櫛

作者

三世瀬川如皐

概要

　原作はお家騒動がからむ全九幕の長編だが、大正期に、十五世市村羽左衛門が与三郎を当たり役にして以降、「源氏店」の場を中心として上演することがほとんどである。与三郎の「しがねえ恋の情けが仇」というせりふは、戦前、戦後も名せりふとして知られ、流行歌の題材になるほど人口に膾炙していた。

　この場のみでの上演も多いが、「見染」を冒頭に上演したり、さらに「赤間別荘」をつけてお富と与三郎の色模様と別離を描いたりすることもある。また、最近では、「源氏店」の最後に、与三郎が戻ってきてお富と手を取り合って幕にし、話の首尾を付ける演出も行われている。

　原作ではその後、与三郎が強請の罪で捕まり、島流しになるが、島から抜け出す場面がある。この場はほとんど上演されないが、それに続く「伊豆屋」の場がまれに上演される。さらに、その後には与三郎の全身の傷が治る場面があり、近年コクーン歌舞伎でアレンジを加えて上演されている。掲載のあらすじは、現在上演される場面と「伊豆屋」を記した。

初演

嘉永6（1853）年3月、江戸・中村座で八世市川團十郎の与三郎ほかにて初演。三世瀬川如皐作。通称「切られ与三郎」「切られ与三」。

Overview

Title

Yowanasake Ukina no Yokogushi

Writer

Segawa Joko III

Overview

　Though the original play included a family dispute storyline, *Yowanasake Ukina no Yokogushi*'s nine acts were abbreviated to focus on the Yosaburo story after Ichimura Uzaemon XV played him during the Taisho period (1912-1926). Yosaburo's line, "Our most bitter enemy is this pitiful thing called love," was popular from before the war and even appears in popular songs.

　The "Genjidana" scene is often played as a standalone performance, but the "Love at First Sight" and "Akama's Villa" scenes are also commonly performed together with it. In recent years, performances will conclude with a scene in which Yosaburo returns and takes Otomi's hand, adding a sense of conclusion to the play.

　In the original play, Yosaburo is later caught and exiled to an island for his crimes of extortion, though he eventually escapes. This scene is not performed anymore, though the following "Izuya" scene is performed on very rare occasions. There is also a scene in which Yosaburo's wounds are healed. In recent years an altered form of this scene is performed at Cocoon Kabuki in Tokyo. The synopsis given here includes summaries of the commonly performed scenes and the "Izuya" scene.

Premiere

First performed at the Nakamuraza Theatre in Edo, March 1853. Feat. Ichikawa Danjuro VIII as Yosaburo, others. Written by Segawa Joko III. Commonly called *"Kirare Yosaburo," "Kirare Yosa."*

登場人物 / Characters

お富
おとみ

元は深川の芸者だが木更津の顔役・赤間源左衛門の妾となっている。ある日木更津の海岸でたまたま伊豆屋の若旦那・与三郎と出会い、共に一目惚れ。しかし源左衛門の留守に与三郎と密会するのが見つかり、与三郎は体じゅうを斬りつけられて海へ投げ込まれ、お富も海へ身を投げる。お富は和泉屋多左衛門に助けられ鎌倉でその妾となっているが、三年後偶然に訪ねてきたのはなんと与三郎。

Otomi

A former geisha, Otomi is now the consort of the powerful gangster Akama Genzaemon. One day she sees the young and dashing Yosaburo on the beach in Kisarazu and immediately falls in love. She arranges a secret meeting with him when Genzaemon is gone, but they are found out and Yosaburo is badly maimed. Otomi escapes and attempts to drown herself in the sea, but is saved by Tazaemon who runs the pawnshop Izumiya. She becomes his mistress and is under his protection for three years before receiving an unexpected visit from Yosaburo.

蝙蝠の安五郎
こうもりのやすごろう

顔に蝙蝠の刺青（いれずみ）があるところから人呼んで「蝙蝠安」。木更津で事件を起こし半死半生で海から流れ着いた与三郎を助け、弟分にして面倒を見ている。人の家に上がり込んでは強請を働き小銭を稼ぐ安っぽい小悪党で、ちょくちょく顔を出す鎌倉の妾宅を訪ね、その主が与三郎とは深い因縁のお富と知る。しかし旦那は父が世話になった和泉屋多左衛門とわかると俄かに縮こまってしまう。

Yasugoro the Bat

Yasugoro goes by the nickname "Komori Yasu," a reference to the bat tattoo on his face. He saves Yosaburo from the sea and looks after him like an older brother. He is a rather harmless scoundrel who makes his living by going door to door extorting small amounts of money from residents. Yasu eventually finds out that Otomi, the concubine living at a house he frequents, has some deep connection with Yosaburo, but shrinks away when he finds out that the owner of the house is Izumiya Tazaemon, a man his father has had dealings with.

藤八
とうはち

和泉屋の二番番頭で、お富に横恋慕している。雨宿りしているところをお富から声をかけられ、呼び入れられると喜んで上がり込みここぞとばかり口説き始める。お富からは適当にあしらわれ、そこへ訪ねてきた与三郎と蝙蝠安を追い払おうと粋がるが、半端な金を出してさらに懲らしめられる。

Tohachi

Tohachi is the assistant head clerk at Izumiya, and is in love with Otomi. While waiting in the rain outside Otomi's house, she invites him in and he immediately begins flirting with her. Otomi ignores his advances, but is impressed with his attempts to throw out Yosaburo and Komori Yasu who come asking for money. After giving them a small sum, however, he and Otomi are chastised into offering more.

与三郎
よさぶろう

江戸の小間物屋・伊豆屋の若旦那だが実は養子で、実子の弟に家督を譲ろうとわざと放蕩にふけっている。木更津の海岸で赤間源左衛門の妾となっているお富と出会って恋に落ち、しかし赤間別荘での密会が源左衛門に見つかり斬り刻まれて海へ投げられ、辛うじて一命を取り留める。疵だらけで人前へは出られない身となり食い詰めて鎌倉の妾宅へ強請（ゆすり）に入るが、そこにいたのは死んだと思ったお富。

Yosaburo

The adopted son of the Izuya merchant family in Edo, Yosaburo has a younger brother whom he believes should inherit the store due to his direct blood relation to the family. He is living a life of debauchery in hopes of disinheritance when he meets and falls in love with Otomi, concubine to the powerful gangster Akama Genzaemon. When their relationship is found out, Yosaburo is severely maimed and thrown in the sea. He somehow survives but can't be seen in public due to his horribly disfigured face. He believes Otomi to be dead until one day he finds her at a concubine's home in Kamakura, having come to extort money from her.

和泉屋多左衛門
いずみやたざえもん

鎌倉の質屋・和泉屋の大番頭で懐の深い立派な人物。木更津沖で波間に漂うお富を助け、以来妾として源氏店に住まわせている。しかし助けて間もなくお富が持つ書きつけから実の妹とわかり、妾ということにしてありながら決して男女の仲にはなっていない。

Izumiya Tazaemon

Proprietor of the pawnshop Izumiya, Tazaemon is an intelligent and broad-minded man. He saves Otomi from the sea in Kisarazu, and protects her as his concubine in Genjidana. Shortly after saving her, however, he finds out from a document she is carrying that she is in fact his younger sister and refrains from having relations with her, though she lives under his protection as a consort.

みどころ
Highlights

1. いやさお富、久しぶりだなあ
—— Long time no see, Otomi...

与三郎が総身に切傷を付けられて海に投げ込まれたのが三年前。お富も海へ飛び込んで死んだと信じていたのが、思いがけなく目の前にいる。芝居の最初、与三郎は頬被りをして表に立っているので、なかの女がお富とは気づいていない。細かい手順が付けられていて、与三郎がお富の顔を見る場面がなかなかないようにできている。そして、お富と気づいても、こんな洒落たせりふを言うまで与三郎は黙っているので、お富の衝撃が大きい。

It has been three years since the mutilated Yosaburo threw himself into the sea in a failed suicide attempt. All these years he thought his lover Otomi had died too, but there she is before him, though it takes him some time to realize who she is. Covering his face to hide his horrible disfigurement, the situation is designed to build tension by having him keep his eyes off of Otomi for an excruciating amount of time. Talkative up until that point, Yosaburo is tongue-tied the moment he sees her, adding to the shock Otomi feels in this moment.

2. しがねえ恋の情けが仇……
—— Our enemy is this pitiful thing called love...

名せりふ中の名せりふは、情けない男のボヤきである。ぼんぼんだった与三郎が、傷だらけにされて海に投げ込まれ、しかし息を吹き返した時の絶望は想像するに余りある。蝙蝠安に連れられて強請の片棒担ぎのやくざな暮らし。江戸の親には顔向けもできはしない。優雅な暮らしのお富に、だんだんと言いつのるボヤキが切ない。「しがねえ恋の情けが仇」。つまらない恋に身を持ち崩した恨みは、いったい幾ら、女からせびったら晴れるだろうか。

These plaintive lines are some of the most famous in kabuki. Audiences over the years have sympathized with the pathetic Yosaburo, who, disfigured and separated from his love, isn't even allowed the consolation of death and eventually becomes a lowly swindler with Komori no Yasugoro. When he finds his lover Otomi living a life of luxury, his resentment bursts forth in the line, "our most bitter enemy is this pitiful thing called love." He and Yasu have originally come to swindle Otomi, but how much money will make up for the terrible betrayal Yasu feels?

3. お天道様はありがてえ —— Thanks to the Sun God

通常はお富と再会するまでが上演される。原作にあるその後の与三郎には、もっと可哀想な運命が待っている。人をあやめて島送りになったが、必死で島抜け。本土に流れ着いて上る朝日を見てつぶやくのがこのせりふ。それから品川で三度目にお富に巡り逢ったとき、お富は島仲間だった男の女房になっていて、与三郎はお富に殺されかける。最後に傷が治るハッピーエンドがあるが、全編なんとも辛い「女に惚れたが運の尽き」というお話。

The play is often performed from the beginning up to the reunion of Otomi and Yosaburo. The original play includes later scenes, however, which show Yosaburo's truly pitiful fate. After wounding another man, he is banished to an island, but manages to escape. As he washes up on the shores of the mainland, Yosaburo offers thanks to the sun god and makes his way to Shinagawa to find Otomi for a third time. He finds that she is now married to a man who had been banished on the island with him, however, and is nearly killed by Otomi. Though the play ends on a high note when Yosaburo's face is healed, overall it depicts the difficulties of love.

4. 八代目市川團十郎 —— Ichikawa Danjuro VIII

八代目團十郎は美男で若旦那が得意だった。天保の改革の折、父の七代目團十郎が八年間も江戸を追放されていたが、八代目は父の不在中も家族を守って表彰された親孝行者だった。本作初演で八代目は与三郎を演じて大評判に。しかし翌年の嘉永7（1854）年、八代目は父の一座に従い大坂で与三郎を演じることになっていたが、初日を前に謎の自殺を遂げてしまった。享年32歳。大量に摺られた「死に絵」が飛ぶように売れたという。

The handsome Ichikawa Danjuro VIII played the perfect young gentlemen in his heyday. He was acknowledged as a dedicated son who took care of his family while his father was exiled from Edo. His 1854 performance as Yosaburo was well received, but he mysteriously killed himself before a performance in Osaka with his father's troupe. After his death at 32, merchants began selling memorial woodblock prints called *shini-e* which practically flew off the shelves due to Danjuro VIII's popularity.

5. お富の動悸 —— A Flustered Otomi

八代目の死後、明治の後半から与三郎役者として名を馳せたのは十五代目市村羽左衛門。羽左衛門は明治から戦前の昭和まで活躍した代表的な美男役者だった。その相手役として度々お富を勤めたのが六代目尾上梅幸。二人はすらりとした美男美女の名コンビであった。梅幸は、与三郎と聞いて驚くときの演技について、「お富が乳の動悸を抑えます……手先の指の開かないようにするのが、これも女形の心得の一つ」と芸談に残している。

After Danjuro VIII's death, Ichimura Uzaemon XV famously played Yosaburo. He played debonair leading men from the Meiji period through the pre-war Showa period, and Onoe Baiko VI performed the perfect Otomi to his Yosaburo. The two were an incredibly popular pair, and Baiko's *onnagata* technique of holding a balled hand to his heart to express consternation was widely discussed in artistic circles.

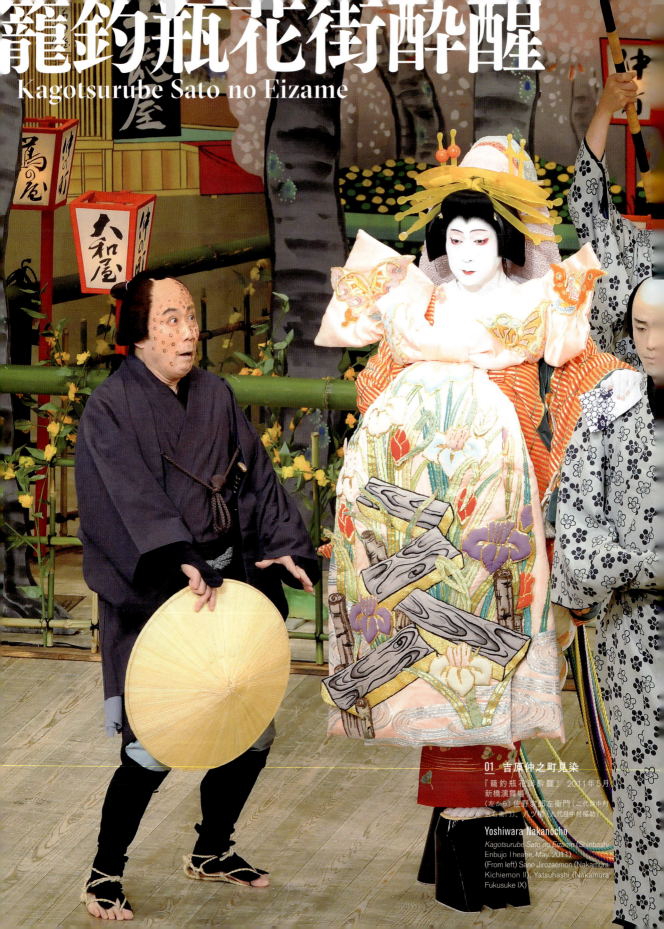

籠釣瓶花街酔醒
Kagotsurube Sato no Eizame

01 吉原仲之町見染

『籠釣瓶花街酔醒』2011年5月
新橋演舞場
（左から）佐野次郎左衛門（二代目中村吉右衛門）、八ツ橋（九代目中村福助）

Yoshiwara Nakanocho
Kagotsurube Sato no Eizame (Shinbashi Enbujo Theatre, May, 2011)
(From left) Sano Jirozaemon (Nakamura Kichiemon II), Yatsuhashi (Nakamura Fukusuke IX)

あらすじ / Synopsis

吉原という華やかな世界の光と影。
今は見ることができない吉原の風俗とともに
描かれる男女の悲哀

「花魁、そでなかろうぜ」男の血を吐く叫び、
「つくづく嫌になりんした」と自らの境涯を嘆く女のつぶやき。
金で恋を売り買いする廓の非情が胸を打つ。

A romantic tragedy set among the glamor and grit of the Yoshiwara pleasure quarters

A geisha is forced to reject her lover, secretly lamenting her terrible lot in life. The sad world of the pleasure quarters, where love is bought with money, is sure to move audiences to tears.

01 吉原仲之町見染

満開の桜が咲き乱れる吉原仲之町。下野国佐野の絹商人佐野次郎左衛門が下男の治六を連れて吉原見物にやって来た。二人は全盛を誇る兵庫屋の八ツ橋の豪華絢爛な道中にぶつかる。その八ツ橋の美貌に次郎左衛門は心奪われてしまう。

02 立花屋見世先

半年ほど経った九月。立花屋の店先では若い者と下女が佐野次郎左衛門を迎える支度をしている。江戸に来るたび八ツ橋のもとへ通うようになった次郎左衛門。あばただらけの容貌ではあるが、人柄も良くその綺麗な遊びぶりから佐野の大尽と呼ばれ、間もなく八ツ橋身請けという話にまで進んでいる。

そこへやってきた釣鐘権八。元姫路藩の侍の娘であった八ツ橋は、父の没後、勤めに出た。一方、権八は以前、八ツ橋の父に中間奉公しており、その縁で八ツ橋の身元を引き受け、全盛の八ツ橋を金蔓としていた。権八は次郎左衛門に金の無心をしようと頼みに来たのだが、度重なる無心に、立花屋の夫婦に断られ、恨み言を言い捨てて帰って行く。

入れ替るようにやって来たのは、故郷の仲間を引き連れた次郎左衛門。上機嫌で、迎えに来た八ツ橋との仲を見せつける。

01 Yoshiwara Nakanocho

The Cherry blossoms are in full bloom in the pleasure quarters of Yoshiwara Nakanocho. Sano Jiroemon, a silk merchant from Sano in Shimotsuke Province, has come to see the sights with his servant Jiroku. There they happen upon Yatsuhashi, a geisha of extreme popularity at the Hyogoya brothel, and Jiroemon immediately falls in love.

02 Tachibanaya Storefront

September of the same year. The staff at the Tachibanaya teahouse make ready to welcome Jirozaemon, who is now a regular there, and has made it a habit to see Yatsuhashi every time he is in town. Though covered in pock marks, Jirozaemon is a man of character with money to spare for play, earning him the nickname, "the millionare from Sano." He is so in love with Yatsuhashi that he has begun discussing buying her out of her service as a geisha.

One day the swindler Gonpachi comes to the teashop. Having taken custody of Yatsuhashi after her father died, Gonpachi now uses her to make money, and hopes to ply Jirozaemon for money after hearing that he plans to redeem her. However, the couple who run Tachibanaya and are familiar with Gonpachi's swindling ways, throw him out of the shop.

Jirozaemon arrives just then, accompanied by two friends from his country, and proceeds to show off Yatsuhashi, who is there to meet him.

03 大音寺前浪宅

ここは八ツ橋の間夫〔恋人〕の浪人繁山栄之丞の住居。栄之丞の暮らしは八ツ橋がすべて面倒をみている。湯屋からの戻りがけ、栄之丞は釣鐘権八から、八ツ橋が栄之丞を袖にして、次郎左衛門に鞍替えして身請けされるという話を聞かされる。栄之丞は権八の話を本気にしなかったが、いつしか権八にたきつけられて兵庫屋へ向かって行く。

04 兵庫屋二階遣手部屋

次郎左衛門一行は兵庫屋に赴き、座敷の支度が調うまで、二階の遣手部屋へ案内される。そこへ栄之丞と権八が、若い者に案内されて通りかかる。その男ぶりにふと不安を覚える次郎左衛門。

05 兵庫屋二階廻し部屋

廻し部屋では、不機嫌な様子の栄之丞が八ツ橋と向き合っている。八ツ橋の心を疑う栄之丞は、次郎左衛門に愛想尽かしをしたならば疑いを晴らそうと、権八と共に八ツ橋に迫る。

06 兵庫屋二階八ツ橋部屋縁切り

八ツ橋の部屋に通された次郎左衛門たち。一座が揃い賑やかに遊ぶうち、やっと八ツ橋が姿を現す。次郎左衛門は沈んだ様子の八ツ橋を気遣う。そんな次郎左衛門に向かい、八ツ橋は愛想尽かしを始める。思いもよらないなりゆきに、驚きを隠せない次郎左衛門。満座のなかで、身請けをきっぱり断った八ツ橋は、今後、もう自分の許へは来ないで欲しいと告げる。

辛い胸中を訴えるうちに次郎左衛門は、部屋の様子を窺う栄之丞の姿に気付く。そして、八ツ橋の愛想尽かしが間夫へ対する心中立てであると察して仔細を尋ねる。すると、八ツ橋は栄之丞との仲を明かして座敷を出て行くのであった。次郎左衛門は国へ帰ると座敷を後にする。

07 立花屋二階

それから数か月が経った。暫くぶりで次郎左衛門が立花屋の二階に上がった。八ツ橋とまた初会となって遊びたいという次郎左衛門を、皆が歓迎する。しかし、八ツ橋と二人になった次郎左衛門は持参した家宝の名刀籠釣瓶で八ツ橋を一刀のもとに斬り、さらには灯りを持って来た下女も斬り捨てる。名匠村正が鍛え、水もたまらぬと喩えられる籠釣瓶の斬れ味。次郎左衛門は刀を灯火にかざし、その妖しい光を魅入られたように見つめている。

03 The House at Daionji Temple

Yatsuhashi takes care of her lover Shigeyama Einojo, who is a masterless ronin. Gonpachi, having just gone to a bathhouse, pays a visit to Einojo's house and tells him about Jirozaemon's plan to redeem Yatsuhashi. Though he doesn't take Gonpachi seriously at first, he slowly realizes that his friend is dead serious. Enraged, Einojo rushes out and heads for Hyogoya.

04 Hyogoya Second Floor

Jirozaemon and his retinue make their way to Hyogoya and are shown to a waiting room as preparations are made for them. Just then, Einojo and Gonpachi are seen being led to another room, making Jirozaemon uneasy.

05 The Waiting Room in Hyogoya

In a waiting room, a disgruntled Einojo is speaking heatedly with Yatsuhashi. He is jealous of Yatsuhashi, and together with Gonpachi, pressure her to break off her relationship with Jirozaemon.

06 Yatsuhashi's Separation

Jirozaemon and his friends have been shown to Yatsuhashi's room and are enjoying themselves as they wait for her. She finally appears, but Jirozaemon notices she seems somewhat upset. As she begins to speak to him in front of all the other customers, Jirozaemon cannot hide his shock as she rejects his offer to redeem her and asks him never to come see her again.

Deeply heartbroken, Jirozaemon notices Einojo watching from nearby and guesses as to Yatsuhashi's reasons. When he asks her, she tells him about her relationship with Einojo and leaves the room. Jirozaemon leaves the shop then and returns to his home in Shinotsuke Province.

07 Tachibanaya Second Floor

Several months later, Jirozaemon returns to the second floor of Tachibanaya and is welcomed warmly when he says that he hopes to see Yatsuhashi as a new customer. When he is alone with Yatsuhashi, however, Jirozaemon draws his family's heirloom sword Kagotsurube and kills her, and then proceeds to kill the servant girl who comes by afterward. With Kagotsurube, a masterpiece of master swordsmish Muramasa, he picks up the lantern held by the now dead servant and stares into the eerie light as though in a trance.

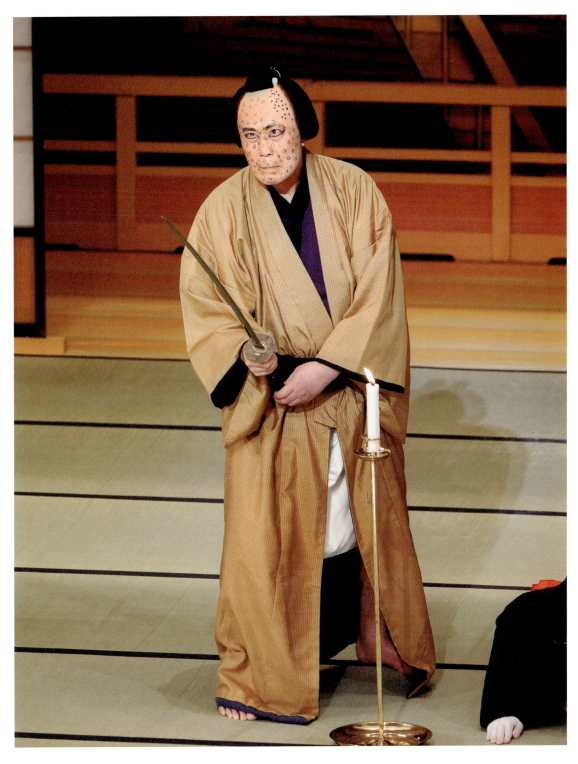

07 立花屋二階
『籠釣瓶花街酔醒』 2016年2月　歌舞伎座　佐野次郎左衛門（二代目中村吉右衛門）

Tachibanaya Second Floor
Kagotsurube Sato no Eizame (Kabukiza Theatre, Feb. 2016)
Sano Jirozaemon (Nakamura Kichiemon II)

作品の概要 / Overview

演目名 / Title

籠釣瓶花街酔醒

Kagotsurube Sato no Eizame

作者 / Writer

三世河竹新七

Kawatake Shinshichi III

概要 / Overview

　江戸時代に起こった「吉原百人斬り」事件を脚色した講談を劇化。明治期世話物の代表作の一つ。全八幕のうち五幕目の「仲之町」以降が上演され、〈見染〉〈縁切り〉〈殺し〉というパターンが典型的に描かれていると同時に、吉原の風俗習慣が活写されている。また、自らの意に反した身請話が進み、間夫との板挟みになる八ツ橋の姿などには、金で身を売る吉原の非情を読み取ることもできる。満座の中で愛想尽かしをされた次郎左衛門の悲痛な心情吐露が、名せりふとしてよく知られている。

　前半は、次郎左衛門の、父次郎兵衛が女乞食を惨殺した祟りであばただらけに生まれてしまうという因果話と、妖刀籠釣瓶を入手するいきさつがあり、近年新橋演舞場で復活された。その折には、後半部であまり上演されない、九重が八ツ橋に、次郎左衛門に詫びるよう意見する、「兵庫屋九重部屋」と、次郎左衛門の立ち廻り「立花屋大屋根」も上演された。

　掲載のあらすじは現在多く上演されている場面のものである。

　A dramatization of a *kodan* story based on the "Massacre of 100" (*yoshiwara hyakunin-giri*) that occured in Edo, Kagotsurube is a representative Meiji-period *sewamono* play. Originally in eight acts, it is often performed from the fifth act onward. While the plot follows a common pattern—the leading man falls in love, is rejected, and in his rage commits murder—Kagotsurube carefully depicts the Yoshiwara pleasure quarters that no longer exit today. Yatsuhashi's plight, particularly, shows audiences how callous the old practice of buying and selling women could be. Jirozaemon's protest after his love Yatsuhashi rejects him is one of the most well-known pieces of writing in kabuki.

　In the first half of the play, Jirozaemon's disfigurement is explained as being karmic retribution for his father's murder of a beggar woman. It is also shown how he comes to obtain the terrible sword Kagotsurube. This portion of the play has been revived at the Shinbashi Enbujo Theatre in recent years, as well as later scenes that are no often performed.

　The synopsis given here is based on the most oft-performed scenes of Kagotsurube.

初演 / Premiere

　明治21（1888）年5月東京・千歳座で、初世市川左團次の次郎左衛門、五世中村歌右衛門（当時四世中村福助）の八ツ橋ほかで初演。三世河竹新七作。通称「籠釣瓶」。

First performed at the Chitoseza Theatre in Tokyo, May 1888. Feat. Ichikawa Sadanji I as Jirozaemon, Nakamura Utaemon V (known as Nakamura Fukusuke IV at the time) as Yatsuhashi, and others. Written by Kawatake Shinshichi III. Commonly referred to as *Kagotsurube*.

登場人物 / Characters

佐野次郎左衛門
さのじろうざえもん

下野（しもつけ）佐野の絹商人。純朴な人物だが父が人を殺した因果で顔に醜いあばたがある。江戸へ商売に来たついでに吉原見物を試みるが、偶然出会った花魁道中の八ツ橋の美しさに肝を抜かれ、やがて常客となって入れ込む。「佐野の大尽」とまで呼ばれて身請けの話まで進むが八ツ橋に満座の中で愛想尽かしをされ一旦は国に帰る。数か月後、村正の名刀・籠釣瓶を持って現れ八ツ橋はじめ大勢を斬り殺す。

Sano Jirozaemon

A silk merchant from Sano in Shimotsuke Province, Jiroemon is a simple man from the country, but his face is covered in pockmarks. It is believed this is a form of karmic punishment due to his father's crime of murder. He comes to Edo for business and drops by the famous Yoshiwara pleasure quarters, where he meets and falls in love with the beautiful Yatsuhashi among a procession of geisha. He becomes a regular customer of Yatsuhashi and attains the nickname "the millionaire from Sano." When Yatsuhashi suddenly breaks off their relationship, however, he returns to his home in Sano. Months later, the bitter Jiroemon returns to Edo with the famed sword Kagotsurube and kills not only Yatsuhashi, but many others.

八ツ橋
やつはし

吉原の兵庫屋の花魁で、吉原一の全盛を誇る美貌と格が匂い立つ。その華やかな花魁道中のまばゆさから佐野次郎左衛門が客として付き、身請けの話まで持ち上がるが、かねてからの恋人の繁山栄之丞から縁切りを迫られ、八ツ橋は心ならずも次郎左衛門にきつい愛想尽かしをする。やがて八ツ橋の前に久々に次郎左衛門が現れるが、隠し持っていた籠釣瓶の名刀で八ツ橋は逃げる間もなく斬りつけられる。

Yatsuhashi

The most beautiful geisha in Yoshiwara, Yatsuhashi works at the Hyogoya brothel. Jiroemon sees her in a procession one day and falls in love, eventually offering to redeem her from her service as a geisha. However, she already has a lover, Shigeyama Einojo, who pressures her to break off her relationship with Jiroemon. Though Jiroemon leaves her in peace directly after their breakup, he appears later with the treasured sword Kagotsurube and murders Yatsuhashi before she can run away.

おきつ
おきつ

吉原の立花屋の女房。八ツ橋を金蔓とする遊び人の釣鐘権八にしばしば金の無心を受けるが、そうはゆかぬときっぱり断り毅然とした態度を見せる。しかしそのため権八が栄之丞をそそのかし、やがて次郎左衛門への愛想尽かしへとつながる。

Okitsu

Tachibanaya Chobei's wife, Okitsu is woman of great fortitude who never lets the swindling Tsurigane Gonpachi get the best of her. She refuses to give him money, but this causes him to manipulate Einojo, who convinces his lover Yatsuhashi to break off her relationship with Jirozaemon.

立花屋長兵衛
たちばなやちょうべえ

吉原の引手茶屋・立花屋の主人。仲之町では悪い客引きに引っ掛かりそうになった次郎左衛門を擁護し、遊びを知らない者がうっかり店へ上がってはいけないと諭す。後に次郎左衛門が客として足繁く通うようになってからも茶屋の亭主として実直にふるまい、愛想尽かしの後始末も何とかつけようと心を配る。

Tachibanaya Chobei

The proprietor of the Tachibanaya Teahouse in Yoshiwara, Chobei helps Jirozaemon from getting swindled, and admonishes him for not being more careful. Chobei remains an honest and admirable character after Jirozaemon becomes a regular customer, and even puts thought into how Jirozaemon can settle things with Yatsuhashi after she breaks up with him.

治六
じろく

佐野次郎左衛門の下男で、吉原見物の折も次郎左衛門に伴ってやって来る。訛りの抜けない田舎者で素朴さの中に道化の味を漂わせ、次郎左衛門の実直さと似合いのコンビでもある。次郎左衛門が大勢の前で愛想尽かしをされた時には、懸命に八ツ橋に喰い下がって金を返せとののしるが、これが次郎左衛門の怒りを多少は鎮め、しばし冷静を取り戻させる役目を果たす。

Jiroku

A comical character, Jiroku is a simple country man who has a thick accent and makes for an interesting duo with his master Jirozaemon. He accompanies Jirozaemon to Yoshiwara where his master sees and falls in love with the beautiful geisha Yatsuhashi. When Yatsuhashi breaks off her relationship with Jirozaemon, Jiroku angrily demands that she return his master's money, which helps calm the enraged Jirozaemon.

籠釣瓶花街酔醒

登場人物／みどころ

繁山栄之丞
しげやまえいのじょう

浪人者で、八ツ橋がまだ身売りをする前から将来を誓い合った仲の色男。しかし一本立ちするでもなく生活は八ツ橋に頼っているばかり。八ツ橋の身請け話を釣鐘権八から焚きつけられ、自分に一言もなく身請けとはあまりに不人情といきり立つ。八ツ橋は世話になるお客ゆえ、いかにやんわり収めようかと思案中だったが、栄之丞は今夜限りきっぱり断れとどこまでも譲らず八ツ橋を追い詰める。

Shigeyama Einojo

A masterless ronin, the handsome Shigeyama Einojo has been Yatsuhashi's lover since before she became a geisha. He has not gone far in life, however, and relies on Yatsuhashi financially. When he hears about Jirozaemon's intention to redeem her, Einojo will hear nothing of it, and though she at first considers the proposal, Einojo's fierce objection causes her to refuse Jirozaemon.

九重
ここのえ

八ツ橋と同じく兵庫屋の花魁で、八ツ橋の次に位置する妹分。廓の習いに従い控えめで穏やか、八ツ橋のきつい愛想尽かしをやんわりとたしなめる。

Kokonoe

A fellow geisha at Hyogoya, Kokonoe is like a younger sister to Yatsuhashi. She is a gentle and soft-spoken geisha who gently rebukes Yatsuhashi's rejection of Jirozaemon.

初菊
はつぎく

兵庫屋の年若い花魁。

Hatsugiku

A young geisha at Hyogoya.

釣鐘権八
つりがねごんぱち

元は八ツ橋の父親の中間（雇われ人）だったが根っからのやくざな遊び人で、八ツ橋の親代わりになっているのをいいことに、食い物にしてもっぱら金を巻き上げている。八ツ橋ばかりでなく立花屋夫婦にもしばしば金の無心をしては断られ、しかも八ツ橋が身請けされたら金蔓が無くなるところから、いよいよ繁山栄之丞を焚きつけて身請け話を断らせようと画策する。

Tsurigane Gonpachi

A former servant of Yatsuhashi's father, Gonpachi is a sly playboy who has taken guardianship of Yatsuhashi since her father's death and now uses her to make money for himself. A man of deep avarice, he constantly pesters the couple who run the Tachibanaya Teahouse, but is refused each time. When Jirozaemon attempts to redeem Yatsuhashi from her service as a geisha, Gonpachi realizes he will lose his source of revenue and conspires with Einojo to have her refuse the offer.

七越
ななこし

兵庫屋の花魁で、八ツ橋の席に同座する。

Nanakoshi

Another geisha at Hyogoya who is seated together with Yatsuhashi.

丹兵衛、丈助
たんべえ、じょうすけ

次郎左衛門の商売仲間。次郎左衛門の吉原での大尽ぶりを聞くにつけ、八ツ橋の美貌を拝んで自分たちもあやかりたいと期待してやって来る。初めは次郎左衛門の豪勢な遊びっぷりに感心するが、八ツ橋が登場してからは雲行きが変わり、ついに愛想尽かしとなると掌を返して散々に罵倒する。

Tanbei, Josuke

One of Jirozaemon's business partners, who comes to Yoshiwara with high expectations after hearing of Jirozaemon's exploits there. At first he admires Jirozaemon for his adventures, but later admonishes him when things with Yatsuhashi turn sour.

みどころ
Highlights

1. 八ツ橋花魁の裲襠 —— Yatsuhashi's Costume

縁切りの場で、八ツ橋花魁が羽織る裲襠(うちかけ)。紅葉に、幔幕(まんまく)と火焔太鼓(かえんだいこ)の刺繍。火焔太鼓は雅楽の巨大な太鼓で、先端には日輪が金色に輝き、三つ巴は陰陽の「陽」を表している。

Yatsuhashi wears an *uchikake* bridal robe in the rejection scene. It features autumn leaves and embroidered patterns of curtains and *kaen-daiko* drums. *Kaen-daiko* are massive drums used in ancient *gagaku* music featuring golden sun patterns along the edges, as well as three *tomoe* symbols symbolizing light.

2. 吉原の道中 —— The Streets of Yoshiwara

吉原は公許の遊郭である。浅草裏のへんぴなところにあったが、堀を巡らした別世界のような豪奢な街であった。上客はまず茶屋を通して遊女を指名する。指名された花魁は茶屋まで出張って客を迎え、客を伴って妓楼へ向かう。その行き帰りの道中が吉原の風物だった。『助六』の揚巻の道中に較べると、本作の花魁の道中姿は描かれる時代が違うので、髪型や衣裳の様子がだいぶ異なっている。その辺りを見較べるのもお楽しみだ。

Yoshiwara was the licensed pleasure quarters in Edo. It was located in a hard-to-reach corner of Asakusa, but once you got there the lavish town was like a different world. A customer would first enter a teahouse and give the name of the courtesan they wish to visit. The girl would then come and escort the man back to her brothel. Along the way, customers would see the tantalizing sights of Yoshiwara. The courtesan shown in *Kagotsurube* are quite different from those in *Sukeroku*, making them quite interesting to compare and contrast.

3. イヤでありんす —— Rejection Stories

芝居の人気ジャンルのひとつに「縁切り物」がある。多くは遊郭の女性と恋人との揉め事、それも忠義や義理が絡んだ末の、女から男へのわざとの愛想尽かしがあって、逆上した男が女を刃に掛けるのが定番だった。しかし本作は明治になってから書かれている。八ツ橋が次郎左衛門に愛想尽かしをするのは、忠義や義理のためではない。純粋に恋人の心をつなぎ止めたいための、身請けをしようとする客への「イヤでありんす」なのである。

One of the most popular genres of the theater is *engiri-mono*, stories in which a courtesan fights with and breaks up with her lover, leading him to murder her in his distress. Normally, the courtesan's motivation in such plays is loyalty or duty, but *Kagotsurube*, written during the Meiji period, features a heroine who simply doesn't like her lover enough to accept her lover's offer to redeem her from her service as a courtesan.

4. 妖刀で一撃、あわれ彼女は —— Silenced by the Blade

まったく恋は魔物である。実直一途だけれど醜い顔の次郎左衛門が、花魁道中の八ツ橋の見せた微笑に心を奪われ、夢中になってしまう。『盟三五大切』も『伊勢音頭恋寝刃』も恋に狂った男が冷静さを失って刃物を手にする芝居だが、『籠釣瓶』には忠義や義理などの複雑な紆余曲折がなく、結末があっけないほど鋭い。次郎左衛門が手にしたのは、斬れ味まことに軽い妖刀「籠釣瓶」。その一撃で絶命する八ツ橋は言葉ひとつ残さない。

Love is truly like a demon in *Kagotsurube*. Jirozaemon falls obsessively in love with Yatsuhashi immediately after she smiles at him on the streets of Yoshiwara, but eventually comes to murder her. Other plays also feature frenzied men who murder their ex-lovers, but without the complex elements of loyalty and duty which often come into play in other plays, the climactic murder scene of this play is over in a single, heartless moment. Swinging at Yatsuhashi with the famous blade *Kagotsurube*, Jirozaemon kills her in one strike, offering her no time for last words.

5. そでなかろうぜ — The "Awful" Ways of Courtesan

満座のなかで八ツ橋にきつい愛想尽かしを言われて、次郎左衛門がいうのが「それはあんまり、そでなかろうぜ」。ここが一番の聴かせどころだ。「そでない」は悪い、ひどいという意味である。「袖」の字を宛てるのは誤り。夜ごとに相手を替える遊女だからといったって、イヤなら最初に言ってくれ、長く通いつめ、身請けの算段に夜も眠れないほど夢中になった今になって、もう来るなとはひどいぜ、という哀しい苦情なのである。

When Yatsuhashi rejects Jirozaemon, he responds, "how awful you are!" In the most memorable monologue of the *Kagotsurube*, he goes on to berate Yatsuhashi. Even a courtesan, who sees different men every night, should know better than to lead a man on so much that he raises money to redeem her from her service. In other words, what Jirozaemon essentially says is, "if you didn't love me to begin with, you should have said so before now."

6. 遊里の生活感 — Life in the Pleasure Quarters

廓を舞台にした芝居は多いが、『籠釣瓶花街酔醒』は、廓のリアルな生活を伝えているところに特徴がある。花魁道中は華やかだが、素人客を騙す客引きなどが出没。それを追い払う実直な茶屋の亭主、花魁を食いものにする請け人、間夫の世話のための雇い女や年増のお針子など、廓で糧を得る人々の生活感あふれるやりとりも面白い。茶屋や妓楼の表座敷や二階座敷、廻し部屋に遣り手の居間、間夫の住居などの風景も見どころ。

There are many plays set in the pleasure quarters, but one of the unique characteristics of *Kagotsurube* is its realistic depiction of life there. You see both the alluring procession of courtesan and the swindlers who try to pull in naive new customers. The honest teahouse proprietor and the avaricious guardian who puts his ward to work as a courtesan to make money furthermore show the many layers of the complex world of the Yoshiwara pleasure quarters. The various settings and stage props are another fascinating highlight of this play, showing the audiences not only the teahouse and various rooms in the brothel, but also private residences in Yoshiwara.

神明恵和合取組
め組の喧嘩
Kami no Megumi Wago no Torikumi
—— Megumi no Kenka

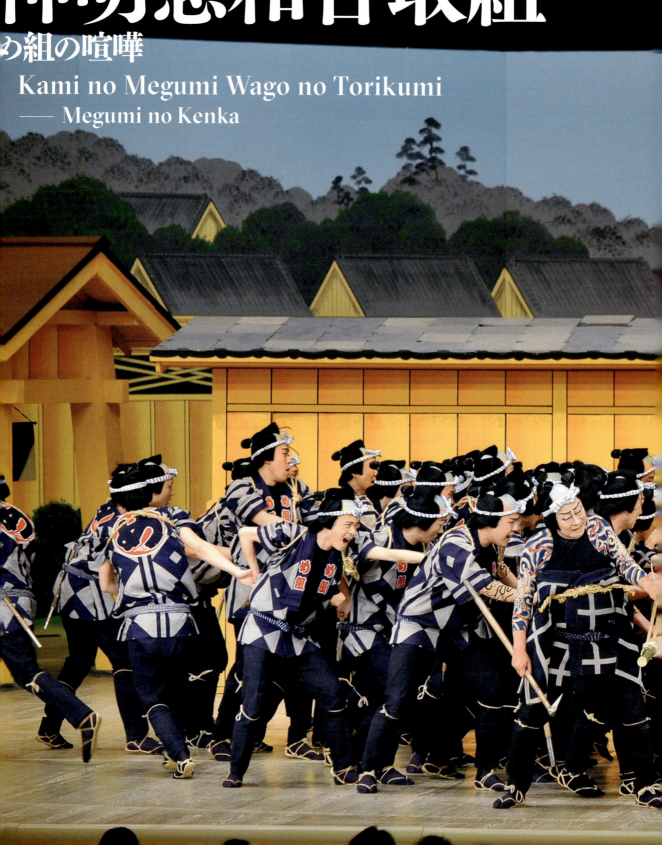

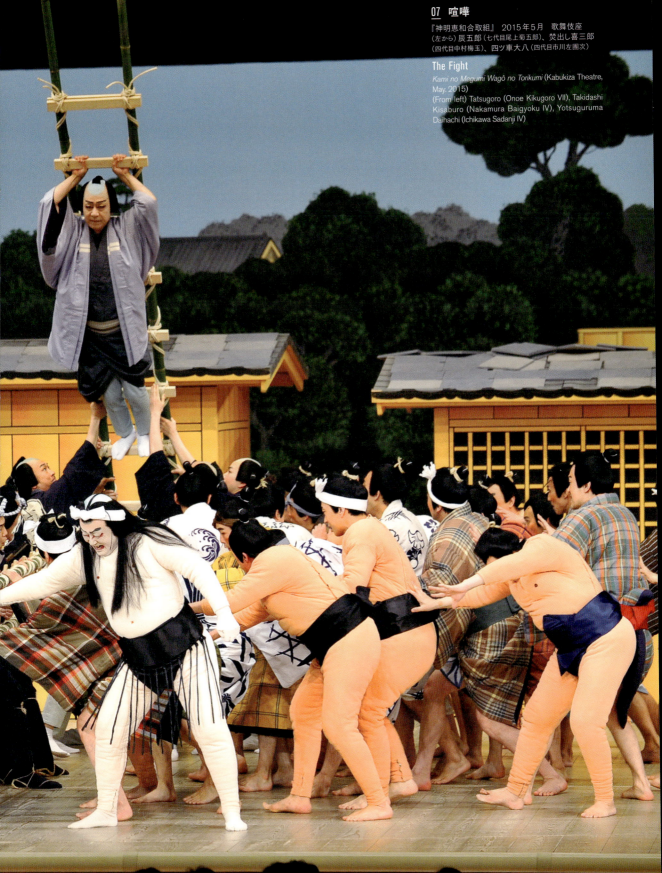

07 喧嘩

『神明恵和合取組』 2015年5月 歌舞伎座
(左から) 辰五郎 (七代目尾上菊五郎)、焚出し喜三郎
(四代目中村梅玉)、四ツ車大八 (四代目市川左團次)

The Fight
Kami no Megumi Wagō no Torikumi (Kabukiza Theatre, May. 2015)
(From left) Tatsugoro (Onoe Kikugoro VII), Takidashi Kisaburo (Nakamura Baigyoku IV), Yotsuguruma Daihachi (Ichikawa Sadanji IV)

あらすじ / Synopsis

**火事に飛び込み、命を懸ける鳶・火消は江戸っ子の誇り。
気は優しくて力持ち、力士も江戸っ子の憧れ。
火事も喧嘩も江戸の華だが、
この男たちの大喧嘩はただ事じゃあねえ!**

明治になって作られた、ノスタルジーの中の江戸っ子たち。喧嘩もなにも命がけ。
終わってしまえばさっぱりあっさり。これも歌舞伎の面白さ。

Tobi firefighters, the pride of Edo, and sumo wrestlers, whom Edokko aspire to, face off in this brilliant with all the vim and vigor of Old Edo!

Even quarrels were matters of life an death in those days…
A nostalgic take on Old Edo written in the Meiji Period (1868–1912).

01 島崎楼広間

品川宿にある島崎楼。広間では葉山九郎次らが屋敷のお抱え相撲の四ツ車大八らを引き連れ賑やかに遊んでいるが、羽目を外して弟子が障子を蹴倒し、隣座敷に踏み込んでしまう。隣座敷にいたのは町火消め組の鳶たち。さきほどからの大騒ぎに腹を立てていたこともあり、喧嘩になる。その場を収めたのがめ組の頭の浜松町の辰五郎。席にいるのが出入り屋敷の侍と知り、丁重に詫びるが、九郎次に屋敷の抱え相撲と鳶では身分が違うと言われ腹を立てる。同じ人間のことと反論するも、尾花屋の女房の取りなしもあり、苦虫をかみ殺してその場を立ち去る。

02 八つ山下の場

辰五郎は腹に据えかね、品川八つ山下の暗がりで四ツ車を待ちぶせる。暗闇の中、四ツ車と辰五郎、尾花屋女房、地廻り、駕で通りかかった焚出し喜三郎の五人で探り合ううち、喜三郎は辰五郎が落とした莨(たばこ)入を拾う。

01 Shimazaki Tower Parlor

Hayama Kuroji has invited the sumo wrestler Yotsuguruma Daihachi to a party in the parlor of Shimazaki Tower. When things get rowdy, one of Daihachi's apprentices crashes through the sliding shoji doors into a neighboring room occupied by the Megumi firefighting unit. A fight breaks out between the two parties, the Megumi party having been upset at the noise coming from the other room. Tatsugoro, Megumi's boss, however, stops the fighting, apologizing to the members present in Kuroji's room, realizing they are samurai. Kuroji, however, holds his party's status, including the great sumo wrestler Yotsuguruma, over that of lowly firefighters. The angry Tatsugoro spits back that they are all human beings, but, having an errand to attend involving the wife of the merchant Obanaya, he leaves it at that.

02 Yatsuyama

Tatsugoro has a hard time letting things end as they did at the parlor, so he waits for Yotsuguruma to come by in the dark of Yatsuyama in Shinagawa. There is a scuffle in the darkness between Yotsuguruma, Tatsugoro, the wife of Obanaya, Jimawari, and Takidashi Kisaburo, and Kisaburo picks up a tobacco pouch dropped by Tatsugoro.

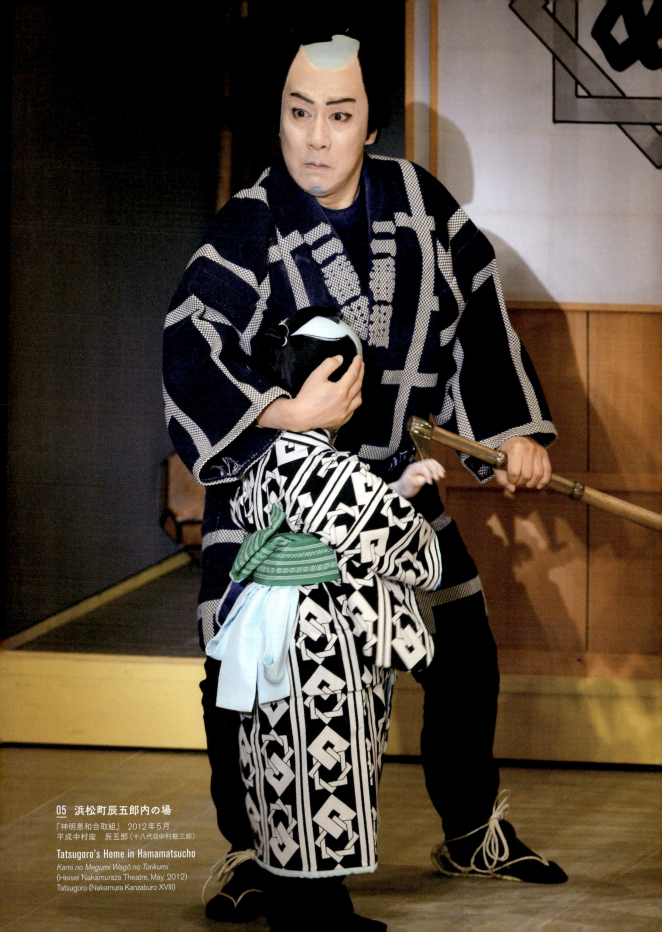

05 浜松町辰五郎内の場
『神明恵和合取組』 2012年5月
平成中村座　辰五郎（十八代目中村勘三郎）

Tatsugoro's Home in Hamamatsucho
Kami no Megumi Wagō no Torikumi
(Heisei Nakamuraza Theatre, May. 2012)
Tatsugoro (Nakamura Kanzaburo XVIII)

03　神明社内芝居前

芝神明境内にある芝居小屋江戸座の前。芝はめ組の持ち場である。辰五郎の女房お仲は息子の又八を連れて通りかかり、小屋で若い者が暴れなければいいと案じながら去る。

やがてめ組の若い者が客席で騒ぐ酔っ払いをつまみ出そうとする。四ツ車の弟分九竜山浪右衛門がなだめる隙に酔っ払いは逃げる。相手を逃がしたと食って掛かる鳶たち。そこに四ツ車と、さらに辰五郎も通りかかる。九郎次が相撲取りをあおるので、品川の遺恨もあり、あわや喧嘩という中に割って入ったのは座元の江戸座喜太郎。双方は喜太郎の顔を立てこの場を収め、相撲の興行が終わったら決着をつけることを約束して立別れる。

04　焚出し喜三郎内

翌日辰五郎は数奇屋河岸にいる兄貴分焚出し喜三郎のもとに行き、それとなく暇を告げる。喜三郎は、以前八つ山下で拾った莨入を見せ意見をする。

05　浜松町辰五郎内の場

辰五郎は千鳥足で喜三郎の家から戻ってくる。横になった辰五郎を、お仲は意気地がないとなじり、居合わせた兄弟分の亀右衛門も同じように辰五郎を非難する。不甲斐なさに愛想をつかしたお仲から離縁を切り出されると、辰五郎は用意していた離縁状を突き付ける。実は今日の喧嘩で命を懸ける気であった。酔ったふりをしていたのは相撲の見物客に迷惑をかけないため、相撲の打出しを待っていたのだ。折しも、相撲興行の終わりを告げる跳ねの太鼓。お仲とわが子に別れを告げ、辰五郎は喧嘩仕度も勇ましく神明社に向かう。

06　神明町鳶勢揃

芝神明町の普請場にはめ組の連中が勢揃いをしている。皆は水盃を交わすと、辰五郎に続き、喧嘩に出立する。

07　角力小屋／喧嘩／神明社境内

相撲小屋の前では、九竜山はじめ相撲取りが待ち構え喧嘩が始まる。激しく戦う鳶と相撲たち。そして辰五郎と四ツ車が決着をつけようと対峙するところに、焚出し喜三郎が到着し、梯子を使って乱闘に割って入る。

喜三郎は、鳶はじめ町方を取り締まる町奉行と、相撲を取り締まる寺社奉行の紋の入った法被を見せる。喜三郎の仲裁を受け、両者ともこの場を喜三郎に預けることにする。

03　The Playhouse in Shinmei Shrine

The Koya Edoza Playhouse located within the Shinmei Shrine precincts is the Megumi group's territory. Tatsugoro's wife Onaka and son Matahachi happen by and Onaka worries about fights breaking out in this area.

No sooner does Onaka leave than some of the young members of Megumi attempt to throw out a drunkard who is causing a commotion in the audience. Yotsuguruma's friend Kuryuzan Namiemon happens by and diffuses the situation and the drunkard runs away. The firefighters, however, are angry that the man got away without punishment. Yotsuguruma and Tatsugoro now appear, and a great fight ensues between the firefighters and sumo wrestlers. Finally, however, the proprietor of the playhouse, Edoza Kitaro appears and asks that the two parties settle their fight after the play has ended.

04　Takidashi Kisaburo's Home

The following day Tatsugoro goes to the local bos Takidashi Kisaburo to report his intention to take time off. Kisaburo takes out the wallet he found days before in Yatsuyama, indicating that he knows Tatsugoro's true intention is to settle the fight with the Megumi.

05　Tatsugoro's Home in Hamamatsucho

Tatsugoro returns home drunk and is scolded for his weak will by his wife Onaka and close friend Kameemon. Onaka threatens to divorce him and he immediately presents her with a prepared divorce slip. Because he plans to throw his life away in the fight with the Megumi, Tatsugoro is hoping to cut ties with his wife who would then be widowed. At this very moment, Tatsugoro hears the taiko drum which signals the end of the sumo match. He leaves the house, heading for Shinmei Shrine to prepare for the fight the following day.

06　Gathered in Shinmeicho

The Megumi are gathered at a building site in Shinmeicho. After a toast, they follow Tatsugoro's lead and head to where they intend to fight.

07　The Sumo Stable / The Fight / Inside Shinmei Shrine

Kuryuzan and the other sumo wrestlers wait in front of the sumo stable, where the fight soon ensues. The fight between the Megumi and the sumo wrestlers intensifies, and just as Tatsugoro and Yotsuguruma face each other to settle the score, Takidashi Kisaburo arrives, climbs up a ladder, and jumps in the middle of the brawl.

Kisaburo shows the brawlers that his jacket is embossed with the crest of both the town magistrage, giving him authoritory over the firefighters and all the townspeople, and that of the magistrate of shrines and temples, giving him authority over the sumo wrestlers. With his mediation, the two sides come to a truce.

作品の概要

演目名

神明恵和合取組――め組の喧嘩

作者

竹柴其水

概要

　明治になってから作られた演目で、他愛もない愚劇などといわれることもあるが、現在まで途切れることなく上演されている、人気作品である。鳶と相撲の喧嘩の顚末を、だんまりなどを織り交ぜ描いた脚本、音楽の使い方などの演出の巧みさ、五世菊五郎らによって工夫された、鳶の者の生活や習慣を活写したすぐれた型などがあいまって、江戸の気分を心地よく味わわせてくれる。これも歌舞伎の世話物を観る楽しみである。

　各場に魅力があるが、「辰五郎内」場は、作者の師匠にあたる黙阿弥が助筆したといわれ、演者の芸の見せどころになる。また、大詰では、工夫された立廻りが楽しい。

　喧嘩の根にあるのが、武士による町人階級を蔑視した言葉というのも作劇のうまさで、鳶の喧嘩に無理なく肩入れするようにしていると同時に、力士側にも疵がつかないようになっているのである。

　掲載のあらすじは、近年定着している場割と内容だが、「喜三郎内」は割愛されることも多い。

初演

　明治23（1890）年3月新富座で、五世尾上菊五郎の辰五郎らにより初演。竹柴其水作。通称「め組の喧嘩」。

Overview

Title

Kami no Megumi Wago no Torikumi — Megumi no Kenka

Writer

Takeshiba Kisui

Overview

　This Meiji period (1868–1912) play is sometimes criticized for its silly plot, but holds a special place in the hearts of many kabuki-goers. Ever aspect—the circumstances surround the conflict between the proud tobi firefighters and the sumo wrestlers, the skillful use of music, the splendid acting style passed down from Kikugoro V, and the vivid depiction of the lives of tobi—adds a unique layer to this bustling play that perfectly depicts the enduring spirit of Old Edo.

　There are highlights in just about every scene, but it is said that the primary author's teacher Mokuami added his own touches to the "Tatsugoro's House" scene. And you won't want to miss the grant *tachimawari* fight scene at the end!

　This skillfully crafted play at once shows sympathy to the tobi firefighters by invoking the disdain of the warrior class toward the lower classes, but also makes sure not to besmirch the proud sumo wrestler's names.

　The Synopsis given here is based on the scenes commonly played today, but it should be noted that the "Kisaburo Home" scene is often omitted from performances.

Premiere

First performed at the Shintomiza Theatre in March 1890. Feat. Onoe Kikugoro V as Tatsugoro and others. Written by Takeshiba Kisui. Commenly called *Megumi no Kenka* (the Megumi Conflict).

登場人物 / Characters

辰五郎
たつごろう

町火消「め組」の頭（かしら）で、芝神明宮界隈を持ち場としている。江戸の火消しの気っ風の良さと鳶の者をまとめる統率力も優れている。品川の島崎楼で鳶と力士が些細なことから争いとなりその場は辰五郎が収めたが、相撲と鳶では身分が違うと言われたことで腹が収まらない。後日の神明社芝居前でも揉め事になり、辰五郎は命をかけて喧嘩をする決心をする。女房子供と水盃で離縁をしてまでもの決意だった。

Tatsugoro

Head of the Megumi unit of firefighters (tobi), Tatsugoro holds authority over the Shinmei Shrine district. He has a strong will and the ability to bring all the firefighters under his command together. His unit get into a minor fight with some sumo wrestlers at Shimazaki Tower in Shinagawa, but Tatsugoro soon squashed the conflict. However, he is angered at the comment that sumo wrestlers are of higher status than lowly firefighters. The conflict between the two groups is aggravated at the Shinmei Shrine later, which leads him to resolve to settle the dispute with his life on the line. Because of the terrible risk to his family, he also resolves to divorce from his wife to spare them from any negative consequences of the fight.

四ツ車大八
よつぐるまだいはち

め組の鳶の者と喧嘩騒動をする力士たちの中心的人物で、腹の据わった大物ぶりを見せる。島崎楼での帰り道、遺恨に思う辰五郎から襲われそうになるが、暗がりの中での立廻りで相手は辰五郎と察したか。神明社の芝居前では客の騒動を止めに入り関取の貫禄を見せるが、再び辰五郎を巻き込んだ喧嘩騒ぎに発展、互いの遺恨は深まるばかり。神明の木戸前で鳶の連中の襲来を受けて立つ。

Yotsuguruma Daihachi

A sumo wrestler and key player in the conflict between the Megumi and the sumo wrestlers, Yotsuguruma is a man of great fortitutde. Though he is attacked under the darkness of night, he survives and surmises that it was Tatsugoro's doing. He helps to calm a commotion at the theater in Shinmei Shrine, but this leads to further conflict with Tatsugoro. In the end, Megumi take one final stand against the sumo wrestlers, which the wrestlers are ready for.

又八
またはち

辰五郎とお仲夫婦の一人息子。幼いながら利発で気っ風の良さは親譲り。辰五郎がお仲に用意した離縁状を破ったり、お仲がなかなか飲まない水盃を進んで飲んだりと、いかにも二人の子供らしい江戸っ子ぶりを見せる。辰五郎がいよいよ喧嘩に出かけてゆくところは、子別れという芝居の上での重要な場面を担う。

Matahachi

Tatsugoro and Onaka's son, Matahachi is an intelligents young man who has inherited his parents' strength of will. He tears up the divorce papers Tatsugoro prepares and drinks from his mother's farewell glass when she refuses, showing the true spirit of a child of Edo (Edokko). He plays an important role in the parting scene between father and son, a staple of the theater.

お仲
おなか

辰五郎の女房で、元は品川宿の遊女。焚出し喜三郎の仲人で辰五郎と夫婦になり、倅の又八を儲けている。男勝りの伝法な性格で、相撲との間に遺恨を持ちながらもなかなか仕返しに立ち上がらない辰五郎をじれったく思うほどの勝気ぶり。辰五郎が決意を固めながらも酔ったふりで時を稼いでいると又八を連れて出てゆこうとまでするが、夫婦の思いはすでに同じ。潔く辰五郎を見送る。

Onaka

Tatsugoro's wife, Onaka is a former geisha from Shinagawa. She married Tatsugoro through Kisaburo's mediation and gave birth to a son named Matahachi. A strong-willed woman, Onaka grows impatient with her husband for not being able to end the conflict with the sumo wrestlers. Though she leaves the house with Matahachi when she Tatsugoro comes home in a pathetic drunken state (which is only an act), her love for him does not die. She finally sees Tatsugoro off as he goes to make his final stand against the sumo wrestlers.

焚出し喜三郎
たきだしきさぶろう

人入れ稼業の親分で土地の顔役。辰五郎とお仲の仲人で、辰五郎にとっても恩のある兄貴分。品川島崎楼での帰り道、暗がりの中で四ツ車を襲ったのが辰五郎だと察したのはこの喜三郎だ。落ちた莨（たばこ）入から辰五郎の気持ちを察したのだ。町火消を管轄する町奉行、相撲を管轄する寺社奉行どちらにも顔が利く人物ゆえ、喧嘩の場に駆けつけて双方の法被（はっぴ）で見事な火消しをする。

Takidashi Kisaburo

Takidashi Kisaburo is the local boss with vast authority. He acted as go-between to arrange for Tatsugoro and Onaka's marriage, and comes by the midnight scuffle between Yotsuguruma and Tatsugoro. He picks up Tatsugoro's dropped tobacco pouch and guesses correctly that there is a great conflict between the two. Holding authority over both the town (including the Megumi firefighters) and the temples and shrines (including the sumo wrestlers), Kisaburo rushes to the scene of the final fight between the two and ends the conflict in brilliant fashion.

九竜山浪右衛門
くりゅうざんなみえもん

め組の鳶の者と対立し喧嘩する力士で、四ツ車の弟分のような存在。島崎楼の宴席は水引という前名から出世して九竜山という名に替わったお披露目の場でもあった。神明社の芝居前で四ツ車と一緒に客の喧嘩の仲裁に入るが、やがて辰五郎をはじめとする鳶の衆との揉め事に発展し、木戸前の乱闘では大きな柱を持って立廻りを演じる。四ツ車と共にこの役も実在の力士がモデルとなっている。

Kuryuzan Namiemon

One of the sumo wrestlers who are feuding with the Megumi, Kuryuzan Namiemon is like a younger brother to Yotsuguruma. The party in the opening scene is meant to be a celebration of his succeeding to the Kuryuzan name as a sumo wrestler. Kuryuzan helps diffuse a fight at the theater in Shinmei Shrine, but this ends up deepening the bad blood between the Megumi and the wrestlers. In the final tachimawari fight scene he can be seen grabbing onto a great pillar, a must-see of the show. Like Yotsuguruma, Kuryuzan is based on an actual sumo wrestler.

亀右衛門
かめえもん

辰五郎の弟分の一人で、辰五郎が遺恨を抱えながらもなかなか腰を上げようとせず、女房のお仲が業を煮やして意気地なしと悪態をつくところへ来合わせ、女房の言い分が本筋だと肩を持つ。しかし辰五郎が命がけで勝負する決意を固め、女房との離縁状まで用意していると知り、心底から感心する。

Kameemon

Kameemon is like a younger brother to Tatsugoro. He joins in with Tatsugoro's wife who criticizes him for being unable to settle the dispute with the sumo wrestlers. He is impressed, however, when he finds out that Tatsugoro has actually resolved to stake his life on the next fight with them, and wishes to divorce from his wife to spare her any troubles to come of his actions.

おくら
おくら

尾花屋という茶屋の女房で、品川島崎楼からの四ツ車の帰り道、提灯を持って道案内をする。その暗がりから辰五郎が飛び出して提灯をはねのけ、真っ暗闇での立廻りとなる。

Okura

The daughter of the Obanaya Teashop, Okura comes to meet Yotsuguruma with a lantern after his quarrel at Shimazaki Tower. Tatsugoro, however, throws the lantern to the side and fights with Tatsugoro in the darkness of night.

藤松
ふじまつ

め組の鳶の一人で、辰五郎の弟分。品川の島崎楼では隣の部屋で宴会をしていた力士の荒浪と勇野(いさみの)が障子を倒し、この藤松に当たったことから口論になった。その時の啖呵で「大道臼(だいどうす)がはね回り、化物じみた大野郎が踊る隣の騒ぎ」と言ってのけ、騒動への火付け役となった。

Fujimatsu

A member of the Megumi, Fujimatsu is like a younger brother to Tatsugoro. The quarrel at Yamazaki Tower arose after Fujimatsu was hit by Isamino, the drunken sumo wrestler who accidentally fell through the sliding shoji doors into their room. Fujimatsu berrates the sumo wrestlers for their "monster-like dance that can be heard from the other room," further aggravating the situation.

おもちゃの文次
おもちゃのぶんじ

め組の鳶の若い者で、もっぱら辰五郎の息子・又八の子守役。弱いくせに喧嘩が好きと、幼い又八にまで図星を言い当てられる始末だが、どこか憎めない。

Omocha no Bunji

A young member of the Megumi group of tobi firefighters, Bunji is the weak-willed babysitter of Tatsugoro's son Matahachi. Despite his weakness, he loves conflict. Even the young Matahachi can beat him at his games, and despite being antagonistic, it's difficult to hate him.

江戸座喜太郎
えどざきたろう

芝神明の社内で行われる芝居の太夫元。客の騒ぎから発展して辰五郎と四ツ車の喧嘩騒ぎになろうかというのを止めに入り、ひとまずその場を収める。

Edoza Kitaro

The proprietor of the playhouse in Shinmei Temple, Edoza Kitaro stops a fight that breaks out between Tatsugoro and Yotsuguruma, temporarily pausing the conflict.

みどころ
Highlights

1. 定火消、大名火消、町火消
The Various Types of Firemen

火事と喧嘩は江戸の華。火消は大切な消防組織だった。旗本が組織したのが定火消（じょうびけし）。火消屋敷はガエンと呼ばれる火消人足を抱えたが、勇み肌の彼らは年中素肌に法被（はっぴ）だけで過ごしたという。大名が組織したのが大名火消。大名火消は江戸城や武家屋敷の防火を担当した。享保頃から町人が組織する町火消が生まれ、いろは48組に分かれて町家の火消しにあたった。町火消は刺子半纏（さしこばんてん）を着ていた。

Fires and quarrels were a thrilling part of life in Edo, making fire departments (*hikeshi*) essential institutions. The *Jobikeshi* were firefighters appointed by the shogun's retainer, and these lively men were said to wear their *happi* coats all year long. The *daimyo-bikeshi* were appointed by the daimyo lords and they were charged with handling fires in the castle and at samurai houses. From the Kyoho Era (1716–1736) there appeared a third group of firefighters called *machi-bikeshi* who were organized by the townsfolk. There were 48 units and they were responsible for putting out fires around town. They wore unique quilted *hanten* coats.

2. 芝神明社
Shiba Shinmei Shrine

「め組」が守ったのは、現在の東京タワーの下から海岸に向かうあたり。『芝浜』でわかるように、この浜に魚の市が立った。『魚屋宗五郎』もこの辺りの住人だった。三田村鳶魚の江戸生活事典によれば、安政年間で「め組」の鳶は239人。江戸時代には相撲や宮地芝居が立つ広い敷地を有していた芝神明社（現・芝大神宮）は、文化2（1805）年に起きため組の喧嘩の舞台となったことで知られる。現在でも祭には「め組」の半纏姿が見られる。

The Megumi unit were responsible for an area near the beach not far from where Tokyo Tower is today. Many kabuki plays feature this area of Edo, including *Shibahama* and *Sakanaya Sogoro*. According to Mitamura Engyo's dictionary of Edo life, the Megumi consisted of 239 firefighters. The Shiba Shinmei Shrine became famous for an altercation that occurred involving the Megumi in 1805, and to this day you can see men at festivals sporting Megumi coats.

3. 下戸の知らない味
A Toast of Water

品川では喧嘩を鎮めた辰五郎だが、腹の虫は収まっていない。女房は、夫の我慢が見ていられない。酔って寝たふりの辰五郎に、女房が水を汲む。酔い覚ましの水を飲んだ辰五郎がつぶやくのが「下戸の知らねえ美味え味だなあ」。喧嘩する決心で女房子供と交わす水盃のつもりなので、言外に苦い気持ちが滲み出る。女房も息子も気配を察し、茶碗の水をひとくち飲む。義太夫が入ってしんみりする場面だ。高輪正覚寺に辰五郎の墓がある。

Tatsugoro stops the fight in Shinagawa, but is still angry afterward. His wife is displeased to see how weak-willed he is when he comes home drunk. To help sober him up, she puts water by where he has fallen asleep. When he awakens and drinks the water, he mutters that "a sober man could never appreciate water so." This comment is imbued with deep sadness, as he is actually planning to leave his family behind to put an end to the quarrel. His wife and son sense what he is up to and the three have a toast of water together in a deeply touching scene featuring *gidayu* music. You can actually see Tatsugoro's grave at Shokaku Temple in Takanawa.

4. 鳶の仕事は壊すこと —— Deconstruction as Firefighting

火消が鳶と呼ばれるのは、手にする鳶口（とびくち）という道具に由来する。棒の先に鳶の口のように曲がった刃が付いている。消防といっても今のように水を大量に使う消火活動はできなかったので、火が回らないように、近くの家屋を鳶口で引き倒すのが主な仕事だった。屋根で振られる纏を目当てに暗闇で鳶口を操って家を引き倒す鳶の勇姿は、江戸っ子のあこがれだったのだ。正月の出初め式は、鳶が日頃の鍛錬を見せる絶好の機会だった。

Though called firefighters, *tobi* of the time didn't have the means to use large amounts of water like we do today when fires break out. Instead, when there was a fire, *tobi* used sickle-like instruments called *tobiguchi* to take down houses surrounding the site of the fire in order to prevent its spread. Their bravery earned them the immense admiration. The *dezomeshiki* ceremony at the new year was an opportunity for common folk to see the firefighters training up close.

5. 喧嘩を止める梯子使い —— Stopping the Fight with a Ladder

喧嘩場は見どころいっぱい。まず喧嘩に向かう鳶たちの足を見てもらいたい。屋根の上など細いところを身軽に歩くため、一本線の上を歩くような機敏な足運びだ。その粋な姿は江戸っ子の憧れだったのも頷ける。対する相撲取りのなかには大銀杏を崩して鉢巻きを締め、ふんどし姿で立ち向かう者もある。両者入り乱れてさまざまに見せる乱闘がお楽しみ。焚出し喜三郎が高梯子の上から飛び込んで、きれいに喧嘩を止める様も見逃せない。

The final fight scene is filled with highlights, including the agile leg movements of the *tobi* firefighters as they run across the eves. Seeing this, even modern audiences couldn't fail to see why these brave men were so admired among Old Edo residents. Of course, the sumo wrestlers also make an impressive show that is not to be missed. The ensuing fight is an all-out brawl that is sure to thrill audiences, and the climax occurs with Takidashi Kisaburo arrives on a great ladder, landing in the very center of the brawl to stop the fighting.

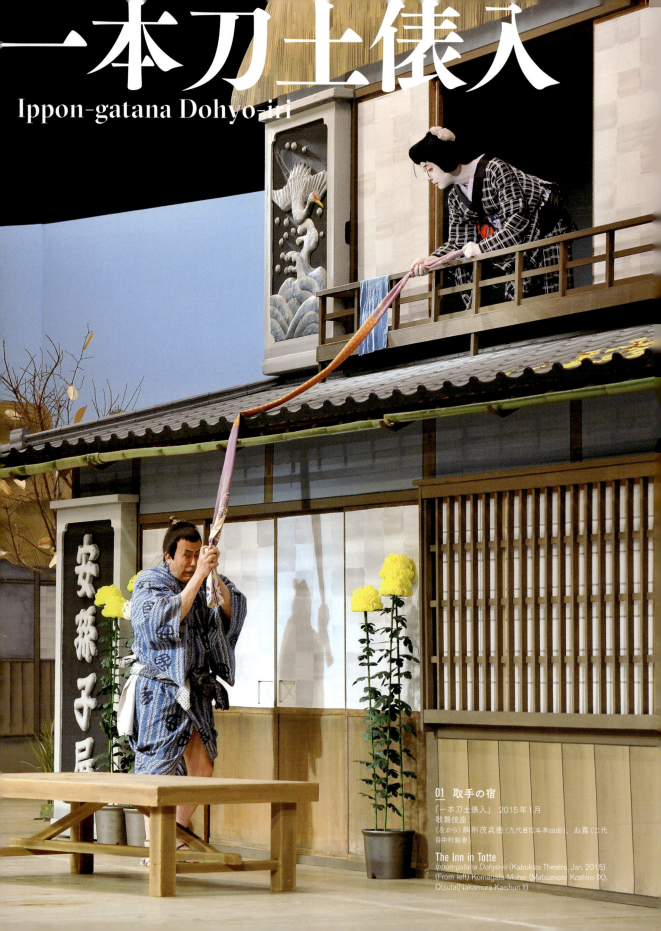

一本刀土俵入
Ippon-gatana Dohyo-iri

01 取手の宿

『一本刀土俵入』 2015年1月
歌舞伎座
(左から)駒形茂兵衛(九代目松本幸四郎)、お蔦(二代目中村魁春)

The Inn in Totte
Ippon-gatana Dohyo-iri (Kabukiza Theatre, Jan. 2015)
(From left) Komagata Mohei (Matsumoto Koshiro IX), Otsuta (Nakamura Kaishun II)

あらすじ / Synopsis

名せりふで知られた人気演目。
詩情豊かにつづられる、
社会の片隅で生きる男と女の人生

やけ酒に酔いどれた女の前に現れた、みすぼらしい相撲取り。
ちょっとした言葉のやりとりと女の気まぐれな親切を相撲取りは生涯忘れないと心に誓った。

Known for its masterful script, this is the melancholy story of a man and woman struggling just to live in a cold world.

A shabby sumo wrestler meets a woman who drinks her days away. After a few short words, the woman decides on a whim to help him, and he vows never to forget her.

01　取手の宿

　水戸街道の宿場町・取手の茶屋旅籠、安孫子屋。店の前では酌婦たちが気だるげに時をもてあましている。

　土地の嫌われ者の船戸の弥八が旅人を脅し、暴れているところに、二階から水をかけた女がいる。酌婦のお蔦である。酒浸りで、酌婦仲間からもやけっぱちだといわれるほどの荒んだ暮らしをしている。

　そこに相撲取りの駒形茂兵衛が、ふらふらと力なく通りかかる。相撲取りだが、取的やふんどし担ぎなどと悪口をいわれる、まだ駆け出しである。巡業先で見込みがないと追い出されたのだが、与えられたわずかな金も使い果たし、飲まず食わずで江戸を目指しているのである。

　弥八に難癖をつけられ絡まれた茂兵衛だが、頭突きで弥八を追い払う。

　その始終を見ていた酌婦お蔦が、茂兵衛を呼び止める。茂兵衛は、親も親戚もいない孤独の身であること、故郷の母親

01　The Inn in Totte

　In front of an inn called Abikoya in Totte, barmaids languidly pass the time with nothing to do.

　As the local scoundrel Funado no Yahachi causes a stir by threatening travelers, a woman throws some water down from the second floor of the inn. It is the barmaid Otsuta who, compared to her colleagues, lives a particularly drunken and miserable life.

　The struggling sumo wrestler Komagata Mohei happens to pass by just then. He has only begun his sumo career but is often ridiculed as an amateur who will never be a true sumo wrestler. Told he has no talent and excluded from official matches, the hungry Mohei heads to Edo with not a penny to his name.

　When Yahachi berates him, Mohei easily drives him away with a headbutt.

　Otsuta, who saw the altercation, calls Mohei over. He tells her that he has neither family nor money but wishes to become a yokozuna (a sumo champion) and to share his accomplishment at his mother's grave. Therefore, he is traveling to Edo in hopes of becoming an apprentice again.

の墓の前で横綱の土俵入りの姿を見せたいから、再び弟子にしてもらおうと江戸へ向かっていることなどを話す。

それを聞いたお蔦も、故郷越中八尾を想って、おわら節を口ずさむ。そして、利根川の渡し賃として持っている金全部、さらに自分の櫛、簪（かんざし）まで茂兵衛に与え、立派な横綱になるようにと励ます。茂兵衛はお蔦の名を聞き、何度も振り返り礼を言いながら去る。

02　利根の渡し

お蔦のおかげで腹を満たした茂兵衛は、一足違いで渡し船に乗り遅れる。そこへ弥八が仲間を引き連れ仕返しに来たが、元気の出た茂兵衛は難なく追い払ってしまう。

03　布施の川べり

十年後。利根川を挟んで取手の向こう岸、下総の布施の川べり。茂兵衛は江戸で博徒になり、再びこの地にやってきた。お蔦に礼をするためである。船の手入れをしていた土地の船頭や船大工たちにお蔦の消息を尋ねるが、安孫子屋は既になく、お蔦の消息は誰にもわからない。

その時茂兵衛は男たちに襲われた。土地の親分波一里儀十の子分で、イカサマ博打の男を探しており、茂兵衛を見間違えたのだ。

茂兵衛らが立ち去った後、細工したサイコロを捨てて逃げ去る男がいた。

04　お蔦の家

お蔦は今では堅気となり、飴売りをして娘のお君とほそぼそと暮らしている。そこへ儀十と子分たちが船印彫師の辰三郎を捜して乗り込んできた。さきほど捜していたイカサマ博打の男は辰三郎で、お蔦の夫、お君の父である。お蔦は何年も行方知れずで、死んだと思っていた夫辰三郎が生きていて、追われる身だと知る。

その夜更辰三郎がやってくる。親子は再会を喜び合うが、すぐに金をすべて置いて、お蔦の故郷へ逃げることにする。そこへお君が無邪気に歌うおわら節の声を聞きつけ、茂兵衛がたどり着いた。

茂兵衛は十年前の恩返しにと金を渡し、礼を言うが、お蔦は博徒になった茂兵衛が誰だか思い出せない。だが襲いかかってきた儀十の手下を追い払う茂兵衛を見て、お蔦は「思い出した」と叫ぶ。十年前の出会いをやっと思い出したのだ。

Otsuta remembers her own hometown and hums a nostalgic melody as she listens to Mohei's story. She decides to give him her comb, hair ornaments, and all of her money (which she had planned to use for the ferry across the Tone River), telling him that he will become a great sumo wrestler. Mohei asks Otsuta for her name and then leaves after promising to repay her one day.

02　Crossing the Tone River

After eating, Mohei rushes to the ferry landing, but just misses the boat. At that moment, Yahachi appears with a band of friends to get back at Mohei for beating him at the inn. Mohei, however, has little difficulty defeating them now that he has eaten a proper meal.

03　The Fuse Riverbank

Ten years later, on the riverbank opposite Abikoya in Fuse, Shimousa. Mohei, who is now a gambler in Edo, has returned to the country to repay his debt to Otsuta. When he asks the local boatmen about her, he finds out that the Otsuta is no longer working at the inn and no one knows of her whereabouts.

Mohei is attacked just then by a group of men. Led by the kingpin Namiichiri Giju, the men are searching for a swindler whom they have mistaken Mohei for.

After Mohei has left, a man who seems to be running away from someone appears, dropping weighted dice along the way.

04　Otsuta's House

Otsuta has become an honest woman and now makes a meager living selling candy with her daughter Okimi. Giju comes into her house with his men in search of Tatsusaburo, Otsuta's husband. Thus, Otsuta finds out that her husband, whom she hasn't seen in years and was thought to be dead, is still alive and wanted by these men.

Tatsusaburo appears at the house that evening. Though everyone is happy to be reunited, they must leave all their money behind and run away to Otsuta's hometown. Just then, Mohei, hearing the innocent Okimi humming the very same tune Otsuta hummed years ago, comes to the house.

Though Mohei says he is there to repay Otsuta, she doesn't remember who he is. Just then, Giju attacks them but is defeated by Mohei. As he fights with Giju, Otsuta suddenly shouts, "I remember!" Seeing Mohei in action, she finally remembers him.

05　Mountain Cherry Blossoms

Otsuta now sets out with her family, looking back and thanking Mohei repeatedly. Mohei watches them as they move on into the distance.

05 軒の山桜

お蔦親子は、十年前のことを忘れずに恩返ししてくれた茂兵衛に何度も振り返り礼を言いながら、旅立って行く。その様子を茂兵衛はじっと見守るのだった。

04 お蔦の家

『一本刀土俵入』 2015年1月 歌舞伎座
〈左から〉波一里儀十（五代目中村歌六）、駒形茂兵衛
（九代目松本幸四郎）

Otsuta's House
Ippon-gatana Dohyo-iri (Kabukiza Theatre, Jan. 2015)
(From left) Namiichiri Giju (Nakamura Karoku V),
Komagata Mohei (Matsumoto Koshiro IX)

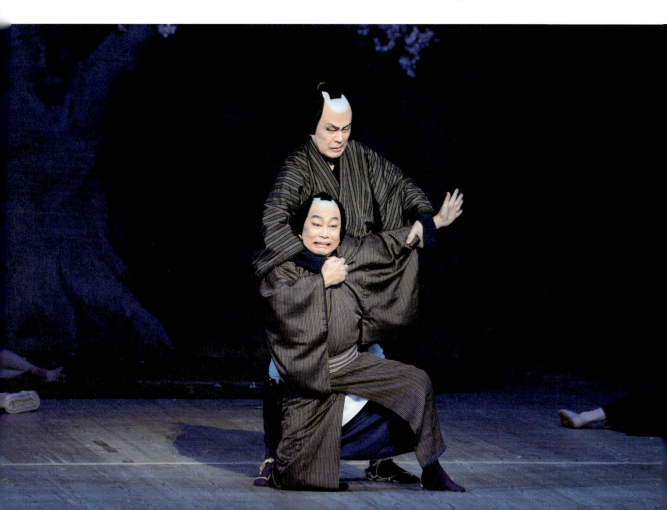

作品の概要 / Overview

演目名 / **Title**

一本刀土俵入

Ippon-gatana Dohyo-iri

作者 / **Writer**

長谷川 伸

Hasegawa Shin

概要 / **Overview**

二幕五場。新歌舞伎の世話物の代表作。作者の長谷川伸は、博徒を主人公とした「股旅物」と呼ばれる一連の作品を書いているが、その一つ。歌舞伎で初演されたが、その後、新國劇をはじめ、大衆演劇、舞台のみならず、映画などの映像作品や歌などの題材になり、歌舞伎以外でもよく知られている作品である。

「棒切れを振り廻してする茂兵衛の、これが、十年前に、櫛、簪、巾着ぐるみ、意見をもらった姐さんに、せめて、見て貰う駒形の、しがねえ姿の、横綱の土俵入りでござんす」

幕切の名台詞で知られている。

親方に見放され飲まず食わずで江戸に向かう茂兵衛の哀れさと、酒浸りで自暴自棄になっている荒んだ酌婦お蔦。十年後の颯爽たる侠客となった茂兵衛と、貧しいながら娘と堅気の生活を送るお蔦。二人の境遇の変わりようが作の巧みなところであり、演じわけが見どころともなる。お蔦のほんの気まぐれの親切を十年間忘れない茂兵衛の思いが観客の胸を熱くさせる名作。

Ippon-gatana Dohyo-iri is a representative *sewamono* play of the shin-kabuki style and consists of 2 acts and 5 scenes. It is one of Hasegawa Shin's series of plays following the travels of gamblers (matatabi-mono). First performed for the kabuki theatre, Ippon has since been adapted to other dramatic forms including film, and has even inspired musicians and song-writers.

The sad final lines of the play are especially well-known: "Mohei nimbly wields a broken pole to drive away Otsuta's assailants as repayment for her kindness ten years ago. What a pitiful ring for a yokozuna wrestler's debut."

The plights of Mohei, a struggling wrestler abandoned by his parents, and Otsuta, a barmaid desperate to drink her misery away, pull at the audience's heartstrings. Yet ten years later Mohei has become a strong and upright man, while Otsuta lives a poor but honest life with her daughter. This masterfully depicted transformation is one of the highlights of the play, along with the constance of Mohei. Though it was but a whim at the time, he remembers his debt to Otsuta for her kindness and finally repays her ten years later in a truly heart-warming scene.

初演 / **Premiere**

昭和6（1931）年6月東京劇場で、初演。配役は六世尾上菊五郎の駒形茂兵衛、五世中村福助のお蔦ほかで初演。長谷川伸作。

First performed at the Tokyo Gekijo Theatre in June, 1931. Featuring Onoe Kikugoro VI as Komagata Mohei, Nakamura Fukusuke V as Otsuta, and others. Written by Hasegawa Shin.

登場人物 / Characters

駒形茂兵衛
こまがたもへえ

上州駒形村の生まれで相撲取りを志すが、親方から見限られ無一文で腹を空かせ取手(とって)の宿へ差し掛かる。喧嘩騒ぎからお蔦に声を掛けられて櫛簪やお金銭を貰い受け、茂兵衛は必ず横綱になって恩返しと約束をする。十年後、博徒となった茂兵衛はようやくお蔦を捜しあてるがお蔦は夫のいかさま博打で追われる身、その追手から救った茂兵衛は「これがしがねえ横綱の土俵入り」とお蔦を見送る。

Komagata Mohei

An aspiring sumo wrestler living in Komagata Village, Mohei was left penniless and starving when his parent abandoned him. He comes to an inn in Totte where he meets the barmaid Otsuta. Feeling pity for him, she lends him money and hair ornaments to help him get by. Mohei promises to repay her when he becomes a famous wrestler. Ten years later, however, he is a gambler but nonetheless intends to repay his debt. He eventually finds Otsuta, whose husband is being pursued by gamblers for cheating. Mohei saves Otsuta's family from these gamblers and sees them off with the words, "What a pitiful ring for a yokozuna wrestler."

船戸の弥八
ふなどのやはち

取手の宿の三太郎という博徒の子分で、血の気が多くて喧嘩沙汰を繰り返し宿場の者から「弥ぁ公」と呼ばれる嫌われ者。毎度ながら喧嘩を吹っかけて暴れるところへ茂兵衛が通りかかり、言いがかりをつけるが逆に強烈な頭突きを食らってしまう。さらに船の渡し場で、腹を満たした茂兵衛にまたもや追い払われる。後には土地の親分となるが評判の悪さは相変わらずの様子。

Funado no Yahachi

A follower of Santaro (the gambler who runs the inn), Yahachi is well-known as a hot-blooded scoundrel who constantly starts fights at the inn. He has just started such a fight when Mohei arrives at the inn. He eventually begins berating Mohei, who drives him away with a great headbutt. He is soundly defeated by Mohei once again at the ferry landing later in the play. Yahachi's character never changes his evil ways, eventually becoming a gang boss in the area.

波一里儀十
なみいちりぎじゅう

利根川の対岸に住み幅を利かせる博徒の大親分で、かつては草相撲で三役を張り少しばかり鳴らしたことのある人物。辰三郎のいかさまで自分の賭場を荒らされたため、縄張りを越えて大勢の子分を引き連れお蔦の家へ乗り込んできた。しかし茂兵衛という予期せぬ来客に阻まれ、子分たちが次々に倒されると、最後は茂兵衛と一騎打ちで相撲に挑むが、ついにねじ伏せられてしまう。

Namiichiri Giju

A notorious gambler and kingpin who lives on the other side of the Tone River who was once a skilled amateur sumo wrestler. After Tatsusaburo cheats at Giju's gambling house, he takes a band of his men out of his territory in pursuit, eventually coming to Otsuta's house. He encounters Mohei there, however, who fights off his men one after another. Finally, Giju and Mohei face off, but Mohei's superior sumo skills prevail.

お蔦
おつた

取手の宿の酌婦で、土地の顔役に惚れられるが晴れぬ心で酒をあおる日々。恵まれない境遇ながら、腹を空かせた茂兵衛に持ち物一切を与え相撲取りで出世するよう励ます。十年後に訪ねてきた茂兵衛をどうしても思い出せなかったが、夫の博打の仕返しにやって来た連中を茂兵衛が頭突きで跳ね返すと、そこで突然記憶がよみがえる。やがて夫・娘と手を取り合い逃れてゆく。

Otsuta

Otsuta is a barmaid at the inn in Totte. Though popular among the influential man who visits, she drinks her days away in misery. Despite her sad lot, she encourages the starving Mohei, giving him everything she owns and telling him to become a great sumo wrestler. Ten years later, she cannot remember who Mohei is, but when she sees him fight off the gamblers pursuing her and her husband, she remembers the struggling sumo wrestler of years before. Thanks to Mohei's help, Otsuta and her family are able to escape their pursuers.

辰三郎
たつさぶろう

お蔦の夫だが十年来姿をくらまし行方知れず、お蔦は死んだものとあきらめ位牌に名を刻んでいる。ようやくお蔦のもとへ帰ろうと思い立つが、帰る前にまとまった金を用意しようといかさま博打に手を出してしまい、追われる身となる。やがて人目を忍んでお蔦のもとへ帰ってくるが、血眼で追ってくる波一里儀十の一味に襲われ、その危ういところを丁度訪ねてきた茂兵衛に救われる。

Tatsusaburo

Tatsusaburo is Otsuta's husband. Because he has been missing 10 years, Otsuta inscribes his name on a mortuary tablet, believing him dead. When Tatsusaburo finally decides to return to his wife, he attempts to cheat a powerful gangster and ends up being pursued. He eventually manages to get to Otsuta, but they are then attacked by the livid gambler Namiichiri Giju and his men. Just then, Mohei arrives and saves them from their assailants.

掘下げの根吉
ほりさげのねきち

波一里儀十の子分。辰三郎を追っている途中、間違って茂兵衛の笠を剥いでしまい詫びを入れるが、そこでびくともしない茂兵衛の男らしさに惹かれ感心して後姿を見送る。お蔦の家では茂兵衛と立廻りとなり、茂兵衛も多少は物のわかるましな奴と見定めるが、「俺たちには理も非もねえ、たったひとつ意地ばかりだ」と鉄砲玉のような一面を見せると茂兵衛の一撃でまいってしまう。

Horisage no Nekichi

One of Giju's men, Nekichi mistakes Mohei for Tatsusaburo and strips his hat off. He then apologizes and is impressed by Mohei's stoic and unperturbed reaction. When he faces off against Mohei at Otsuta's home, Nekichi acknowledges Mohei as a man who knows what he is doing. Even so, he tells Mohei, "We know nothing of right and wrong. All we know is strength of will." Nonetheless, he is defeated in a single blow by Mohei.

みどころ
Highlights

1. 取的（とりてき）── The *toriteki* Wrestler

相撲の世界で、取的とは幕下以下の力士をさす言葉だ。兄弟子たちのまわしを担ぐので、ふんどし担ぎなどとも呼ばれる。親方に追い出され空腹でふらふらの取的がこの芝居の主人公である。ところで、いったい誰が、空腹の相撲取りを主人公に据えようと思い立つだろう。苦労人で、空腹の切なさ辛さをよくよく知っている作者ならではと思われる。長谷川伸の劇作にはいつも、世の片隅で厳しい運命に耐える人々への温かいまなざしがある。

Toriteki in the world of sumo refers to wrestlers below the *makushita* division, also referred to as *fundoshi-katsugi* for the fact that they often carried their senior's loincloths for them. A poor *toriteki* who was abandoned by his parents stars as the protagonist of *Ippon-gatana*. The dramatist Hasegawa Shin often depicts poor and struggling protagonists, so it is easy to imagine that he was a deeply empathetic man who knew the struggles of such people.

2. 酌婦（しゃくふ）── Barmaids

街道筋の旅籠（はたご）には酌をする名目の女がいて、客を取ることもあった。芝居の冒頭で、我孫子屋の店先で始まった喧嘩を無邪気に見物するお松という酌婦が描かれている。数年後再び現われた茂兵衛が、利根川辺りで出会った老大工にお蔦の行方をたずねるが、老大工は覚えていない。代わりに自分が昔夢中になった我孫子屋の女を思い出し、「お松だったかなぁ」と懐かしむばかり。人の出会いのはかなさが、淡く浮き彫りになる渋い場面だ。

In the past, most inns employed barmaids who would pour drinks for patrons. We see the naive barmaid Omatsu at the beginning of the play as a quarrel breaks out between the sumo wrestler Mohei and another customer. Years later, Mohei comes to the Tone River inquiring after a woman named Otsuta, but the old carpenter he inquires to doesn't remember her. He reminisces about Omatsu instead in a scene that shows the fleeting nature of human relationships in this world.

3. おわら節が引き寄せる ── A Nostalgic Song

お蔦は、越中八尾という山奥の町から来た女だ。恋人との間に娘をもうけたが男は行方知れず。自暴自棄になりながら三味線を手に唄うのが八尾の民謡「越中おわら節」だ。八尾は、おわら節を夜通し踊る「風の盆」で知られる土地。お蔦の脳裏には、故郷の祭りの熱い景色が映っているのだろう。たった一度の出会いでも茂兵衛の耳にその歌声が残った。お蔦の娘が唄うおわら節に導かれて、茂兵衛はお蔦との再会を果たす。

Otsuta is a country girl who comes from the Etchu Yatsuo area near the Japan Sea Coast. She had a child with her lover but the father is now missing. Now in a desperate state, she can be seen drunkenly singing a folk song from her hometown, shamisen in hand. The tune, called *Owara-bushi*, is famous in Yatsuo for its use in the *kaze no bon* festivities. When she meets Mohei, Otsuta hums this tune, and when Mohei searches for her years later, it is her daughter's singing that leads him to her.

4. お蔦のモデル —— Otsuta's Model

作者の長谷川伸は裕福な家に生まれたが、家業が傾いて一家離散の憂き目にあった。学校にもろくに通えなかったが、新聞社の給仕から記者になって働いた。ある日、やけを起こして飲んだくれていたところ、ある女性に親身な意見をされて小遣いまでもらったことがあるという。その女性がお蔦のモデルとなった。その後一念発起して文筆業で身を立て、劇作も始めた長谷川伸の作品には、若い頃に出会った人々の面影が投影されている。

Dramatist Hasegawa Shin was born into a wealthy family, but his family was broken up due to the collapse of his father's business. He didn't attend school, yet still managed to move up the ranks in a newspaper company and become a reporter. After a desperate drinking spree one day, he met a kind woman who spoke with him and gave him some money, and this woman became the inspiration for Otsuta's character. It is fascinating to see how Hasegawa's early life directly inspired his plays.

5. 「思い出した！」 —— "I remember!"

出会った時の茂兵衛は朴訥な相撲取り、お蔦はばくれん女の酔っ払い。数年後、きりりとした渡世人となって戻った茂兵衛に昔の面影はない。つましい飴売りになって娘と暮らすお蔦にも、かつての面影はない。このコントラストがこの芝居の見どころだろう。茂兵衛はおわら節がきっかけでお蔦を見つけるが、お蔦が茂兵衛を思い出すのには時間がかかった。お蔦は、相撲の姿勢で相手をやっつける茂兵衛の後ろ姿を見て、やっとこう叫ぶのだ。

Otsuta was a drunk and Mohei was a poor low-ranking sumo wrestler when they first met. Years later, Mohei has become a gambler and looks nothing like his former self, and Otsuta is now a humble candy seller. This contrast between the past and present characters is one of the highlights of *Ippon-gatana*. Though Mohei finds Otsuta due to her daughter singing an old folksong, Otsuta doesn't immediately recognize Mohei. Only when she sees him fighting off her pursuers does she remember the sumo wrestler from years before, shouting "I remember!"

女殺油地獄
Onna Koroshi Abura no Jigoku

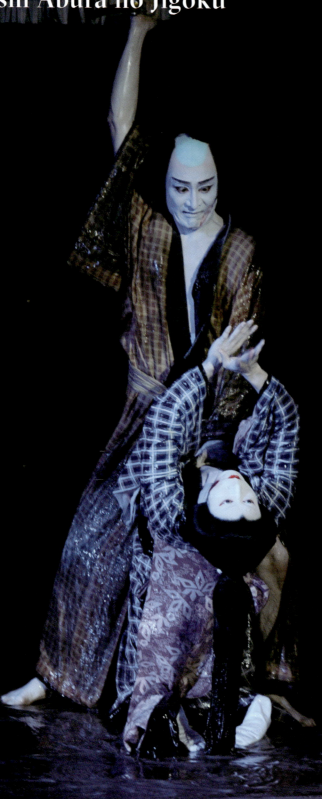

03 豊嶋屋油店

『女殺油地獄』 2009年6月
歌舞伎座
(左から) 河内屋与兵衛 (十五代目片岡仁左衛門)、お吉 (初代片岡孝太郎)

Teshimaya Oil Shop
Onna Koroshi Abura no Jigoku
(Kabukiza Theatre, Jun. 2009)
(From left) Kawachiya Yohei (Kataoka Nizaemon XV), Okichi (Kataoka Takataro I)

あらすじ / Synopsis

「無軌道な青年の、衝動的で刹那的な殺人事件。背後にある複雑な家庭環境と生い立ち……」。
現代の話ではありません。
300年以上前に書かれた作品です

複雑な家庭環境のもとで甘やかされた青年の、
衝動的な殺人事件を題材にした近松門左衛門の異色作。
現代的な解釈が可能で、多くの演者によって演じられている人気作。
変わらぬ親の情愛、その情にうたれて改心しようにも、借金返済のあてがない。
切羽つまった若者は……。油に滑りながらの凄惨な殺し場の迫力も見どころ。

A reckless young man murdered a woman on an impulse, the result of a troubled upbringing... Though it sounds like something you might hear about on the news, this is the plot of a 300-year-old play.

Onna Koroshi is a unique work of Chikamatsu Monzaemon that tells the story of a young man with a complicated home life who commits an impulsive murder.
It is a popular piece that can be analyzed very easily from a modern perspective.
Though the prodigal son's heart is changed by his parents' undying love, he finds himself with no way to repay his mountain of debt…
All this leads to the visceral scene of the murder, the troubled young man slipping on the oil-drenched floor as he flees.

01 徳庵堤茶店

大坂の郊外、野崎観音への参詣の人で賑わう徳庵堤。天満の油屋豊嶋屋の女房お吉は、茶屋で娘とともに、遅れて来る夫を待っている。

そこに現れた天満の油屋河内屋の道楽息子与兵衛。馴染みの遊女小菊を巡り、田舎客に喧嘩を売る気でやってきたのだ。かねて道楽を見かねていたお吉の親切な意見も聞かず、与兵衛とその悪友は喧嘩騒ぎをおこす。そのうち与兵衛の投げた泥が馬で通りかかった侍の小栗八弥にかかってしまう。八弥に仕える与兵衛の伯父山本森右衛門は無礼に怒り、与兵衛を手打ちにしようとするが小栗に止められる。難をのがれ

01 The Teashop at Tokuan Bank

The embankment in Tokuan is bustling with people on their way to visit Nozaki Kannon Temple on the outskirts of Osaka. At a teashop there, Okichi waits with her daughter for her husband, the proprietor of the Teshimaya oil company.

Yohei, the prodigal son of another oil merchant called Kawachiya, appears while the ladies are waiting. The belligerent Yohei immediately picks a fight with some of the other visitors regarding his lover, the geisha Kogiku. He refuses to listen to Okichi's advice regarding his immoral ways, and together with his scoundrel friend escalates the quarrel by accidentally hitting a high-ranking samurai named Koguri Yatsuya with a clump of mud. Yohei's uncle Yamamoto Moriemon, who serves Yatsuya, is deeply angered

た与兵衛は、参詣から戻ってきたお吉に、喧嘩で汚れた着物を濯いでもらう。

02　河内屋内

　河内屋の主人徳兵衛は、与兵衛の実の父ではなく義理の父親である。もとは河内屋の番頭であったが、与兵衛の実父が亡くなったため、内儀のおさわと一緒になった。そのため先代の子の与兵衛には何かと遠慮がちで、与兵衛はこれに付け込んで放蕩三昧である。

　与兵衛の兄太兵衛は、伯父森右衛門が過日徳庵堤での与兵衛の無礼のために面目を失い、浪人したことを徳兵衛に告げ、遠慮せずに与兵衛を勘当するよう忠告する。

　与兵衛はそうとも知らず、伯父が主人の金を使い込み、困っていると偽って徳兵衛から金をだまし取ろうとするが失敗してしまう。

　また、病で臥せっていた妹おかちが、祈祷を受けるうち、与兵衛の思う人を請け出し、この店を任せろという言葉を口走る。これは与兵衛の差し金であったが、おかちにそれを明かされてしまう。与兵衛は父、妹さらには母にまで暴力をふるい、とうとう家を追い出される。

03　豊嶋屋油店

　五月四日の夜。当時は皆掛け払いで節季ごとに支払をする。そのためどこの商店でも男たちはみな掛取りに行き慌ただしい。豊嶋屋も同じく、主人七左衛門は掛取りに出かけ、お吉が店番をしている。

　そこに与兵衛が通りかかる。与兵衛は、親の印判を無断で用い、銀二百匁を借りていた。明日になるとこの借金は、五倍の一貫目に膨れ上がり、払えなければ印判を無断で使用したことが表沙汰になる。困った与兵衛はお吉を頼ろうとやってきたのだ。

　その時、徳兵衛が豊嶋屋を訪れる。与兵衛を案じてお吉に金を託していると、続いて、母おさわもやってくる。徳兵衛のその情けが与兵衛には毒になると口では言うものの、実はおさわも夫に黙って与兵衛への金を託しに来たのだ。その様子を門口で立ち聞きし、親の心を知った与兵衛は、何としても借金を返済しようと決意する。

　豊嶋屋に現れた与兵衛に、お吉は両親から預かった銭八百文を渡すが、返済額には到底足りない。与兵衛はお吉に金を貸してくれるよう頼むが拒否されてしまう。他に金策の当てがない与兵衛は、お吉を殺して金を奪おうと、隠し持っていた

and attempts to kill him. His master Yatsuya, however, stops him. Having avoided a serious conflict, Yohei has Okichi wash his soiled robes when she returns from the temple.

02　Kawachiya's Residence

　Tokubei is the proprietor of Kawachiya, but is actually Yohei's stepfather. Formerly the head clerk, he married the widow Osawa after her husband died and inherited the business. Because he is not Yohei's true father, he is reluctant to scold him, a fact that Yohei takes advantage of by living a thoroughly dissolute life.

　Yohei's older brother Tahei comes and reports to Tokubei the events that took place at the bank in Tokuan, which led to his uncle Moriemon losing face and becoming a masterless ronin. He therefore asks Tokubei to disown his brother, who is completely out of control.

　Yohei, unaware of his brother's report to Tokubei, lies and tells Tokubei that his uncle has embezzled money from his master. He therefore asks Tokubei for money to help Moriemon, but Tokubei, who knows the truth, refuses.

　Meanwhile, Yohei's sister Okachi is sick in bed, having a priest pray over her. As she is being prayed over, she suddenly blurts out that Yohei should marry whom he pleases and take over the business. It is revealed, however, that this was a trick by Yohei. In his anger, Yohei lashes out violently at his stepfather, his sister, and even his mother before being thrown out of the house.

03　Teshimaya Oil Shop

　On the night of May fourth, businesses are busy making rounds to collect money from customers. The Teshimaya oil merchant is no different, so he leaves Okichi to tend the shop.

　Yohei arrives just when Teshimaya is out to ask Okichi for money. He has borrowed a large sum of money using his father's seal, and if he doesn't pay by the next day the sum will be increased five times and he will be outed for having used the seal without permission.

　Just at that moment, Tokubei comes to Teshimaya with money for Yohei, whom he is greatly worried about. Next, Yohei's mother also comes with money for her son. Though the two have disowned their dissolute son, they secretly feel sorry for him. Yohei, standing at the entrance to the store, overhears all of this and realizes his parents' true feelings. He resolves to pay back the money he owes with the money they left for him.

　Yohei appears at the shop and Okichi gives him the money from his parents, but it is not nearly enough to pay his debts. He therefore asks Okichi for a loan, which she refuses. Yohei, with no other way to get money, kills Okichi with a sword he has hidden in his robes and steals the money he needs, spilling oil all over the store in the struggle. He then leaves the store covered in oil and blood.

た刀で斬りつける。売り物の油がこぼれた中を逃げ回るお吉。血と油に滑りつつ、与兵衛はお吉にとどめを刺し、戸棚の金を奪いその場から逃げていく。

03 豊嶋屋油店
『女殺油地獄』 2009年6月
歌舞伎座
河内屋与兵衛（十五代目片岡仁左衛門）

Teshimaya Oil Shop
Onna Koroshi Abura no Jigoku
(Kabukiza Theatre, Jun. 2009)
Kawachiya Yohei (Kataoka Nizaemon XV)

03 豊嶋屋油店

『女殺油地獄』 2009年6月 歌舞伎座
(左から) 豊嶋屋七左衛門 (四代目中村梅玉)、お吉 (初代片岡孝太郎)

Teshimaya Oil Shop
Onna Koroshi Abura no Jigoku
(Kabukiza Theatre, Jun. 2009)
(From left) Teshimaya Shichizaemon
(Nakamura Baigyoku IV), Okichi
(Kataoka Takataro I)

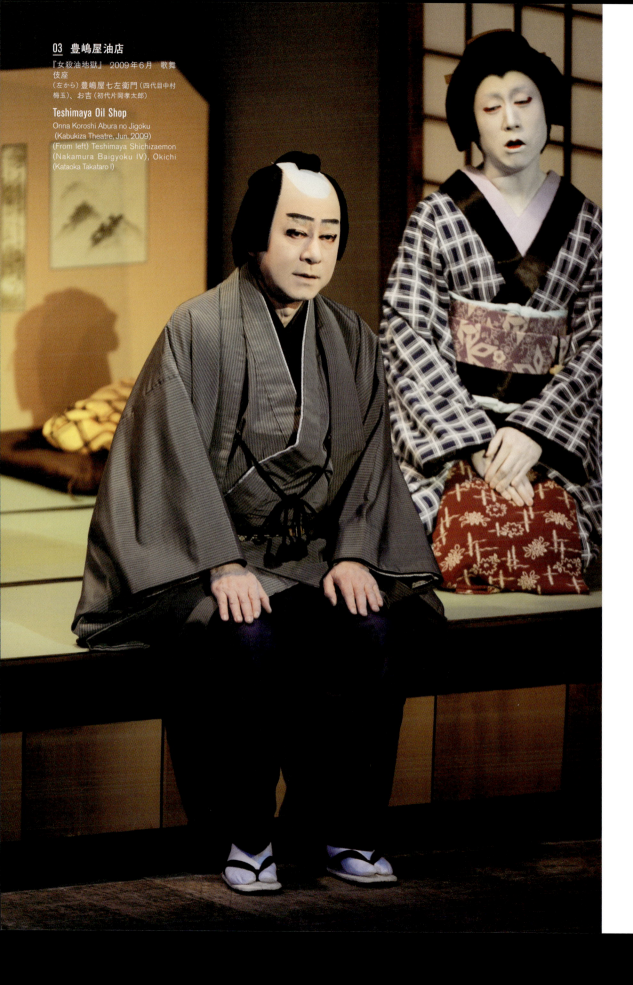

作品の概要

Overview

演目名

女殺油地獄

Title

Onna Koroshi Abura no Jigoku

作者

近松門左衛門

Writer

Chikamatsu Monzaemon

概要

　近松門左衛門作の世話浄瑠璃の異色作。享保6 (1721) 年7月大坂・竹本座で人形浄瑠璃として初演。同年5月に大坂で起こった殺人事件を脚色したもの。この殺人事件はすぐに歌舞伎でも脚色上演されているが、本作との関連は不明。浄瑠璃は再演されず、歌舞伎に移されることもなかったが、明治になり、主人公の近代的な性格描写や、周囲の人々の描写、また殺し場の凄惨な迫力などが高く評価され、歌舞伎でも脚色上演されるようになった。明治40 (1907) 年女芝居での上演が舞台化の始まりで、明治42年11月に二世實川延若 (当時延二郎) が、渡辺霞亭補作により大阪・朝日座で上演。以降さまざまな脚色により、多くの俳優が手掛けている。

　掲載のあらすじは、現在もっとも多く上演される三場面を中心にしたもの。原作にはこの後、与兵衛が廓を遊び歩く「新町の場」「北の新地の場」と、お吉の三十五日の逮夜で与兵衛が捕縛される「豊嶋屋逮夜の場」があり、上演されることもある。

Overview

　Originally written for the puppet theater by Chikamatsu Monzaemon, Onna Koroshi Abura no Jigoku was first performed at the Takemotoza Theatre in Osaka in July, 1721. It was based on an actual murder that occurred in Osaka in May of the same year. The murder was also dramatized for the kabuki theater around the same time, but its relation to the modern piece is unclear. The puppet theater version was never performed again, and it failed to be adapted to the kabuki theater until the Meiji period (1868-1912), when modern touches were added to make it more relatable. It came to the kabuki stage from the "women's theater" (onna-shibai) in 1907 and was performed with additions made by Watanabe Katei at the Osaka Asahiza Theatre in 1909. Since then, many different dramatizations have been rendered and each actor has brought a new approach to the story and characters.

　The synopsis given here is based on the script most often used in modern performances and focuses primarily on the third scene. A number of scenes after the events described here are also performed sometimes. These scenes show Yohei walking through the pleasure quarters and being arrested at Okichi's memorial service.

初演

人形浄瑠璃初演　享保6 (1721) 年7月大坂・竹本座

Premiere

First performed as a joruri puppet play in July 1721 at the Takemotoza Theatre in Osaka.

登場人物 / Characters

河内屋与兵衛
かわちやよへえ

大坂本天満町の油屋・河内屋の次男坊。父の徳兵衛は先代の死により跡を取った義理の父、それゆえ遠慮がちで与兵衛は放蕩を繰り返した。たまりかねた母親に勘当され金に困った与兵衛はなおも借金、その期限が迫ると近所の同業者豊嶋屋の女房お吉に金の無心をする。承知しないお吉に「いっそ不義になって貸してくだされ」と色と欲の混ざり合った言葉を投げ、ついには油まみれの惨劇となる。

Kawachiya Yohei

The second son of the oil merchant family Kawachiya in Osaka, Yohei, whose father has passed away, lives a debauched life that his stepfather Tokubei does not approve of. Disowned by his mother, Yohei has no means and has taken to borrowing money. When the due date for his loan approaches, he asks Okichi, the wife of fellow oil merchant Teshimaya, for money. When she refuses, he tries to coax her into lending him money with lewd comments, which eventually leads to a tragedy covered in oil...

おさわ
おさわ

油商人河内屋徳兵衛の女房で与兵衛の母。元は武家の出で先代徳兵衛に嫁いで太兵衛・与兵衛の二人の男子をもうけるが夫に先立たれ、番頭であった徳兵衛を迎えて店の暖簾を守る。徳兵衛との間に娘のおかちも生まれた。与兵衛の不徳放蕩には散々手を焼き、ついに勘当はするものの、やはり親子の情は捨てきれず、与兵衛が立ち寄りそうな豊嶋屋を訪れ内緒で金を預けてゆく。

Osawa

Yohei's mother and Kawachiya Tokubei's wife, Osawa married the late Tokubei and had two sons, Tahei and Yohei before Tokubei passed away. Now she works at the shop with the new proprietor, who is also named Tokubei, and this new Tokubei is the father of her daughter Okachi. Yohei's immoral lifestyle causes her to disown him, but in the end, she cannot completely abandon her son, and she secretly takes money to Teshimaya.

河内屋太兵衛
かわちやたへえ

河内屋の長男で与兵衛の兄。七歳の時に店の先代である父に死なれ徳兵衛に養育されるが、すでに独立して順慶町で同じく油屋を営んでいる。弟の与兵衛が放蕩を繰り返し素行が良くないことを日頃から腹立たしく思っている一人である。伯父の山本森右衛門が徳庵堤で与兵衛から多大な迷惑をこうむり、その一件を父徳兵衛に報告し早く縁を切るようにとも勧める。

Kawachiya Tahei

The eldest son of the Kawachiya family and Yohei's elder brother, Tahei was raised by Tokubei since his father died at the age of seven. He now runs his own oil business in a neighboring district and is deeply ashamed of his younger brother's immoral ways. When Yohei is involved in an incident with his uncle Yamamoto Moriemon on the bank of Tokuan, Tahei goes to his stepfather Tokubei, asking that he disinherit his younger brother.

お吉
おきち

与兵衛の河内屋とは同じ町内で向かい合った油屋・豊嶋屋の女房。子持ちながら年若く美しくてよく出来た女房である。同業の河内屋の与兵衛が放蕩する様を見ていろいろと心配し時には親切にもするが、それをいいことに与兵衛は金を貸してくれとせがむのである。お吉は夫の留守にそれも出来ず、また与兵衛への親切を夫に勘ぐられてもいけないため断るが、店の中でついに与兵衛に殺されてしまう。

Okichi

The wife of Teshimaya, another oil merchant in the same area as Yohei's Kawachiya, though Okichi has children, she is still quite young and very attractive. She is kind to Yohei, whom she worries about because of his debauched lifestyle, which Yohei takes advantage of by asking her for a loan. She refuses, saying she would have to ask her husband before lending him money, but is eventually killed by Okichi inside the shop.

河内屋徳兵衛
かわちやとくべえ

油屋を営む河内屋の主人。先代の徳兵衛に仕えた番頭であったが、先代の没後その妻のおさわが幼い二人の子を抱えていたため、婿として入り店の跡取りとなった。温厚で義理堅く実直な人間だが、先代によく似た与兵衛に意見することも叶わず、それゆえつい放蕩を許してしまう。与兵衛が母のおさわに暴力をふるうのを見るにつけ勘当に同意するが、母と同様こっそり金を届けに行く。

Kawachiya Tokubei

Tokubei is the current proprietor of Kawachiya. He was formerly the head clerk at the shop under the former proprietor (also named Tokubei), but came to inherit the shop after marrying the widow Osawa who had two young sons to support. He is a very kind and straight-laced man, but has trouble admonishing Yohei, who greatly resembles his father, for his immoral lifestyle. After seeing him lash out violently at Osawa, he agrees with her to disown Yohei, but, like Osawa, secretly sends him money.

おかち
おかち

河内屋徳兵衛の娘。先代徳兵衛が亡くなった後、番頭から婿となった現在の当主徳兵衛がおさわとの間にもうけた子。すなわち与兵衛は腹違いの兄である。両親は与兵衛の日頃からの素行の悪さを見かね、おかちに婿を取って店の跡を継がせようと考えているが、それを知った与兵衛は身持ちを改めることを約束し、おかちに死霊が付いた真似をさせて破談にしようと画策する。

Okachi

Okachi is Kawachiya Tokubei's daughter and Osawa's daughter. Osawa's two older sons were fathered by the previous proprietor of Kachiwaya, so they are Okachi's half-brothers. Osawa and Tokubei, alarmed at Yohei's immoral lifestyle, intend to have Okachi take a husband who will inherit the business, but Tokubei promises to change his ways and comes up with a scheme to have Okachi's marriage called off.

山本森右衛門
やまもともりえもん

河内屋与兵衛の母方の伯父で高槻の武士。主人小栗八弥の伴として野崎詣りに向かうところ、徳庵堤で与兵衛の喧嘩沙汰から主人に泥が掛かり、その場で与兵衛を殺し自ら腹を切る覚悟であったが、主人の寛大な計らいで窮地を逃れた。しかし武士としての面目を失った痛手は大きく、浪人となって大坂にやって来る。後にお吉殺しの犯人を与兵衛と見定め、探し求めて追いつめてゆく。

Yamamoto Moriemon
Yohei's uncle on his mother's side, Moriemon is a samurai from Tatasuki. As he and his master Koguri Yatsuya make their way to the Nozaki Kannon Temple, Yohei gets into an argument with them at the embankment of Tokuan. Yohei throws mud at Moriemon's master, angering him greatly. He decides to kill Yohei and commit suicide himself, but the generous Yatsuya stops him. Having lost face as a samurai, however, Moriemon becomes a master-less ronin and heads for Osaka. He later finds out that Yohei has killed Okichi and decides to pursue him.

小菊
こぎく

大坂の曽根崎新地、天王寺屋の遊女で河内屋徳兵衛とは深い馴染みである。その小菊が会津の客に連れられて野崎詣りに出掛けたことが与兵衛に知れ、腹を立てた与兵衛が徳庵堤まで追ってきて客との喧嘩となる。そこで泥を投げ合ううち、通りかかった小栗八弥に掛かり伯父である山本森右衛門の難儀となってしまう。

Kogiku
Kogiku is a geisha and Yohei's lover. When Yohei finds out that she is going to Nozaki Kannon Temple with another client, he follows them there and gets into a fight. Amidst this fight, Yohei's uncle Moriemon and his master Koguri Yatsuya happen by. As Yohei flings mud at his adversary, he accidentally hits Yatsuya, leading to Moriemon's dismissal.

豊嶋屋七左衛門
てしまやしちざえもん

大坂本天満町の油商人で、同業の河内屋とは筋向い。妻はお吉。まじめ一方で商売熱心、それだけにお吉が与兵衛の放蕩ぶりを心配し何かにつけて親切に計らうのも気に入らず、日頃から言い聞かせている。しかし心配は的中、自分が集金に出掛けているすきに与兵衛が現れて金の無心、ついには妻のお吉が与兵衛に殺されてしまう。後にお吉の法要の場で与兵衛の犯行が露見する。

Teshimaya Shichizaemon
A fellow oil merchant in Osaka located close to Kawachiya. Shichizaemon is Okichi's husband and a serious and diligent worker. He disapproves of Okichi's kindness toward Yohei and never misses an opportunity to admonish her for it. Yohei takes advantage of her kindness, sneaking into the shop when Shichizaemon is away to ask Okichi for a loan. He ends up killing her, but his crime is outed at the scene of Okichi's memorial service.

みどころ
Highlights

1. 無軌道な青年の衝動殺人 —— An Impulsive Murder

本作には、ほかの近松作品にあるような恋のもつれの要素が薄く、理不尽で凄惨な殺し場がある。初演は不評で、江戸時代には再演されていない。ありのままの人間の心の闇を突き詰めた末の惨劇は、江戸時代の観客には好まれなかったのだろう。明治42年、近松門左衛門185年忌記念として、二世實川延若が歌舞伎で復活している。特に戦後、無軌道な青年の衝動殺人というテーマが受け入れられるようになり、上演が増えている。

Onna Koroshi is an interesting piece by Chikamatsu in that it shows very little of his trademark themes of the troubles of love, opting instead to show an utterly shocking and impulsive murder. It was unpopular when it debuted and was not performed during the Edo Period, during which the utter darkness of the human soul was not a popular topic for theater-goers. In 1909, however, 185 years after Chikamatsu Monzaemon's death, the play was revived by Jitsukawa Enjaku II. After the war, such depictions of reckless men committing impulsive murders became more popular, resulting in a boom in the popularity of *Onna Koroshi*.

2. 義理の父、実の母 —— Stepfather, Real Mother

河内屋与兵衛は、先代の息子で跡取り。父の死後母が店の番頭と再婚して家業を維持し、父の違う妹が生まれている。もとは使用人だった義理の父は与兵衛を叱ろうとしない。母には夫への遠慮がある。兄は他所へ店を出している。父も母も厳しいことを言いつつ、与兵衛が心配でならない。そういう気遣いの人間関係のなかで、与兵衛の心は捻れてしまったのだ。今の時代にもどこにでもありそうな、普通の家族関係のなかで暴発する悲劇である。

Kawachiya Yohei is the son of the previous proprietor of the Kawachiya shop and is meant to inherit the business. When his father passed away his mother remarried the former head clerk Tokubei and had a child by him. Tokubei used to be a servant but now is his stepfather, making it very difficult for Tokubei to scold his stepson. Though both Tokubei and Yohei's mother try their hardest, Yohei has had an unstable upbringing that has warped his mentality. In a series of events that seem like they could just as easily happen today, this seemingly normal family is suddenly rent in two by terrible acts of violence.

3. 関東は金、関西は銀 —— Golden Kanto, Silver Kansai

江戸の通貨単位は金だが、商人の多い上方では銀が流通していた。銀は匁（もんめ）という重さの単位が通貨単位でもあった。1匁は3.75g、1000匁（3.75kg）が1貫。重さが単位だと海外貿易にも都合が良かった。寛永頃には金1両が銀60匁に相当したが、相場は変動し、本作が書かれた頃のレートでは享保金1両が新銀（享保銀）で約48匁ほどだった計算になる。数種の通貨が流通した当時の大変さも近松は描いている。

The economy of old Edo used gold as its currency, but the *Kamigata* region (including Kyoto) which had a large merchant population, used silver. Silver was measured in units of weight called *monme* (3.75g), and 1000 *monme* constituted 1 *kan*. Using units of weight was especially convenient for international trade at the time. During the Kan'ei period (1624–1644), 60 *monme* was equivalent to 1 *ryo* of gold, but due to market fluctuations, 1 *ryo* was equivalent to 48 *monme* in so-called "new silver" that circulated during the Kyoho Era which is the time of *Onna Koroshi*'s events. The trouble of having multiple currencies in circulation is another aspect of life during this period that Chikamatsu masterfully depicts.

4. 借金が5倍になる手形 —— Outrageous Interest!

ろくに働かず、手にした金は女遊びに使ってしまう与兵衛。その与兵衛が内緒で父親の判を使って新銀200匁を借りている。しかも期限までに返せないと、その5倍の1貫目もの銀が父親に課されてしまう手形で借りたのであった。自分どころか何も知らない親へも累の及ぶ借金である。夜ふけて与兵衛の焦りと怒りは頂点に達する。与兵衛の父母が豊嶋屋に預けた銭は800文。銭4000文が1両相当だったので、まったく足りなかった。

Yohei borrows 200 *monme* using his stepfather's official seal so that he can enjoy the pleasure quarters. The agreement he entered dictates that, should he fail to return the money by the promised date, Yohei's father would be charged 1 *kan*, or five times the original amount borrowed. Such an amount would cause trouble not only for Yohei but his entire family. Desperate to pay the money back, Yohei is at a loss when the money his parents deliver to him is a mere 800 *mon*, not nearly enough.

5. 親切が仇の、油まみれの殺し場 —— Kindness Leads to an Oil-covered Murder

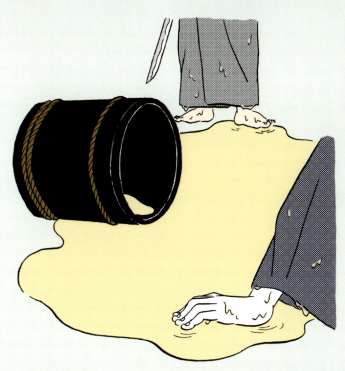

当時の商いは基本は掛け売りで、盆暮と節季ごとに掛け取りをする習慣だった。掛け取りに出かけた夫の留守を守るお吉は三人の子持ちだがまだ若い。序幕で、お吉が同業者のよしみで、喧嘩で汚れた与兵衛の着物をきれいにしてやったことが仇となり、与兵衛が無心に来る動機を作ってしまう。破れかぶれの与兵衛が「不義になって貸してくだされ」と食い下がり、逃げるお吉が倒した油桶からあふれた油は、お吉の逃げ道をも奪ってしまう。

Most business was run on credit during the time of *Onna Koroshi*, which business owners had to make their collection rounds seasonally. When the shop proprietor leaves Okichi to man the store while he is out collecting payments, the sly Yohei takes advantage of the situation to ask her for money. In the opening act we see the kind Okichi cleaning off Yohei's dirtied clothes, and it is this kindness that ends up being her downfall. Yohei, desperate for money, threatens Okichi and chases after her, eventually killing her amid the oil spilled all over the floor in their struggle.

曽根崎心中
The Love Suicides at Sonezaki

02 北新地天満屋

『曽根崎心中』 2009年4月 歌舞伎座
(左から) 平野屋徳兵衛 (五代目中村翫雀)、天満屋お初 (四代目坂田藤十郎)

Tenmaya
The Love Suicides at Sonezaki
(Kabukiza Theatre, Apr. 2009)
(From left) Hiranoya Tokubei (Nakamura Kanjaku V),
Tenmaya Ohatsu (Sakata Tojuro IV)

あらすじ / Synopsis

恋の手本となりにけり……。手代と女郎。
大坂のどこにでもいた若い二人の、永遠に残る恋物語。
戦後歌舞伎を彩った世話物の名作。
名高い原作浄瑠璃を脚色した作品

遊女お初のために、せっかく用意された店の跡取り話を蹴ってしまう徳兵衛。
友人に騙され、大事な金も、信用も、すべてを失ってしまった徳兵衛のために死ぬお初。
自らの恋を成就させるために手を取って曽根崎の森に向かう二人の姿……。

─── A paragon of love…The everlasting love story of a young clerk and a working girl in Osaka. The Love Suicides is a masterful example of *sewamono*, the genre that captivated post-war theatre-goers.

For Ohatsu's sake, Tokubei throws away his opportunity to inherit his uncle's business. For Tokubei, who lost everything after his friend deceives him, Ohatsu resolves to die. Hand in hand, the two make for the Sonezaki Forest for the sake of their love…

01　生玉神社境内

大坂堂島新地の天満屋の遊女お初は、醤油屋平野屋の手代徳兵衛と将来を誓う仲だった。

客に連れられて生玉神社に来ていたお初は、商いで通りかかった徳兵衛と出会う。久しぶりに会ったお初に、徳兵衛はこれまでのことを話して聞かせる。

平野屋の主人久右衛門は、徳兵衛とは伯父甥の間柄であるが、この度自分の女房の姪とめあわせ、平野屋の身代を継がせようという話が持ち上がった。徳兵衛はお初を思い縁談を断ったが、徳兵衛の継母が勝手に縁談を承諾し、持参金として銀二貫目を受け取っていた。怒った久右衛門は、持参金の返済を迫り、大坂から追い出すと息巻く。徳兵衛は、もう会うことが出来ないと嘆くが、お初は徳兵衛に二人の仲はこの世だけではない強い絆だと励ます。

01　At Ikutama Shrine

Ohatsu, who works at the brothel Tenmaya, and Tokubei, a clerk at the soy sauce shop Hiranoya, are in love and have made vows to each other. They run into one another at Ikutama Shrine, both on separate business. Tokubei talks at length since the two haven't met for some time.

He speaks of his uncle Kyuemon, the proprietor of Hiranoya who has insisted that Tokubei marry his wife's niece and take over the shop. Though Tokubei refused due to his relationship with Ohatsu, Kyuemon, who had already given a dowry of two kanme (a unit of silver) to Tokubei's stepmother, has demanded the return of his dowry and threatened to banish him. Tokubei is distraught at the thought of never seeing Ohatsu again, but she consoles him, saying that the strength of their bond surely transcends this life.

It is now the day before Tokubei is to return the dowry money which he retrieved from his stepmother. Tokubei,

明日が持参金返済の期日。ところが徳兵衛は継母から取り戻した二貫目を、親友油屋九平次に貸していた。しかし九平次は約束の日が来ても金を返さない。

ちょうど来合わせた九平次に、徳兵衛は証文を出し返済を求める。ところが九平次は証文の印判は先月紛失した物と言い立て、徳兵衛こそ拾った判を使って証文を偽造した犯罪者だと騒ぎだす。初めから金をだまし取るつもりだったのである。

九平次らは大勢の前で徳兵衛を散々に痛めつける。商人の信用を失った徳兵衛は、近いうちに身の潔白を証明すると言い、去っていく。

02　北新地天満屋

その夜更け、天満屋では女たちが、生玉で徳兵衛がひどい目にあった噂をしている。お初が胸を痛めていると、久右衛門も家に戻らぬ徳兵衛を案じて天満屋にやってきた。

やがて徳兵衛が隠れるようにやってきた。お初は誰にも知られぬように裲襠の裾で徳兵衛を隠し、店の縁の下に忍ばせる。そこへ酔った九平次がやってきて、徳兵衛が騙りをしたと悪口を言い始める。怒りに震える徳兵衛をお初は足で押しとどめ、徳兵衛は死んで潔白を明かすはずだ、とその無念を訴える。それを聞いた徳兵衛は、お初の足を刃物のように自分の喉にあて、自害する覚悟を伝える。さらに、もし徳兵衛が死んだら自分がお初を身請けするという九平次の言葉に、お初は独り言を装い、徳兵衛が死んだら自分も共に死ぬと言うのであった。

夜更け、人が寝静まるのを待って二人は店を抜け出した。そこへ油屋から知らせが来て、印判を偽った九平次の悪だくみが露見し徳兵衛の無実が明らかになる。始終を聞いていた久右衛門も実は二人を添わせる心だったと明かすが、すでに二人は書置きを残し出て行った後だった。

03　曽根崎の森

この世の名残　夜も名残　死にに行く身を　たとうれば
仇しが原の道の霜　一足ずつに消えてゆく
夢の夢こそあわれなれ

あれ数うれば　暁の七つの時が六つなりて
残る一つが今生の　鐘の響の聞き納め

曽根崎の天神の森へとやってきた二人はともに死ぬ喜びを感じながら覚悟を決める。

however, doesn't have the money since he has lent it to Kuheiji who was supposed to have returned it by now.

The two happen to return to each other, and Tokubei demands the money, showing Kuheiji the promissory note he had stamped as proof of the transaction. Kuheiji then claims that he lost his seal the previous month and accuses Tokubei of using it to forge the promissory note. It is now clear that framing Tokubei was his plan all along.

Kuheiji thus ridicules Tokubei in front of a large crowd, completely discrediting him. Tokubei leaves the scene, vowing to clear his name.

02　Tenmaya

Tokubei eventually comes to Tenmaya secretly. Ohatsu hides him under the floor with the hem of her bridal robes as a drunken Kuheiji arrives spreading lies about Tokubei trying to swindle him. Tokubei shakes with anger, but Ohatsu holds him back with her leg as Kuheiji claims that Tokubei should be prepared to kill himself to prove his innocence. Hearing this, Tokubei presses Ohatsu's leg to his neck to convey to her that he intends to take his own life. Kuheiji continues, saying that he will take care of Ohatsu after Tokubei dies, but Ohatsu quietly says that she would choose to die together with Tokubei.

Tokubei and Ohatsu slip away in the middle of the night just before a notice arrives from the oil shop Kuheiji works for. It says that the supposedly stolen seal has been found. With this information, Kuheiji's deeds are outed and Tokubei is proven innocent. Kyuemon, who hears this news, now reveals that he had intended to allow Tokubei and Ohatsu to be together, but it is too late. A note is found in Ohatsu's room, and the two are nowhere to be found.

03　The Woods of Sonezaki

This world ends
as does this night.
This fate of facing death,
if one should put it so,
is like the dew in a field
which disappears with each footstep.
How truly sorrowful is this dream within a dream

Count and you find
that the daybreak bell strikes six of seven.
The last is but this life—
the bell's echo, heard for the last time.

The two lovers arrive at the forest of Tenjin at Sonezaki and joyously vow to die together.

Somehow rumors spread
As though carried by the wind from Sonezaki forest.
People rich and poor
began to flock there
to pray for their own relationships,
as this story has become a paragon true love.

誰が告ぐるとは曽根崎の森の下風
音に聞こえ　取伝へ
貴賤群集の回向の種
未来成仏　疑いなき
恋の手本となりにけり

二人は死んで、自らの思いを成就させたのだった。

And so, the two fulfilled their heart's desire by dying together.

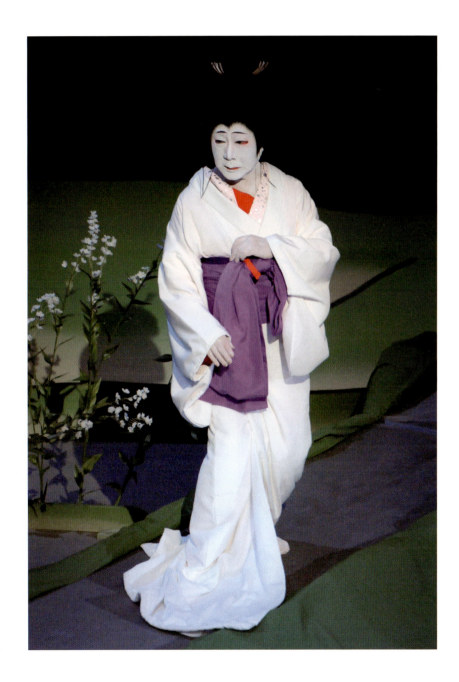

03　曽根崎の森
『曽根崎心中』 2014年4月
歌舞伎座
天満屋お初（四代目坂田藤十郎）

The Words of Sonezaki
The Love Suicides at Sonezaki
(Kabukiza Theatre, Apr. 2014)
Tenmaya Ohatsu (Sakata Tojuro IV)

作品の概要 / Overview

演目名 / Title

曽根崎心中

The Love Suicides at Sonezaki

作者 / Writer

近松門左衛門

Chikamatsu Monzaemon

概要 / Overview

近松門左衛門作の義太夫節の傑作として知られる。元禄16（1703）年5月大坂・竹本座で初演された。前月曽根崎で起きた心中事件を脚色したもので、最初の世話浄瑠璃であり、心中物流行のきっかけとなった作として、近世の戯曲の中で大きな意義を持っている。また、古来道行の文章も名文として知られている。初演後、さまざまな改作が生まれたが原作の上演は絶えた。歌舞伎でも改作は上演されているが、原作による歌舞伎化は行われなかった。現在上演されているのは、昭和28（1953）年8月、新橋演舞場において宇野信夫の脚色・演出で歌舞伎化されたもの。宇野の脚色は、改作版の内容を加え、道行なども適宜削除を加えるなど、原作そのままではないが、その香気を失わず、アレンジを加えている。舞台はお初を演じた二代目中村扇雀（現・坂田藤十郎）の清新な演技に加え、自らの愛の成就のために心中に赴くという二人の姿が、戦後の風潮にも合致し大当たり。以後上演を繰り返している。

Known as one of Chikamatsu Monzaemon's masterpieces of *gidayu-bushi*, The Love Suicides was first performed in May 1703 in Osaka's Takemotoza Theatre. Based on an actual incident that had taken place the previous month, this play was the first domestic drama written for the puppet theater, and became the impetus for the many love-suicide-themed works to come. Some lines from the michiyuki scene are especially well-known for their literary value.

Since its first performance, a number of altered versions of The Love Suicides have been written and the original script is no longer used in the puppet theater. The kabuki adaptation, too, is based on one of the altered scripts, and the original script has never been used in the kabuki theater. The current version is a kabuki adaptation of the script by Uno Nobuo which was first performed for the puppet theater in August, 1953. Uno made careful additions, as well as cuts to the michiyuki and other scenes, but maintained the essence of the original work. The refreshing performance of Nakamura Senjaku II (now Sakata Tojuro) as Ohatsu and the moving portrayal of the two faithful lovers who meet their end together perfectly tapped into the artistic preferences of post-war audiences. It has been performed regularly since then.

初演 / Premiere

昭和28（1953）年8月、新橋演舞場で、二世中村鴈治郎の徳兵衛、現・坂田藤十郎（当時二代目扇雀）のお初ほかで初演。宇野信夫脚色・演出。

Shinbashi Enbujo Theater, Aug. 1953. Nakamura Ganjiro II as Tokubei, Sakata Tojuro (then Nakamura Senjaku II) as Ohatsu, others, at debut. Script and production by Uno Nobuo.

登場人物 / Characters

天満屋お初
てんまやおはつ

天満屋の遊女で、醤油屋の手代の徳兵衛とは将来を誓い合った深い仲。その徳兵衛が友人の九平次の悪だくみによって金をだまし取られた上、大勢の前で散々に罵られ、心も体もすっかり傷ついている。天満屋に忍んでやって来た徳兵衛を床下に隠すが、九平次からはさらなる悪口雑言、一緒に死んであの世で結ばれようと互いの決心を固める。そしてその晩、ついに二人は曽根崎の森で心中する。

Tenmaya Ohatsu

A worker at the brothel Tenmaya, Ohatsu and Tokubei have vowed their lives to one another. Tokubei, however, is swindled by his friend Kuheiji and deeply humiliated in public. He sneaks into Tenmaya to see Ohatsu, but Kuheiji comes there and his reputation takes a further blow due to the slander being spread. Ohatsu and Tokubei, seeing little prospect of a happy life in this life, decide to commit suicide together so that they might be together in the next. And so, on that very night, the two make their way to the forest at Sonezaki and breathe their last together.

油屋九平次
あぶらやくへいじ

油屋の主人で徳兵衛はこの九平次を親友と思っていたが、九平次がお初に横恋慕しており、二人を心中に追いやる徹底した敵役。徳兵衛から借りた金を返さず、さらに借金証文の印判はすでに紛失の届けを出してありこれは偽物と徳兵衛を罵倒する。さらに天満屋にやって来てお初の前で徳兵衛の悪口を散々に言いふらすが、その後、紛失とされた印が奉行所に発見され計画的な悪があばかれる。

Aburaya Kuheiji

Kuheiji runs an oil shop and is supposedly Tokubei's friend. However, he is the villain of the story who harbors a strong desire for Ohatsu, and eventually leads her and Tokubei to their suicide. He refuses to repay his loan to Tokubei and ruins his reputation by claiming that his seal was stolen to forge the promissory note that Tokubei produces as proof of their transaction. Though Kuheiji slanders Tokubei in front of Ohatsu at the Tenmaya brothel, his evil deeds are eventually outed when the supposedly stolen seal is found at the magistrate's office.

天満屋惣兵衛
てんまやそうべえ

お初を抱えている天満屋の主人で温厚な人物。店先で徳兵衛の声を聞いてはいるものの、見て見ぬふりをして情と思いやりのあるところを見せる。しかしお初の部屋から書置きが見つかり、家の者に急いで後を追わせる。

Tenmaya Sobei

Sobei is the kind proprietor of Tenmaya where Ohatsu works. Though he hears Tokubei's voice as he sneaks into Tenmaya, he looks the other way and pretends not to hear. When he finds the suicide note left in Ohatsu's room later, he immediately have his clerk chase after them.

平野屋徳兵衛
ひらのやとくべえ

伯父の久右衛門が営む醤油屋の平野屋で手代として働いているが、天満屋のお初と深い仲になっているため伯父の勧める縁談を断ってしまう。その結納金の銀二貫目を切羽詰まっているという九平次に貸すが、催促するとそんな金は知らぬと開き直られた上に借金証文の印判も偽造と濡れ衣を着せられる。追い詰められた徳兵衛はお初と共に死ぬ覚悟を決め、あの世で必ず一緒になれると信じ合う。

Hiranoya Tokubei

Tokubei works as a clerk at his uncle Kyuemon's soy sauce shop. He is given a large sum of silver as dowry but refuses the bride his uncle offers due to his relationship with Ohatsu who works at Tenmaya. Though he must return this silver, he is pressured by his friend Kuheiji to loan it to him. When Tokubei requests Kuheiji repay his loan, however, he claims that he never took such a loan, claiming that the stamp on Tokubei's promissory note was forged. With his reputation ruined, Tokubei decides to commit suicide together with Ohatsu, convinced they can be together in the next life.

平野屋久右衛門
ひらのやきゅうえもん

徳兵衛の伯父で、醤油商いをする平野屋の主人。女房の姪と徳兵衛を夫婦にさせて店を継がせようと結納の金まで用意するが、徳兵衛はお初と深い仲ゆえにそれを断ってしまう。しかもその金を徳兵衛は、友人と信じた九平次に騙し取られてしまう。徳兵衛を案じ天満屋を訪ねた久右衛門は九平次の悪事をあばき折檻するが時すでに遅し、お初と徳兵衛の姿はなく、死ぬなよと一心に願うのみだった。

Hiranoya Kyuemon

Kyuemon is Tokubei's uncle who runs the soy sauce shop Hiranoya. He wishes for Tokubei to marry his wife's niece and take over the shop, going as far as to prepare a dowry of silver. Tokubei, who is in love with Ohatsu, refuses, but is tricked into lending the dowry money to his friend Kuheiji. Though Kyuemon eventually outs Kuheiji's deeds at Tenmaya, it is too late, as Tokubei and Ohatsu have already left. He can only pray that the two haven't died yet...

みどころ
Highlights

1. 作者は近松門左衛門
── Written by Chikamatsu Monzaemon

原作は近松門左衛門の世話浄瑠璃である。それまでは人形浄瑠璃は古典的な英雄を描く時代浄瑠璃ばかりだったが、本作は実際に起きてニュースになった心中事件を題材に書かれた。これが大評判となり、以後同時代を描いた作品が世話浄瑠璃と呼ばれるようになった。近松は、『冥土の飛脚』『心中天網島』『心中宵庚申』など心中物を次々書いた。冷静な目で人間を捉え、鋭く美しい文体で綴る近松作品は文学としても高く評価される。

The kabuki script is based on Chikamatsu Monzaemon's play for the puppet theater. Until this play, most puppet theater plays depicted historical events involving classical heroes, but this was the first play to touch on true contemporary events. With its success came more such plays, birthing a genre called *sewa-joruri* (domestic *joruri*). Chikamatsu went on to pen a number of plays involving love suicides. His works are highly regarded as works of literature that calmly examine and depicts the truths of people's lives.

2. 庶民が主人公
── A Commoner Protagonist

日本文学研究者ドナルド・キーンは、『曽根崎心中』が世界で初めて、悲劇の主人公に庶民を登場させたと指摘している。ギリシャ悲劇に代表されるように、それまでの悲劇は王侯貴族を主人公にしていた。ラシーヌもシェイクスピアも然りだ。しかし『曽根崎心中』の平野屋徳兵衛は醤油問屋の手代で、お初も新地の遊女。本作は普通の人の身の上に起こった悲劇である。それを生んだ大坂が市民社会として成熟していたとも言えるのだろう。

The American-born Japanese scholar Donald Keene has noted that *The Love Suicides* is the first play to ever feature commoners as protagonists. Greek drama and the plays of Shakespeare and Racine all notably featured royalty or nobility as their protagonists. *The Love Suicides*, however, stars Hirano Tokubei, a lowly shoyu shop clerk, and Ohatsu, a prostitute. It depicts a great tragedy which occurred among the common folk, and many say this play is part of why Osaka birthed so many companies owned by commoners.

3. 幕府が心中を罰する
── The Punishment for Love Suicide

心中は、元々相手に誠意を見せる約束を意味したが、後に共に自殺することを指すようになった。心中物が流行すると、追随して心中する者たちが出るようになった。仏教の俗説として「夫婦は二世（にせ）」の縁なので、この世で添えなくとも来世で添い遂げられると考えられていた。八代将軍吉宗はこれを問題とし、心中物の出版や上演禁止令を出した。心中者の遺骸は埋葬を禁じられ、野ざらしにされるなど厳しい法令が定められた。

The term *shinju* originally referred to a vow or promise, but later came to mean joint suicide. As dramas involving love suicides became popular, so rose the actual act of committing such a suicide among the people. In the past, it was believed that lovers were given two lives together, meaning that if things did not turn out well with your love in this life, you would surely be able to have a happy life in the next. Because of the shocking rise in love suicides at the time, the shogun forbade the production of plays relating to love suicide (*shinju-mono*). He also prohibited the burial of those who committed love suicide, forcing their bodies to be left out for everyone to see.

4. 第二次世界大戦後に、復活された — Revived After WWII

歌舞伎での復活は昭和28年新橋演舞場で、二世中村鴈治郎の徳兵衛に二代目中村扇雀（四代目坂田藤十郎）のお初。戦後の「新しい女」を描こうという機運のなかの復活であった。絶望する徳兵衛に、お初は寄り添い、心中しようと言う。ふたり手を取り合って逃げ出す場面で、ある時お初が徳兵衛の前に出て、自然に徳兵衛の手を取って花道を駆け込んだ。舞台は大評判となり、藤十郎のお初は上演1300回を超えることとなった。

The Love Suicides was revived in 1953 at Shinbashi Enbujo Theatre, starring Nakamura Ganjiro II as Tokubei and Nakamura Senjaku II as Ohatsu. This revival was part of a movement to depict the postwar "New Woman," a more individualistic ideal of womanhood. In The Love Suicides, we see Ohatsu approach the dejected Tokubei and suggest love suicide. In another scene, we see Ohatsu take Tokubei's hand and take the lead as they escape onto the *hanamichi*. The play became so popular that the great Tojuro is said to have played Ohatsu over 1,300 times.

5. 死ににゆく身をたとえるなら — The Fate of Facing One's Death

近松の道行場面の美文が名高い。「此の世のなごり　夜もなごり　死ににゆく身をたとうれば　あだしが原の道の霜　一足ずつにきえてゆく　ゆめのゆめこそあわれなれ」と綴って、暁近い森へ心中にゆくふたりの身の上を、すぐに消えゆく道の霜のはかなさに喩えている。また、ふたりが息絶えた後は「未来成仏うたがいなき　恋の手本となりにけり」と結んでいる。心中に憧れを抱く恋人たちが増えたのも無理はないと思われる。

Chikamatsu is known for writing beautiful lines for *michiyuki* scenes. The Love Suicides features a beautiful poem likening the lovers' fate to the fleeting dewdrops along the road: "This world ends / as does this night. / This fate of facing death, / if one should put it so, / is like the dew in a field / which disappears with each footstep. / how truly sorrowful is this dream within a dream." After the two pass away, this poem is concluded with the lines, "No doubt of nirvana in the next life. These two are a paragon of true love." It is easy to see how plays like this might lead to a rise in joint suicide rates.

伊勢音頭恋寝刃
Ise Ondo Koi no Netaba

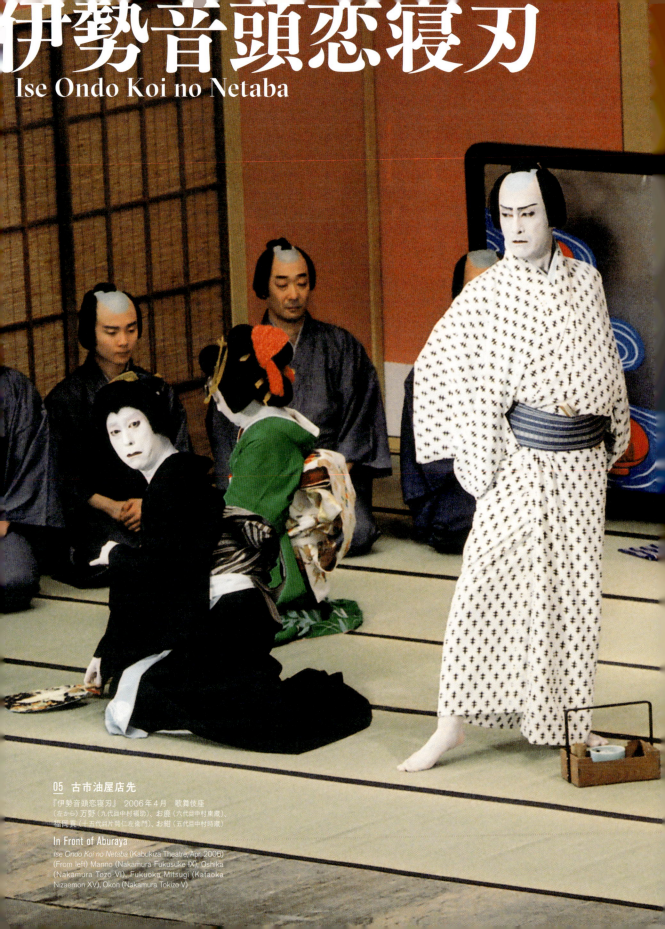

05 古市油屋店先
『伊勢音頭恋寝刃』 2006年4月 歌舞伎座
(左から) 万野 (九代目中村福助)、お鹿 (六代目中村東蔵)、
福岡貢 (十五代目片岡仁左衛門)、お紺 (五代目中村時蔵)

In Front of Aburaya
Ise Ondo Koi no Netaba (Kabukiza Theatre, Apr. 2006)
(From left) Manno (Nakamura Fukusuke IX), Oshika (Nakamura Tozo VI), Fukuoka Mitsugi (Kataoka Nizaemon XV), Okon (Nakamura Tokizo V)

あらすじ　　　　　　　　　　　　　　　Synopsis

すれ違う思惑・取り換えられた刀……。
真夏の観光地で起こった大量殺人事件の顛末

刀は手に入ったが、鑑定書がない！　焦る恋人のために女のとった行動は……。
恋の恨みか、満座の中で恥をかかされた怒りか、はたまた妖しい刀の力か。
真夏の夜に起こった惨劇。

━━ An anticipated meeting and a sword that was swapped... These are the circumstances of a terrible killing spree that happened in a popular tourist location.

The treasured sword has been retrieved, but without its certificate its worthless! That's when our hero's lover decides to act… Resentment at his lost love, or rage over his public disgrace--or yet again, was it merely the cursed sword's lust for blood? What truly happened that tragic summer night?

01　伊勢街道相の山

阿波の大名家の家老の息子今田万次郎は、名刀・青江下坂を献上するようにとの命を受けていたが、遊興にふけり、いったん手に入れた刀を質入れし、さらに折紙（おりかみ・鑑定書）まで騙し取られてしまう。

02　妙見町宿場

万次郎の父から命を受けた藤浪左膳は、御師の福岡貢に首尾よく刀を取り戻すよう依頼する。阿波の家中ではお家騒動が起こっており、当主の伯父大学がお家を乗っ取ろうとしている。折紙を奪ったのも大学の家来徳島岩次の一味である。

03　野道追駈け / 野原地蔵前 / 二見ヶ浦

奴の林平が、岩次にあてた大学の書状をめぐり、岩次の家来と争う。悪事の証拠となる手紙は最後に貢の手に入る。

04　御師福岡孫太夫内太々講

貢は、叔母の尽力で青江下坂の刀を手に入れることができた。

01　On a Road in Ai no Yama, Ise

Imada Manjiro, son of Awa Daimyo elder retainer, is ordered to bring the famed blade Aoe Shimosaka. Squandering his money in the pleasure quarters, however, he racks up so much debt that he must pawn the sword. He is then tricked and the certificate of authenticity for the sword is also taken from him.

02　The Inn in Myokencho

Daigaku, the uncle of the current Awa clan leader, is plotting to seize power from his nephew and has made Tokushima Iwaji steal the treasured sword. Fujinami Sazen, under the Awa Daimyo's order, employs Fukuoka Mitsugi to help return the lost sword.

03　Pursuit Through the Fields / Before the Jizo Statue / Futami Bay

The servant Rinpei fights with Iwaji's retainer over a letter from Daigaku to Iwaji. This letter, which is evidence of their evil deeds, eventually finds its way into Mitsugi's hands.

04　The Ise Priest

Mitsugi is finally able to secure the sword Aoe Shimosaka thanks to his aunt's painstaking efforts.

05　古市油屋店先

　伊勢古市の遊郭油屋。貢が腰に青江下坂の刀を差し、万次郎の行方を捜しにきた。万次郎とは入れ違いだったため、貢は油屋で万次郎を待つことにする。

　また、油屋に逗留している徳島岩次と阿波の商人藍玉屋北六が馴染みのお紺と、万次郎の馴染みのお岸を今日明日にも身請けしようとしていることを聞く。

　そこへ仲居の万野が出てくる。普段から邪険な万野は、貢の馴染みのお紺は今日は都合が悪いので代わりを呼ぶように無理強い、さらに貢の刀を預かろうという。青江下坂を預けてはと貢が困っていると、料理人の喜助が自分が刀を預かると申し出る。喜助は貢の親に中間奉公していた者。貢は、喜助に今預けた刀が青江下坂であり、紛失した折紙も油屋に逗留している岩次とその一行が持っているらしいと言い聞かせる。この話を聞いていた岩次はひそかに貢の刀と自分の刀の刀身を入れ替えた。この様子を陰で見ていた喜助は、貢に帰りに誤ったふりで岩次の刀を渡すことにした。

　万野の言いつけで代わりとしてお鹿が来る。お鹿は今まで貢に何度も恋文を送り、文で言われるままに金まで渡したという。貢には一向に覚えがないが、仲立ちをし、金を渡したのは万野だと聞き、万野を呼び出す。だが万野も金は貢に手渡したと言い張り、貢に恥をかかせる。

　さらに、その様子を見ていたお紺は岩次や北六の前で貢に愛想尽かしをする。満座の中で恥をかいた貢は油屋を去るが、去り際に喜助が刀を貢に渡す。喜助の渡した刀は岩次の刀、すなわち中身は青江下坂である。貢は万次郎を訪ねに走り去った。

　お紺が貢と縁を切るのを見ていた岩次たちは、阿波の侍徳島岩次と名乗っていたのはじつは藍玉屋北六、北六というのがじつは徳島岩次であったとあかす。お紺は岩次じつは北六に、懐中の祓紗の中身を問う。それは青江下坂の折紙で、その詮議のため、お紺は心にもない愛想尽かしをしたのだ。

　万野が現れ、喜助が間違えて岩次の刀を貢に渡したと告げる。青江下坂が手に入ったと万野と岩次は喜ぶが、刀の中身を取り替えていた北六は仰天。万野は喜助に刀を取り戻すよう言いつける。しかし喜助が貢の家来筋だと思い出した万野は、その喜助のあとを大急ぎで追ってゆく。

　入れ違いに、刀が違うのに気づいた貢が戻ってくる。刀の中身が替わったことを知らない貢は、刀を手に戻ってきた万野と争う。貢が鞘で万野を叩くと、鞘が割れ万野を切ってしまう。騒ぐ万野を一刀のもとに切った貢は、さらに何かに取

05　In Front of Aburaya

Mitsugi searches for Manjiro at Aburaya in the pleasure district, the blade Shimosaka worn at his waist. Having arrived just as Manjiro was leaving, Mitsugi decides to wait for Manjiro in the brothel.

While he waits, Mitsugi hears that Iwaji and Aidamaya Kitaroku (a merchant from Awa) are planning on buying Okon and Okishi, who work at the brothel and are close to Mitsugi and Manjiro, out of their service at Aburaya.

The rather cold waitress Manno comes to Mitsugi and tells him that his usual girl Okon is unavailable and that he must choose a different girl if he wishes to stay at Aburaya. She also attempts to take his sword to look after, but Mitsugi refuses. Kisuke, the cook and a former servant of Mitsugi's father, comes forward and offers to look after the sword. Afterward, Mitsugi tells Kisuke that the sword is Shimosaka, and that Iwaji and his men have its certificate of authenticity. Iwaji, however, overhears their conversation, and later replaces the blade of his sword with Shimosaka. When Mitsugi leaves, however, Kisuke, who knows the blades have been switched, gives him Shimosaka, which is now in Iwaji's scabbard and fittings.

A girl named Oshika comes to Mitsugi at Manno's request. She claims that she has exchanged love letters with Mitsugi and even given him money when he asked for it. Mitsugi, however, has no recollection of this. Hearing that Manno was the go-between who took the money from Oshika, Mitsugi calls her over, but she reprimands him for forgetting about the money she herself passed along to him.

After this, Okon, who had close relations with Mitsugi before, expresses her disgust at Mitsugi for his callousness in front of Iwaji, Kitaroku, and the other patrons of Aburaya. Deeply shamed by this turn of events, Mitsugi leaves to find Manjiro after retrieving his sword from Kisuke. The sword he is given, though fitted to look like Iwaji's, is actually Shimosaka.

After this it is revealed that the Awa samurai Tokushima Iwaji and Aidama Kitaroku have been impersonating each other. Okon then takes a look at a silk wrapper that Iwaji (actually Kitaroku) has been carrying and finds Shimosaka's certificate of authenticity. Okon's true intention was not to break up with Mitsugi, but to help him by finding this certificate.

Just then Manno appears and claims that Kisuke mistakenly gave Mitsugi Iwaji's sword. She and Iwaji then rejoice, believing that they have obtained the famed blade Shimosaka. Kitaroku, however, is at his wit's end because he is the one who switched the blades. Manno then suddenly remembers that Kisuke was a retainer for Mitsugi's family and chases after him in a hurry.

Unaware the blades have been switched, Mitsugi then returns to Aburaya. He runs into Manno and strikes her with his sheathed sword. The force of the blow, however,

り憑かれたように人々を斬っていく。

06 油屋奥庭

　芸妓たちが賑やかに伊勢音頭を踊る油屋の奥座敷。その庭先に血刀を持った貢が姿を現わす。追ってきたお紺の言葉に我に返った貢。そこへ喜助が駆けつけ、手に持つ刀こそ青江下坂だと告げ、ようやく刀と折紙の二品が揃ったのであった。

breaks the sheath and Manno is killed. After this Mitsugi is suddenly possessed by a strange force and begins killing people at indiscriminately.

06　Aburaya's Inner Courtyard

　The geisha perform the lively Ise Ondo dance in Aburaya's inner parlor. Mitsugi suddenly appears beyond the courtyard, sword drawn, but is brought back to himself after hearing Okon's voice. Kisuke then comes running in, declaring that Mitsugi is holding the true Aoe Shimosaka blade. With this, the blade and its certificate are finally reunited, marking the completion of Mitsugi's task.

05　古市油屋店先
『伊勢音頭恋寝刃』2006年4月
大阪松竹座
お紺（五代目中村時蔵）

In Front of Aburaya
Ise Ondo Koi no Netaba
(Osaka Shochikuza Theatre, Apr. 2006)
Okon (Nakamura Tokizo V)

作品の概要

演目名
伊勢音頭恋寝刃

作者
近松徳三

概要

　寛政8(1796)年5月に伊勢古市の遊廓で殺人事件が起こった。その事件を題材にして、二ヶ月後に大坂で上演された演目。話題の事件を当て込んだ、こうした作品は際物(きわもの)とよばれ、後世に残らないのがほとんどであるが、本作は、さまざまな要因から現在まで上演されている。一つには、当時の庶民の憧れでもあった伊勢参りに関わる場所や風物を取り上げたことがある。典型的な縁切り物で、ありふれた構成といわれるが、展開にうまく伊勢の名所や風物を織り交ぜ、お家騒動の筋が進んでいく。典型のもつ、安定した面白さも今や貴重である。登場人物が、それぞれ涼しげな夏衣裳で登場する季節感あふれる夏芝居の代表作でもある。

　四幕七場のうち、三幕目の油屋から奥庭に至る、二場が独立してよく上演される。愛想尽かしと殺しの場面である。通し狂言として前の場面も上演される。「青江下坂」という妖刀と折紙(おりかみ・鑑定書)を巡る、お家騒動の筋がよくわかる。あらすじは奥庭までの各場面の概略を示した。

初演

　寛政8(1796)年7月大坂・角(かど)の芝居で二世中山文七の福岡貢ほかで初演。近松徳三作。通称「伊勢音頭」。

Overview

Title
Ise Ondo Koi no Netaba

Writer
Chikamatsu Tokuzo

Overview

　This play was based on an actual murder that took place in Old Ise in May 1796, and debuted in Osaka two months after the event. Such pieces based on contemporary events are called Kiwamono, and most of them have been lost. Ise Ondo, however, has endured for a number of reasons. One reason is that it featured the setting of Ise, a city many people at the time revered. Though sometimes criticized for its hackneyed plot and structure, the play masterfully takes audiences through the plot of a family feud while showing the most famous parts of Ise. It's typical plot and simplicity are part of what people love about Ise Ondo now. With characters wearing cool summer clothes, it has become a staple show of the summer season.

　Ise Ondo was originally in four acts and seven scenes. Now, however, the Aburaya and Inner Courtyard scenes (Okon's disownment of Mitsugi and the killing spree) are often played on their own. The previous scenes are sometimes played as *toshi-kyogen*. The family feud involving the enchanted sword and the certificate of authenticity is well-known to audiences, and our synopsis summarizes everything that happens up to the inner courtyard scene.

Premiere

First performed in Osaka in July 1796. Feat. Nakayama Bunshichi II as Fukaoka Mitsugi. Written by Chikamatsu Tokuzo. Commonly known as "Ise Ondo."

登場人物 / Characters

福岡貢
ふくおかみつぎ

元は武士で今田家に仕えていたが、養子に行き伊勢神宮の御師（おんし＝下級の神官で旅の世話などもする）となっている。主君の子息である今田万次郎のため名刀・青江下坂を捜し出したが、折紙（鑑定書）がまだ手に入らない。一方、伊勢古市の遊女で貢の恋人お紺は店の客からその折紙を入手するため貢に偽りの愛想尽かしをするが、真意を知らぬ貢は逆上し青江下坂で大勢を殺してしまう。

Fukuoka Mitsugi

A former samurai in the service of the Imada family, Fukuoka Mitsugi was adopted by the head priest of the Ise Shrine and now serves as a low-level priest there. He undertook the task of finding the famed sword Aoe Shimosaka but failed to find the certificate of authenticity which proves its worth. When his lover Okon, a prostitute in Ise, breaks up with him, he goes into a killing frenzy, unaware that Okon was only acting in order to get the certificate for him.

万野
まんの

古市の遊郭油屋の仲居で意地の悪い性格の持ち主。阿波の侍・徳島岩次が悪事を企むのに加担し、北六がお紺に横恋慕しているのも手助けしてお紺と貢との仲を裂こうと画策する。さらに貢に惚れている遊女のお鹿をだまし偽の手紙を使って金を横取りした上、貢を満座の中でさんざんになぶってさらし者にする。青江下坂を貢から奪おうと奔走するが、ついにはその妖刀で斬られてしまう。

Manno

Manno is a mean-spirited waitress working at the brothel Aburaya. She conspires with the Awa samurai Iwaji as well as helping Kitaroku in his pursuit of Mitsugi's lover Okon. She also tricks the prostitute Oshika with fake love letters from Mitsugi to get money from her, then uses it to disgrace Mitsugi in front of a full house at Aburaya. Her final sin is helping to steal the sword Shimosaka, but in the end she is cut down by this very blade.

お鹿
おしか

油屋の遊女だが容姿が醜く一向に客がつかない。しかし気持ちはやさしく気立てのよい女性で貢にはかねてから心を寄せている。それを万野に利用され、貢からという偽の手紙に踊らされて金を次から次と万野に騙し取られてしまう。たまたま夜更けに起き出したのも不運、青江下坂を手にした貢に斬られてしまう。

Oshika

A prostitute of the brothel Aburaya whose plain looks have kept all customers away from her. She is nonetheless a kind and gentle woman who has loved Mitsugi for some time. Manno uses these feelings to forge love letters from Mitsugi to Oshika, acting as go-between to take money from her. Oshika is unlucky until the very end, waking late at night during Mitsugi's killing spree and dying at his blood-crazed blade.

お紺
おこん

伊勢古市の遊女で、福岡貢とは深い仲。貢がようやく探し出した名刀・青江下坂も折紙が無くてはならず、その折紙を自分に言い寄ってくる店の客の徳島岩次が持っていることがわかり、お紺はそれを手に入れるため岩次になびいたように見せかけ、貢には心ならずもうわべの愛想尽かしをする。貢は大勢の人を殺しお紺にも刃を向けるが、お紺が折紙を差し出してようやく我に返る。

Okon

A prostitute in Ise, Okon is very close to Mitsugi. She finds out that her regular customer Tokushima Iwaji has the certificate of authenticity that Mitsugi is searching for, and schemes to get it for him. To do this, she pretends she does not love Mitsugi anymore, which causes him to lose his mind in a killing spree. Finally, he turns his blade to Okon, but she brings him back to his sense by showing him the certificate which she succeeded in retrieving.

喜助
きすけ

油屋の料理人だが、かつて亡父が福岡貢の親に仕えていたため、今でも貢に忠誠を尽くす実直な人物。廊の習いで客の刀は店が預かる決まりだが、喜助が機転を利かして貢の青江下坂を預かり、それを別の刀とすり替えた岩次の裏をかいて無事に刀を守る。貢が刀を紛失し多くの人を殺めて失意のところ、喜助が駆け付けて本物の青江下坂であると告げ、早く国表へと勇気付ける。

Kisuke

A former servant in the service of Mitsugi's father, Kisuke currently works at a cook at Aburaya. He is an honest man who remains faithful to Mitsugi. He uses his wit to take charge of Mitsugi's sword, Shimosaka, which he then witnesses Iwaji replacing with a false blade. Kisuke is therefore able to give Mitsugi the correct blade when he leaves to keep it from Iwaji's hands. Mitsugi believes this is not the same blade, however, and he subsequently goes on a killing spree. Kisuke finally appears after Mitsugi has killed many people and tells him that the blade is actually Shimosaka, finally encouraging him to return home.

今田万次郎
いまだまんじろう

阿波の家老・今田九郎右衛門の嫡子だが、国の横領を企む一味の誘いに乗り、国主から預かった大切な名刀の青江下坂を遊ぶ金欲しさに質に入れてしまったり、その折紙（鑑定書）をだまし取られたりと頼りなく情けない人物である。その刀も福岡貢によってようよう見つけ出されるが残るは折紙、貢は刀と折紙を揃えて万次郎に渡すため苦労を惜しまず忠誠を尽くしている。

Imada Manjiro

Son of the Awa retainer Imada Kuroemon, Manjiro is a pathetic character who receives the famed sword Aoe Shimosaka from the local daimyo but then loses it. Accepting an invitation to the pleasure quarters from men plotting to seize power, he accumulates so much debt that he must pawn the sword to pay it. To top this, he is further tricked into giving up the certificate of authenticity. He charges the faithful Fukuoka Mitsugi with finding the sword and certificate, and due to his hard work finally takes them back.

お岸
おきし

伊勢古市の油屋の遊女で今田万次郎とは恋仲、またお紺の妹分のような存在である。放蕩を繰り返す万次郎の身を案じ、福岡貢とも打ち解けて優しい気立ての持ち主。

Okishi
Prostitute at Aburaya and Manjiro's lover, Okon looks up to Okon like an older sister. She is a kind woman who confides in Mitsugi about Manjiro who has been spending too much time in the pleasure quarters.

藍玉屋北六
あいだまやきたろく

徳島岩次のところへ出入りする商人で、国の横領を企む一味に加担している。岩次と共に伊勢古市にやってきているが、人目への用心から互いの名を交換し、当初は侍のふりをして徳島岩次としてふるまっている。古市油屋ではお紺に惚れ、そのお紺が女房になるという巧みな誘導でつい折紙をお紺の手に渡してしまう。

Aidamaya Kitaroku
A merchant who often does business with Iwaji and helps in the plot to seize power. He comes to Ise with Iwaji, and the two use each other's names to hide their identities. Because of this, at first Kitaroku acts as a samurai even though he is a merchant. He falls in love with Okon and is tricked by her into handing over the certificate of authenticity for the blade Shimosaka.

徳島岩次
とくしまいわじ

阿波の国の横領をたくらむ蜂須賀大学に加担する国侍で、青江下坂を手に入れるため伊勢の古市に来ている。今田万次郎と恋仲の油屋お岸に横恋慕しており、その油屋で貢が持っていた刀が青江下坂と知り、刀の中身をすり替えてまんまと手に入れる細工をする。この地では同行している町人の藍玉屋北六と互いの名を入れ替えて人目をくらましているので、町人から武士へと演技が変わる。

Tokushima Iwaji
A samurai who joins in Hachisuka Daigaku's plot to seize power, Tokushima Iwaji comes to Ise to steal the sword Aoe Shimosaka. He is in love with Okishi who is in love with Manjiro, and when he finds out Shimosaka has been brought to Aburaya, he swaps the blade with his own, placing the fittings of his own sword on it to fool others. He and the merchant Aidamaya Kitaroku swap names so that the character of Iwaji goes from playing as a merchant to a samurai in a very versatile performance.

林平
りんぺい

今田万次郎に従う奴（やっこ）で忠義心が強く一本気な性格。世に疎い万次郎を守って伊勢へ向かい、紛失した青江下坂の探索に専心するが、悪人たちと追いつ追われつの大立廻りを演じる。その過程で密書を手に入れ、二見ヶ浦で貢の手へと渡す。

Rinpei
Rinpei is a single-minded and faithful servant in Manjiro's service. He comes to Ise to protect Manjiro and dedicates himself to the task of retrieving the lost sword Shimosaka. This results in a great cat-and-mouse fight scene that ends with him getting hold of a secret letter with evidence against the villains which he finally gives to Mitsugi at Futami Bay.

みどころ
Highlights

1. お伊勢参りと御師
── The Ise Pilgrimage and the *Oshi* Priests

お伊勢さんと親しまれる伊勢神宮の人気は今も大変なものである。幕藩体制の江戸時代、庶民が旅行することはなかなかむずかしいことだったが、お伊勢参りにかぎり大目に見られていた。各地で伊勢参りのための講を組織し年中伊勢参りが行われていた。現地の伊勢では御師（おんし）と呼ばれる人々が宿の手配や案内なども引き受けていた。御師は言わば頼りになる団体旅行の添乗員みたいな存在だった。福岡貢はその御師であった。

The popularity of Ise Shrine survives to this day. During the Edo Period, when travelling was made quite difficult by the oppressive shogunate, people still made painstaking efforts to make the Ise Pilgrimage every year. Each region had special organizations that would help make the pilgrimage possible, and the *Oshi* priests of Ise would help the pilgrims make arrangements for lodgings and generally guide them around town like modern-day tour guides. The character Fukuoka Mitsugi is an *Oshi* priest.

2. 実説は医者の騒動
── Based on a Contemporary Incident

伊勢神宮の外宮と内宮は5.5kmほど離れている。その中間の宿としてかつて古市の町が栄えていた。遊女たちによる伊勢音頭（川崎音頭ともいう）という揃いの踊りを見せるのが名物だった。寛政8（1796）年5月医者の孫福齋（まごふくいつき）が、古市の遊女や客たちに斬りつけた事件があり、同年に舞台化された。事件をすぐに脚色することを際物（きわもの）という。古市には現在旅館は一軒のみだが、芝居と同じ二階廊下が残っている。

The outer and inner shrine of Ise are 5.5 kilometers apart. Between the two existed a thriving town where geisha would dance the *Ise Ondo* (also called *Kawasaki Ondo*) in a popular local event. In 1797 a doctor named Magofuku Itsuki attempted to murder a geisha in this town, an event that was immediately dramatized. This type of play, based on contemporary events, is called *kiwamono*. There is now only a single Japanese hotel left in the old town, though it has a second-floor hallway just like the one shown in the play.

3. ぴんとこな —— The *Pintokona* Role

物柔らかな風情のなかに、どこかぴんと芯が通っているような美男のタイプを、歌舞伎では「ぴんとこな」という。福岡貢がその典型的な役だ。上方芝居のモテ男の代表「つっころばし」は、突けば転びそうなほどなよなよっとしたシティーボーイだが、「ぴんとこな」は転ぶ心配はなさそうな、きりっとした感じ。普段はおっとり優しく身構えているのだが、一端プライドを傷つけられたりすると自制心を失って、切れてしまうので要注意。

Pintokona refers to the role of handsome man who has both a soft and gentle side while maintaining a strong resolution. Fukuoka Mitsugi is a typical example of this type of role. *Pintokona* characters are cautious and smart, which contrasts with *Tsukkorobashi* (the handsome and reckless city boy) characters common in Kamigata plays. Though normally slow to anger, a *pintokona* character is quick to act when they have been insulted.

4. 愛想尽かしが山場 —— The Climactic Rejection Scene

福岡貢は恋仲のお紺から愛想尽かしを言われ、次第に怒りで顔を紅潮させていく。貢は元主家の若君のために刀を取り戻そうと必死で奔走している。その最中に、突然に恋人からの縁切り話。貢にしてみれば、あまりに唐突な出来事なのだ。その裏に訳があるなどと夢にも思わない。納得できない貢を真ん中に、居並ぶ女たちがあれこれ騒ぎ立てる山場は、見ようによっては女たちが寄り集まって貢ひとりをだますかのよう。巧みな芝居運びだ。

Fukuoka Mitsugi is deeply enraged when his lover Okon rejects him in public. This happens as he frantically searches for a sword to return to his master, and it isn't difficult to imagine how shocking and sudden it must seem to him. Embarrassed in front of all the other busy geisha and customers, he struggles within his mind to make sense of what has happened in the truly tremendous climax of *Ise Ondo*.

仲居の手管 —— The Wily Waitress

仲居の万野は不思議な魅力を持った敵役の女である。黒紗の着物をすっきりと着こなし、容易に本心がつかめない不気味さがある。酸いも甘いもかみ分けた熟女の落ち着きがある。客と遊女との仲を取り持つ立場を利用してひそかに私腹を肥やし、それが知られても動じることなく、なめらかな口先で相手を煙に巻く。その悪女の魅力がたっぷりあると、貢の刃にかかる場面が引き立つ。立女方が演じることも、立役が出て演じることもある。

The waitress Manno possesses monstrous powers of duplicity. Wearing black robes, her mannerisms leave her oddly unreadable, maintaining the calm of a matured woman that somehow mixed sweetness with acidity. Though she uses her proximity to the working girls for her own profit, she doesn't bat an eyelash at being found out, confusing her accuser with her silver tongue. This tantalizing duplicity makes the scene in which she dies upon Mitsugi's blade even more satisfying. She is often played by either *tateoyama* or *tachiyaku* leading men.

夏祭浪花鑑
Natsumatsuri Naniwa Kagami

05　長町裏殺し

『夏祭浪花鑑』　2011年6月　新橋演舞場
（左から）団七九郎兵衛（二代目中村吉右衛門）、三河屋義平次（四代目市川段四郎）

An Alleyway in Nagamachi
Natsumatsuri Naniwa Kagami
(Shinbashi Enbujo Theatre, Jun, 2011)
(From left) Danshichi Kurobei (Nakamura Kichiemon II), Mikawaya Giheiji (Ichikawa Danshiro IV)

あらすじ / Synopsis

悪い人でも舅は親……。
油照りといわれる夏の大坂。祭り囃子の聞こえる中、夕闇の町のはずれで起こる舅殺し。
数ある歌舞伎の「殺し場」の中の白眉

恩人の息子のために立てぬく意気地。兄弟分を舅殺しの大罪から救おうと苦心する友情。個性あふれる男たち、そして女たちもまた熱い……。大坂を舞台にした、大坂人の心意気を描く名作。

A young man murders his own evil stepfather in the oppressive heat of an Osaka summer... This is one of the finest examples of murder scenes in the kabuki theater.

The loyalty to protect the son of an old benefactor, and to save a sworn brother from punishment after killing his stepfather… Both men and women show the spectacular spirit of Osaka in this riveting play.

01 お鯛茶屋

和泉国浜田家の侍玉島兵太夫の息子磯之丞は、遊女琴浦を身請けし、堺の「お鯛茶屋」で大鳥佐賀右衛門らと連日連夜遊興にふけっている。佐賀右衛門は琴浦に横恋慕、邪魔な磯之丞を失脚させようとしているのだ。以前玉島家に奉公していたお梶は、居合わせた一寸徳兵衛に遊びが過ぎて乞食にまで落ちぶれたという身の上話をさせる。その話を聞いた磯之丞は家に帰ることにする。

02 住吉鳥居前

お梶の夫団七は堺で魚屋をしている。ある時喧嘩で人を死なせ、牢に入れられるが、兵太夫の力で死罪をまぬかれた。団七の出牢の日、お梶は息子市松をつれ、老俠客の釣船三婦とともに、住吉神社の鳥居前まで迎えにやってくる。お梶母子が神社に参詣しているあいだに、三婦は駕籠に乗ってきた磯之丞が、駕籠かきのこっぱの権となまこの八に法外な値を要求されているのを助ける。磯之丞は親兵太夫から勘当を受けてしまっていた。

01 Otai Teahouse

Tamashima Isonojo, the son of a samurai in the service of the Hamada house in Izumi, has redeemed his love Kotoura from her contract as a geisha and has spent many days and nights in the pleasure quarters with Ohtori Sagaemon and his friends. Sagaemon is also in love with Kotoura, and is actually trying to get Isonojo out of the way by ruining his reputation. Seeing this, Okaji, a woman who once served the Tamashima house, has Issun Tokubei recount the story of how he lost everything and became a beggar due to his life spent in the pleasure quarters. Isonojo listens to the story and decides to go home.

02 Before the Torii Gate

Okaji's husband Danshichi makes a living selling fish. He was imprisoned for a time for killing a man during a heated quarrel, but escaped the death penalty through Heidayu's good graces. Okaji, her son, and the elderly Tsurifune no Sabu go to the Sumiyoshi Shrine gate to meet him on the day of his release. While Okaji goes to make an offering at the shrine, Sabu sees two palanquin drivers attempting to extort Isonojo, who has been disinherited by his father Heidayu and doesn't have the money to pay. Sabu steps in and saves him.

出牢した団七は、兵太夫の恩を思い、磯之丞のことは何があっても世話をすると心に決める。また、磯之丞を慕って来た琴浦が、佐賀右衛門に捕まりそうになるのを救う。やがてこっぱの権となまこの八を従え、佐賀右衛門の命を受けた一寸徳兵衛が団七に言い掛かりをつけ、喧嘩になる。お梶が止めに入ると夫の喧嘩の相手はお鯛茶屋の徳兵衛。話のうちに徳兵衛も兵太夫の家来筋であることがわかり、団七と徳兵衛は互いの片袖を取り交わし、義兄弟の契りを交わす。

03　内本町道具屋〜南横堀浜側番小屋

磯之丞は清七と名乗り、団七の世話で内本町の道具屋の手代となった。清七は主人の娘お中と恋仲になる。また、団七の舅の義平次の悪だくみに巻き込まれ殺人を犯すが、三婦に助けられる。

04　釣船三婦内

高津神社の夏祭りの宵宮の日。琴浦と磯之丞は三婦の家に匿われている。

三婦の女房おつぎが、鉄弓で魚を焼いていると、徳兵衛の女房お辰が訪ねてくる。徳兵衛の故郷備中玉島に帰るのでその挨拶に来たのである。三婦の女房おつぎはよい折とお辰に磯之丞を同道して欲しいと頼み、お辰は快諾する。しかし三婦は、美しいお辰に若い磯之丞は預けられぬと止める。するとお辰は、自分の顔に焼けた鉄弓を当て、自ら傷を作り心意気を示す。感心した三婦は磯之丞を預けることにする。

そこにこっぱの権となまこの八が、琴浦を連れ去ろうとやってくる。三婦は二人の手をねじ上げ、喧嘩に出かける。

そこへ義平次がやって来て、団七の使いといつわり、琴浦を駕籠で連れ去る。また、磯之丞もお辰とともに玉島に下っていく。

やがて三婦とつれだって団七と徳兵衛が帰ってくる。義平次の話を聞いた団七は、琴浦を佐賀右衛門に売ろうとする舅の悪だくみと心づき、阻止するため大急ぎで後を追う。

05　長町裏殺し

長町裏で義平次に追いついた団七は、琴浦を返すよう懇願するが、義平次は聞き入れない。団七は琴浦を返せば今持ち合わせている金三十両を渡すと説得し、琴浦の駕籠は三婦の家へ戻された。しかし団七に金があるはずもなく、怒った義平次は、団七をさんざん罵倒する。団七が耐えかねて刀に手をかけると、義平次は刀を抜き、斬ってみろと挑発する。舅

Danshichi is released and, remembering a debt of gratitude he owes to Heidayu, resolves to help Isonojo. He saves Isonojo's lover from Sagaemon's clutches, and gets into a fight with Issun Tokubei, who is working for Sagaemon. Okaji, however, mediates and points out that Tokubei works for Otai Tea House and has ties to Heidayu, just like Danshichi. The two then make up and swear an oath of brothership.

03　The Shop in Uchihonmachi

Isonojo is now working at a curio shop in Uchihonmachi under an alias thanks to Danshichi's help. There he becomes involved with the shop owner's daughter Onaka. Later, as he again becomes embroiled in Giheiji's evil plots, he commits murder but is once again saved, this time by Sabu.

04　At Tsurifune Sabu's home

On the eve of the summer festival at Kozu Shrine, Kotoura and Isonojo are both hiding out in Sabu's house. As Sabu's wife Otsugi is cooking, Tokubei's wife Otatsu arrives at the house. She has come to tell Tokubei that she will be returning to her hometown of Bicchu Tamashima, and Otsugi sees this as an excellent opportunity to have Isonojo go with her. Otatsu agrees immediately, but Sabu dissents, saying that it is dangerous for a young man and a beautiful woman to travel together. Otatsu then takes the iron Otsugi was cooking with and burns her face with it to show that her looks don't matter. An impressed Sabu then allows Isonojo to travel with her.

Just then, the palanquin bearers from before arrive to take Kotoura away, but they are driven away by Sabu, who twists their arms and drags them away from the house. While he is gone, however, Giheiji arrives, claiming to be Danshichi's servant, and takes Kotoura away in his palanquin. Meanwhile, Isonojo and Otatsu have left for Tamashima.

Sabu returns with Danshichi and Tokubei, and the three hear about what has happened. Realizing that Danshichi's evil stepfather may be planning to sell Kotoura to Sagaemon, Danshichi hurries to rescue her.

05　An Alleyway in Nagamachi

Danshichi has followed Giheiji to a back alley in Nagamachi and asks that he return Kotoura. Giheiji of course refuses, but Danshichi offers all the money he has on him in exchange for her. His negotiation succeeds and he safely retrieves Kotoura, but Giheiji soon realizes he has been swindled by Danshichi, who of course has no money. The enraged Giheiji then slanders Danshichi and eventually the two draw swords. Giheiji taunts Danshichi, but, realizing what a grave crime it is to murder a stepfather, he attempts to disarm Giheiji. In the scuffle he accidentally cuts Giheiji, and, having no choice now but to finish the job, kills his stepfather. Throwing the body in a nearby pond and washing himself off, he slips away into the festival crowd.

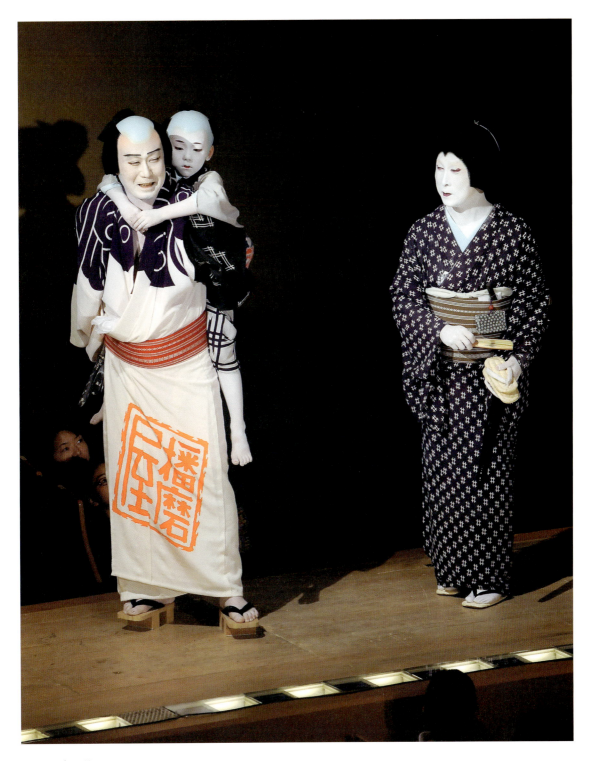

02 住吉鳥居前
『夏祭浪花鑑』 2011年6月 新橋演舞場
（左から）団七九郎兵衛（二代目中村吉右衛門）、市松（四代目松本金太郎）、お梶（七代目中村芝雀）

Before the Torii Gate
Natsumatsuri Naniwa Kagami (Shinbashi Enbujo Theatre, Jun. 2011)
(From left) Danshichi Kurobei (Nakamura Kichiemon II), Ichimatsu (Matsumoto Kintaro IV), Okaji (Nakamura Shibajaku VII)

殺しは重罪である。刀をもぎ取ろうと争うはずみに、誤って団七は義平次に傷をつける。親殺だと騒ぎ立てる義平次。もはやこれまでと心を決めた団七は義平次を殺害する。死骸を池に捨て、井戸で身体を洗うと、通りかかった宵宮の御輿の人混みに紛れ、逃げていく。

06　田島町九郎兵衛内〜同屋根上

　団七の家に玉島に帰る徳兵衛が来て、団七も一緒にと誘う。長町裏で団七の雪駄を拾った徳兵衛は、団七が義平次を殺したと察していた。さらにその罪を引き受けようとするが、団七は取り合わない。そこで徳兵衛はわざとお梶に不義をしかけ、団七を怒らせる。互いに取り換えた片袖を投げ捨て争う二人。仲裁に入った三婦のはからいでお梶は離縁される。団七とお梶が別れれば舅殺しの罪にはならず、妻子に難が及ぶこともない。徳兵衛も三婦も団七のことを思っての行動だった。そこに捕手がやってくる。徳兵衛は団七捕縛を申し出て、屋根上で団七を捕える。しかし路銀を首にかけ、見逃してやるのだった。

06　Danshichi's Home in Tajimacho

Tokubei meanwhile has found Danshichi's sandals in the alleyway where the murder took place and guessed what happened. He arrives at Danshichi's house and invites him to go with him to Tamashima. Tokubei furthermore offers to take the fall for the murder, but Danshichi will not hear it. Tokubei decides to trick Okaji into an act of infidelity, thus angering Danshichi and causing a scuffle. Sabu mediates and suggests that Okaji and Danshichi divorce, explaining that if the two are not married then the crime of killing a parent will not have been committed. Eventually officers arrive to arrest Danshichi, but Tokubei convinces them to let him go and get him. Tokubei then finds Danshichi on the roof, but instead of capturing him, gives him money and allows him to escape.

作品の概要 / Overview

演目名 / Title

夏祭浪花鑑

Natsumatsuri Naniwa Kagami

作者 / Writers

並木千柳・三好松洛・竹田小出雲

Namiki Senryu, Miyoshi Shoraku, Takeda Koizumo

概要 / Overview

人形浄瑠璃を歌舞伎に移したもの。歌舞伎では浄瑠璃初演の翌月、京都・都万太夫座で上演されている。

原作は全九段で、現在多く上演されているのは、原作浄瑠璃の三段目に当たる「鳥居前」、六段目の「三婦内」、七段目の「長町裏」の三場面であるが、前後の場面を加えた通し上演も行われる。あらすじでは、通しの際に上演されることの多い、原作初段「お鯛茶屋」、四段目「道具屋」、八段目「田島町団七内」を加え、全容を理解できるようにした。

大坂を舞台に、三人の侠客とその女房たちの活躍を描いた作品で大坂の風土、生活、季節感に基づいた、上方世話狂言の人気作であり、典型的な夏狂言である。

祭り囃子が聞こえる夕闇の長町裏で繰り広げられる「殺し場」が大きな見どころ。赤い下帯一つになった団七の体の彫り物。数々の見得など、様式的、絵画的な美しさ、ほとばしる本水。陰惨な殺人でさえも美しく見せようとする、歌舞伎ならではの場面である。

Natsumatsuri Naniwa Kagami was first performed for the puppet theater and was adapted to kabuki within a month of its debut. The kabuki version debuted at the Miyako Mandayuza Theatre in Kyoto.

Though the full play is in nine acts, the most commonly performed scenes are "Before the Torii Gate" from Act III, "Sabu's Home" from Act VI, and "Back Alley in Nagamachi" from Act VII. Other scenes related to these are sometimes performed for *toshi-kyogen* performances as well. The synopsis here includes such related scenes so that readers may get a more complete sense of the story.

Natsumatsuri is the quintessential summer drama. It is extremely popular, especially among those from Osaka, as the play is set in Osaka and features gallant male and female heroes as well as some of the local culture.

The scene of the murder, with nostalgic festival music heard in the background, is one of the highlights of the show. It features stunning mie poses that give formal intrigue to the show as well as boasting truly picturesque scenery. Even the tragic murder scene is shown in a most opulent and appealing manner, a unique feature of this play and of the kabuki theater.

初演 / Premiere

人形浄瑠璃の初演は延享2（1745）年7月 大坂・竹本座。作者は並木千柳・三好松洛・竹田小出雲。翌延享2（1745）年8月 京都・都万太夫座で、歌舞伎に移して上演された。

First performed for the puppet theater at the Osaka Takemotoza Theatre in July, 1745. Written by Namiki Senryu, Miyoshi Shoraku, and Takeda Koizumo. Debuted for the kabuki theater one month later in August, 1745 at the Miyako Mandayuza Theatre in Kyoto.

夏祭浪花鑑

登場人物 — Characters

団七九郎兵衛
だんしちくろべえ

堺の魚屋。元は孤児だったところ三河屋義平次に拾われて魚屋となり、義平次の娘のお梶と結婚した。恩ある玉島兵太夫の息子磯之丞を手助けし、その恋人・琴浦をかくまう。しかし釣船三婦に預けた琴浦を義平次が金にしようと連れ去ってしまう。ようやく追いついて取り戻すが、その後の義平次の執拗な悪態と打擲に耐えかね、揉み合う内に義平次を斬ってしまい、凄惨な立廻りの末ついにとどめを刺す。

Danshichi Kurobei
Once an orphan, Danshichi Kurobei was taken in by Mikawaya Giheiji and eventually married his daughter Okaji. Now a fish seller, Danshichi helps Tamashima Heidayu's son Isonojo and tries to protect Isonojo's lover Kotoura. Despite this, she is kidnapped by Giheiji who hopes to make some money off of her. Danshichi makes chase and eventually retrieves Kotoura, but the no-good Giheiji taunts him relentlessly until he draws his sword and kills his adopted father in a grand tachimawari fight scene.

釣船三婦
つりふねのさぶ

老侠客で昔は凄腕だったが、今は寄る年波で耳に数珠をかけ喧嘩を戒めている。団七が日頃から大いに世話になっている人物で、喧嘩で入牢していた団七が戻ってくるのを快く出迎える。その場では駕籠かきに責められる磯之丞を救い、さらにその磯之丞を一寸徳兵衛の女房・お辰に預ける。老齢とはいえ家に乱入してきたならず者を見事な啖呵で追い散らす元気は衰えを知らない。

Tsurifune no Sabu
Tsurifune no Sabu was a force to be reckoned with in his prime, but in his old age he has taken to carrying rosary beads and mitigating conflicts. When he hears that Danshichi, who had been imprisoned for quarreling, is to be released, he happily goes to greet him. There he finds and saves Isonojo who is being attacked by palanquin bearers. Afterwards he leaves Isonojo in Tokubei's wife Otatsu's care. Though Sabu is an old man, he shows surprising strength in driving away the intruders who later break into his house.

お辰
おたつ

一寸徳兵衛の女房で、美しい上、夫に引けを取らぬ気っ風のよさが際立つ。釣船三婦が若い玉島磯之丞をお辰に預けるのは心配だというと、お辰は焼けた鉄弓を顔に当てて醜い姿になり、その心意気に三婦も感心せざるを得ない。さらに帰り際、「亭主が惚れるのはここ（顔）じゃない、ここ（心）でござんす」と見得を切る姿があまりに見事で印象を残す。

Otatsu
Tokubei's wife, Otatsu is not only a pretty face but a strong-spirited woman who doesn't fear to stand up to her husband. When Tsurifune no Sabu expresses concern over her travelling together with the handsome Isonojo, Otatsu unflinchingly disfigures herself with a piece of hot iron. Sabu stands in awe of her spirit as she leaves, saying, "It is my heart, not my face, which my master most admires."

一寸徳兵衛
いっすんとくべえ

備中玉島の出で侠客の身。一寸というのは一端引き受けたら一寸も引かないという意味でかなりの強者である。当初は琴浦に横恋慕する大鳥佐賀右衛門から依頼を受け、琴浦を連れ去ることに加担したため団七九郎兵衛とは争いになる。しかし、そこを止めに入ったお梶の話から、共に玉島兵太夫に恩のある同士ということがわかり、団七と仲直りをして義兄弟の約束をする。

Issun Tokubei
Bicchu Tamashima native and a self-styled humanitarian, Issun Tokubei is a force to be reckoned with. The title "issun" means "one inch," indicating that once his mind is made up he will not stand his ground completely. Though he initially helps in Kotoura's kidnapping under Ohtori Sagaemon's orders, making him and Kurobei enemies, the two join forces and swear an oath of brothership after he hears from Okaji that Danshichi serves Tamashima Heidayu, to whom he himself also owes a debt of gratitude.

お梶
おかじ

団七九郎兵衛の女房で三河屋義平次の娘。元は玉島家で腰元奉公をしており、夫の団七と共に玉島磯之丞を手助けしている。団七と一寸徳兵衛が争っている現場に来合わせると番付板で颯爽と仲裁に入り、徳兵衛もかつて玉島家の恩義に与った身と諭し、二人の仲を取り持つ。

Okaji
Danshichi Kurobei's wife and Mikawaya Giheiji's daughter, Okaji formerly served the Tamashima house as a chambermaid. Because of this, she helps her husband in helping Tamashima Isonojo. She steps in to mediate in the fight between Danshichi and Tokubei, helping to uncover the fact that the two have a common loyalty to the Tamashima house.

玉島磯之丞
たましまいそのじょう

玉島兵太夫の嫡男。遊女の琴浦に入れ上げ、そこに恋敵の大鳥佐賀右衛門の策略もあって親から勘当される。兵太夫に恩のある団七九郎兵衛夫婦や三婦が何かと世話をし力になるが、身を隠して奉公に出た先の娘とまたしても恋仲になるなど、少々あきれた放蕩ぶりの優男。

Tamashima Isonojo
Tamashima Heidayu's eldest son, Isonojo intentionally causes his father to disinherit him as part of a plan to keep his lover Kotoura out of Ohtori Sagaemon's hands. Danshichi, his wife, and Sabu all lend him a hand due to their loyalty to Heidayu, but he becomes romantically involved with a girl at the shop where he is hiding, making the suave Isonojo a somewhat debauched young hero.

琴浦
ことうら

堺の遊女で玉島磯之丞と馴染み身請けされた。大鳥佐賀右衛門に横恋慕されて追われるが、団七に助けられて三婦の家にかくまわれる。しかし義平次が琴浦をさらって佐賀右衛門へ渡そうとし、駕籠で連れ去られるが懸命に追ってきた団七に救われる。

Kotoura

A former geisha who was redeemed by her lover Isonojo, Kotoura is pursued by the lustful Ohtori Sagaemon. Danshichi saves her and hides her at Sabu's house, but Giheiji then kidnaps her and attempts to give her to Sagaemon. The heroic Danshichi follows the palanquin she is taken in and eventually saves her.

おつぎ
おつぎ

釣船三婦の女房。三婦の家にやってくるお辰や団七を取り持つ細やかな役だが、義平次の嘘を見抜くことは叶わず、琴浦をやすやすと義平次に渡してしまう。

Otsugi

Otsugi is Tsurifune no Sabu's wife. She plays the minor role of mediating for Otatsu and Danshichi but fails to see through Giheiji's lies, handing Kotoura over to him.

玉島兵太夫
たましまひょうだゆう

お梶や一寸徳兵衛の旧主にあたる武士で、団七が魚屋として出入りしていた。団七が喧嘩騒ぎで入牢した際も兵太夫の尽力で出牢を許されるなど、団七にとっては大恩人。しかし、息子の磯之丞の放蕩には散々苦労させられる。通常の上演場面には登場しない役。

Tamashima Hyodayu

Okaji and Tokubei's former master, and a patron of the fish seller Danshichi works for. Hyodayu helps to get Danshichi released after he is imprisoned for belligerence. He is deeply troubled by his son Isonojo's debauchery. Hyodayu's character does not appear in most performances of Natsumatsuri.

三河屋義平次
みかわやぎへいじ

お梶の父親で団七九郎兵衛にとっては義父にあたる。強欲で、琴浦をさらって大鳥佐賀右衛門に届ければ大金にありつけると、三婦の留守にやって来る。団七からの頼みで琴浦を預かると嘘をつき駕籠で琴浦を連れ出す。追って来た団七が金を出すというのを信じて琴浦を帰すが、金包みと見えたのは石ころ、逆上して団七を罵倒し小突き回す。やがて団七の手が滑って斬りつけられる。

Mikawaya Giheiji

Okaji's father and Danshichi's stepfather, Mikawaya Giheiji is a man of deep avarice who kidnaps Kotoura in hopes of getting a reward from Ohtori Sagaemon who is pursuing her. He takes advantage of Sabu's absence and claims to be there to pick up Kotoura on Danshichi's request. When Danshichi follows the palanquin and gives Giheiji money, he returns Kotoura but soon realizes Danshichi gave him rocks wrapped in paper. Now enraged, he berates Danshichi for his deception and begins pushing him around. In the midst of this scuffle, Danshichi's hand slips and accidentally cuts Giheiji.

大鳥佐賀右衛門
おおとりさがえもん

玉島磯之丞と同じ家中の侍で、磯之丞の馴染みである琴浦に惚れこんでいる。磯之丞を勘当に陥れる細工をした上、琴浦をどこまでもつけ狙い、義平次を使って我が物にしようと画策する。

Ohtori Sagaemon

Sagaemon is a samurai in the service of the same house as Isonojo and is in love with his lover Kotoura. He goes to great lengths to get her, plotting to have Isonojo disinherited and collaborating with Giheiji.

みどころ
Highlights

 男を売る男伊達 —— Selling Chivalry

男伊達とは、義を重んじ面目を大切にする男、弱きを助け強きをくじく、などと辞書にはある。「男を売る」とは、その義侠心を売り物にして世間にアピールしようということだ。この芝居の主人公堺の魚売団七が何より大切にするのが、その「男」。人助けを頼まれれば、否とは言わない。売られた喧嘩は買う。卑怯未練が一番きらい。男伊達の芝居が喝采を受けるのは、普通の世の中では男を立て通してばかりはいられないからだろう。

Otokodate refers to a chivalrous man who puts justice first and protects the weak, a character type that is incredibly popular. The phrase "*otoko o uru*" in Japanese, meaning "to sell chivalry," is indicative of this popularity. The fish seller Danshichi in *Natsumatsuri* is the very epitome of *otokodate*. He accepts any request for help, involves himself in others' conflicts, and absolutely hates cowardice. The reason such a character receives such thunderous applause in theaters is perhaps because such a person couldn't possibly exist in real life.

 うちの人の好くのは、ここじゃない。 —— "This Isn't What People Admire About Me"

男伊達の女房もまた、鉄火な心を持っている。男伊達徳兵衛の女房お辰は、日傘を差し涼しい顔で現れる美女だが、訳ありの若侍を預かるのに顔の色気が邪魔だと言われると、ためらわず顔に火傷を作ってみせる。首尾よく若侍を預かることになるが、夫の気持ちを心配されて言うのが、このせりふ。自らの顔を指し「うちの人の好くのはここじゃない」、続いて胸をぽんと叩き「ここでござんす」と笑う。「顔じゃなくて心」という矜持だ。

The wife of an *otokodate*, or chivalrous man, is no less fiery. Tokubei's wife Otatsu, for example, makes her entrance with a parasol and a calm expression, but shows her mettle in the scene where she burns her own face to show that her looks mean nothing and that she should be allowed to travel with another man. She then defiantly claims that "this [her face] isn't what people admire about me; this [her heart] is."

3. 泥まみれの殺し場 —— A Murder Scene Covered in Mud

団七は肌に見事な彫り物をしている。義平次は日焼けで真っ黒な顔を汚い笠で隠している。団七の刀が誤って義平次を斬ってしまい、「人殺し」と叫ぶ義平次の口を押さえたあとは凄惨な殺し場だ。本物の泥にまみれた黒い義平次と、赤い下帯姿の団七の彫り物があざやかなコントラストになる。殺す身体が美しく、殺される身体が醜悪なのだ。団七役者がいくつもの見得を重ねて義平次を泥に沈めてしまうまで、錦絵そのままの殺し場が続く。

As Giheiji hides his sunburned face with a conical *kasa* hat, Danshichi accidentally kills him, frantically holding his mouth shut as he shouts "murderer!" The gruesome corpse, covered in mud, ironically contrasts the gorgeous tattoos of Danshichi. Striking a number of impressive *mie* poses as Giheiji slowly sinks into the mud.

4. 祭りのにぎわいに紛れ —— Amid the Confusion of the Festival

殺し場のせりふはほとんどなく、逃げ回る義平次と追い詰めていく団七の絵のようなパフォーマンスに客席が息を呑む。遠く夏祭のだんじり囃子が聞こえ山車が通り過ぎるが、誰も二人の争いに気づかない。団七が井戸水で血を洗い、身体を浴衣で隠すとそこへ神輿がやってくる。まだ残っているであろう血の匂いを、神輿の行列が消していく。祭りの熱狂に紛れ、髷がほどけたざんばら髪を隠し、よろよろ進む団七の姿が極めてリアルだ。

The murder scene has remarkably little dialogue. Danshichi chases after Giheiji in an oddly beautiful performance that keeps the audience on the edge of their seat. While the festival music plays and floats pass by, none of the festival participants take notice of the scuffle taking place. After murdering Giheiji, Danshichi washes the blood off himself with water from a nearby well, then puts on a *yukata* just as the procession of portable *mikoshi* shrines comes by, helping to hide the scent of blood that must be emitting from his body. Danshichi makes use of the confusion of the festival to slip away, making sure to hide his disheveled hair in a highly realistic scene.

5. ニューヨークでも絶賛 —— Praise from the New York Times

義平次を殺したあと花道にへたり込んだ団七が「悪い人でも舅は親……」と呟く。封建社会では尊属殺人はことに罪が重い。2006年平成中村座ニューヨーク公演で、串田和美演出『夏祭浪花鑑』が上演されると、辛口批評で知られる「New York Times」が大絶賛。父殺しというテーマにドストエフスキーを引き合いに出して解説した。この時はニューヨーク市警が登場し、団七たちにピストルを向け「freeze!」と叫ぶ衝撃のエンディングだった。

Giheiji exits on the *hanamichi*, muttering "even an evil stepfather is still a father…" Having killed his stepfather, he would be severely punished if found out, as the murder of parents or other elder family members was a grave crime in feudal Japan. When Kushida Kazuyoshi produced a performance of *Natsumatsuri* in New York, it received great praise from none other than the highly critical New York Times, which compared the killing of a father to Dostoevsky's work. This production was adapted to modern times, and featured NYPD officers arresting Danshichi at the end of the play. In true American fashion, the officers command Danshichi to "freeze!" when they catch up to him.

Appendix

付録

Domestic Dramas ——— 世話物

歌舞伎の歴史

日本の伝統芸能と歌舞伎の特徴

日本には伝統的な音楽・舞踊・演劇などが数多く伝承されています。

成立した順に挙げると、まず雅楽があります。現在伝わる形が整ったのが、10世紀頃。1000年以上の歴史がある音楽と舞で、宮廷音楽として、また寺社で受け継がれました。貴族たちの芸能といっていいでしょう。

次が能楽。能と狂言を合わせた呼び名で、室町時代に大成し、650年近い歴史があります。江戸時代は武家式楽、武士の儀式に使われる音楽となりました。いわば武士たちの芸能。

そして、歌舞伎。

それから、人形浄瑠璃、文楽。浄瑠璃という音曲の語りに合わせ人形が動く人形浄瑠璃の内、現在、義太夫節を使用する「文楽」が代表的です。義太夫節の成立は300年ほど前。

また、沖縄には、宮廷の音楽として作られ、300年近い歴史を有する「くみおどり」が伝わっています。

今上げた五つの芸能は、ユネスコの無形文化遺産にも登録され、日本を代表する古典芸能です。さらに、落語や講談などの大衆芸能、琴や三味線を使った音楽、舞などの古典舞踊などもあります。これらは、国も専用の劇場を設け保護育成に力を入れている音楽・舞踊・演劇であり、それぞれ専門の実演家、プロフェッショナルがいる芸能、いわゆる人間国宝が出るジャンルともいえます。

実はこれほど古い芸能が数多く残っているのは世界的にも珍しいのです。

西欧では、新しい芸術が起きると、先行するものは淘汰されてしまうことが多い。それは芸能も同じで、先行の芸能は衰退してしまうのがほとんどです。ところが日本では、先行する芸能も大事に伝承してきました。いくつものジャンルがあって、それぞれ歴史が古い、これが日本の古典芸能の大きな特徴です。

さらにもう少し大きく見ていくと、民俗芸能といわれるものがあります。地域の祭りや行事などの際、普段は別の仕事をしている人たちにより演奏され、演じられます。この中にもアイヌの民俗音楽など、無形文化遺産に登録されている芸能があります。

また、声明などに代表される宗教音楽、さらに、民謡、盆踊り、太鼓、また、津軽三味線、沖縄の三線など、地方独自の音楽もあります。

少し周りを見渡してみると、現代でも伝統的な音楽や舞踊は意外と身近にあるのです。

そして、明治から取り入れた西洋の音楽や舞踊、これもまた、当たり前のように身近にある。どころか、世界中で活躍している音楽家やダンサーも輩出しています。

つまり、日本には伝統的な音楽や舞踊も、西洋的な音楽や舞踊も身近にあり、我々はその中で生活している。なかなか気が付かないことですが、これは日本の文化の大きな特徴なのです。

宮中や寺社で継承された雅楽、武家に庇護された能楽、宮廷音楽として発生した組踊と違い、人形浄瑠璃と歌舞伎は庶民が支持した芸能です。歴史をみても権力者による庇護はおろか、むしろ弾圧をうける方が多く、その網の目をかいくぐってきました。

次からはその歴史を見てみましょう。

歌舞伎の歴史①―野郎歌舞伎まで

慶長8(1603)年、京都でお国(出雲阿国)という女性が始めた「歌舞伎踊り」が歌舞伎の発祥とされます。

これは歴史の教科書にも載っていることなので、ご存知の方も多いでしょう。

では、なぜ女性の始めた芸能が、現在は男性だけによって演じられているのでしょう。実は現在の歌舞伎に至るまで、様々な紆余曲折があったのです。ここでは現在の歌舞伎の直接的な始まり「野郎歌舞伎」までの道のりをたどります。

さて、お国の「歌舞伎踊り」は男女混交の一座により、歌と踊りを中心に、時に滑稽な寸劇が上演されました。お国は当時流行していた「かぶき者」の男に扮し、茶屋の女に扮した男性のもとに通う、茶屋遊びの踊りを見せたと言われています。この芸能は「お国歌舞伎」とも呼ばれ大流行。そのスタイルはすぐ全国に追随者を生み出しました。

類似の集団に加え、人気に目を付けた遊女屋が抱えている遊女を舞台に上げ、歌や踊りを見せ始めました。遊女も含めた女性が登場する「女歌舞伎」は人気を博しましたが、風紀を乱すという理由で幕府は女性芸能を禁止してしまいます。

かわりに台頭してきたのが、若い少年たちが歌舞を見せる「若衆歌舞伎」。これは「女歌舞伎」全盛時代から並行して行われてきていましたが、「女歌舞伎」衰退により一世を風靡しました。しかしこれも風紀を乱すという理由で禁止されます。

一旦消えかけた歌舞伎の火は、関係者の熱意により、若衆

たちの若さと色気のシンボルである前髪を剃り落とし、野郎頭で演じる「野郎歌舞伎」として再興しました。

この「野郎歌舞伎」が現在の歌舞伎につながります。前髪を剃り落とされ、容色だけで売ることができなくなったこと、また、「狂言尽くし」として、歌舞でなく、演劇を主体とするように制限されたことが、現在の歌舞伎への道を切り拓いたのです。

お国が演じたレビュー的な「歌舞伎踊り」は、度重なる禁令と圧力を巧みにかわし、やがて男性のみで演じる演劇として姿を変えたのです。

「歌舞伎」と「傾(かぶ)き」

現在用いられる「歌舞伎」の表記は、音楽的(歌)で、舞踊の要素(舞)、芝居の要素(伎)もある演劇という特徴をよく表していますが、これは、後世の当て字。「かぶき」という言葉は、並外れたもの、常軌を逸するものという意味の「傾く(かぶく)」という動詞から来ています。

お国が歌舞伎踊りを始めた当時、「かぶき者」と呼ばれる一団がいました。わざと珍しい、人の目を驚かせるような奇抜な扮装や髪型をしたり、わざわざ目立つような行動を取ったりする若者たちでした。お国はかぶき者の男性に扮して、かぶき者たちの行動を舞台に取り入れました。

発生がかぶき者たちの姿を取り入れてできた芸能ゆえか、歌舞伎には常に同時代の流行を取り入れたいという傾向があるのです。

歌舞伎の歴史②──野郎歌舞伎から現在まで

野郎歌舞伎として再出発した歌舞伎は、江戸から現在にいたるまで様々に発展してきました。長い期間にわたる話なので、駆け足になりますが、後の「歌舞伎の言葉」で説明する用語を中心にざっと見ていきましょう。

元禄時代、江戸で「荒事」、上方で「和事」という対照的な芸が生まれました。また、この時代の作者としては近松門左衛門が知られています。やがて、人形浄瑠璃(現在の文楽)が、ドラマ性の優れる数多くの作品を生み出し人気を博したので、それらの作品を取り入れ上演するようになります。これらの作品を「義太夫狂言」と呼び、レパートリーの大きな位置を占めています。

文化文政期には、江戸で四世鶴屋南北が作者として活躍。南北が得意としたのは、それまでの「世話物」をさらにリアルにした、後に「生世話」と呼ばれるジャンルでした。

江戸の終わりには「歌舞伎十八番」が制定されました。天保の改革では当時辺鄙であった浅草猿若町に劇場移転を命じられたり、人気俳優の追放などの弾圧をうけました。また、明治にかけては作者の河竹黙阿弥が活躍しました。

一方、舞踊も「三味線音楽」とともに目覚ましく発達を遂げました。天明期の舞踊や、江戸中期以降に流行した「変化舞踊」。江戸の終わりに端を発し、明治以降多く作られた「松羽目舞踊」など、様々な演目が今に伝えられています。

そのほか、舞台機構も発達。「花道」「廻り舞台」「セリ」など現在でも多用される機構が発達しました。

やがて明治維新を迎えると、歌舞伎も大きな転機を迎えます。高尚な作品を上演するようにという明治新政府の意向を受け、歴史に忠実であることを目指した、後に「活歴物」と呼ばれる作品群や、新たな時代の風俗をそのままに取り入れた「散切物」などの作品が生まれました。その後、外部の劇作家による、西洋戯曲に倣った「新歌舞伎」が新たなレパートリーに加わりました。

その後も軍部の統制、空襲による劇場の焼失、占領軍による封建的演目の上演禁止などの危機を乗り越えましたが、生活の急激な変化などにより、一時は公演数も少なくなります。しかし関係者の不断の努力もあり現在は隆盛が続いています。

また、海外公演を積極的に行い、日本だけでなく、広く世界の歌舞伎として認知されています。

以上駆け足で概要を紹介しましたが、歌舞伎の歴史は決していつでも順調だったわけではありません。激動する時代に適応し、たくましく歴史を重ねていることがおわかりいただけたのではないかと思います。

歌舞伎のように発生当時から今に至るまでショウビジネスとして成り立っている芸能というのは、ユネスコの無形文化遺産に登録されている世界の芸能の中で類を見ないことなのです。

The History of Kabuki

Traditional Japanese Performance Arts and the Characteristics of Kabuki

In Japan, there are many a great number of traditional styles of music, dance, and drama, each of which has been carefully passed down from generation to generation.

Gagaku music is the very first of these art forms to develop, the style as we know it today having been established in the 10th century. This thousand-year-old tradition of court music was passed down directly from the court and through temples and shrines. It is a high form of music originally meant for the aristocracy.

The next performance art to develop in Japan is *nogaku*. A general term that includes both noh and *kyogen* dramatic forms, *nogaku* was popular during the Muromachi Period of Japan (1336–1573) and has a history of over 650 years. In the Edo Period (1603–1868), samurai started using this style of music for ceremonies. It thus became very closely associated with the warrior class.

And finally, we come to kabuki and the puppet theater, *bunraku*.

The puppet theater involves the use of puppets which are skillfully manipulated in sync with the music and actors' spoken word. "*Bunraku*" which uses *gidayu-bushi* music is the most commonly known form of puppet theater and was established about 300 years ago. There is also a style of puppet theater music used by the royal court in Okinawa that has close to 300 years of history. This tradition is called "*kumi-odori*."

The above five performing arts are inscribed by UNESCO as intangible cultural heritage elements, and as such are the most representative of Japan's classical performing arts. There are, of course, many other performance arts, such as *rakugo* and *kodan* storytelling, *koto* and *shamisen* music, and traditional dances like *buyo*. These all fall under the categories of music, dance, or drama. The Japanese government has erected specialized theaters and supports the training of professionals in each field. These arts forms require specially trained professionals, and often produce living national treasures.

The number of ancient arts that have been preserved in Japan is actually quite high when compared to countries around the world. In western Europe it is common for new technologies to supersede the old, and the same goes for performance arts: when a new performance art is born, the previous one inevitably goes into decline. In Japan, however, the older traditions are passed on just as diligently as newer art forms. The most unique characteristic of Japanese arts is that there are so many genres, each with its own rich history.

There are also a number of folk art forms that have not been mentioned yet. These include the music played during regional festivals, often by locals who have normal day jobs. Another prime example is the folk music of the Ainu (native people of northern Japan), which has been inscribed as an intangible cultural heritage element.

Another example is Buddhist chants called "*shomyo*," a type of religious music. *Min'yo* folk songs, *bon-odori* dance, taiko drums, *Tsugaru-shamisen* and Okinawan *sanshin* music are just a few examples of Japan's rich tradition of unique regional arts.

Look around Japan and you'll find traditional art forms all around you. Our country has also absorbed a great number of Western art forms, and they, too, can be found everywhere in Japan. What's more, Japan boasts a great number of musicians and dancers who enjoy international acclaim.

The Japanese live amongst this rich intermingling of traditional Japanese and modern Western arts. Easy to overlook, this is one of the unique characteristics of Japanese culture.

Gagaku was preserved by shrines and temples, nogaku by samurai, and *kumi-odori* by the court. The puppet theater and kabuki, however, were popular arts supported by the public. Historically, these arts received no support from the government. In fact, they were often suppressed. Despite this, however, these dramatic art forms persevered.

Let's take a closer look at the history of the puppet and kabuki theaters.

History of Kabuki 1 —Beginnings to *Yaro-kabuki*

As commonly noted in history books, kabuki originated as a style of dance called *kabuki-odori,* which was developed in Kyoto in 1603 by a woman named Izumo no Okuni.

Now, how did this art created by a woman turn into a dramatic form performed exclusively by men? Well, there were a lot of twists and turns along the way before kabuki became what it is today. First, let's look at the early history leading up to *yaro-kabuki*, a form which more closely resembles modern kabuki.

Okuni's *kabuki-odori* featured a mix of both women and men depicting often comical sketches through song and dance. Okuni herself would dress as a male "*kabuki-mono*" and a male actor would dress as a female tea-shop worker. The two would perform a dance called "*chaya-asobi*," or "tea-house fun." Also called "*Okuni-kabuki*," *kabuki-odori* gained incredible popularity all around the country.

Soon rival troupes were formed, and brothels also began having their prostitutes perform songs and dance in this new style. "*Onna-kabuki*," for which prostitutes were used, gained enormous popularity, but was soon banned by the shogun because of its

negative effect on public morality.

With the decline of onna-kabuki came the rise of "*wakashu-kabuki*," which had young boys perform instead of women. Despite its popularity, however, wakashu-kabuki was likewise prohibited due to its negative effects on public morality.

In response to these prohibitions, a new form of kabuki was developed which eliminated boy actors and the sexually suggestive bangs that female roles often called for. This new form of kabuki was called "*yaro-kabuki*."

Modern kabuki is derived from *yaro-kabuki*. With this new form of kabuki, actors who could no longer wear bangs were forced to rely on more than physical features to charm audiences. Furthermore, instead of song and dance, performers were made to use their dramatic skills in a form called "*kyogen-tsukushi*." These developments are what paved the road for modern-day kabuki.

Okuni's kabuki-odori evolved in response to the numerous prohibitions which threatened to stifle it, and thus it became a dramatic art performed exclusively by men.

Etymology of "Kabuki"

The modern-day word "kabuki" uses three Chinese characters meaning "song," "dance," and "skill," but these do not indicate kabuki's original meaning. The word "kabuki" derives from a verb meaning "to slant," and used to referred to an off-beat or eccentric person.

In Okuni's time, there were people known as "*kabuki-mono*," who donned strange clothes and hair styles, and conducted themselves in a strange fashion deliberately to shock other people. Okuni herself chose to dress as these *kabuki-mono* and incorporate their ways into her *kabuki-odori*.

It may be because kabuki originally sought to incorporate eccentricity that it continued to integrate modern fads into its performances through the ages.

History of Kabuki 2
—From *Yaro* to modern-day kabuki

The reborn *yaro-kabuki* underwent many changes from the Edo period (1603–1868) to the modern day. Since we will now cover a long period of history, this will be an abridged explanation. We recommend referring to the "Kabuki Glossary" for more detailed information about kabuki terms.

During the Genroku years (1688–1704), two contrasting performance styles developed: "*aragoto*" in Edo (Tokyo) and "*wagoto*" in Kyoto. The renowned writer Chikamatsu Monzaemon is also from this period. He and his contemporaries wrote a great number of masterful dramatic works for the puppet theater (*bunraku*), making it the premier dramatic form of the time. These plays are commonly called "*gidayu-kyogen*" and constitute a large part of the repertoire.

The Bunka-Bunsei years (1688–1704) saw the works of Nanboku Tsuruya IV, who developed the "*nama-sewamono*" which brought a deeper realistic element to the everyday genre of "*sewamono*."

The Eighteen Great Kabuki Plays was established at the end of the Edo Period. The Tenpo years (1830–1844) saw various reforms resulting in the banishment of many actors from Edo and the relocation of theaters to Asakusa on the outskirts of the city. The dramatist Kawatake Mokuami was active during these final years of Edo and well into the Meiji Period (1868–1912).

While the dramatic arts were dampened, buyo dance thrived alongside *shamisen* music. The *buyo* style of dance from the Tenmei years (1781–1789) developed into the henka-buyo dance popular from the mid-Edo period, and the *hatsubame* style of dance was born at the end of the Edo period, continuing to thrive during the subsequent Meiji period.

Great developments were also made in staging and mechanics during this period, including the *hanamichi* platforms, the *mawari-butai* (rotating stage), and the *seri* lift.

With the Meiji Restoration, kabuki once again saw a great shift. Under orders from the Meiji Government to produce plays of high artistic value, writers now focused on plays that were historically accurate, now called "*katsureki-mono*." Another new form, called "*zangimono*," were meant to integrate aspects of modern thought and ways. Furthermore, a new style of kabuki that attempted to imitate Western theater was developed by non-kabuki writers. This new form was called "*shin-kabuki*" (new kabuki).

Later during the war, a number of playhouses were burned down in air raids, and during the occupation all feudalistic plays were prohibited. Kabuki persevered through this, but even after the occupation, due to the aftershock of the war kabuki plays were scarce for a time. Despite this, the art form was faithfully preserved and now enjoys great popularity again.

Nowadays kabuki is not only performed in Japan, but in countries all around the world.

This ends our abridged overview of kabuki's history. As you can see, kabuki did not always enjoy the popularity it has now but evolved with the violent changes of history to become what it is today. We hope that our readers have gained an appreciation for this rich history.

Kabuki started and developed until the modern day as a show business that exhibited great innovation and adaptability to survive to the modern day. We believe it is a performance art unlike any other inscribed as a UNESCO intangible cultural heritage element.

付録　歌舞伎の見方

　もとより歌舞伎に「正しい」見方や作法、堅苦しいルールなどはありません。それぞれの心のままに見て楽しんでもらえればそれで十分であり、観客の数だけ見方があるともいえます。
　しかし中には、心のままに、と言われても不安が残る方もいるようです。難しいのではないか、勉強しないと理解できないのではないか、などと見ない前から思い込んでいる方もいます。見たことがない方ほどその傾向は強く、堅苦しいものと決めつけてしまう人も多い。こうした思い込み、不安が先に立ち、歌舞伎の魅力に触れることができないとしたら、これは大変にもったいないことです。

歌舞伎は「商業演劇」

　歌舞伎は400年を超す歴史を持ち、日本を代表する古典芸能の一つとして、ユネスコの無形文化遺産にも登録されていることはご承知の通り。それと同時に、発生から現在に至るまで、観客の入場料ですべてを賄う「商業演劇」でもあり続けています。これは大きな特徴です。
　観客の支持なくしては立ち行かないのですから、観客の喜ぶものは何でも取り入れてきました。その集積が現在の歌舞伎です。400年以上お客様を喜ばせ続けてきた芸能、とも言えましょう。
　現在隆盛の歌舞伎ですが、世間でよく言われるように、難しく退屈なだけの芸能だったら、果たしてこれほど多くの観客を集められるでしょうか。400年にもわたり続くでしょうか。
　しかも、一度でも劇場に足を運んでいただけばわかるのですが、多くの観客が舞台を見ながら、笑ったり、涙を流したり、と舞台を楽しんでいます。現代においても十分「楽しめる」演劇なのです。「古典」や「伝統」と肩書がつくと、まるで博物館に展示されている骨董品であるかのように思えますが、現代の俳優が演じ、現代の観客が見て楽しんでいる、現代のエンターテインメントなのです。
　もちろん長い時間をかけ磨き抜かれ、古典というにふさわしい大きさと深さを持つ戯曲や役も数多くあります。古典ならではの豊かな世界に身を任せ、深い感銘を抱く、これも楽しみの一つであることはいうまでもありません。

歌舞伎といってもいろいろある

　歌舞伎を初めて観劇した人から、思っていたよりも「〇〇」だった、という声を聞くことがあります。「〇〇」の内容は様々ですが、いずれも観劇前に抱いていた印象――綺麗だとか華やかなどのプラスの印象もあれば、退屈そうだとか寝てしまいそうだというマイナスの印象もある――とは違っていた、といいます。
　観客の喜ぶものを取り入れ成長した歌舞伎は、実は大変に幅が広く、バラエティーに富んでいます。ひと口に歌舞伎といってもいろいろあるのです。
　一般によく言われる歌舞伎のイメージがあります。例えば顔や体に色の線を描く独特の化粧「隈取」や、男性が女性の役も演じる「女方」、大きくポーズを決める「見得」、独特の発声と台詞まわし、などです。誇張されたものではありますが、これらは確かに歌舞伎の一部。しかしすべてではありません。
　隈取は歌舞伎を特徴づけるものですが、歌舞伎の演目に必ず隈取の化粧をした人物が登場するわけではなく、隈取の人物が一人も登場しない演目も数多くあります。劇場に行くと隈取が見られるだろうと思っている人がそうした演目を見ると、これは私が想像していた歌舞伎とは違う、となるかもしれません。
　『勧進帳』という演目はよく知られていますが、この演目には女性の役はありません。普段女性を演じている女方の俳優が、源義経の役で出演することはありますが、これは男性の役。『鈴ヶ森』と呼ばれる演目も登場人物は男ばかり。つまり、女方といえども、すべての演目に登場するわけではありません。
　独特の発声と台詞まわしも、実は様々な演技様式のうちの一つであり、様式が違えば台詞の印象も大きく違います。また、難しいと思われがちな言葉にしても、平易な現代語による脚本も数多くあります。
　なかには、見終わって、これ《が》歌舞伎なの、と驚かれる作品もありますが、それ《も》歌舞伎。最初にこうしたもの、と思い込んでくると、大概そのイメージは覆される、それほど歌舞伎のレパートリーは広くて深いのです。
　歌舞伎の幅広さを理解するには、「映画」に置き換えるとわかり易いかもしれません。ひと口に映画といっても様々です。ハリウッドの超大作、単館で上映される小品。ミュージカル、ホラー、スプラッタ。恋愛もの、アクション。アニメ、コメディー、ドキュメンタリー。歌舞伎も同じで、様々なジャンルの演目が揃っています。
　幅広いレパートリーを持っていますので、華やかな世界を期待していったら、たまたまその月は渋い演目だった、とか、古典を期待していったら、新作歌舞伎の月だったなど、ミスマッチも起こります。ただそれで歌舞伎＝（イコール）つまらな

い、ということになってしまうのは残念、もったいない。

映画であれば、たまたまミュージカル映画を最初に見たからといって、映画には必ず歌や踊りがあるものとは思わないはず。たまたま見た映画が面白くなかったからといって、映画というジャンル自体をつまらないものと決めつけはしないでしょう。

ところが、歌舞伎は、最初に見たものが気に入らないと、歌舞伎そのものがつまらないと思われてしまう。いろいろとある中の一部分でしかないものをそれだけで判断されてしまうのです。

初めて歌舞伎を見たら、想像していた通りだったということもあるけれど、思っていたのと違うこともある。その時、思っていたのと違うけれど、これはこれで面白い、となる方もいるし、思っていたのと違うからダメだとなる方もいる。

もし、見たものが「私の考える歌舞伎」と違っても、ぜひ演目を選んで再挑戦してみてください。必ず「あなたの考える歌舞伎」が見つかるはず。逆に言えば何かしらお気に召す歌舞伎はあるはずです。

そしてそこから様々な歌舞伎に触れてみてください。あなたの考えていた歌舞伎以外にもきっと面白い歌舞伎が見つかるはずです。

歌舞伎の見方

「歌舞伎は商業演劇であり、今を生きているエンターテインメントである」ということと、「歌舞伎といってもいろいろある」この二点を覚えておいて、肩に力を入れず、気持ちを楽に持って、生の歌舞伎に触れてみてください。

歌舞伎には一言では言い尽くせないほどの魅力が詰まっています。

とにかく一遍実際に歌舞伎を「体験」してみてください。400年間エンターテインメントであり続けた歌舞伎は、様々な魅力や特徴を備えています。俳優の姿や演技、衣裳の華やかさ、音楽の楽しさ、お芝居の内容。きっとどこかで何かしら感じるところがあるはず。どこをどう面白いと思うか、素敵だと思うかはご覧になった方次第。そこを入り口にして、歌舞伎の世界を覗いてみてください。間口が広くて奥が深い、すばらしい世界が目の前に広がります。

同じ時間と空間を共有するのが、歌舞伎に限らずライブパフォーマンスの醍醐味です。その時、その場所で起こることを楽しむこと、歌舞伎の見方、というものがあるとしたらこの一言に尽きるだろうと思います。

ざっくりまとめると、歌舞伎の「多様性」と「商業性」の話で、あまり堅く考えすぎないで、ライブを楽しみに来てくださいね、というのが大意です。

ところでこの多様性、歌舞伎の特徴の一つでもあります。

歌舞伎に携わる人々には常にこの多様な演目とそれらの様式を身につけること、また、継承と創造との両方に精進することが課せられているともいえましょう。

一方で古典であり堅苦しく、敷居が高いと思われ、もう一方で、様々な新しい試みがマスコミで大きく報道されています。ややともすると現代的な試みばかりもてはやされがちですが、これらの試みも古典あってのこと。歌舞伎の俳優やスタッフは、そのことをよく知っています。どちらも歌舞伎であって、どちらも必要なことなのです。

「商業性」については、これが舞台の原動力であることは言うまでもありません。

ただし注意していただきたいのは、しばしば商業性と芸術性が対立しているかのように考えられることです。商業的になりすぎると芸術性が失われてしまう、むしろ芸術とは商業的であってはならないという考えすら見受けられます。確かに相反することもありますが、決して両立しないものではありません。商業的であることが芸術的ではないということは決してないのです。

歌舞伎を見たことがない人でも歌舞伎俳優の名前や顔を知っています。それは歌舞伎の俳優は映画やテレビにも出ているからです。時代劇はもちろん、現代を舞台にしたドラマなどにも出演しています。では、歌舞伎以外の伝統芸能の関係者で、ドラマに出演する人は何人ぐらいいるでしょうか。数人はいらっしゃいますが、歌舞伎ほど多くはいません。

歌舞伎の俳優は、舞台のみならず映画やテレビにも出演しており、歌舞伎を知らない人にも知られている。歌舞伎の俳優は、伝統の担い手であると同時に、現在でも一般的な知名度が高く、人気がある。これはほかの伝統芸能にはない、大きな特徴です。

また東京の歌舞伎座を国の施設だと勘違いしている人もいますが、歌舞伎座は松竹が経営しています。伝統芸能でもありながら、現代でも民間企業が公演する商業演劇でもあるのが現在の歌舞伎なのです。

How to Watch Kabuki

There is no such thing as a "proper" way to watch kabuki, nor are there any strict rules. The only thing a viewer has to do is watch and enjoy in his or her own way. You could say that there are as many ways to watch kabuki as there are audience members.

That being said, many still feel uneasy about watching kabuki, thinking that it will be too difficult to understand without studying beforehand. This is especially true of those who have never seen a kabuki play before. However, it would be a terrible shame if such preconceptions kept potential viewers from ever enjoying the many charms of kabuki.

Kabuki is Commercial!

One of Japan's representative classical art forms, kabuki boasts a history of over 400 years and is inscribed by UNESCO as an intangible cultural heritage element. At the same time, kabuki developed over the years funded entirely by its viewers who paid for entrance at theaters. This commercial element is a unique characteristic of kabuki. Since it couldn't survive without the support of its viewers, kabuki has constantly added new elements to please its audiences, and modern kabuki is the accumulation of that 400-year history of happy audiences.

Modern kabuki, too, is incredibly popular, and it is often argued that a boring, archaic art form couldn't possibly garner the audience that kabuki has, let alone survive off proceeds alone for 400 years. If you ever make your way to a performance, you'll see that kabuki audiences are incredibly engaged, laughing and crying throughout the program. When we use heavy terms like "classic" and "traditional" to describe kabuki, it may feel like an antique displayed at a museum. But in reality, contemporary actors stand on the stage and people just like you and me are in the audience watching. Kabuki really is a very modern form of entertainment.

Of course, many kabuki plays are old classics that have stood the test of time. Being able to enjoy these rich pieces of classical literature that have been polished over hundreds of years is naturally one of the many joys of the kabuki theater.

Kabuki is Multi-faceted

Many first-time viewers of kabuki say that it wasn't what they expected. Now, what they expected and how it was different varies greatly from person to person—some people expect brilliant stages and costumes, while others expect to be bored to death. This is because kabuki, which evolved by constantly incorporating new elements to bring joy to audiences, has an incredibly varied repertoire. The word "kabuki" itself, therefore, cannot be summed up by any single image or expectation.

There are many well-known characteristics of kabuki, such as the bold kumadori makeup that is applied to the face and body of actors. Other characteristics of kabuki include *onnagata* (male actors who play female roles), bold poses called *mie*, and unique cadences and speech styles used by actors. These are indeed a part of kabuki, but it would be a mistake to think that any one of these applies to all of kabuki.

Kumadori is considered a staple of kabuki, but in fact kabuki plays do not all necessarily feature this unique makeup style. In fact, there are entire plays in which not a single actor wears *kumadori*. If you went to kabuki expecting *kumadori*, but happened to choose a play such as this, undoubtedly you will be surprised and even disappointed when the play ends.

Kanjincho is a very well-known play that features absolutely no *onnagata* parts. Sometimes an *onnagata* actor will play Minamoto no Yoshitsune, but the role is still that of a man. The play Suzu ga Mori is another play featuring all male characters. As you can see, kabuki does not necessarily imply the presence of *onnagata*.

The same goes for the unique cadences of kabuki. There are actually a number of different styles that can be used, and which is used may greatly affect the ultimate impression left on the audience. Furthermore, some old plays which originally used very antiquated and difficult language have been rewritten to be easier to understand.

It is very easy to see why some viewers get to the end of a play and think, is this really kabuki? The answer is yes, this too is kabuki. If you are convinced that kabuki must be this or that way, your entire view of it may be turned upside down by the time you get to the end of a play. That is just how deep and varied the kabuki repertoire is.

An easy way to think of this may be to compare kabuki to movies. The word "movie" encapsulates an unbelievable variety of genres, from big Hollywood blockbusters to independent films only shown at small local theaters, from musicals to horror films. Even within the horror genre there are subgenres such as splatter films. There are romantic, action, animated, comedy, documentary, and various other genres. Now, just think of kabuki the same way, with the same rich variety of genres.

It is because of this great variety that viewers are sometimes surprised at the plays they see. Some expect an opulent piece only to find they went to the theater during the run of a very dark play, while others may expect a classic piece only to find that the theater was producing a *shinsaku-kabuki* (contemporary kabuki) program that month.

However, it would be a shame for those viewers to think that all kabuki is uninteresting from just one such experience. If the first movie you saw was a musical, you probably wouldn't assume that all movies include singing and dancing. Neither would you assume all movies are boring just because of a bad movie you happened to watch.

When it comes to kabuki, however, this is exactly what some viewers do. Often times, viewers see a single play that only showcases a fragment of kabuki's variety, yet they proceed to cast judgement on the entire field. Some viewers may find that the play they watched was exactly what they expected, while others find it completely different. Some find kabuki interesting from the start, while others are displeased by their experience.

If you happen to see a kabuki production that didn't live up to your expectations, then try picking a different program next time. There are definitely plays that will live up to those expectations. To put it another way, I'm confident that, among the vast repertoire of kabuki, there is a play out there for you. Once you've found that, I encourage you to branch out from there. If you do, you are bound to find that some of the plays that don't quite match those initial expectations are quite enjoyable.

How to Watch Kabuki

Kabuki is commercial—a constantly changing, living form of entertainment. It also encapsulates an incredible depth of variety. From now on I ask that you approach kabuki with these two points in mind, and when you get to the theater, just relax and enjoy the story that unfolds before your eyes.

The many charms of kabuki defy attempts to define it in a single word, but I encourage everyone to go and see one live. It is a 400-year-old form of entertainment that has evolved and grown with audiences over the ages. The actors' stances and performance styles, the gorgeous costumes, the unique music, and the stories themselves—every aspect of kabuki is the product of years of tradition and evolution, and there is bound to be something that moves you. What it is that you find funny, stunning, or deeply moving, is entirely up to you. Whatever it is, use that as your gateway to the world of kabuki. An incredibly vast and deep world is just waiting for you to explore.

When watching kabuki, there is an incredible sensation of sharing in this moment, in this space. This isn't unique to kabuki; it is exactly what makes any live performance exciting. If I had to explain what the proper way to watch kabuki is, it would be simply that: experiencing the events unfolding before you, here and now.

In other words, as a multi-layered form of commercial entertainment, don't think too hard about what kabuki is. Rather, just sit back and enjoy the live performance.

The variety of experience is again another important aspect of kabuki. In the past, many have tried expounding on kabuki as though it could be expressed in so many sentences. But kabuki is something that defies such simple explanations. After all, by saying "kabuki must be thus," you run the risk of missing out on all the forms of kabuki that do not fit that description.

Those involved in the kabuki industry are constantly honing their skills to tackle the many different styles and forms that make up the industry. They are also charged two-fold with honoring long-standing traditions and creating new ones.

On the one hand, kabuki can be archaic, formal, and unapproachable, but on the other hand it can be an incredible cutting-edge experiment that spreads like fire through the media. Though we are prone to get caught up in these exciting new experiments, they are only possible because of the classics. Kabuki actors and crew members all know this, as should everyone. Both the classical and the modern are vital aspects of kabuki.

At this point it hardly warrants saying that the commercial aspect of kabuki is a driving force of the field. However, we must be careful when talking about this. It is often said that business and art are opposed to one another. Indeed, many believe that the more commercial art is, the less valuable it is as art. Some even believe that art must not be commercialized at all. I recognize that the two are at time opposed, but that does not mean that they cannot coexist. Just because art is commercialized does not take away its artistic value.

Have you ever wondered why it is that some people who have never watched kabuki nonetheless know the names of kabuki actors? The answer is simple: those actors also appear in movies and on TV. They often play in period pieces, and even in dramas set in modern times. Though there are a few artists from other traditional performance arts who appear in dramas like this, no other art boasts the number that kabuki does.

This is another important characteristic of kabuki—that many of its actors are popular figures who appear in other productions such as TV programs and movies.

Kabuki actors shoulder the heavy burden of a rich tradition but are at the same time highly popular figures widely known to the public. There are no other artists from other fields who appear on variety and quiz shows like kabuki actors do.

There are also some who come to the Kabuki-za Theatre in Tokyo and mistakenly assume it is a government-run establishment. It is in fact the Shochiku Company that runs Kabuki-za, making kabuki a truly unique hybrid—a traditional performance art and commercial show run as a private business.

歌舞伎の言葉

演目に関する言葉

【狂言】
能とともに上演される狂言。その狂言と全く同じ文字、同じ発音だが、歌舞伎関係者が狂言という時は、大概「演目」と同じような意味になる。「襲名披露狂言」「追善狂言」「狂言作者」など様々に使われる。

【みどり狂言】【通し狂言】
一日の内に数種類の演目を並べて上演する興行方法を、「みどり」「みどり狂言」という。見せ場を抜きだし並べることで、歌舞伎の持つ多彩な魅力が味わえる。漢字をあてれば「見取」で、より取り見取りのみどりだと言われている。これに対し、最初から最後まで、ストーリーを通して上演することを「通し狂言」「通し上演」という。

【純歌舞伎狂言】【義太夫狂言】【舞踊】
歌舞伎の狂言は、成立によって「純歌舞伎狂言」「義太夫狂言」「舞踊」に大別される。「舞踊」は「所作事」ともいい三味線音楽とともに発達した。また、人形浄瑠璃から移入した作品群を「義太夫狂言」や「丸本歌舞伎」などと総称する。「純歌舞伎狂言」というのは、歌舞伎のために書きおろされた演目のことである。

【和事】【荒事】
演技の様式。元禄期、京・大坂を中心とした上方と、江戸とで、それぞれ異なる芸が生まれた。上方では、後に「和事」と呼ばれる演技術が生まれた。優雅でやわらかい身のこなしが特徴。「荒事」は江戸で発達した芸で、「隈取」をはじめとする扮装や、「六方」などの演技により表現される豪快で力強い芸。

【活歴物】【散切物】
明治維新以降、時代の流れに乗り、それまでの荒唐無稽な作劇法ではなく、時代考証を重視し、史実に忠実な作品、「活歴物」が作られた。また、髷を切った散切り頭の人物が登場する「散切物」も創出された。どちらも明治の新時代に合わせ、従来の歌舞伎にはない新たな活動であった。

【新歌舞伎】【新作歌舞伎】【スーパー歌舞伎】
明治中期以降、外部の文学者・作家によって書かれた戯曲作品のことを「新歌舞伎」という。欧米の演劇や小説の影響を受けた作品が、近代的な演出で上演された。また戦後に新たに書かれた作品は、「新作歌舞伎」として区別されるのが一般的。さらに現代でも「スーパー歌舞伎」をはじめ様々な新しい試みがされている。

【時代物】
公家や武家の社会で起こった事件を題材にした演目をいう。狭義には平安中期から戦国期までの武将を主人公にした演目を指すが、平安以前の貴族社会を題材にした「王代(朝)物」、江戸時代の武家のお家騒動を題材にした「お家物」も含むことがある。
時に史実に大胆な虚構を加え、正史でない、歴史の裏側を描き出す。いわば江戸時代の庶民から見た歴史フィクション。登場人物は、名前こそ歴史上の人物だが、姿も行動もすべて徳川時代の人間の投影である。
豪華な衣裳、誇張された台詞など、いわゆる歌舞伎らしい演出が見られる。

【世話物】
「世話」とは、「世」間の「話」というほどの意味であり、世上に起こることは善悪を問わず題材となる。盗賊が主人公になる「白浪物」や、落語や講談の人情話を脚色した作品など様々な演目が含まれ、登場人物もアウトローや名もなき市井の人々といった同時代人。いわば江戸時代の現代劇である。江戸と上方で地域色あふれる演目が生まれ、今に伝承されている。
衣裳や台詞、演技も誇張の少ないものとなり、演者には、リアルな味わいが求められる。今や失われてしまった江戸時代の風俗習慣が舞台上で再現されることも楽しみの一つ。

【舞踊】
「歌舞伎踊り」から現在に至るまで、舞踊はレパートリーの大きな位置を占め、俳優は踊りの修練が欠かせない。もとは女方の専門領域であったが、やがて立役も踊るようになり、伴奏音楽の発展とともにレパートリーが広がった。音楽にのせ躍動的な動きを見せる舞踊の魅力に溢れる作品に加え、演劇的な構成と内容を持ち、かつ音楽的舞踊的な見せ場もある「舞踊劇」ともいうべき演目もある。長さも小品から大作まで多彩である。一人の踊り手が次々と様々な役を踊り分ける「変化舞踊」、能狂言の様式を取り入れた「松羽目舞踊」などがある。

【新作歌舞伎】
古典の継承と新作の創造は現代の歌舞伎の大きなテーマである。一見相反するように見えるが、どちらも歌舞伎の発展には欠かせない両輪である。新作は内容や表現に新たな地平を拓くとともに、新たな客層を開拓する役目をはたし、現代においても様々な新作が試みられている。古典様式に則った擬古典的な作品、現代の作家・演出家と組んだ作品、原作をマンガなどに求めた作品もある。埋もれた過去の作品を現代に合わせ再創造することも大きな意味での新作である。優れた新作は再演を重ね、やがて新たな古典となっていくのである。

俳優に関する言葉

【名跡】【襲名】【追善】
代々継がれていく名前を「名跡」という。名優の「名跡」はことに大切にされ、継いだ俳優も、名前にふさわしい名優にならなければならないとされる。名を名乗ることを「襲名」という。襲名披露の公演はことに華やかである。また亡くなった名優を偲ぶことを「追善」とよび、追善狂言もまた華やかである。みどりのうちの一本を追善狂言として上演することもある。襲名や追善は歌舞伎の活性化につながっている。

【屋号】【俳名】
歌舞伎の俳優はそれぞれ屋号を持っている。市川家の「成田屋」が始まりといわれ、初代團十郎が成田山を信仰したことに由来するといわれる。
また「俳名」を持つ俳優もいる。俳名とは俳句の号。俳句の趣味はなくても俳名を持つ俳優もあり、名跡同様継承されることもある。また、俳名を芸名として襲名することも多い。

【女方】【立役】【敵役】
女性の役、またはその役を演じる俳優を「女方」という。対して、男性役全体、または善人の役を主に演じる俳優、またはその役を「立役」という。本来は「敵役」に対する、善方の役を指す言葉だが、後に男性の役全般を表す言葉になった。

【家の芸】
俳優の家に代々伝えられた得意芸や演目を集めたもの。市川團十郎家の「歌舞伎十八番」「新歌舞伎十八番」が知られている。他に尾上

菊五郎家の「新古演劇十種」などがある。また、俳優一代の当たり役を集めることもあり、初代中村鴈治郎の当たり役を集めた「玩辞楼十二曲」、初代中村吉右衛門の「秀山十種」などがある。最も新しいものは平成22年に選定された「三代猿之助四十八撰」である。

演技に関する言葉

【見得】
演技のクライマックスで、一瞬動きを止め、その演技を誇張する手法。多くにらみを伴う。形により「元禄見得」「柱巻の見得」などの名前がある。

【立廻り】【立師】【とんぼ】【所作立】
劇中の戦いの場面を「立廻り」、立廻りを考案する担当者を「立師」と呼ぶ。立廻りの途中、切られたり投げられたりした者が空中で回転する動きを「とんぼ」、また、舞踊の中で、曲に合わせ演じる立廻りを特に「所作立」という。

【だんまり】
登場人物が暗闇の中で探り合う動きを様式的に表した場面。暗闇の場面であるが、照明は暗くせず、明るい中で演技される。

扮装に関する言葉

【隈取】
顔の筋肉を誇張したものとも血管を表したものともいわれる。役柄により色や形が異なり、主に赤（紅色）、青（藍色）、茶（代赭色—たいしゃいろ）の三色が用いられる。赤い隈は、若さや正義、力、激しい怒りなど発散する陽の力を表し、青い隈は邪悪や怨霊など陰の力を表現。茶色の隈は、人間に化けた妖怪変化などに使用される。隈取は、筆や指で直接顔に描く。これを「隈を取る」、という。

【ぶっかえり】【引き抜き】
「引き抜き」は、衣裳を一瞬にして変える仕掛け。舞踊で曲調の変わり目に、場の雰囲気を一変させたい時などに使われる。「ぶっかえり」は隠していた正体を現したり、性格が一変する際などに使われる技法。衣裳はその役の性格や境遇を表しているので、性格が変わったり、本名を名乗るなど境遇が変わると、当然衣裳も変わるというのが歌舞伎の考え方。その大胆なデザインや色遣いで、世界的にも評価されている歌舞伎の衣裳は劇的効果を高める役割も果たしている。歌舞伎では衣裳も芝居の一部なのだ。

【黒衣】
全身黒ずくめの着衣、またはそれを着ている人を「黒衣」という。歌舞伎では、黒で無を表すので、黒く塗られている、また、黒布で覆われたり、隠されているものは、ないもの、見えないものとする、という約束がある。ゆえに黒衣姿で舞台に登場しても、その人物はいない、見えないということになる。なお、通常「くろご」と濁って発音される。

音に関する言葉

【三味線音楽】
歌舞伎には三味線音楽が欠かせない。舞台に溢れる音のほとんどは、三味線の音色だ。戦国時代に琉球から伝来したというが、「お国歌舞伎」の後に取り入れられた。当時最先端の楽器だったのだ。やがて江戸時代の音楽は三味線抜きでは語れないくらいに広がりをみせる。ひと口にいっても、様々な流派があり、音域や表現方法、用いる楽器の大きさなども違う。歌舞伎では、「長唄」「義太夫節」「常磐津節」「清元節」などが多く用いられる。

【黒御簾音楽】
舞台に向かって左手、下手にある黒御簾と呼ばれる場所で演奏される音楽。中には、長唄と囃子の担当者がいて、舞台に合わせて音楽を演奏している。ここで演奏される音楽を黒御簾音楽といい、芝居を盛り上げるバックミュージックや、雨の音や雪の音などの効果音を演奏している。水、雨、雪、幽霊の出現などを太鼓で打ち分け表現するなど優れた工夫が伝承されている。

【柝（き）】
幕開きなどに鳴る拍子木。この拍子木は「き」と呼ばれ、舞台進行の合図である。開幕、閉幕、道具の転換などはこの「柝」の合図で行われる。ゆえに、舞台進行を担当する「狂言作者」が打つことになっている。

【ツケ】
上手、舞台に向かって右側で、拍子木のような棒を板に打ち付けてバタバタという音を出すのがツケ。立廻りや見得を引き立てる、一種の効果音。

【掛け声（大向こう）】
演技の途中に客席から掛かる声。観客が演者をほめる掛け声で、大向こうと通称されるが、本来大向こうというのは客席の一部を指す言葉である。掛け声は屋号のほか、代数などを掛ける。観客も一体となって芝居を作り上げているのだ。

舞台機構の言葉

【花道】
歌舞伎に欠かせない舞台機構の一つ。舞台の一部が客席を貫いて張り出し、主要な役の登退場に使われる。観客のすぐ近くを俳優が通ることで、客席と舞台に一体感が生まれる。時にはこの花道での演技が大きな見せ場になることもある。

【セリ】
舞台を四角に切り、昇降するようにした機構。上に人物や大道具を乗せて上げ下げする。花道のセリを特別に「スッポン」と呼ぶ。「セリ」「スッポン」を使用する演出も多い。

【廻り舞台】
舞台を円形に切り、回転するようにした機構。今では外国のミュージカルなどでも使われるが、発祥は日本。現在のような大掛かりな機構は250年ほど前の大坂で、世界に先駆けてつくられた。

【揚幕】
花道の突き当たりに吊ってある幕。この幕を開け閉めして、人物が登退場する。劇場の座紋などが染め抜かれていることが多い。

【定式幕】
黒色、柿色、萌葱色の三色の引幕。歌舞伎をイメージする色としてよく知られている。色の並びは劇場により異なる。江戸時代には幕府から認められた「大芝居」のシンボルであった。

Kabuki Glossary

Performance Terms

"kyogen"
Though "*kyogen*" originally refers to short skits performed together with noh plays, it is also often used in a kabuki context. In this case, "*kyogen*" simply refers to a program. *Shumeihiro-kyogen*, for example, refers to a program featuring an actor who is succeeding to another actor's stage name.

"toshi-kyogen" and "midori-kyogen"
A program which takes scenes from various plays to perform in a single day is called "*midori-kyogen*." The term "*midori*" refers to the action of selecting the best out of a pool of candidates, making a *midori-kyogen* program the perfect way to get a taste of the kabuki's great variety. "*Toshi-kyogen*," on the other hand, refers to a program that showcases scenes from a single play in a way that shows audiences the full story.

"jun-kabuki kyogen" / "gidayu-kyogen" / "buyo"
Kabuki plays can be classified into three broad categories: *jun-kabuki-kyogen*, *gidayu-kyogen*, and *buyo*.
"*Buyo*" is a type of dance-drama that developed in conjunction with shamisen music. Several sub-genres are included in the category of buyo. "*Henka-buyo*" is a variation in which a single actor performs multiple roles, while "*matsubame-mono*" are Noh plays that were adapted for kabuki. Kabuki plays that have been adapted from bunraku scripts are called "*gidayu-kyogen*" or "*maruhon-kabuki*."
"*Jun-kabuki*," or "pure kabuki," refers to plays originally written specifically for the kabuki theater.

"aragoto" / "wagoto"
These are contrasting acting styles that developed during the Genroku Period (1688–1704) in Kyoto/Osaka and Edo (Tokyo). The graceful *wagoto* style was developed in Kyoto and Osaka, while the rough *aragoto* style was developed in Edo. The wild *kumadori* makeup and dramatic *roppo* exit are characteristics of the vigorous *aragoto* style.

"katsureki-mono" / "zangiri-mono"
During the Meiji Restoration, the writing of *bunraku* and kabuki plays shifted from the absurd and comical to the historical, and these plays were called "*katsureki-mono*." Plays featuring characters sporting the *zangiri-atama* ("cropped head") hairstyle also appeared. These were called *zangi-mono*. Both forms were innovations to kabuki that had never been seen before the Meiji Period.

"shin-kabuki" / "shinsaku-kabuki" / "super kabuki"
"*Shin-kabuki*" (new kabuki) refers to plays written by non-kabuki writers from the mid-Meiji Period onward. These pieces were influenced greatly by western theater and novels and strived for a modern performance style. Plays written after the war are commonly called "*shinsaku-kabuki*" (contemporary kabuki) while "super kabuki" refers to experimental plays written very recently.

"jidai-mono"
Broadly defined as a play featuring historical events involving nobles or warriors, a "*jidai-mono*" is narrowly defined as a piece featuring a warrior hero from the Heian through the Warring States period. Pieces featuring nobles from before the Heian Period are called "*odai-mono*" or "*ocho-mono*," and those involving family disputes of warriors from the Edo period are called "*oie-mono*."
A feature of some *jidai-mono* is the inclusion of elements that are not true to history. This historical fiction of the people often features historical names whose appearance and actions are made to reflect those of the Tokugawa Period.

"sewa-mono"
"*Sewa*" refers both to "taking care of" someone and "worldly talk." Thus "*sewa-mono*" plays depict real-life events in the world without drawing conclusions about good and evil. Including "*shiranami-mono*" in which the knave is the hero, and dramatizations of heartwarming *rakugo* / *kodan* stories, sewa-mono feature casts of common folk and outlaws. *Sewa-mono* were created during the Edo Period and have been passed down to the modern day.

"buyo"
"*Buyo*" dance constitutes a large part of the kabuki repertoire and has been a feature of kabuki since the original *kabuki-odori*. Therefore any aspiring kabuki actor must practice dance. Originally only required of onnagata actors, eventually leading roles came to require dancing, expanding the repertoire together with developments in music. Over time more dramatic elements were added to kabuki along with the lively movements of the buyo dance. Still, there are "*buyo-geki*" which feature striking scenes in the *buyo* style. The length of a *buyo-geki* can vary from a short sketch to an epic, from the "*henka-buyo*" featuring a single actor playing multiple parts to the "*matsubame-buyo*" which take their cue from noh plays.

"shinsaku-kabuki" (contemporary kabuki)
A major issue in modern kabuki is the balance between traditional methods and the creation of something novel. Although these two may seem contradictory at first glance, they are both vital to the development of kabuki. The creation of new works paves the way for kabuki in the modern world and attracts new audiences. Some modern dramatists conform to classical formats, while others experiment by working together with other writers and actors. There are even cases of kabuki plays based on manga! Reproductions of forgotten plays is yet another form of *shinsaku* ("new production"). The best of these *shinsaku-kabuki* plays, after all, will eventually become the classics of tomorrow.

Terms Relating to Actors

"myoseki" / "shumei" / "tsuizen"
A name that is passed down from generation to generation is called "*myoseki*." *Myoseki* of great actors are particularly important, and their successors are under a lot of pressure to live up to that name. "*Shumei*" refers to the act of succeeding to another's stage name. Performances honoring such a succession are often particularly lavish to denote the occasion. "*Tsuizen*" refers to the memorial of a great actor who has passed away. *Tsuizen* performances are also very lavish, and occasionally portions of a *midori-kyogen* will be dedicated as a *tsuizen* performance. As such, *shumei* and *tsuizen* are often important catalysts for kabuki performances.

"yago" / "haimyo"
All kabuki actors have a *yago*, or stage name. The Ichikawa family, for example, used the name "Narita-ya" presumably because the first Danjuro believed in the faith of Mt. Narita.
There are also actors who possess a *haimyo*. Originally meaning a pen name for haiku poets, some actors also have a *haimyo*, which is sometimes passed on to a successor like *myoseki*.

"onnagata" / "tachiyaku" / "katakiyaku"
Both female roles and the actors who play them are referred to as "*onnagata*." Male roles in general and the actors who play them are called "*tachiyaku*." In a narrow sense, "*tachiyaku*" can also refer specifically to male protagonists. *Tachiyaku* was originally meant to contrast the term "*tekiyaku*" (villain) but is more often used to refer to male actors in general now.

"ie-no-gei"
Specialized arts and roles passed down within an acting family are called *ie-no-gei*. The *Eighteen Great Kabuki Plays* and *New Eighteen Great*

Kabuki Plays of the Ichikawa Danjuro family, and Onoe Kikugoro's *Ten New and Old Plays* are just a few examples. In some cases *ie-no-gei* can be a compilation of roles played by a single generation, as with the first Nakamura Ganjiro's collection, *Ganjiro's Twelve Selections*. The most recent example of this is *Forty-eight Selections of Ennosuke III*, which was compiled in 2010.

Performance Features

"Mie"
"*Mie*" refers to the dramatic pose taken by an actor at the climax of a play, often accompanied by a sharp glare. There are many varieties of mie, including *genroku mie* and *hashiramaki no mie*.

"tachimawari" / "tateshi" / "tonbo" / "shosa-date"
"*Tatemawari*" refers to fight scenes in kabuki plays, and "*tateshi*" refers to the actor who specializes in staging such scenes. When an actor is cut or thrown in a fight scene, the "*tonbo*" (flip) movement is used, and *tachimawari* scenes that are staged in sync with music are a type of *buyo* called "*shosa-date*."

"danmari"
"*Danmari*" refers to a scene in which characters are supposed to be in darkness. Though the stage lights are lit for the audience to see, the actors use a formal technique to seem as though they are groping in the dark.

Costumes and Cosmetics

"kumadori"
"*Kumadori*" makeup is meant to exaggerate facial muscles and/or blood vessels in the face. The color of *kumadori* can be red, blue, or green depending on the role. Red *kumadori* suggests youth, justice, power, and anger, and is used for righteous roles. Blue, on the other hand, is used to express vengeful spirits and evil. Green *kumadori* is used for spirits that have transformed into humans. *Kumadori* makeup is applied with brushes or directly with one's hand.

"bukkaeri" and "hikinuki"
"*Hikinuki*" refers to a dramatic, instantaneous costume change. A *hikinuki* occurs together with a musical shift to completely alter the mood of a scene. "*Bukkaeri*" also refers to a costume change in which a character reveals his/her true identity or undergoes a change in character. In kabuki, a costume is an expression of a character's personality, so it is common sense that a change in character or name would result in a costume change. This bold aspect of kabuki design serves an important role in productions and is widely acclaimed around the world. Costumes are thus an integral part of kabuki.

"kurogo"
"*Kurogo*" refers to an actor who wears all black or to the costume itself. Black represents nothingness in kabuki, and therefore any character or thing that is painted or clothed in black is meant to be invisible or nonexistent. Therefore, if you see a character wearing all black appear on stage, he is meant to be ignored as though he does not exist in the world of the play.

Musical / Audial Terms

"shamisen ongaku"
"*Shamisen ongaku*," or "shamisen music," is an integral part of kabuki that makes up most of the music in kabuki. This music which came from the Ryukyu Islands during the Warring States period, was incorporated after the original *okuni-kabuki*. It was the premier instrument of its time and had become completely inseparable from kabuki by the Edo period. There are several different styles of music and sizes of shamisen instruments, and kabuki uses a great number of these, including the "*nagauta*" and "*gidayu-bushi*."

"kuromisu-ongaku"
This refers to the music played in the pit ("*kuromisu*") located in a corner of the left-hand side of the stage. The conductor makes sure the music is in sync with the play, guiding both the dynamic background music and sound effects such as rain and snow. The orchestra uses a number of traditional techniques, such as the striking of the taiko drum when the weather changes or an apparition appears.

"ki"
"*Ki*" are simply wooden clappers used at the opening of the curtain and other pivotal moments during a play, such as the lowering of the curtain and changing of the set. The actor in charge of the "*ki*" is called the "*kyogen-sakusha*."

"tsuke"
"*Tsuke*" refers to the sound effect produced by striking wooden clappers against a board on the right-hand side of the stage. It is used to emphasize the *tatemawari* and *mie*.

"kakegoe" ("omuko")
"*Kakegoe*" refers to a shout by audience members in the middle of a performance. It is commonly called "*omuko*" (referring to a portion of the audience) and is meant as a form of praise to the actor. Calling an actor's *yago* or succession number is a common form of *kakegoe*. It is meant to include the audience as a participant in the production.

Stage Mechanisms

"hanamichi"
The "*hanamachi*" is an indispensable part of kabuki. It is a piece of staging that juts out into the isles between the audience's seats and is used for entrances and exits of important characters. By having the actors pass right through the audience, the hanamichi creates a sense of unity between the audience and the stage. Some plays even feature important scenes performed on the *hanamichi*.

"seri"
"*Seri*" simply refers to a rectangular lift used to raise and lower the stage or portions of the stage. A lift used for the *hanamichi* is called a "*suppon*," and many kabuki performances utilizes either one or both of these mechanics.

"mawari-butai"
"*Mawari-butai*" refers to a stage cut into a circular pattern to allow it to rotate. Many musicals around the world now use such a mechanism, but it originated in Japan. The first time a large-scale mawari-butai was ever used was in Osaka 250 years ago.

"agemaku"
The "*agemaku*" is the curtain that hangs down at the end of the *hanamichi*. It is opened and closed in conjunction with entrances and exits of important characters and often bears the theater's crest.

"joshiki-maku"
The "*joshiki-maku*" is a unique and well-known feature of kabuki. It is the main stage curtain and consists of 3 colors: black, reddish-brown (*kaki-iro*), and green (*moegi-iro*). The order of these colors differs depending on the theater. This style of curtain was officially recognized as a symbol of a major theater by the government of the Edo period.

付録　隈取一覧　　　　　　　　　　　Kumadori

筋隈 すじぐま / Sujiguma*

超人的な力強さを備え、激しいエネルギーを発する正義の側の人物にしばしば用いられる。梅王丸（『菅原伝授手習鑑 車引』）、曽我五郎（『矢の根』）など。赤い隈（紅隈）は、主に力強さ、若さ、血気などを表す。

This mask is often used for characters on the side of justice possessing superhuman power and energy. Used for Umeomaru ("Sugawara Denju Tenarai Kagami Kurumabiki") and Soga Goro ("Ya no Ne") etc. Red kuma (crimson kuma) mainly express power, youthfulness, and passion.

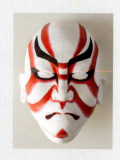

むきみ隈 むきみぐま / Mukimiguma

目元にのみ施す隈。血気、力強さなどとともに、二枚目の要素をもあわせもつ人物に用いられることが多い。桜丸（『菅原伝授手習鑑 車引』）、助六（『助六』）など。

Kuma are only found around the eyes on this mask. This kuma is used for characters who posess both passion and strength, such as Sakuramaru in Sugawara and the Secrets of Calligraphy.

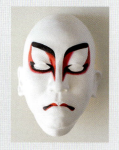

一本隈 いっぽんぐま / Ipponguma

血気、力強さを備えた若い荒武者の役に用いられることがある。梅王丸（『菅原伝授手習鑑 賀の祝』）など。

This mask is sometimes used for the role of a young warrior with passion and physical strength. Used for Umeomaru in Sugawara and the Secrets of Calligraphy.

二本隈 にほんぐま / Nihonguma

比較的珍しい隈。松王丸（『菅原伝授手習鑑 車引』）に用いられる。

This mask is fairly unusual. It is used for Matsu Ohmaru ("Sugawara and the Secrets of Calligraphy").

猿隈 さるぐま / Saruguma

額に複数の横筋を描いた隈。力強さとともに、おどけた人柄を表している。小林朝比奈（『寿曽我対面』など）に用いられる。

This mask features several horizontal kuma lines on the forehead. It indicates a strong and jocular character such as Kobayashi Asahina in "The Soga Confrontation."

弁慶 べんけい / Benkei *2 kinds (1 and 2)

源義経の豪勇無双の忠臣・武蔵坊弁慶の隈。『御所桜堀川夜討 弁慶上使』『義経千本桜 鳥居前』で用いられる（1）。また別の演目では、やや異なる形の隈がみられることもある（2）。あごや口のまわりの淡い青は、濃いひげを表したものと考えられ、勇猛で男性的な弁慶の人物像を感じとることができる。

Minamoto Yoshitsune's courageous and matchless loyal retainer Musashibo Benkei's kuma. Used for *Gosho Zakura Horikawa Youchi, Benkei Jou no Dan*" and "*Yoshitsune and the Thousand Cherry Trees*" (1). In other programs somewhat different forms of kuma can be seen (2). The pale blue around the chine and mouth is meant to be a dark beard, giving audiences the impression that Benkei is truly a brave and masculine character.

1　　2

奴 やっこ / Yakko

武家の従僕である「奴」の役に見られる隈。左右へはね上げた「鎌ひげ」が特徴的。

The *kuma* for this mask is used for characters playing the role of an attendant or servant of a samurai. This mask is characterized by the sickle-shaped moustache turned up on the left and right.

火焔隈 かえんぐま / Kaenguma

炎を思わせる曲線を描いた隈。精霊などに用いられる。源九郎狐(『義経千本桜 鳥居前』)が代表例。

Kuma drawn as curves reminiscent of a flame. It is used for spirits and the like. Genkurou Gitsune ("*Yoshitsune and the Thousand Cherry Trees*") is a typical example.

公家荒 くげあれ / Kugeare (2 varieties)

天皇の位を奪おうともくろむ、皇族や公家の極悪人に用いられる隈。「公家荒」の青(藍)は、冷酷さ、邪悪さ、さらには妖気を表す。役や俳優により、いくつものパターンがある(1:藤原時平『菅原伝授手習鑑』)(2:蘇我入鹿『妹背山婦女庭訓』)。

This *kuma* is used for villains that are from the royal family or court nobles that endeavor to usurp the Emperor. The blue (indigo) of *kugeare* represents coldness, evilness, and even spirited vibe. There are several patterns depending on roles and actors (1: Fujiwara Tokihira "*Sugawara and the Secrets of Calligraphy*") (2: Soga no Iruka "*Imoseyama Onna Teikin*").

 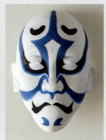

1 2

平知盛の霊 たいらのとももりのれい / Taira no Tomomori no Rei

『船弁慶』に登場する、平家随一の勇将・平知盛の霊に用いられる隈。平家一門の仇・源義経に、怨霊となって襲いかかる知盛の執念や妖気を表す。

Used for the spirit of the famous Heike warlord Taira no Tomomori (Funa Benkei). It evokes the otherworldly mood of the revengeful spirit that attacks Yoshitsune, the Taira clans enemy.

般若 はんにゃ / Hannya

鬼女と化した女性の、すさまじいねたみや復讐の念に燃えるさまを表した、能の面「般若」を思わせる。

This mask is reminiscent of the noh mask called "*Hannya*," which represents a woman turned into a devil, consumed by envy, and obsessed with revenge.

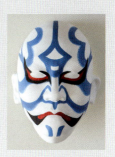

土蜘 つちぐも / Tsuchigumo

『土蜘』に登場する土蜘の精の隈。僧侶に化けていたところを見破られたのち、妖怪の本性を現した時に用いる。黛赭(たいしゃ・茶色)の隈は、主に妖怪変化に用いる。

This is the *kuma* of the ground spider that appears in *Tsuchigumo*. It is used to show the true nature of a phantom after its disguise as a monk is revealed. The mayuzumi (brown) *kuma* is mostly used when characters change into phantoms.

茨木 いばらき / Ibaraki

『茨木』に登場する妖怪・茨木童子の隈。切り落とされた腕を奪い返すため老婆に化けていた茨木童子が、本性を現した時に用いる。

This *kuma* is used for the phantom Ibaraki Doji that appears in "Ibaraki". This mask is used to show the true nature of Ibaraki Doji, who turns into an old woman to take back her arm that was severed.
* (the term "kuma" stands for the makeup seen on each mask)

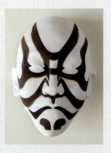

歌舞伎名演目
世話物

監修　松竹株式会社
発行日　2019年3月31日　第1刷

デザイン	TAKAIYAMA inc.
イラスト	大津萌乃
執筆・原稿提供	松竹株式会社　演劇ライツ室 （概要・あらすじ・歌舞伎の言葉・隈取一覧） 金田栄一（登場人物） 関根和子（みどころ） 元禄鯨太（演目紹介・歌舞伎の歴史・歌舞伎の見方）
監修協力	松竹衣裳株式会社 歌舞伎座舞台株式会社
写真	松竹株式会社　演劇ライツ室
写真協力	公益社団法人　日本俳優協会
翻訳	クリストファー・E・ザンブラーノ
校正（日本語）	みね工房
校正（英語）	アーヴィン香苗
編集	碓井美樹（美術出版社）
印刷・製本	凸版印刷株式会社
発行人	遠山孝之、井上智治
発行	株式会社美術出版社 〒141-8203 東京都品川区上大崎3-1-1 目黒セントラルスクエア5階 Tel. 03-6809-0318（営業）、03-6809-0542（編集） 振替　00110-6-323989 http://www.bijutsu.press

禁無断転載
落丁、乱丁本、お取り替えいたします。

松竹株式会社
明治28（1895）年創業。映像事業、演劇事業、不動産・その他事業の3つを主体とする、総合エンターテインメント企業。

ISBN978-4-568-43107-0 C0074
© Shochiku / BIJUTSU SHUPPAN-SHA CO., LTD. 2019
All rights reserved Printed in Japan

KABUKI GREATS
Domestic Dramas

Supervised by SHOCHIKU
The First Edition Published on March 31, 2019

Designer	TAKAIYAMA inc.
Illustrator	Moeno Ootsu
Manuscript	SHOCHIKU Co., Ltd. / Play Rights Division (Overviews, Synopses, Kabuki Glossary / Kumadori explanation) Eiichi Kaneda (Characters) Kazuko Sekine (Highlights) Geita Genroku (Introductions, The History of Kabuki, How to Watch Kabuki)
Editorial Assistance	SHOCHIKU COSTUME KABUKIZA BUTAI
Photography	SHOCHIKU Co., Ltd. / Play Rights Division
Photography Assistance	Japan Actors Association
Translator	Christopher E. Zambrano
Proofreader (Japanese)	Mine Kobo
Proofreader (English)	Kanae Ervin
Editor	Miki Usui (BIJUTSU SHUPPAN-SHA CO.,LTD.)
Printing and Binding	TOPPAN PRINTING CO., LTD.
Publisher	Takayuki Toyama, Tomoharu Inoue

Published by BIJUTSU SHUPPAN-SHA CO.,LTD.
MEGURO CENTRAL SQUARE 5F, 3-1-1
Kamiosaki, Shinagawa-ku, Tokyo 141-8203 Japan
Tel. 03-6809-0318 (Sales), 03-6809-0542 (Editorial)
Transfer account 00110-6-323989
http://www.bijutsu.press

All Rights Reserved
We will happily replace any copy of this book that contains missing pages or pages bound out of order.

SHOCHIKU CO., LTD.
Est. 1895, Shochiku is a general entertainment enterprise consisting of the three primary divisions of Motion Picture, Theater, and Real Estate among other divisions.